MASS
EFFECT

Critical Anthologies in Art and Culture
Johanna Burton, series editor

.........

Mass Effect: Art and the Internet in the Twenty-First Century,
edited by Lauren Cornell and Ed Halter

MASS EFFECT

ART AND THE INTERNET
IN THE TWENTY-FIRST CENTURY

EDITED BY LAUREN CORNELL AND ED HALTER

The MIT Press / Cambridge, Massachusetts / London, England

This book was set in Chaparral and PF Din by The MIT Press. Printed and bound in the United States of America.

Library of Congress Cataloging-in-Publication Data

Mass effect
Mass effect : art and the internet in the twenty-first century / Edited by Lauren Cornell and Ed Halter.
pages cm.—(Critical anthologies in art and culture)
Includes bibliographical references and index.
ISBN 978-0-262-02926-1 (hardcover : alk. paper)
1. Art and the Internet. I. Cornell, Lauren, editor. II. Halter, Ed, editor. III. Title.
NX180.I57M275 2015
776—dc23
 2015001909

10 9 8 7 6 5 4 3 2

CONTENTS

Between 1984 and 2004, the New Museum produced six anthologies under the series title "Documentary Sources in Contemporary Art." Initiating these books was *Art After Modernism: Rethinking Representation* (1984), a volume that, some thirty years after its appearance, continues to stand as a model for what it looks like to consider and reflect upon a historical moment even as it unfolds. Indeed, the pivotal nature of that book, and those that followed, evidenced a new model for scholarship within the purview of a contemporary art museum. Taking the art sphere (and its attendant discourses) as a nodal point by which to investigate larger culture, *Art After Modernism* gave shape and visibility to an arena of debate. The broad questions being considered—Were modernism's effects truly waning? What movements or reorientations were replacing its foundation?—found provocative, pointed answers in wide-ranging texts by equally wide-ranging authors. In today's much-changed context, the seminal arguments that appear in *Art After Modernism* are often discussed as having produced their own foundation, now itself in the process of being productively overturned.

Our decision to reinvigorate the series in the year 2015, under the new rubric "Critical Anthologies in Art and Culture," came out of discussions with museum and academic colleagues, with students, and with artists, all of whom expressed a hunger for platforms that equally prioritize debate and experimentation. Rather than focusing on topics around which there is already broad consensus, these books aim to identify and rigorously explore questions so salient and current that, in some cases, they are still unnamed, their contours in the process of being assumed. To that end, the series aims less to offer democratic surveys of themes under consideration and rather hopes to stage arguments and offer conflicting, even contrasting, viewpoints around them.

The role of art has substantially, perhaps fundamentally, shifted in the last several decades. What has not changed, however, is its ability to channel,

magnify, and even alter the ways we approach the world around us. The increasing speed and density of cultural information ironically create an even greater need for the kind of rigorous and sustained engagement that the Critical Anthologies volumes set forward as their ultimate priority. These books serve to underscore the importance of intellectual endeavors as political and ideological acts. We hope they will become, like their predecessors, invaluable documents of our histories as we come to make them.

.

Johanna Burton, Series Editor
Keith Haring Director and Curator of Education and Public Engagement

The impact of the internet and, more generally, of digital technology on both contemporary life and culture has profoundly altered our world. Indeed, the infiltration of the digital into every facet of our lives—whether through smart phones, which give us the ability to communicate with nearly anyone at any time, or by virtue of surveillance and information-sifting algorithms that have erased traditional divisions of public and private—has ushered in a new age that defines this century. And yet the path of artists making work in response to these vast changes is largely uncharted or, more accurately, given over to so many false histories, overlooked legacies, and general misperceptions. This book is the first resource of its kind to bring together primary research on the ever-evolving relationship between art and technology in the new millennium.

Anyone reading the current volume will, in fact, recognize that the themes put forward by *Mass Effect* are anything but technocentric by ordinary standards. Instead, they summon questions that are historical in nature, even while utterly specific to our times: What is the status of the artist studio in an era of total interconnectivity and online production? How should we think about authorship and identity in the context of crowdsourcing and online communities? Furthermore, where should we draw the boundaries of the art world when artists are increasingly apt, with each new generation, to circulate their work on platforms far removed from traditional institutional frameworks? The present volume brings together so many of the artists, curators, art historians, and other, more hybrid, figures who have been devoted to plumbing such matters, and collectively they offer us an astonishing portrait of debates around art and technology. As important, they provide us with the terms for a richer debate during the years ahead.

The publication of this anthology marks the first in our revival of a series that was active between 1984 and 2004, during which time six seminal volumes

were coproduced by the New Museum and the MIT Press. We are delighted to resume this partnership, which marks a shared commitment to the field of contemporary art as a primary platform for scholarship, intellectual exchange, and the evolution of new ideas. Our sincere thanks go to Roger Conover, Executive Editor at the MIT Press; we couldn't imagine a better—and more historically appropriate—collaborator on these books. Roger helped steer the first series of books we did together, and we so value his partnership. We are also enormously grateful to the Andrew W. Mellon Foundation, Earl Lewis, President, and Mariët Westermann, Vice President, for their generous support of these books and the related research initiatives that will fuel their production.

My deepest thanks go to Lauren Cornell, Curator and Associate Director, Technology Initiatives, and writer and curator Ed Halter, coeditors of this volume, which goes further than any existing narrative in chronicling and analyzing the last fifteen years' generative intersections between art and technology. As Cornell and Halter note in their introduction, the rapidly shifting stakes for engaging technology—to say nothing of the advanced tools that allow for such engagement—offer a case study that marks radical shifts not only in the art world but also well beyond. The deftly chosen roster of texts collected and commissioned within these pages offers a portrait of a cultural moment as it emerges and evolves in real time. We could not be more proud to have fostered many of these debates within the Museum and, of course, in collaboration with our affiliate partner Rhizome (directed by Cornell from 2005 to 2012). Heather Corcoran, Executive Director of Rhizome, and Michael Connor, Editor and Curator of Rhizome, have been wonderful colleagues and champions as we've developed this volume, with its aims so deeply tied to their own work and community.

Johanna Burton, Keith Haring Director and Curator of Education and Public Engagement, is the series editor for our relaunched Critical Anthologies. Her initiative, intelligence, and dedication in conceiving the structure for these books and overseeing every aspect of their production have been—and will continue to be—fundamental to their realization.

Many other members of the Museum's staff have been fundamentally and enthusiastically involved in every step of this book's publication, contributing not only in terms of sheer labor power but with unquantifiable excitement and belief as well. Particularly deserving of thanks are Frances Malcolm, Editor and Publications Coordinator, who brought this project to a higher level through her precise and thoughtful attention to every one of its elements; Sara O'Keeffe, Assistant Curator, who assisted on virtually every aspect of this volume's creation; and Kaegan Sparks, Publication Associate, whose tireless efforts securing rights, transcribing audio files, and offering editorial support literally helped to hold

the project together. We also wish to acknowledge our wonderful intern, Lexi Kaplan, whose important contributions to this volume are evident throughout.

Others within the Museum who assisted on this project should be mentioned, and our appreciation conveyed to them. Olivia Casa, Assistant Editor, provided important copyediting and proofreading support throughout the process. Alicia Ritson, Research Fellow, and Taraneh Fazeli, Education Associate, jumped in at critical moments during the book's production. Curatorial interns Jordan Barse, Leyla Hamedi, and Elizabeth Lorenz also all provided crucial assistance to the project at various stages of its development. Karen Wong, Deputy Director, was instrumental in advancing discussions about reviving this series, and Massimiliano Gioni, Artistic Director, and Regan Grusy, Associate Director and Director of Institutional Advancement, lent their support in many ways as well.

At MIT, in addition to Roger Conover, we extend our thanks to Ariel Baker-Gibbs and Justin Kehoe, with whom we have worked with great synergy on the preparation of the manuscript as well as Emily Gutheinz for her design for this and future volumes in the series.

Finally, we are most grateful to the artists and writers represented in this volume, all of whom, in addition to contributing texts, images, and other materials, had a tremendous desire to see this book come into being. The essayists who wrote new texts or agreed to have previously published texts contextualized within this new framework provide key insights into the topic under discussion and, together, make an essential, groundbreaking contribution to the dialogue. Their work and thinking continue to lead us toward compelling new futures.

.........

Lisa Phillips
Toby Devan Lewis Director

Lauren Cornell and Ed Halter

Today, there is widespread confusion and debate around art engaged with the internet, and even whether such a category remains valid. This is understandable, given how digital technologies have become part of everyone's lives in the form of ubiquitous computing and 24/7, always-on connectivity. Before the advent of the new millennium, "new media art" constituted a specialized genre, at times arcane to non-practitioners; now, virtually every field of cultural activity has been altered by changes in networked technology, and the conception, production, and distribution of art have proven to be no exception. This rapid sea change is partly cause for the hasty adoption of dubious catchphrases like "the new aesthetic" and "postinternet art," which remain current as we go to press.

Mass Effect was motivated by the desire to provide historical background to this complex moment by collecting and commissioning scholarship, criticism, and original documentation that deal with how art and artists have functioned in this accelerated environment. While bracketing generations can lead to oversimplification, we feel it is important to focus on artistic practices at the forefront of this conversation from roughly 2002 onward, rather than those of the first generation of net.art, which have already been extensively historicized.[1] Broadly speaking, this subsequent generation could be described as the first to respond to the internet not as a new medium, but rather a true *mass medium*, with a deeper and wider cultural reach, greater opportunities for distribution and collaboration, and advanced corporate and political complexities. With *Mass Effect*, our ambitious goal is to reset the conversation on art's relationship to the internet by focusing closely on the lessons of its recent history.

This volume brings together some of the most crucial essays, artistic practices, and debates of the last decade, along with new commissioned writings that reflect back upon the same time period. The essays are ordered within this collection so

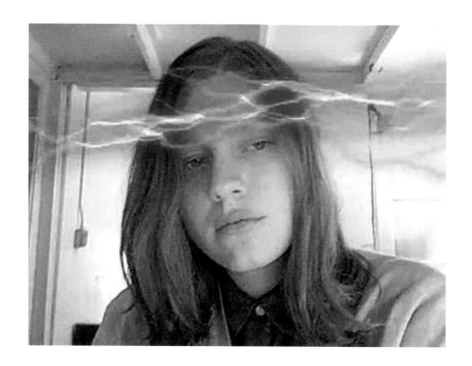

Petra Cortright, *VVEBCAM*, 2007 (still).
Webcam video; 1:43 min. Courtesy the artist

that their subjects form a chronological arc through these inquiries. We've placed prominent theorists alongside writings by artists, many of whom have never appeared together in the same collection, despite clear affinities. As partial explanation of the selections we've made, we should make clear that we, the editors, were active participants in this second generation, both in our professional roles and in our inevitably intertwined social lives: Lauren Cornell as Curator at the New Museum and former Director of Rhizome; Ed Halter as a critic, staff writer for Rhizome, and Founder of Light Industry; and both as educators at Bard College. We have collaborated with many of the artists and writers featured here; with some we have had deep and long-lasting friendships, while others we have admired and followed from a distance. These biographic realities have inevitably shaped our outlook on the subject of art's relationship to the internet. More importantly, our attempt to grant a coherent narrative to this expansive era has been informed by a cluster of evolving questions that we and the contributors in these pages have thought about and discussed for years.

What is the legacy of net.art within our new technological paradigm? How can artists adapt and assimilate to social media and the democratization of "creativity"? Has the web-savvy user of the 1990s been sidelined in favor of the creative consumer? How do artists wrestle with the realities of surveillance and data-mining, which have arrived hand-in-hand with greater freedoms and openness in culture? How have self-identification and representation evolved in contemporary culture, where the multicultural goal of achieving visibility has become inflected by the anxiety of being overseen? How can we retrieve, experience, and study art operations that anticipated our current mass tools, when changeovers in formats and platforms can make the past unreadable?

DISTRIBUTED HISTORIES

"Originally conceived as an alternative social field where art and everyday life were merged," Rachel Greene observed a decade and a half ago, "net.art may now seem threatened by its own success—that is, likely to cede a degree of its freewheeling, antiestablishment spirit as it is further brought into the institutional fold."[2] Appearing in the conclusion to her influential article "Web Work: A History of Internet Art," these words were published in the May 2000 issue of *Artforum*, even as the dot-com bubble that had magnified interest in new media art was in the midst of a rapid and dramatic deflation. And net.art's place in the art world, as it turned out, wasn't as certain as it may have seemed when the twenty-first century began.

One issue quickly became apparent: museums and galleries in the first decade of net.art had failed to successfully integrate internet-based practices into traditional art spaces. Despite best intentions and forward-looking curatorial ideals, trailblazing early exhibitions[3] were often based around awkward situations of exhibition: screens sequestered in dim "media lounges," commissioned online projects that felt disconnected from larger museum programming, desktop computers plopped in gallery spaces where viewers were uncomfortable touching artworks—or where they might simply be used to check email. So, for many reasons, artists devoted to the internet entered the new millennium with a certain amount of frustration with how institutions had attempted to embrace their work. How the greater art world would deal with internet art remained an open question at the beginning of the twenty-first century (as did, moreover, the question of what continued role the internet would play in culture), and soon, propositions would be offered by a new generation of artists.

Take, for instance, the examples set by three very different figures that emerged early in this decade: Cory Arcangel, Seth Price, and Paper Rad. In 2002, the artist Arcangel, then just out of college, uploaded a video file with open-source code called *Super Mario Clouds* to his personal website. Arcangel had hacked a Nintendo cartridge to create the work; in his words, he had "reverse-engineered" the cartridge so that its iconic bouncing mushrooms, grassy knolls, and indefatigable protagonist, Mario, were erased, leaving only scrolling white clouds on a blue sky. In its earliest iterations, *Super Mario Clouds* was meant to be shared with the artist's peers and anyone who might be interested in hacking 8-bit Nintendo cartridges, but it gained critical attention quickly. In 2003, Arcangel presented the work at Team Gallery in New York as a multichannel video projection, running off its doctored Nintendo box, which was also on view.[4] This same configuration was shown one year later in the 2004 Whitney Biennial—a moment that signaled the presence of an emergent generation of artists that was not only familiar with video and new media art but had also grown up with gaming, personal computers, and the nascent web of the mid-'90s. Arcangel was well aware of the early days of net.art, which he first came to love while in college, and has often cited the Belgian-Dutch duo JODI as his long-standing artistic heroes.

The same year Arcangel uploaded *Super Mario Clouds'* source code, Price published the first version of his essay "Dispersion." Originally trained in the media arts, Price up to this point had exhibited primarily in film and video contexts with his early moving-image works. But "Dispersion" highlighted his growing interest in exploring new forms of file-sharing on the internet as a source and context. In 2001, he had released the album *Game Heaven*, collecting often anonymous video-game soundtracks from fan communities online as

an experiment in what he would come to call "redistribution"; in the next few years, as the major agents of file-sharing migrated from the doomed Napster to a multiplicity of torrent aggregators like The Pirate Bay, Price enacted similar operations on a number of other marginal and maligned musical genres—New Jack Swing, Industrial, early academic experiments with synthesizers—using his online research to produce CD and cassette compilations, writings published in music magazines, gallery exhibitions, and his personal website, distributed history.com. In doing so, he enacted in practice what his "Dispersion" explored in theory: how an artist might exist outside the confines of the art world, tentatively proposing that an answer might lie in the distribution networks of mass culture, which now included the internet.

The trio known as Paper Rad—composed of brother and sister Jacob and Jessica Ciocci as well as Ben Jones, all artists and musicians—founded its website in 2001. Paperrad.org featured an original cartoon cosmos that jittered and thumped within a kind of visual rave, a pulsating low-fi tapestry of animated characters that emerged from the zine aesthetics of DIY art scenes in places like Providence, Rhode Island, as well as the graphic design and user expression of the '90s web. Paper Rad evolved from printed comics and music to encompass digital animation, MIDI files, videos, installations, live performance, and books, all of which revolved around its website, which drew an international readership. The group's distinctive style and forward-looking approach to media circulation positioned it on the border between two cultural time zones—the artistic subcultures of the '90s and the social web. In his essay "coming soon: ebay blogs paypal the internet," Arcangel, one of the trio's peers and early collaborators, discusses how Paper Rad members' powerful "refusal to distinguish between hierarchies of distribution eventually led them to infiltrate nearly every level of popular culture" and, simultaneously, "led to their work slipping out of the art historical discussion" because of the art world's "limited amount of patience for practices that color outside the lines of its own dialogue."[5]

Arcangel, Price, and Paper Rad all showed that the either/or choice posed by Greene in 2000—net.art's institutionalization vs. its continued underground existence—proved premature. The future of net.art would be the dispersion of the category's legacy into a wide range of practices: open-source sharing, gallery installations, live performances, cinema screenings, talks, and publications. *Super Mario Clouds*, Price's PDF "Dispersion," and paperrad.org crystallized the multi-platform approach to internet art that became the dominant paradigm in the '00s, mobilizing online audiences and traveling through the contemporary art world in the form of established disciplines like video installation, performance, photography, or sculpture. This diversity and multiplicity was at play

in earlier manifestations of networked art, for instance in the work of Eva and Franco Mattes, who have worked within a similarly expansive logic since '95 and are examined in an essay within this collection by Domenico Quaranta.[6] Outside of an ongoing commitment to the web centrally as a site of creation and exhibition by artists, what is formally distinct in this period is that the presence of the network (a computer, a browser, a mouse) diminishes in lieu of installations that invoke the internet or online culture through their materials and underlying concepts. Today, we have arrived at a "poststudio" situation for artists, where, as John Kelsey says in his essay "Next-Level Spleen," the imperative is "to go mobile, as a body and a practice" and production is dispersed across discussion, exhibition, and publicity: "the laptop and phone have already supplanted the studio as primary sites of production."[7]

THE SOCIAL NETWORK

Net.art of the 1990s had always clustered around online communities—indeed, it could easily be argued that the discussions that took place on Nettime, Rhizome, and The Thing constituted the movement's most central activity—but the intense, interpersonal experience of a social web soon became part of global culture at large. Consider a brief timeline of major platforms founded in the first decade of our century: Wikipedia (2001); Friendster (2002); Blogger (2003); Myspace (2003); Second Life (2003); Facebook (2004); Flickr (2004); Reddit (2005); YouTube (2005); iPhone (2007); Twitter (2007); Tumblr (2007); Grindr (2009); Instagram (2010). Blogs, wikis, social media applications, and other forms of networked social life have become commonplace sites of personal and professional expression. These inventions have radically changed popular culture and our personal lives, wrenching us out of the broadcast television era and into a more democratized media condition. Each, however, has risen so rapidly that it's unclear how these platforms have affected our interactions with one another, what kinds of materials we choose to share, and how we imagine ourselves.

Artists who emerged in the '00s took on these central questions as they exchanged links, created photo-blogs, aggregated digital folk art,[8] performed on YouTube or in virtual worlds, and published texts via social media. Long-held fantasies of a more participatory media era, imagined by early electronic artists like Nam June Paik, Marta Minujín, or the Videofreex, as well as by net.artists of the '90s who first identified the web as a fraught but radically more horizontal cultural space, have arrived, and yet with vastly greater complexity than could

have been previously understood. In the essay "Arcades, Mall Rats, and Tumblr Thugs," Jesse Darling explores how the current landscape of social media differs markedly from the early hopes that its interactive nature would "empower" a new generation of engaged reader-writers. "Social media is to the read/write web what sprawl is to the metropolis of modernity," Darling offers, "a homogenous, cancerous, rhizomatic junkspace that expands exponentially outward on a sludgy wave of strip malls and sponsored links, greed and induced demand."[9] For Darling, one of the most prominent London artists engaged with the internet, this virtualized "junkspace" is also *home*: Darling's writings reflect an adolescence spent on Myspace or AOL chat—the commercialized spaces that now dominate the once utopian "cyberspace."[10]

Original contributions included in this volume by Caitlin Jones and Ceci Moss explore ways artists employed commercial platforms to share conceptual strategies and hash out aesthetic interests.[11] Primarily visual, these forums notably lacked the overt critical dialogue so fundamental to net.art, favoring instead modes of expression that were more oblique but no less potent. In her conversation with artists Aleksandra Domanović and Oliver Laric, Jones focuses on the impact of their blog *VVORK*, active from 2006 to 2012, on which they posted daily selections of art documentation that wordlessly editorialized on thematic and formal aspects through visual juxtaposition. A selection of works presented on *VVORK* in August 2010 demonstrates the breadth of form and approach seen on the site: *Rock My Religion* (1982–84) by Dan Graham; *Marble Ass* (1995) by Želimir Žilnik; *Ambiguous Gestures* (2004–09) by Felix Gmelin; *Gleaming the cube (press kit)* (2006) by Marius Engh; *Every Phrase and Every Sentence is an End and a Beginning* (2009) by Lorna Macintyre; Untitled (2009) by Marlie Mul; and Untitled (2010) by Damon Zucconi.[12] *VVORK* became a beacon for artists around the world, an invaluable resource to see work from the perspective of voraciously curious and diligent artists clearly tracking two major underlying questions throughout the website's five-year run: First, how does the increasingly prevalent method of encountering art through digital images, i.e., scaled to fit and lacking broader context, affect our perception of art? And, second, how might their own artistic practices and those of their internet-aware peers fit into a wider, international art history? *VVORK* preceded the vast prevalence of image-sharing services today, like Instagram, and news sites, like *Contemporary Art Daily*, through which artists and art professionals alike research, discover, and share art. Reflecting back on the project, Domanović states: "*VVORK* and the kind of logic around it influenced the way I made art. I realized that many of my own projects had the same methodology of researching (surfing), finding the right combinations, archiving, and finally redistributing."[13]

Moss gives a brief history of how, between 2006 and 2008, artists ran their own websites for exhibition and community, conceiving of experimental designs that bucked the sterile conventions of white cube–style gallery websites. One core platform of this time came to be known as the "surf club," in which artists collectively shared and commented on digital folk art—strange GIFs, previous eras' web graphics, advertising or branding fails, intriguing textures or chat poetics. The practice of surfing was a way to process and synthesize the emergent mass culture of the web. This experience is summed up iconically in *VVEBCAM* (2007) by Nasty Nets surf club member Petra Cortright; in this video, Cortright stares disinterestedly into her computer, while her screen—here, a kind of literalization of her mental space—slowly fills with a series of default effects, such as dancing pizza slices and lightning. Moss argues that "surf clubs foreshadowed the popular blogging platform Tumblr, which, by the 2010s, became a key part of mainstream web culture."[14] This phenomenon was analyzed closer to its own time when, in her 2008 essay "Lost Not Found: The Circulation of Images in Digital Visual Culture," Marisa Olson asked how the circulation of images through such communities might change their original meaning, examining specific works by artists Kari Altmann, Michael Bell-Smith, Charles Broskoski, and others, who were actively appropriating found digital material in their work.[15] More recent examples would be The Jogging, a collectively authored Tumblr feed, or the online work of artist Juliana Huxtable, who asserts an ever-evolving, unfixed trans identity through her own distinctive mode of writing, image-making, and image-sharing, all across multiple platforms. Writings in *Mass Effect* foreground a rich history of activity that led to projects like these.

Despite the use of social media platforms to find, circulate, and comment on images, some of the biggest platforms have been surprisingly resistant to use as spaces for art. Ed Fornieles's project *Dorm Daze* (2011), a multi-person, scripted soap opera that unfolded through the Facebook accounts of fictional personae, is an oft-cited exception that proves the rule. Several influential artists during this period initiated independent platforms that might represent a future for artists working with, or inspired by, social media. One is Ryder Ripps's project dump.fm (2009–present), a fast-paced visual chat room that he describes as a place "where content is hyper-transient and used to facilitate connections and induce creativity."[16] Other examples include artist Rafaël Rozendaal's "BYOB (Bring Your Own Beamer)" (2010–present), an exhibition format that carries the spirit of open-source development into gallery spaces by inviting artists to present their work via "beamers" (projectors) in a shared venue, and Rozendaal's own ongoing series of single-server-sites-as-artworks like *i am very very sorry .com*

(2002), *broken self .com* (2007), *like this forever .com* (2011), and *random fear .com* (2013), all of which, by their nature, currently resist full embedding and sharing within the protocols of contemporary social media platforms.

INVISIBLE ADVERSARIES

"Dispersion" suggests that the next frontier for artists might be in forms of mass distribution; in this regard, Price's prophecy came true. But the side effects of this cultural shift raised their own questions. In the series of "Net Aesthetics" panels—organized by Rhizome in 2006, 2008, and 2013, and transcribed and reprinted for this volume—key artists of the period discuss how their appreciation and use of social media find them walking a fine line between art and nonart. In the first "Net Aesthetics" panel, Arcangel describes engaging with the web (or "web 2.0," as it was called in 2006) as both wildly inspiring and, simultaneously, cause for artistic crisis: "All this stuff out there made by all these people is probably better than the stuff I'm making. How do you deal with that?... As an artist, what is my role on the internet?... I call it the fourteen-year-old Finnish-kid syndrome. Basically there are people doing things on the internet right now that are above and beyond."[17]

Here, Arcangel lays out a key question that troubles networked approaches to art in this period, one that is returned to—again and again with different inflections—throughout this volume: in a world in which new forms of software have made the creation of music, images, video, and new software easier than ever to master, and the internet has fostered an unprecedented amount of activity in terms of showing, sharing, and remixing this work, how does the work of artists utilizing these same practices differ in any fundamental respect? Artist Guthrie Lonergan's piece *Hacking vrs. Defaults* (2007) became one widely discussed proposal for how artists might move forward by embracing the preset restrictions inherent in commercial software. In his lecture "'We Did It Ourselves!' aka 'My Favorites' Volume 1: 2005 to 2009," published here for the first time, Lonergan explores more fully the implications of this gesture. "We're all using this preexisting foundation that will always be there no matter what," he notes. "Defaults are also a reaction to the 'infinite' choices and possibilities offered by the virtual (letting the computer choose for you). You can't get off the grid, but the struggle of normal, basic internet users to get something real through this existing grid is really exciting."[18]

But, as Lonergan himself discusses, this tactic leaves in place the problem of how to tell the difference between artists and "normal, basic internet users,"[19] and whether such distinctions remain valid at all. In "The Centaur and the Hummingbird," Halter's essay (written for Cornell's 2010 exhibition "Free" and reprinted as part of *Mass Effect*) questions how the disappearance of the artist into larger structures—whether it's Joel Holmberg posting questions to Yahoo! Answers in his work *Legendary Account* (2011) or Jill Magid joining a Dutch surveillance agency for her piece *Becoming Tarden* (2009)—illuminates how online existence has subtly altered the legacy of Conceptualism. "As the old *New Yorker* cartoon says, 'On the Internet, nobody knows you're a dog,'" Halter writes. "We might instead propose that on the internet, nobody knows you're an artist."[20] Artists have explored different solutions to this conundrum.

One answer might be found in the mid-'00s fascination with "crowdsourced" art, which rose to prominence as a practice in the wake of writer James Surowiecki's influential concept of the "wisdom of crowds,"[21] epitomized by the mass-editing process behind Wikipedia. Aaron Koblin's work is perhaps the most successful implementation of this paradigm, producing lucid visualizations that mobilize freely available personal data sets as raw material. *SMS Amsterdam* (2007), for instance, is a dynamic, auto-updating work that illustrates the relative volume of text messaging throughout the city of Amsterdam. The rise of user-generated spaces becomes inspiring fodder for art in this period, with figures like the trailblazing Chinese artist Cao Fei, who Alice Ming Wai Jim has written about in "The Different Worlds of Cao Fei," reprinted in this volume. In the virtual world of Second Life, Cao Fei found a preponderance of exoticizing references to Asian culture, emblematic of the West's lingering orientalism. In an act of virtual colonization, she has built *RMB City* (2008–present)—a hybrid landscape permeated with architectural references to her native Beijing—creating her own territory within Second Life through her powerful and consciously self-fetishized avatar "China Tracy." In forerunning projects like *RMB City*, we see the rejection of long-standing binaries and default representations in favor of more contradictory and complex personae.

More recently, self-described trend-forecasting group K-HOLE (composed of artists, programmers, and marketing professionals) proposed something like an answer with "normcore," which they introduced in the PDF report "Youth Mode: A Report on Freedom w/Box 1824." Following a widely shared profile by a New York writer, the term became a familiar catchphrase, frequently summarized as hipsters who dress like Seinfeld.[22] But in K-HOLE's own definition, normcore is a more nuanced concept, involving a move "away from a coolness that relies on difference to a post-authenticity coolness that opts in to sameness.… To be truly

Normcore, you need to understand that there's no such thing as normal."[23] The lightning-speed rise and fall of normcore—which became adopted as merely a fashion-style term and just as quickly rejected by the Twitterati, all the while effacing K-HOLE's attempt at a greater discussion—points to the fact that, as of our current moment, no easy answers to the riddles posed a decade ago by "Dispersion" have been offered.

IMMEMORY

The disappearance of art into general culture—a long-standing challenge for art that deals with media appropriation—has also become an urgent historiographic problem, aggravated by the fast turnover of platforms, software, and formats that has made large chunks of the online past unreadable.

Consider, for example, the fate of art made in response to mapping technologies, introduced in the mid-'00s by companies like Google (via Google Earth and Street View) or Second Life. Only a few years ago, concepts like "mapping" and "geolocative art" seemed to be on everyone's mind, from the bloggers at Boing Boing to cultural funding agencies to curators at major institutions. Using then-new platforms such as these, artists as diverse as Cao Fei, JODI, Aaron Koblin, and Jon Rafman interrupted or reframed these augmented cartographies and ways of navigating the world, exploring an emergent relationship between the physical and virtual that has today become much more part of everyday life. But like so much art over this past decade, the profundity and experimentation of this work can be difficult to see today, as platforms have become outmoded (for example, the now largely derided Second Life), have been radically transformed through updates, or have simply vanished altogether. Decade-old hacks of Google Maps and performances staged in virtual worlds can therefore have a hard time carrying their original critical weight into the future, particularly as, even in their time, they required "squinting."[24]

Similarly, Alex Kitnick's essay on artist Mark Leckey analyzes how Leckey responded to the concept of "the long tail,"[25] a phrase introduced by *Wired* editor Chris Anderson in a 2004 article,[26] followed by a best-selling book of the same name in 2006.[27] For a few years, "the long tail" seemed inescapable in discourse about the internet, beginning as a marketing term but becoming something much larger, a way to think about changes in society. Barely a decade later, the term has become more obscure, and the labors of an art historian like Kitnick are required to put Leckey's once-immediate project back into context—a novel

challenge for a profession whose skill set originally evolved to study the ruins of antiquity and the canvases of old masters.

Understanding a historical moment on its own terms is a key factor behind selections taken from Gene McHugh's blog *Post Internet*, which ran in 2009 and 2010.[28] In this work, McHugh attempted to chronicle a moment when artists had embraced the new term "postinternet"[29]—a moment also discussed by Ben Vickers, Harm van den Dorpel, and Karen Archey in the transcription of the "Post-Net Aesthetics" panel in this book. Later, this term would take on a much broader usage, referring to artists whose works share a similar, if undefined, visual grammar. But reading McHugh's contemporary account foregrounds how "postinternet" began as a much more speculative term, an attempt to understand a very wide range of artists and practices, rather than the simplistic and some-what meaningless curatorial shorthand, vaguely gesturing toward a generational label, which by now it has become.

A key challenge in developing this volume was "turning back the clock" for readers and restating why these interventions were significant in their moment, however subtle and slight. We hope these essays lend clarity to artworks and dis-courses that have become hard to grasp, in light of the rapid succession of new tools and behaviors that succeeded them.

WE ARE EVERYWHERE

But since the year 2000, it's not merely artists or their artworks that have dis-persed and disappeared—so has the internet itself. Today, the connections and operations once confined to desktop computers and laptops have grown to encompass almost every aspect of our lives, keeping us connected through our phones, our televisions, our cinemas, our stores, our cars. The sites of input and output continue to proliferate, pushed forward by the speculative engines of the market, most dramatically represented in recent years by the rise of 3-D scan-ning and printing, which heralds a new dematerialization (and rematerializa-tion) of the object in everyday life.

How art will catch up to this moment, though, has become a pressing con-cern. For instance, in her widely read essay "Too Much World: Is the Internet Dead?," Hito Steyerl describes the way digital images transubstantiate as they circulate, erupting into physical form across mediums and sites:

> Data, sounds, and images are now routinely transitioning beyond screens into a different state of matter. They surpass the boundaries of data

channels and manifest materially. They incarnate as riots or products, as lens flares, high-rises, or pixelated tanks. Images become unplugged and unhinged and start crowding off-screen space. They invade cities, transforming spaces into sites, and reality into realty. They materialize as junkspace, military invasion, and botched plastic surgery. They spread through and beyond networks, they contract and expand, they stall and stumble, they vie, they vile, they wow and woo.[30]

In Steyerl's argument, digital media is radically elastic, as it can move across multiple, changing platforms, scaled to fit (or not fit), be read, accessed, broken down, and embedded in ways that previous cultural forms cannot. The aesthetic implications of this situation are analyzed in Michael Wang's essay focusing on Ryan Trecartin's movies. Here, Wang theorizes that Trecartin's work visualizes the new quasi-physical state of digital media, always in flux, through Trecartin's use of complex, multiple layers of transformation and transition. Wang offers that Trecartin's work envisions "a representational order in which words, images, and objects no longer inhabit separate strata of experience, but instead intermingle, hybridize, and transform into one another."[31] (Or, as a character in Trecartin's *A Family Finds Entertainment* [2004] puts it, while holding up a painted beach lounger: "I made this chair on Photoshop! Do you like it?")

For exhibitors of digitally based art, this fluid quality has long posed a challenge: what is the best way to exhibit works of natively online art in physical spaces? In its short life, And/Or—Paul Slocum's gallery in Dallas, Texas—showed dozens of artists' work in sensitive configurations that considered how digital media, as Steyerl says, "incarnate as riots or products, as lens flares, high-rises, or pixelated tanks."[32] *Mass Effect*'s And/Or portfolio provides an important early example of artists working together to think through how engagements with digital culture could be shown to publics offline, a trend that by necessity has now moved from the relatively small scene of internet art to the general practice of art exhibition as such.[33]

In 2010, artist Paul Chan founded independent publisher Badlands Unlimited, an imprint devoted to questioning how books might exist in a more "expanded field" of the sort Steyerl describes—or, as Badlands' own statement puts it, when "historical distinctions between books, files, and artworks are dissolving rapidly."[34] Badlands' inventory of e-books, printed publications, and original artist works includes "How to Download a Boyfriend" (2012), a group exhibition in the form of an interactive e-book; Petra Cortright's electronic artist's book *HELL_TREE* (2012); and the "Wht Is?" series (including, for example, *Wht is Lawlessness?*, *Wht is a Book?*, *Wht is lust a?*, *Wht is a Kardashian?*, *Wht is a Wu Tang?*), in which

Chan lays images and text over preexisting texts to pose epistemological inquiries about the experience of reading today. Badlands' philosophy is influenced by early works by Chan, such as *RE: THE OPERATION* (2002), *Baghdad in No Particular Order* (2003), and *Happiness (Finally) After 35,000 Years of Civilization* (2004), all of which existed both offline as videos and online in the form of websites and downloadable files. In his speculative text "A Theorem," written for *Mass Effect*, Chan uses an emergent form of writing poised between coding and concrete poetry to raise questions about the fundamental relationships between pictures, text, and information.[35]

But this tangled intertwining of online and offline existence has had a much more profound effect beyond the art world and on the political nature of our lives. Alexander Galloway's statements about the Radical Software Group's project Carnivore (2002–present), a downloadable application that enables targeted surveillance of data networks, show how, early on, artists engaged with the internet were sensitive to issues of mass surveillance and control through digital networks.[36] The ensuing decade is a time of widespread, anonymized anxiety: conflicts on a global stage—terrorism, ongoing US interventions—are hacked by activists across the world. In Jens Maier-Rothe, Dina Kafafi, and Azin Feizabadi's account of alternative artistic reportage around the Arab Spring, we find a compelling example in Mosireen's Tahrir Cinema (2011) as one such act of resistance that dilates between physical places and a territorialization of social media networks, where hashtags replace slogans: #occupy, #gezi, #ferguson, #prayforgaza.[37] The world pivoted in 2013 with former US intelligence agent Edward Snowden's revelation of NSA domestic spying, re-enlivening the importance of works like Carnivore that foretold possibilities for surveillance within intimate communications. Now, artists and citizens alike are reckoning with the reality that our greater digital freedoms have been delivered to us at a deep cost to our sense of privacy. In this period, the fluidity and freedoms at play within the internet's emergent mass culture are in sharp contrast to artistic response to this greater surveillance state. In a new interview here, artist Trevor Paglen, whose work has long attempted to debunk misleading metaphors of the internet's ephemerality and openness, notes:

> Our experience of "the Internet" is strongly at odds with what actually happens, and is a source of incredible mystification. "The Internet" *feels* very free; it feels like we can anonymously explore whatever ideas, images, or desires we want without fear of reprisal or ostracism. It feels like we can be one person today, and another tomorrow, and that we could try on a new personality the day after that. It would be very difficult from

our direct experience of "the Internet" to derive the fact that it is also a surveillance platform of immense power, reach, and recollection—one that makes the STASI's system informants and file cards seem utterly quaint. As such, "the Internet" is a tool for a literally incredible consolidation of state power, the likes of which have never been seen on earth.[38]

In *Mass Effect*, we include artists working alongside this narrative in response to the dawn of social media and the entrenchment of corporate interests in our personal space. All of the friending, upping, liking, and starring has transformed our time and emotions into fresh commodities—impressions for corporations that, recently, are seen to have as many rights as we do.[39] As Jonathan Crary writes: "There are now very few significant interludes of human existence (with the colossal exception of sleep) that have not been penetrated and taken over as work time, consumption time, or marketing time."[40] Recent projects like DIS and K-HOLE have been criticized for engaging too enthusiastically with the market culture that has come to define our era and for failing to propose any alternative. In response, they might say: What alternative could there be, when commercially driven technology has become a totalizing force in every aspect of our lives?

Early forms of net.art lent more critical bite to some of these questions, and looking back at them might provide important frameworks for understanding our current time.[41] In the most recent "Net Aesthetics" conversation in 2013, Josephine Berry Slater questions why artists haven't formulated enough strong critical response to the politics wrought by contemporary networks. She writes:

> Where is the technical specificity? Where is the site-specificity in the work, as it relates to a global regime, a techno-capitalist regime that is using the internet or digital networks as a way to intensify capitalist processes of reification, to machine subjectification into us, to basically control us through the credit card writ large? The way that those data trails produce individuated identities speaks to the lack of producing commons or resources…why is that missing?[42]

IDENTITY VERIFICATION

One of the side effects of the commercialization of the web has been the loss of widespread anonymity, which typified the early web. Pioneering projects like Mouchette or ®TMark depended on these conditions for their very meaning.

With the mainstreaming of e-commerce and the rise of Facebook as a primary social arena, the real identities of users have taken on crucial value. In his 2013 "Art Workers: Between Utopia and the Archive," reprinted in this collection, Boris Groys proposes that the new commodification and surveillance of identities present a political quandary for artists, challenging modernist ideas of how the self should be fashioned. "Modern artists revolted against the identities imposed on them by others—by society, state, school, parents. They wanted the right of sovereign self-identification," he writes. "This means that the struggle against my own public persona and nominal identity in the name of my sovereign persona, my sovereign identity, also has a public, political dimension, since it is directed against the dominating mechanisms of identification—the dominating social taxonomy, with all its divisions and hierarchies."[43]

But Groys's insistence that artists might desire the "right of sovereign self-identification" is challenged by a number of essays, also in this volume, which present complex relationships between an artist's individual identity and her or his identification through gender, race, sexuality, nation, or other social categories. In her essay "Bodies in Space: Identity, Sexuality, and the Abstraction of the Digital and Physical," Karen Archey argues that "We see a surfeit of artwork dealing with theoretical themes such as artwork documentation, new philosophies such as speculative realism, and the ever-loved topic of image circulation, yet none of these directly addresses our lived experience."[44] Described by Archey as a "corrective" to this dearth of criticism, her essay explores how "the body is mediated by both virtual and physical space" in artworks by Nicolas Deshayes, Ann Hirsch, Charlotte Prodger, Magali Reus, and Bunny Rogers, among others. Morgan Quaintance argues in his essay "Here I Am: Telepresent Subjecthood in the Work of Lotte Rose Kjær Skau" that Kjær Skau's performance videos need to be understood in the context of the online history of "camgirls" and focuses on how such a practice has complicated the problem of the male gaze, which had plagued older media.[45] In a new essay based on her lecture "Black Vernacular: Reading New Media," artist Martine Syms analyzes the work of Keith Obadike, Steffani Jemison, Jayson Musson, and others to show how the histories of "black expression" have informed new art practices of the internet age and argues for a closer reading of the work of black artists. "We don't need validation," she writes. "Black expression is much more than a replacement of or reaction to dominant culture. It's an integral part of American culture."[46]

The resurgence of a new form of networked identity politics is a thread that runs through many more of the essays and projects presented in these pages. One striking example is the emergence of a more visibly queer aesthetic in digitally informed art, whether as embodied in the slippery personae of Trecartin or the Instagram feed of K8 Hardy, and here legible in the DISimages portfolio—a

selection from DIS's custom database of stock images that introduces alternate gender, sexual, and cultural norms to replace those offered by a more staid photography archive like Getty Images.[47]

U MAD BRO?

Finally, the volume expands to consider not just the ways that artist practices have evolved, but also how the language, relationships, and power structures of the art world have transitioned over the past decade, in uncertain terms and across clear digital divides. In "Digressions from the Memory of a Minor Encounter," originally published in 2006, Raqs Media Collective traces the implications of global communications on the infrastructure of the art world, arguing that a broader diversity of positions would radically reshape art discourse and trouble existing notions of authorship and intellectual property.[48] These implications are also explored through two key debates that we have included in *Mass Effect*. Part of our desire to include these debates is to highlight how the internet remains a space for open, often heated, discussion at a time when money and power within the art world proper have palpably inhibited open disagreements of this nature.

The first is a discussion initiated by the 2010 publication of "International Art English" by the online journal *Triple Canopy*. Using new techniques of data aggregation—in this case, analyzing the press releases stored by the e-flux announcements news service—Alix Rule and David Levine proposed, with tongue half in cheek, that a new dialect of English had emerged in the art world, with its own internal tics, unspoken rules, and effects on power and agency.[49] But as *Triple Canopy* Editor Alexander Provan relates in his own analysis of the essay, the text itself soon became a flashpoint for larger issues about the dominance of English in the art world, the economics of gallery labor, and the legacy of critical theory.[50]

Likewise, Claire Bishop's "Digital Divide," first published in the fiftieth-anniversary issue of *Artforum*, devoted to technology and art, sparked an unexpectedly strong response from readers. In her essay, Bishop asks why the mainstream art world had been hesitant, up to that point, to acknowledge the existence of the internet and its impact on art, citing work by Carol Bove, Manon de Boer, and Akraam Zaatari that, she argued, was in fact shaped by this very denial.[51] But readers who had long been involved with internet-based practices bristled at Bishop's mode of argumentation. The comments feed for her article on Artforum.com—a site not usually marked by active response—filled with counterarguments from a range of artists and writers. One of the editors of this volume, Lauren Cornell,

collaborating with writer Brian Droitcour, penned a letter to *Artforum*'s editors in response to the article, which was published in a subsequent print issue. "Claire Bishop asks: 'Whatever happened to digital art?'," Cornell and Droitcour wrote. "Why does this work remain invisible to Bishop? It is partly due—as per her own admission—to her focus on a 'mainstream'.... Still we would argue that even here the 'divide' she describes is actively being bridged and, because of a critical blind spot, she is forcing it back open."[52] In a follow-up essay commissioned for *Mass Effect*, Bishop reflects back on this event, offering her own theories about the response, and examining the recent work of artists like Ed Atkins and Helen Marten as examples of how artists themselves have already moved on into new territories and concerns.[53]

Many of the issues raised by these debates remain with us in 2014. As we complete our editing process and finalize this volume for print, we would like to propose a new question: Will a future anthology on art and the internet need to be published ten or twenty years from today, chronicling the art made between now and then? Or will the concept of a specific mode of art engaged with the internet have, by then, become completely meaningless? The current confusions and concerns around this category today might indicate an impending obsolescence. Perhaps it's best to follow Oliver Laric's recommendation, voiced in his discussion with Jones and Domanović, that instead of employing the term "postinternet art" to categorize the present day, we should rather invent a new label for all art that came before us and accept that everything earlier was simply "preinternet."[54]

NOTES

1. See, for example, Julian Stallabrass, *Internet Art: The Online Clash of Culture and Commerce* (London: Tate Publications, 2003); Rachel Greene, *Internet Art (World of Art)* (New York: Thames and Hudson, 2004); Alexander R. Galloway, *Protocol: How Control Exists after Decentralization* (Cambridge, MA: MIT Press, 2006).

2. Rachel Greene, "Web Work: A History of Internet Art," *Artforum* 38, no. 9 (2000): 162–67.

3. For instance, documenta X, Kassel (1997); Gallery 9 at the Walker Art Center, Minneapolis (1998–2003); "Bitstreams" at the Whitney Museum of American Art, New York (2001); and the "Net Art" sidebars at the 2000 and 2002 Whitney Biennials.

4. Prior to this, in February 2003, the work was shown in "Americana," an exhibition organized by Anne Ellegood and Rachel Gugelberger at the SVA Westside Gallery, New York, as a single-channel video on a television monitor.

5. In this volume, Cory Arcangel, "coming soon: ebay paypal blogs the internet," 17.

6. In this volume, Domenico Quaranta, "Internet State of Mind."

7. In this volume, John Kelsey, "Next-Level Spleen," 329.

8. Olia Lialina and Dragan Espenschied, *Digital Folklore Reader* (Stuttgart, Germany: Mertz & Solitude: 2009). In this volume, see Lialina and Espenschied's "Do You Believe in Users? / Turing Complete User."

9. In this volume, Jesse Darling, "Arcades, Mall Rats, and Tumblr Thugs," 326.

10. A term popularized in 1980s science fiction, notably in Willam Gibson's *Neuromancer* (1984).

11. In this volume, "Aleksandra Domanović and Oliver Laric in Conversation with Caitlin Jones," and Ceci Moss, "Internet Explorers."

12. *VVORK*, "August 2010," <http://www.vvork.com/?m=201008>.

13. In this volume, "Aleksandra Domanović and Oliver Laric in Conversation with Caitlin Jones," 108.

14. In this volume, Ceci Moss, "Internet Explorers," 152.

15. In this volume, Marisa Olson, "Lost Not Found: The Circulation of Images in Digital Visual Culture."

16. Ryder Ripps, "Introducing: dump.fm," *Rhizome*, March 5, 2010, <http://rhizome.org /editorial/2010/mar/5/introducing-dumpfm/>.

17. In this volume, "Net Aesthetics 2.0 Conversation, New York City, 2006: Part 1 of 3," 104.

18. In this volume, Guthrie Lonergan, "'We Did It Ourselves!' aka 'My Favorites': Volume 1, 2005 to 2009," 173.

19. Ibid.

20. In this volume, Ed Halter, "The Centaur and the Hummingbird," 236.

21. James Surowiecki, *The Wisdom of Crowds* (New York: Random House, 2004).

22. Alex Williams, "The New Normal: Normcore: Fashion Movement or Massive In-Joke?" *New York Times*, April 3, 2014, <http://www.nytimes.com/2014/04/03/fashion/normcore -fashion-movement-or-massive-in-joke.html?_r=1>.

23. K-HOLE and Box 1824, "Youth Mode: A Report on Freedom," 28, <http://khole.net /issues/youth-mode/>.

24. Lauren Cornell and Ed Halter, "Mass Effect," *Mousse* 41, <http://moussemagazine.it /articolo.mm?id=1054>.

25. In this volume, Alex Kitnick, "Everybody's Autobiography," and Mark Leckey, "In the Long Tail."

26. Chris Anderson, "The Long Tail," *Wired*, issue 12.10, October 2004, <http://archive.wired .com/wired/archive/12.10/tail.html>.

27. Chris Anderson, *The Long Tail: Why the Future of Business Is Selling Less of More* (New York: Hyperion, 2006).

28. In this volume, Gene McHugh, "Excerpts from Post Internet."

29. Artie Vierkant, "The Image Object Post-Internet," 2010, <http://jstchillin.org/artie /vierkant.html>.

30. In this volume, Hito Steyerl, "Too Much World: Is the Internet Dead?," 441.

31. In this volume, Michael Wang, "Made of the Same Stuff: Ryan Trecartin's Art of Transformation," 401.

32. Steyerl, 441.

33. In this volume, Paul Slocum, "A Brief History of And/Or Gallery."

34. Badlands Unlimited, "What is Badlands Unlimited?" <http://badlandsunlimited.com /about/>.

35. In this volume, Paul Chan, "A Theorem."

36. In this volume, Alexander Galloway, "Two Statements on Carnivore."

37. In this volume, Jens Maier-Rothe, Dina Kafafi, and Azin Feizabadi, "Citizens Reporting and the Fabrication of Collective Memory."

38. In this volume, "Trevor Paglen in Conversation with Lauren Cornell," 260.

39. See Citizens United v. Federal Election Commission Case, <http://www.law.cornell.edu /supct/html/08-205.ZS.html>

40. Jonathan Crary, 24/7: Late Capitalism and the Ends of Sleep (London and Brooklyn: Verso, 2013), 15.

41. For instance, Heath Bunting's BorderXing Guide (2002–2003), Young-Hae Chang Heavy Industries' Cunnilingus in North Korea (2003); and Alexei Shulgin's Desktop Is (1997–98).

42. In this volume, "Post-Net Aesthetics Conversation, London, 2013: Part 3 of 3," 417.

43. In this volume, Boris Groys, "Art Workers: Between Utopia and the Archive," 363.

44. In this volume, Karen Archey, "Bodies in Space: Identity, Sexuality, and the Abstraction of the Digital and Physical," 451.

45. In this volume, Morgan Quaintance "Here I Am: Telepresent Subjecthood in the Work of Lotte Rose Kjær Skau."

46. In this volume, Martine Syms, "Black Vernacular: Reading New Media," 373.

47. In this volume, DIS Magazine, "A Selection from DISimages: New Stock Options."

48. In this volume, Raqs Media Collective, "Digressions from the Memory of a Minor Encounter."

49. In this volume, Alix Rule and David Levine, "International Art English."

50. In this volume, Alexander Provan, "Chronicle of a Traveling Theory."

51. In this volume, Claire Bishop, "Digital Divide: Contemporary Art and New Media."

52. Lauren Cornell and Brian Droitcour, "Technical Difficulties," Artforum 51, no. 5 (2013), 36.

53. In this volume, Bishop, "Sweeping, Dumb, and Aggressively Ignorant! Revisiting 'Digital Divide.'"

54. In this volume, "Aleksandra Domanović and Oliver Laric in Conversation with Caitlin Jones," 114.

DO YOU BELIEVE IN USERS? / TURING COMPLETE USER

Olia Lialina and Dragan Espenschied

DO YOU BELIEVE IN USERS?
———

We are all naive users at some time or other; its [sic] nothing to be ashamed of.
Though some computer people seem to think it is.
Ted Nelson, *Dream Machines*, 1974 (III)

The personal computer (a *meta medium*), and the internet (aka *network of the networks*), are mistakenly regarded as mere extensions of pre-computer culture. Net-, web-, media-, computer-, and digital- are the miserable and inadequate prefixes still used to indicate that something was produced with a computer and was maybe digitized or accessible through a computer interface. The industry puts a lot of effort into increasing the "fidelity," "realism," and "emotion" of the "content" rushing through digital circuits. These perceived improvements, however, are likely to wipe out the very reality and emotion that is living inside the computer. It seems that in spite of its prevalence in our culture, the computer's ultimate purpose is to become an invisible "appliance," a transparent interface and device denying any characteristics of its own. Most computing power is used in an attempt to make computers invisible. Thus, the often-heard statement that computers are a common thing in today's world is a fallacy. Never before has computer technology been so widely spread and computer *culture* been so underdeveloped in relation.

If you ask a search engine what "digital folklore" is, it will pull up links to e-books on folk art or recordings of folk music in MP3 format. Likewise, five years ago if you looked for "internet art," you would get linked to galleries selling

paintings and sculptures online, even though net.art (where "net" was more important than "art") had long been a unique art form.

This has to change for the betterment of human culture as a whole, so here we proudly coin the term "Digital Folklore."

.

Digital Folklore encompasses the customs, traditions, and elements of visual, textual, and audio culture that emerged from users' engagement with personal computer applications during the last decade of the twentieth century and the first decade of the twenty-first century.

This seemingly overdetermined time frame is needed to distinguish Digital Folklore from Home Computer Culture, which ceased to exist in the 1990s. Home computers—machines elegant and quirky at the same time—nurtured the development of a passionate community. Using mostly their free time, these self-taught experts created their own culture. Meaningful contributions could be made quickly and with relative ease because of the home computer's technical simplicity. When the home computer became merely a machine for work, when it became a requirement in life to know Microsoft Office, when the workings of the machine became increasingly complex and business-oriented, the role of computer users changed (VIII).

With the advent of the world wide web, not only did this technical simplicity return to the hands of users, but since it was a communication medium with no perceivable cultural history, instruction manuals, or even purpose, users from all kinds of backgrounds quickly defined a shared set of visions, values, practices, and rituals on their personal websites, creating the surprisingly consistent body of Digital Folklore from nothing but usage.

So what do we exactly mean by user? The movie *TRON* (1982) marks the highest appreciation and most glorious definition of this term (VII). The film is mostly set inside a computer network; programs, represented by actors in glowing costumes, are the main heroes. One program asks another: "You believe in the users?" The other answers: "Yes, sure. If I don't have a user, then who wrote me?" In another conversation it becomes clear that both an account manager and a hacker are called "user" by "their" programs. The relationship between users and programs is depicted as a very close and personal one that is almost religious in nature, with a caring and respecting creator and a responsible and dedicated progeny.

This was in 1982. Ten years later the situation became dramatically different. The term "users" was demoted to what the fathers of computer technology dubbed "Real Users" (III), those who pay to use a computer but are not interested

in learning about it, or "Naive Users" (IV), those who simply don't understand the systems.

In 1993, AOL connected its customers to the internet for the first time and naive users showed up in the thousands, invading the Usenet discussion system formerly only frequented by computer enthusiasts with a university background. These AOLers became part of the internet without any initiation, and none had any of the technical or social skills that were deemed necessary to the previous generation of internet users. The "old guard" was unwilling to deal with a mass of "users" who were ignorant of their highly developed culture, and the increasing onslaught was often referred to as an "Eternal September" (IX). "User" became a derogatory term for people who need things to be as simple as possible, and users became cannon fodder for system administrators and real programmers.

In 1996, *The New Hacker's Dictionary* clearly distinguished two classes: Implementors (hackers) and Users (lusers) (X). Twelve years later, *Software Studies: A Lexicon*, released by the same publisher, the MIT Press, doesn't contain an article on the user at all. As a way to deal with this new influx of "lusers," the prevailing tactic was to give them a nice and colorful playground ("user-friendly," "user-oriented") where they would not cause any real damage and would leave the hackers alone.[1] This rather cynical view is still perpetuated today—users are highly entertained by their online activities, but also exploited as content producers and ad-clicking revenue generators.

While more and more people had personal computers and net access, fewer and fewer were seeing the value of their contributions. As most had agreed to have "no idea about computers," it became virtually impossible for them to reflect on the medium itself. At the same time however, these lusers were using computers very intensively and effectively, communicating, producing, improvising, and uploading nonstop.

And here we reach the point where we would like to highlight artifacts of Digital Folklore, a distinct user culture developed *inside* user-oriented applications and services despite their low social status and technical limitations, when their cumulative output began to dominate that of hacker culture.

Consider the way early amateur websites were made: as clumsy as they might appear to trained professionals, they were of huge importance in terms of forming and spreading the internet's architecture and culture. In fact, the mental image we have of the medium today—intelligence on the edges of the network, many-to-many communication, open source (even if it was just about how to use the <blink> HTML tag)—is the result of these early efforts. Users could easily write the code for their own webpages and were, by building their pages, literally building the internet. By the end of the 1990s, however, the rise of web design,

the web designer as a new profession, the "new economy," and the whole industry around this economy, all conspired to point lowly users back to their place.

These days we can witness how the users' role has been reconsidered in the web 2.0 hype: noble amateurs, crowd-wisdom, user-generated content, folksonomy, all crowned by the triumphal YOU as the "person of the year" on the cover of the December 25, 2006/January 1, 2007, issue of *TIME* magazine (XI). This grand "comeback" of the user, heralded by the glossy mirrored cover, illustrated just how vast the gap between users and their computers had grown, the implication being that a powerful user is a one-time sensation, not the norm.

During this short time, the users' creativity earned a lot of praise, whether it was "blinging up" their kids, rating books on Amazon.com, or "rickrolling" colleagues. But being so busy and creative, we missed the moment when web 2.0 was replaced by a new trend: "The Cloud," which placed users in front of dumb terminals, feeding centralized databases and über computer clusters. One is easily reminded of the Master Control Program, the bogeyman from the aforementioned movie *TRON*. Whatever association your mind is offering here, whatever the name of the system, it is about powerful computers, not powerful users.

But it won't be technology that will stand up for values like free speech and free thought. And the technological mastery of a few bright minds will not protect the internet from being blocked, split up, throttled, or censored by repressive or well-meaning governments, powerful industries, or religious zealots. Hackers and professionals will have to understand that in order to advance "their" medium and "their" culture, they, too, have to tap into the powers of Digital Folklore. Not by educating the masses, but by respecting and learning from them.

In Germany, where the book *Digital Folklore* originates, the problem has its own specificity because one gets the feeling that "The Internet" is happening somewhere else. Journalists praise Iranian bloggers in their struggle for freedom, yet regard German bloggers voicing their concerns about German governmental control of the web as nutty freaks. A strong sense of the web serving a certain well-defined and quantifiable purpose prevents understanding of the most valuable contribution of users, which is not about filling out online forms to create "content," but constantly recreating, changing, and fleshing out the medium itself.

And there seemed to be little time for reflection in between the total neglect of computers and their sudden, unscrutinized adoption: in the 1980s, many members of the general public thought of computers as Cold War machines that guided nuclear missiles, or as surveillance apparatus for turning humans into numbers for the 1987 census. Even playing the coin-operated Pac Man arcade machine was illegal for minors. By contrast, today's schoolchildren are educated as "Real Users." They learn how to use Microsoft Office to type business

letters and design PowerPoint presentations before they learn how to play a game or even spell IKEMZDOL[2] correctly. Users must understand their integral role in the process, demand comprehensible systems, work for media-specific computer education, and begin to see themselves as the avant-garde of digital culture again.

The domain of the digital must belong to users, not just those who admire computing power. The networked personal computer must be regarded as a medium with a cultural history shaped more by its users and less by its inventors. Then hopefully a reasonable relationship between users and their medium can be restored. Studying Digital Folklore instead of seeking ways to exploit how users behave can help us achieve this, and help give back users the power they have earned and deserve.

In February 2009, speaking at a TEDx conference, Tim Berners-Lee stated that he invented the web "twenty years ago" (XIII). Though officially he has the right to claim this, the web was at this point in fact sixteen years old, as it was only in 1993 when the web started to leave academia with the availability of the Mosaic browser, and folks who didn't create this medium for their own needs became active with it. The intricacies of this history are further illuminated by Henry Jenkins, who, discussing another history, wrote in his 2002 article "Blog This!": "We learned in the history books about Samuel Morse's invention of the telegraph, but not about the thousands of operators who shaped the circulation of message."[3] To rephrase him, we could say that we have studied the history of hypertext, but not the history of Metallica-fan web rings or web rings in general.

TURING COMPLETE USER: INVISIBLE AND VERY BUSY

It is wrong to think that first there were computers and developers and only later users entered the scene and had to "adapt," in the best case, as "early adopters." In fact, the opposite happened. At the dawn of the personal computer, the user was the center of attention. The user did not develop in parallel with the computer, but prior to it. Think about Vannevar Bush's 1945 article for the *Atlantic*, "As We May Think," one of the most influential texts in computer culture. Bush spends more words describing the person who would use the "memex" than the memex itself. He defines a scientist of the future, a super human. The user of the memex, not the memex itself, headed the article (I). Twenty years later, Douglas Engelbart, inventor of the pioneering personal computer system NLS as well as hypertext and the mouse, talked about his research on the augmentation

of human intellect as "bootstrapping"—meaning that human beings, and their brains and bodies, will evolve along with new technology (II). French sociologist Thierry Bardini describes this approach in his book about Douglas Engelbart as such: "Engelbart wasn't interested in just building the personal computer. He was interested in building the person who could use the computer to manage increasing complexity efficiently."[4]

When the personal computer was getting ready to enter the market fifteen years later, developers thought about who model users would be. At Xerox PARC, Alan Kay and Adele Goldberg introduced the idea of kids, artists, musicians, and others as potential users for the new technology (VI). Their paper "Personal Dynamic Media" from 1977 describes important hardware and software principles for the personal computer. But we read this text as revolutionary because it clearly establishes possible users, distinct from system developers, as essential to these dynamic technologies. Another Xerox employee named Tim Mott (aka "the father of user centered design") brought the idea of a secretary into the imagination of his colleagues. This image of the "Lady with the Royal Typewriter" (V) predetermined the designs of Xerox Star, Apple Lisa, and other digitally emulated offices.

So, users are a figment of the imagination. As a result of their fictive construction, they continued to be reimagined and reinvented through the '70s, '80s, '90s, and into the new millennium. But however reasonable or brave or futuristic or primitive these models of users were, there was a constant.

Let us refer to another guru of user-centered design, Alan Cooper. In 2007, when the U-word was still allowed in interaction design circles, he and his colleagues shared their secret in *About Face 3: The Essentials of Interaction Design*:

> As an interaction designer, it's best to imagine that users—especially beginners—are simultaneously very intelligent and very busy.[5]

It is very kind advice and can be translated roughly as "hey, front-end developers, don't assume that your users are more stupid than you, they are just busy." But it is more than that. What the second part of this quote so importantly gets to is that users are people who are very busy with something else.

Alan Cooper is not the one who invented this paradigm, nor is Don Norman with his "concentration on task rather than the tool." It originated in the 1970s: listing the most important computer terms of that time, Ted Nelson mentions so-called user-level systems and states that these "User-level systems, [are] systems set up for people who are *not thinking about computers* but about the subject or activity the computer is supposed to help them with."[6] Some pages before, he claims:

Top: Alfred D. Crimi, *A Scientist of the Future*, title illustration of "As We May Think" by Vannevar Bush, published in *Life Magazine*, September 10, 1945. Bottom: Russian travel blogger Sergey Dolya, 2012. Photo: Mik Sazonov

> Computing has always been personal. By this I mean that if you weren't intensely involved in it, sometimes with every fiber in your mind atwitch, you weren't doing computers, you were just a user.[7]

One should remember that Ted Nelson has always been on the side of users and even "Naïve Users" (IV), so his bitter "just a user" means a lot.

Alienation of users from their computers started in Xerox PARC with secretaries, as well as with artists and musicians. And it never stopped. Users were seen and marketed as people whose real jobs, feelings, thoughts, interests, talents—everything that matters—exist outside of their interaction with personal computers.

When Don Norman first started his campaign to rename "Users" as "People" in 2008 (XII), it seemed like the tension between arrogant developers and users could finally be overcome. But in fact his chosen term describes users outside of the field of computers, effectively making them invisible by removing their online identities and any interest they might have in developing their culture.

The "tech community" does understand that its traditional notion of user = luser is only hurting itself in the end; but instead of changing its own prospects, the community is trying to get rid of the very idea of users altogether. Naming them "customers" or "people"[8] seems like applying outdated metaphors to a role that is actually the defining force of digital culture. Terms like "simplicity," "usability," "user experience," or "emotional design" describe an implementation of this ideology, glossing over increasingly restrictive, belittling, and exploitative systems with elements of entertainment or simulation of meaning.

Bruce Tognazzini's analysis of the "Third User" (XVI) even goes so far as to assert that many systems are designed for users that aren't even using those systems—that is, they're designed to entice buyers—which is probably the ultimate betrayal of any respect for or empowerment of users in the computer's history.

In other words: the Invisible User is more of an issue than an Invisible Computer. This Invisible User, without a name, a role, or any interest, who is assumed to always have something better to do, is not the center of digital culture. She is not even considered part of it.

	Year	Source	Imagined User	Statement
I	1945	Vannevar Bush, "As We May Think," *The Atlantic*, September 1945	Scientist	"One can now picture a future investigator in his laboratory. His hands are free, and he is not anchored. As he moves about and observes, he photographs and comments."
II	1962	Douglas Engelbart, "Augmenting Human Intellect: A Conceptual Framework," 1962	Knowledge Worker Intellectual Worker Programmer	"Consider the intellectual domain of a creative problem solver [...]. These [...] could very possibly contribute specialized processes and techniques to a general worker in the intellectual domain: Formal logic—mathematics of many varieties, including statistics—decision theory—game theory—time and motion analysis—operations research—classification theory—documentation theory—cost accounting, for time, energy, or money—dynamic programming—computer programming."
III	197x	J.C.R. Licklider, "Some Reflections on Early History," 1988, in Adele Goldberg (ed.), *A History of Personal Workstations*, 1988, p. 119	Real Users	"People who are buying computers, especially personal computers, just aren't going to take a long time to learn something. They are going to insist on using it awfully quick."

	Year	Source	Imagined User	Statement
IV	1974	Ted Nelson, "The Most important Computer Terms for the 70s," in *Computer Lib/ Dream Machines*, revised edition, 1987, p. 9	Naïve User	"Person who doesn't know about computers but is going to use the system. Naive user systems are those set up to make things easy and clear for such people. We are all naive users at some time or other; its nothing to be ashamed of. Though some computer people seem to think it is."
V	1975	Tim Mott, as quoted in *Fumbling The Future: How Xerox Invented, Then Ignored, the First Personal Computer*, 1999, p. 110	Lady with the Royal Typewriter	"My model for this was a lady in her late fifties who had been publishing all her life and still used a Royal typewriter."
VI	1977	Alan Kay, "Personal Dynamic Media," 1977, in Noah Wardrip-Fruin and Nick Montfort (ed.), *The New Media Reader*, MIT Press, 2003	Children Artists Musicians	"Another interesting nugget was that children really needed as much or more computing power than adults were willing to settle for when using a timesharing system. [...] The kids [...] are used to finger-paints, water colors, color television, real musical instruments, and records."
VII	1982	Steven Lisberger, *TRON*, Walt Disney Pictures, 1982	Deity	— "You believe in the users?" — "Yes, sure. If I don't have a user, then who wrote me?" (view this dialogue on YouTube)

	Year	Source	Imagined User	Statement
VIII	1983	*TIME* magazine, January 3, 1983	Papier-mâché man	The "person of the year" is a machine: "Machine of the Year: The Computer Moves In"

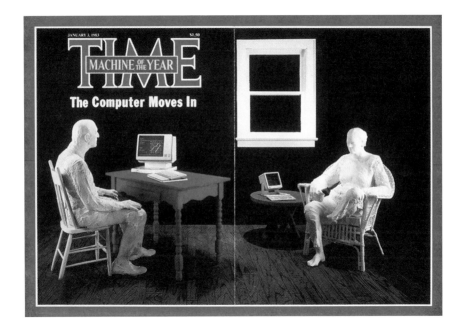

Cover of "The Computer, Machine of the Year," from *Time* magazine, January 1, 1983. © 1983 Time Inc. Used under license. *Time* magazine and Time Inc. are not affiliated with, and do not endorse products or services of, Licensee.

	Year	Source	Imagined User	Statement
IX	1993	Eric S. Raymond, "September that never ended," Jargon File	Clueless Newbies	"September that never ended: All the time since September 1993. One of the seasonal rhythms of the Usenet used to be the annual September influx of clueless newbies who, lacking any sense of netiquette, made a general nuisance of themselves. This coincided with people starting college, getting their first internet accounts, and plunging in without bothering to learn what was acceptable."
X	1996	Eric S. Raymond, *The New Hacker's Dictionary*, MIT Press, 1996, pp. 233, 275	hackers = Implementors lamers = Users	"**hacker** *n.* [...] 1. A person who enjoys exploring the details of programmable systems and how to stretch their capabilities, as opposed to most users, who prefer to learn only the minimum necessary." "**lamer** *n.* [...] Synonym for **luser**, not used much by hackers but common among **warez d00dz**, crackers and **phreakers**. Oppose **elite**. Has the same connotations of self-conscious elitism that use of **luser** does among hackers."
XI	2006	*TIME* magazine, December 25, 2006/ January 1, 2007 <http://content.time .com/time/covers /0,16641,20061225, 00.html>	YOU	The cover of the 2006 *TIME* magazine "Person of the Year" issue features a computer screen-cum-YouTube video frame announcing that "You" are the winner of this year's award. The subtitle is "Yes, you. You control the Information Age. Welcome to your world."
XII	2008	Don Norman, talk at UX Week 2008, San Francisco	People	"I'd prefer to call them people."

	Year	Source	Imagined User	Statement
XIII	2009	Sir Tim Berners-Lee, "The Next Web," TED Talk 2009, Lon Beach	Them	"20 years ago [...] I invented the World Wide Web."
XIV	2012	Jack Dorsey (executive chairman of Twitter), "Let's reconsider our 'users'," <http://jacks.tumblr.com/post/33785796042/lets-reconsider-our-users>	Customer	"If I ever say the word 'user' again, *immediately charge me $140.*"
XV	2012	Janet Murray (interaction designer, educator, author of *Hamlet on the Holodeck*) in the introduction to *Inventing the Medium*, MIT Press, 2011, p. 11	Interactor	"[User] is another convenient and somewhat outdated term, like 'interface.' [...] A user may be seeking to complete an immediate task; an interactor is engaged in a prolonged give and take with the machine."
XVI	2013	Bruce Tognazzini (principal of Nielsen Normal Group), "The Third User," 2013 <http://asktog.com/atc/the-third-user/>	Buyer	"Apple has concentrated virtually all their effort on potential users—buyers—and new users, leaving out, in the last several years, experienced users almost entirely."

Bruce Tognazzini, *The Third User*, 2013. Graphic from online text "The Third User." Courtesy the artist

Olia Lialina and Dragan Espenschied's book *Digital Folklore*, published in 2009[9] explores an alternative way of writing a history of the digital age. The authors argue that traditional narratives and images of cultural value fail users by denying them a history of their own. The book's preface, "Do you believe in Users?," served as the starting point for further research into their understanding of what a user is. It is presented here along with an edited excerpt from Lialina's 2012 essay "Turing Complete User"[10] under the heading "Turing Complete User: Invisible and Very Busy." "Users Imagined," the table from "Turing Complete User" documenting how images of users and their roles evolved, appears at the end of this essay and is referenced throughout via roman numerals. It provides insights on the ideologies that might have driven influential system designers in their decisions and how the self-image of the user developed accordingly.

NOTES

1. The graphical user interface for "users" is also often called "WIMP," for "Windows, Icons, Mouse Pointer." Real programmers would use a command line interface of course.

2. IKEMZDOL = "Ich könnte mich zu Tode lachen," the German version of ROFL or LOL.

3. Henry Jenkins: "Blog This!," *Technology Review Issue* (March 2002), <http://www.technologyreview.com/article/401372/blog-this/>.

4. Thierry Bardini, *Bootstrapping: Douglas Engelbart, Coevolution, and the Origins of Personal Computing* (Palo Alto: Stanford University Press, 2000).

5. Alan Cooper, David Cronin, and Robert Reimann, *About Face 3: The Essentials of Interaction Design*, 3rd ed. (Indianapolis, IN: Wiley Publishing Inc., 2007), 45.

6. Ted Nelson, *Computer Lib/Dream Machines*, revised ed. (Redmond, WA: Tempus Books/Microsoft Press, 1987), 9.

7. Ibid., 3.

8. The term "people" is useful when it comes to distinguishing human agency from bots.

9. Olia Lialina and Dragan Espenschied, eds., *Digital Folklore* (Stuttgart: Merz and Solitude, 2009).

10. Olia Lialina, "Turing Complete User," October 14, 2012, Contemporary Home Computing, <http://contemporary-home-computing.org/turing-complete-user/>.

COMING SOON: EBAY PAYPAL BLOGS THE INTERNET

Cory Arcangel

In the late '90s, you couldn't find a motlier crew than the typical group of students who hung out in collegiate computer labs. Consider the computer science lab at my school: a long corridor lined with LINUX workstations with bulky, beige CRTs, filled most days with computer science students deep inside what could best be described as an IRL social network. Trenchcoats, *Lord of the Rings*, and Mountain Dew dominated the scene. To put it more bluntly, these were <i>not</i> the cool kids. There was, though, another computer lab on the other side of campus filled with—incredibly!—an even more socially malformed group of lesser-known nerds. The computer lab to which I am referring was known then simply as "the media lab." It was the computer lab dedicated to (what we would refer to today as) the "creative industries"—web, print, user interface, 3-D, and interactive design.

It wasn't exactly clear yet that computers would soon revolutionize the economic and communications landscape, and accordingly, the media lab had an understated campus presence. Unlike the computer science lab, which at least had a window, the media lab was a former storeroom in the back basement of the library with a notably low ceiling, due to a floor that had been raised to accommodate computer cables for the room's four Macintosh Power PC towers. It was always terribly hot.

Though both rooms had scores of computers running software with roughly the same capabilities, the media lab differentiated itself from the computer science lab by the presence of a certain machine—a CD-ROM burner. This external device, when hooked up to one of the Macintosh towers could—seemingly like magic!—turn a blank CD-ROM into an audio CD. And while it may seem insignificant now, at the time this represented a giant leap forward. The ability to manufacture and distribute media in professional standards was still largely the

domain of top-down publishers—even an indie record required an indie record label. Therefore, to be able to burn a CD and play it on one's own stereo was still an unspeakable thrill. If today you could call up CBS and have them broadcast your home movies after Letterman, you might get some idea of the excitement felt by those in the lab as a result of having access to such a machine. This shift from professional to amateur would eventually migrate online and be known as web 2.0.

Basically, if you were interested in computers, but not able (or willing) to code bubble sorts and recursive arrays all day, chances were you were probably playing around on multimedia machines like the CD-ROM burner. There were only a handful of students who fit this description in the late '90s. And unlike the computer science students—who all shared an interest in programming—this group had nothing much in common. It was an assortment of various square pegs: cyberpunks, gravers (gothic ravers), virtual hoarders, and net freaks.

In a recent interview, Seth Price astutely describes the shifts in the culture around computers and new media: "'Media art' felt so geeky. I remember artists I knew in college who ran away from computers, never got a cell phone, listened to music only on vinyl. That was what it meant to be an artist, not toying around with your computer. That's all changed now...back then there was a stigma attached to new media."[1] There was, though, one art student who hung out in the media lab. This was surprising and rare. The media lab's lone art student was a curious combination of backpack hip-hopper, Chapel Hill–indie rock polymath, and Anglefire.com enthusiast, who dressed head-to-toe in matching primary colors. His name was Jacob Ciocci, and in just a few years he would be a founding member of the art group Paper Rad—a group whose work would bridge the divide between the stifling geek-filled media labs of the '90s and the IRL "digital casual" of today's world.

Active roughly from 2000 to 2008, Paper Rad's primary members were Jacob, his sister Jessica Ciocci, and their friend Ben Jones (though depending on the project and year, other collaborators came in and out of the mix). The works they created were variously attributed to Paper Rad, to the individual members, or sometimes to both. In this way, the Paper Rad name was used similarly to the way a group of musicians use their band name as a collective umbrella under which charismatic individual players can operate. The group's output was extremely diffuse in both its medium and distribution. They culled found images and produced and published inspirational cards, videos, installations, performances, comics, and zines, all of which could be bought, traded for, or seen in galleries, bookshops, suburban garage parties, museums, and big box chain stores, as well as on TV and the internet.

Paper Rad's refusal to distinguish between hierarchies of distribution eventually led them to infiltrate nearly every level of popular culture. Bands and musical acts featuring members of Paper Rad (Extreme Animals, Dr. Doo, Doo Man Group, DJ Jazzy Jess, and Natural Rephlex) toured the country on the underground noise circuit, and their video work ended up screening at MoMA, on VH1, and even behind M.I.A. in concert. Once, even, in the mid-'00s, late and unprepared (as usual) to a class I was teaching at Parsons, I was able to duck into the Virgin Megastore around the corner from the school and buy their *Trash Talking* DVD to screen to my class. This wider diffusion of their works ensured that, to a certain generation of culture-forward youth, the group figured as a formative influence. Just <i>last month</i> I had two unrelated studio visits on the same day, and both of my visitors randomly mentioned they were into Paper Rad "in high school." Ultimately though, because the fine art industry—the dominant mechanism for the archiving of creative culture—has a limited amount of patience for practices that color outside the lines of its own dialogue, Paper Rad's dispersion led to their work slipping out of the art historical discussion.

The nexus of Paper Rad's activities and mass-culture interventions—their "home," literally and metaphorically—was definitely their website: paperrad.org. But before I talk about paperrad.org, it's important to briefly consider what exactly <i>is</i> a website. Dragan Espenschied's observation that "everything inside a computer is a performance"[2] comes in handy here. Though Espenschied points specifically to the physical artifact that is the computer, the sentiment can be applied to the networked dynamics of the internet. A website consists of code that is transmitted across the globe through a dizzying array of gizmos— fiber optic cables, routers, and ethernet switches—and then rendered in real-time on a screen by a web browser running on an OS. It's complicated business! In this way, browsing a website is not unlike seeing a performance. I don't mean naked-people-in-a-gallery performance with a capital "P"; I mean something that happens in real time, at a specific time and location.

And since technology changes at such a rapid pace, it's actually very difficult to recreate these performances after a few years. Just to give you one of many examples, monitors are much higher resolution now than fifteen years ago, and this means they show pixels that are much smaller (so they can show a lot more). Therefore, if I were to see a copy of a website from 2000 on my laptop today, it would display nearly half the size that it displayed originally. What a world it would be if fifteen years after Koons made *Balloon Dog*, the sculpture shrunk to half its original size? SMH. Disconnects like these make internet art so difficult to consider historically, because you really did "have to be there." And for me, being "there" was seeing paperrad.org for the first time in 2001 on my shitty

Paper Rad with Andrew MK Warren, PaperRad
homepage, historically accurate screen capture
created using the digital archival technology
bwFLA: Emulation as a Service, University of
Freiburg. Courtesy Dragan Espenschied and
Cory Arcangel

computer at work one day after clicking the URL Jacob casually emailed me. As discussed above, Paper Rad the group went on to many more triumphs over the next decade, but at that moment I saw—to paraphrase(ish) Jon Landau's famous quote about seeing Springsteen for the first time—the "internet's future."

What rendered in my browser, on my 800 by 600 pixel monitor, was a long vertical webpage. At the top were oversized blue, white, and pink pixels arranged abstractly, creating what looked like a crashed Nintendo cartridge. Below this arrangement was a scanned drawing consisting of cartoon characters, peace signs, and colored lines in the style of a high-school-stoner notebook or a third-grade drawing contest. Below this was a kind of portfolio-style menu featuring links to other parts of the site, although it was difficult to make any sense of it, as the links had labels like "The Perfect Tan," "Gumby: the C.P.U is G.O.D.," and "K-A BBQ." At the very bottom of the page, in what was perhaps the site's most confounding gesture, there was a link labeled "Main Site Index." When clicked, it brought me to—confusingly—a totally <i>other</i> homepage that had a completely different design, though many of the same links as the first…but also a few more. <i>What site had two main homepages?</i> When I finally did navigate through this maze and found the FAQ—a common feature of sites of the day—it was less than helpful: "faq what? paper rad is a company non profit formed by members of paper radio, paper rodeo, and radical nation. we are making books and plan to make more things. like movies rock concerts and plays and audio stories. where? we might be moving so hold on?" At the end of this FAQ was a link back to the first homepage, not the homepage from which the FAQ was linked. This was a site like none I had never seen before. It was chaos. It looked like someone at JODI had handed the reins over to a fan fiction–obsessed preteen Geocities HTML coder.

The hints of JODI in Paper Rad were not surprising. As Olia Lialina maps out in her "Net Art Generations" online notes, the second generation of internet artists "studied jodi at university."[3] The second generation were "artists who were trained to pay attention to the Internet, understand the concept of media specificity, who see their work in relation to projects previously created."[4] JODI projects were—for a brief time in the '90s—something of an art meme. Links to their projects spread far and wide, and were even something Jacob and I ended up gawking over at the previously mentioned media lab. We browsed their projects carefully, and with a bit of trepidation, as it was rumored at the time that JODI was a group of East European hackers whose webpages would destroy computers. LOL.

What distinguished Paper Rad's website from the work of this earlier generation, though, was an appreciation and use of "my kid could do that" elements of digital vernacular expression, and a use of the language of pop culture in their

work. Their site was littered with default Photoshop elements, low-res digital doodles, vernacular "Welcome To My Homepage"–era HTML design, as well as references to pop culture imagery like Gumby, hot-rodded vans, Pink Floyd, and video games. After the incredible (though relatively dry) structural browser and coding experiments of the late '90s, this use of both pop and amateur digital vernacular sources was lid-blowing, and ultimately made it possible for Paper Rad's work to have its own reach in the popular sphere. There was also—in a link near the bottom of their homepage labeled Hot Pix—a crystal ball–like early experiment in public image sharing.

The "Hot Pix" link led to an open directory filled with images located at paperrad.org/hotpix. An open directory refers to a folder on a server that has no HTML file or style sheet associated with it, in which case the server software generates a file listing in a default template. While not exactly common in the late '90s and early years of the twenty-first century, open directories were spotted from time to time, usually at some long-lost and unknown URL on a big corporation's website. Thus, peering into one often felt a bit like trespassing because the directory was either in-progress or not supposed to be public.

Paperrad.org/hotpix displayed a file listing that contained about one hundred files. The images contained in this directory were found on the net, drawn in digital paint applications, and scanned. They were mostly cartoons, digital doodles, photographs, and drawings. By clicking on the "last modified" heading, the files could be arranged in the order they were uploaded, therefore the directory could be visited like a current-day social media feed as recently uploaded images would show at the top. The directory itself was created in order to organize various images that Paper Rad members and friends were emailing around to one another for fun at their office day jobs (many were contributed by Andrew MK Warren, a friend of Jessica and Jacob's at the time). As recounted by Jessica: "I think maybe at some point Jacob or I made that directory to sort of just more easily 'dump' or centralize or collect a bunch of those images, which had probably been emailed to each other.... This would have been in the day, after college, of lots of us having mostly boring 'office' day jobs."

Filenames are usually hidden on the web, but in paperrad.org/hotpix they were "active." For example, mrs.&mrs.whogivesafu.., f**ckthapolice.jpg, and stoner_freak_out.jpg were setups to the images themselves that functioned as punchlines. And what images they were! OMG. The file mrs.&mrs.whogivesafu..—whose full name helpfully appeared when rolled over as "mrs.&mrs.whogivesa fuck2001.jpg (Last modified, 10-Jul-2001 16:01; Size, 68K)"—was a scan of a slightly crumbled paper print of a photo (obscured by several abstract black lines) of a man and woman in suits smiling smugly at the camera. It was possibly

Paper Rad with Andrew MK Warren, HotPix
Directory, historically accurate screen capture
created using the digital preservation technology
bwFLA: Emulation as a Service, University of
Freiburg. Courtesy Dragan Espenschied and
Cory Arcangel

from a law firm advertorial, but any further explanation was left to the imagination. It also looked like the paper print itself was adhered to a door for some reason. Much more clear was f**ckthapolice.jpg (Last modified, 10-Jul-2001 15:54; Size, 70K), a photo of someone jumping off of an exploding police car while giving the peace sign with one hand and a thumbs up with the other. And stoner_freak_out.jpg (Last modified, 10-Jul-2001 16:06; Size, 276K) led to an image of Jessica herself playing the flute, backed by a bass player in a motorcycle helmet—a glimpse of Paper Rad in action at their HQ, presumably. It's also worth mentioning a few other Hot Pix images uploaded after my first visit to the directory. The file titled debbie.jpg (Last modified, 02-Mar-2002 19:26; Size, 133K) showed an image of a cheery teen Debbie Gibson posing in her bedroom in front of a Kenny Scharf–style painting she painted. And 11FANS1.jpg (Last modified, 11-Jan-2003 15:57; Size, 18K) depicted an LA Raiders fan, dressed up in a black-and-white KISS cosplay–style, Roman-inspired tunic with an Egyptian headdress. He is standing on the flat bed of a pick-up truck, holding a Raiders flag, and fittingly for Paper Rad, also giving a peace sign. I could go on and on. There was a glamour shot of a male figure skater (elvis.jpg; Last modified, 10-Jul-2001 15:53; Size, 29K), a school yearbook–style photograph of a swim team (team2000.jpg; Last modified, 10-Jul-2001 16:06; Size, 247K), a screen still of a Simpsons character drawing a cartoon cat on a computer (C-A-T.gif; Last modified, 10-Jul-2001 15:50; Size, 49K), and a photo of a hot tub full of overweight, naked men featuring a long-range rifle (end.jpg; Last modified, 11-Oct-2002 12:57; Size, 32K). Clicking through the nearly one hundred images, one got a stark picture of contemporary American life: violent, enthusiastically ignorant, and extremely bizarre. Paper Rad's eye is and was unrivaled. It was the best Instagram feed I ever saw, not only ten years before such a service existed, but before I had <i>ever</i> seen a curated collection of found digital images.

My wife and I have lived in the same apartment in Brooklyn for nearly ten years. At a certain point in the building's history, our apartment was the superintendent's, and so he raided it whenever something was needed elsewhere in the building. Thus, our apartment is missing moldings, lighting fixtures, and many of its doors. Due to our lack of practical knowledge (I know how to fix software—anything else, not so much), we have never bothered to put in any doors, and therefore over the last decade have gotten used to hearing most every movement in the apartment. But in the last few years, I am often startled by an eerie silence. It is a silence that can happen any time of day, and can last from as little as thirty seconds to as much as a half hour. Luckily, at this point, I know better. It means my wife is somewhere in the apartment, usually standing, in an Instagram hole, scrolling endlessly through her feed, neither moving nor

Paper Rad with Andrew MK Warren, website,
mrs.&mrs.whogivesafuck2001.jpg image file,
historically accurate screen capture created using
the digital preservation technology bwFLA:
Emulation as a Service, University of Freiburg.
Courtesy Dragan Espenschied and Cory Arcangel

COMING SOON: EBAY PAYPAL BLOGS THE INTERNET

Paper Rad with Andrew MK Warren, website,
stoner_freak_out.jpg image file, historically
accurate screen capture created using the digital
preservation technology bwFLA: Emulation
as a Service, University of Freiburg. Courtesy
Dragan Espenschied and Cory Arcangel

Paper Rad with Andrew MK Warren, website,
f**ckthapolice.jpg image file, historically
accurate screen capture created using the digital
preservation technology bwFLA: Emulation
as a Service, University of Freiburg. Courtesy
Dragan Espenschied and Cory Arcangel

Paper Rad with Andrew MK Warren, website,
debbie.jpg image file, historically accurate
screen capture created using the digital
preservation technology bwFLA: Emulation
as a Service, University of Freiburg. Courtesy
Dragan Espenschied and Cory Arcangel

11FANS1.jpg 184x208 pixels

Back Forward Stop Refresh Home AutoFill Print Mail Larger Smaller Preferences

Address http://paperrad.org/hotpix/11FANS1.jpg go

Internet zone

Paper Rad with Andrew MK Warren, website,
11FANS1.jpg image file, historically accurate
screen capture created using the digital
preservation technology bwFLA: Emulation
as a Service, University of Freiburg. Courtesy
Dragan Espenschied and Cory Arcangel

making a sound. Full disclosure: this situation is often reversed, but with me it's Twitter. In these uncanny moments of pure silence, I often think back to my first experience clicking through paperrad.org/hotpix. Like the CD-ROM burner in the media lab Jacob and I hung out in at college, it embodied all the excitement of the expressive possibilities of the near technological future.

So just imagine for a second that it's 2001. It's a world where your computer science friend recently told you about a cool new search engine called "Google"; a world before moms could email; a world before mileycyrus.com; a world before chic galleries showed anything involving computers; and a world before social networks like Facebook, Instagram, and YouTube. And now imagine experiencing the possibilities, energy, and euphoria of those technology-driven situations, and they were brought to you—while you were at work!—not by some dweeb Silicon Valley CEOs, but by a group of media lab nerds and bored office workers who somehow transformed themselves into an internet art Wu-Tang. WTF! This is what it was like to have been "there." This was Paper Rad.

..

This essay was commissioned in 2014 for the present volume.

..

NOTES

1. Seth Price, "Interview, Chris Bollen & Seth Price," Distributed History (Jan. 2012), ‹http://www.distributedhistory.com/Thisthaang.pdf› (accessed Sept. 12, 2014).

2. Dragan Espenschied, "Big Data, Little Narration," 1x-upon (Sept. 2014), ‹http://1x-upon.com/~despens/keynote-digital-preservation-2014/› (accessed Sept. 13, 2014).

3. Olia Lialina, "Net Art Generations," Teleportacia (Nov. 19, 2013), ‹http://art.teleportacia.org/observation/net_art_generations/› (accessed Sept. 12, 2014).

4. Ibid.

Tina Kukielski

ALL THINGS DIGITAL
—

A native of Buffalo, Cory Arcangel moved to New York City after graduating from Oberlin College in 2000, trading a skyline of aging grain elevators along the Erie Canal for views of lower Manhattan and a community of artists, musicians, comedians, and programmers. The dust was starting to settle after the deflation of the dot-com bubble, and speculators in the arts were pulling back support for new media art and net.art as the next frontier—victims of newfound cynicism for the web. Although Arcangel began his creative career by studying classical guitar at Oberlin, a turn toward electronic music composition ignited an interest in computers and art. But he found himself moments too late for inclusion in that last gasp—the swan song for all things digital—which was marked by major museum exhibitions like "Bitstreams" at the Whitney Museum of American Art (2001), "010101: Art in Technological Times" at the San Francisco Museum of Modern Art (2001), and "Body Mécanique" at the Wexner Center for the Arts (1998). This crescendo of institutional enthusiasm led to a quick fall as the mainstream art world ended its love affair with new media.[1] In the wake of this wreckage, and amid the discipline's ensuing entanglements with the institution, Arcangel emerged as an artist whose career would be marked by successes and influences found in equal measures both inside and outside of institutional frameworks.

Arcangel could have made a go at the dot-com world, but he landed instead as a computer tech at Harvestworks, a nonprofit founded in 1977, where he assisted artists using new technologies in their work.[2] At Harvestworks, he also taught children how to modify computer games and created some basic content management systems for the organization's website. But mostly he surfed the

web and inaugurated *My Home Page* (2000–ongoing), which he calls his longest-running artwork.[3] Arcangel saw the potential for the web early on, recognizing it as a versatile tool and portal for communication, promotion, recognition, and sociality. It was one of the first places Arcangel exhibited his work, and, from then on, all of his projects have emerged from or returned back to the web.[4]

In the early 2000s, Arcangel found his way into art despite no formal training, bouncing between occasional stints as a touring artist on the road, a comedian, a sometimes programmer, a curator,[5] and a collaborator on the record label Beige, cofounded by Paul B. Davis. Known for *8-bit Construction Set* (2000), a successful record popular among DJs and composed of infectious samples taken from the rudimentary sounds of old 8-bit computer and video games, Beige (or Beige Programming Ensemble) was part electronic music recording company, part coterie of computer programmers. Arcangel split from the group shortly after its participation in 2003's "THE SUMMER OF HTML" tour that also included performances and music by the members of the artist collective Paper Rad, notable also as an early collaborator on projects like the epic *Super Mario Movie* (2005) that debuted at Deitch Projects in 2005. Arcangel taught the crowd HTML during the summer tour, in between the occasional improvised lecture on "whatever."[6] During a set with Beige member Joseph Beuckman, for instance, they dialogued about a single song, "Higher State of Consciousness" by Josh Wink, in a test of the audience's patience. By some accounts, these awkward, humorous ramblings predate Arcangel's talk band, Title TK, started with Howie Chen and Alan Licht and on (occasional) tour since 2010.[7] Arcangel's output then, as it is now, was prolific, varied, collaborative, and committed to new methods of dispersion[8] initiated mostly via the web, with preference given to forms deemed potentially "contagious."[9] These early years of exploration built fruitful relationships from which Arcangel would draw on for years to come as he discreetly redefined our notions of art over the next decade.

THE ARTIST-PARTICIPANT
———

While *Super Mario Movie* delights in narrative, cacophony, and polychromy, hallmarks of Paper Rad's output of the time, the visual effect of Arcangel's solo project *Super Mario Clouds* (2002), while similarly pop-oriented, purposely underwhelms in comparison. An abjectly beautiful modification of the popular Nintendo video game from the 1980s, *Clouds* highlights the game's crude simulation of sky, isolating its display to just a few pixelated white clouds scrolling slowly over an arid

blue field. For many who grew up playing the game, there is a hint of melancholy in Arcangel's alteration of the familiar landscape, rendered abandoned and vacant. Too feeble to change its display, we are instead left to relish in its now obsolete readymade beauty.

Despite his stand-out multi-screen presentation of *Super Mario Clouds v.2k.3* at the 72nd Whitney Biennial in 2004,[10] Arcangel got off to a rocky start as a young artist with uneven dual solo gallery debuts. Lukewarm reviews of Arcangel's gallery efforts suggested the critical divisiveness that would follow his work for a number of years, despite his broad influence and the attention he garnered across an increasingly dominant and widespread public interested in art, culture, music, and tech—worlds that he easily bridged.[11] The indignation toward some of Arcangel's web antics would reach a fever pitch in 2006 when he launched *Punk Rock 101*, a website hosting Kurt Cobain's suicide letter that, as websites had been set up to do, generated clickthrough Google ads specific to the site's interests. In this case, ads for antidepressants and public speaking and social anxiety workshops populated the page, and the artist suffered online rebukes such that Google canceled the ads and Arcangel disabled the site altogether, never cashing in on the advertising money. Nonetheless, the website generated a lot of press and spread rapidly after being picked up and featured by the news aggregator Digg that relies on user votes to move or "digg" a news headline to the top of the page in a manner similar to Reddit. Despite its popularity among online users, *Punk Rock 101* rarely found its way into museum or gallery presentations of the artist's work. Nonetheless, this gap is telling. It signifies Arcangel's dance between online and offline presence and performativity, and by the same token, how critical response to his work vacillated within each of these, at times, mutually exclusive worlds. Arcangel's widespread influence is fueled by the work's undeniable accessibility and shareability, attracting audiences from both spheres.

"Subtractions, modifications, addenda, and other recent contributions to participatory culture" (2006)—his second solo exhibition at Team Gallery in New York—honed in on Arcangel's developing interests and suggested a more serious tone and direction for his work, which had been up until then infatuated with the idea of amateurism and low-fi aesthetics, and whose titles oftentimes were accompanied by an abundance of exclamation points. Because of their simple default design, 8-bit computer games are easy targets for amateur modifications, as demonstrated by a number of Arcangel's works, from the well-known aforementioned Nintendo mods to Atari mods like *Space Invader* (2004). The Team Gallery exhibition dealt exclusively with appropriated media, including performances by Guns N' Roses and the Beatles, and the now legendary re-dubbing of Richard Linklater's cult film *Dazed and Confused* by a Bangalore outsourcing firm.

http://www.beigerecords.com/cory/kurt/

's suicide letter vs. Google AdSense

To Boddah,

Speaking from the tongue of an experienced simpleton who obviously would rather be an emasculated, infantile complain–ee. This note should be pretty easy to understand.

All the warnings from the punk rock 101 courses over the years, since my first introduction to the, shall we say, ethics involved with independence and the embracement of your community has proven to be very true. I haven't felt the excitement of listening to as well as creating music along with reading and writing for too many years now. I feel guity beyond words about these things.

For example when we're back stage and the lights go out and the manic roar of the crowds begins., it doesn't affect me the way in which it did for Freddie Mercury, who seemed to love, relish in the the love and adoration from the crowd which is something I totally admire and envy. The fact is, I can't fool you, any one of you. It simply isn't fair to you or me. The worst crime I can think of would be to rip people off by faking it and pretending as if I'm having 100% fun. Sometimes I feel as if I should have a punch–in time clock before I walk out on stage. I've tried everything within my power to appreciate it (and I do,God, believe me I do, but it's not enough). I appreciate the fact that I and we have affected and entertained a lot of people. It must be one of those narcissists who only appreciate things when they're gone. I'm too sensitive. I need to be slightly numb in order to regain the enthusiasms I once had as a child.

On our last 3 tours, I've had a much better appreciation for all the people I've known personally, and as fans of our music, but I still can't get over the frustration, the guilt and empathy I have for everyone. There's good in all of us and I think I simply love people too much, so much that it makes me feel too fucking sad. The sad little, sensitive, unappreciative, Pisces, Jesus man. Why don't you just enjoy it? I don't know!

I have a goddess of a wife who sweats ambition and empathy and a daughter who reminds me too much of what i used to be, full of love and joy, kissing every person she meets because everyone is good and will do her no harm. And that terrifies me to the point to where I can barely function. I can't stand the thought of Frances becoming the miserable, self–destructive, death rocker that I've become.

I have it good, very good, and I'm grateful, but since the age of seven, I've become hateful towards all humans in general. Only because it seems so easy for people to get along that have empathy. Only because I love and feel sorry for people too much I guess.

Thank you all from the pit of my burning, nauseous stomach for your letters and concern during the past years. I'm too much of an erratic, moody baby! I don't have the passion anymore, and so remember, it's better to burn out than to fade away.

Peace, love, empathy.
Kurt Cobain

Frances and Courtney, I'll be at your alter.
Please keep going Courtney, for Frances.
For her life, which will be so much happier without me.

DOING ASSEMBLY: THE ART OF CORY ARCANGEL

Cory Arcangel, *Punk Rock 101*, 2006
(screen capture). Website. Courtesy the artist

Noticeably absent were the video games, although they returned to Arcangel's stable later. An outmoded notion of interactivity, developed in the '60s and '70s, is often applied to Arcangel's works, where he in fact responds astutely to the complexities of today's democratized and also corporatized participatory culture. Take for example *Masters* (2011), where a coy modification of a golf video game invites the audience to pick up the putt. Inevitably, however, every swing is reprogrammed to miss the hole. Unlike Nam June Paik's *Participation TV* (1963), where the sound of a voice could change an image onscreen to wondrous effect, *Masters* employs a method of participation that results in total frustration.[12] Challenging the concomitant fantasies and goals of new media, Arcangel continued to pursue works that evoked a more nuanced reality of engagement.

It is fitting here to introduce the idea of the "prosumer"—one who enacts an equally participatory role in both his or her own consumption and commodification as a consumer—a term that has gained popularity since the rise of web 2.0.[13] Arcangel consistently plays with the current tendency to adopt prosumer models for engagement. Today, this model fuels profit- and influence-driven organizations, and its implementation across the web is widespread and pervasive. The model relies on established systems for exchange: the very tendency to share something with others online, the expert-to-novice relay made easy through information sharing on the web, a strong sense of social connection built through online modules, and the interdependencies and interconnectedness of people and products. Pondering the shift, Arcangel says: "I mean, where is art left when everyone is a producer?"[14] More than critique, his work tests a developing model that brings with it fundamental and essential transformations of the ways in which we interact and socialize in the twenty-first century. The effect is wildly different from that which is explored by Nicolas Bourriaud's practitioners of relational aesthetics. Neither communal nor even convivial, Arcangel's relational, "participatory" works at times embody a deep sense of alienation and

disconnection, nowhere more evident than in the mystery, hollowness, and succinct brilliance of the kinetic sculpture *Permanent Vacation* (2008). *Permanent Vacation* is composed of two iMac computers programmed to ping "Out of Office" replies back and forth at each other with a few seconds delay, bouncing between absence and presence ad infinitum, or at least until either of the hard drives crashes from memory overload. The utopia implied by the machine as a reasonable human stand-in quickly becomes a dystopian joke as the replies advance and aggregate endlessly on screen to the point of malfunction.

This is not to say that all of Arcangel's projects that play with prosumer technologies have that tinge of bleak machinist automation. Recently, the artist formed an unwitting special interest group through the online "performance" *Working on My Novel*, in which Arcangel brought together both real and would-be novelists who have used the phrase. Since 2009, Arcangel has been collecting instances and applications of those four words found in various Twitter feeds and retweeting the results, such as: "Working on my novel and watching Family Guy. Oh yeah!!"[15] For those in creative outlets, the experience of procrastination, delay, and distraction is a real threat to productivity, and social media provides a welcome, if ironic, place to waste time. Arcangel's revelation here is huge; it signals the fractured relationship between technology and creativity, individuation and the collective. It warns of a future devoid of original content, but full of mindless pings.

With astonishing prescience, Arcangel's work adopts or mimics the strategies and operations of some of the most important concepts of the early 2000s, from prosumerism to the Twitter feed. Other technologies or innovations that became democratized through their popular dissemination during this time include data compression, open sourcing, outsourcing, e-commerce, flat screens, smartphones, and YouTube. Of the ensuing works, some prove more successful than others. *Pizza Party* (2004) figures as one of Arcangel's initial forays into e-commerce (as well as into open-sourcing with the work's eventual software release). A commission from Eyebeam Art + Technology Center made in collaboration with programmer Michael Frumin, the work featured a command-line utility that could be used (within a computer's operating system) to order one or more pies and have them delivered by Domino's Pizza with just a few strokes of the keyboard. *Pizza Party* immediately went viral after Arcangel released it online in 2004.[16] Incorporated since 2011, Arcangel Studios' recently launched line of clothing dabbles in a new breed of internet commerce. Arcangel Surfware—cotton sweats designed to be worn while surfing the web—just hit the market.[17] The impact of this "(in)activewear" designed in collaboration with the "global merchandising giant" the Bravado Group, a division of Universal Media Group, necessitates a wait-and-see approach.[18]

Courtesy Arcangel Surfware, 2014

MUSICAL ROOTS AND METHODS

In the critical reception of Arcangel's work, much attention has been paid to the relationship between art and nonart, and there is a tendency to situate his work in the lineage of appropriation and Pop art that includes figures like Richard Prince, Jeff Koons, and especially Andy Warhol.[19] While not entirely incorrect, Arcangel's Pop tendencies consistently skew toward objects or symbols of meme culture over readymades of mass production. From Warhol's box of tricks, what Arcangel borrows most are wide-reaching strategies for circulation, distribution, and entrepreneurship. As an artist whose practice is predicated on the digital, such processes and strategies are of paramount consequence.

For Arcangel, the internet is both subject and medium. What interests Arcangel the artist is the same thing that interests Arcangel the web-surfer: amateur culture, fan culture, emulation culture, remix culture, popular music, garbage TV, YouTube, procrastination, mediocrity, brand culture, the early internet, web "trash," default design, and communicating through au courant varieties of social media like the social bookmarking website del.icio.us (now partially deprecated and undergoing a redesign), Friendster (on which he "committed suicide" publicly in a performance at P.S.1 Contemporary Art Center [now MoMA P.S.1]), and Twitter. If there is one commonality in this diverse array of stimuli that stops Arcangel in his tracks, it is those aspects of our culture that are generative—that suggest a lifespan with a tendency to reproduce. Arcangel takes note of how media presences grow, change, and extend over time, transforming meaning through a process of creation, repetition, depreciation, and archiving. Such is the artist's approach to his own heterogeneous work *Continuous Partial Awareness (C.P.A.)* (2008–ongoing), a collection of his artistic ideas in list form that arise predominantly from the aforementioned areas of interest. Released as PDFs on his website in 2008 and again in 2009, Arcangel returns and builds on the list all the time.

Arcangel's ongoing list is indebted to generative systems propelled by the advent of the computer, but "partial awareness" gets at attitudes unique to this moment: attention economy, internet addiction, and the futility of multitasking. Some prompts from *C.P.A.* include: "Make a blog where I steal posts from other blogs that contain the phrase 'Sorry, I haven't posted in a while'"; "Start a lecture with almost no battery left on my laptop, and end when the computer runs out of power"; or, "re-do Bas Jan Ader's *In Search of the Miraculous* on a Segway." A database of his own mind, the work is built on endless assembly, questioning, and propositions—on breaking things down and building them back up again. On a number of occasions, Arcangel has performed *C.P.A.*, during which he reads through the list before a live audience; like a lot of his performative work, it is

iterative, repetitious, and repeatable, sometimes uncomfortable, slightly navel-gazing, and comedic. It captures the spirit of Arcangel the artist experimenting with dissemination, aggregation, immateriality, and mimicking the web as a clearinghouse for culture at large—a bit of an actor or agent provocateur, yet strict, precise, and disciplined.

Here Arcangel's education in the conservatory should not be overlooked. Courses in electronic music composition emphasized minimal and chance compositions like those of John Cage and La Monte Young.[20] The Deep Listening theories of avant-garde musician Pauline Oliveros, a professor of Arcangel's, focused on telepresence, spirituality, and improvisation. Beyond this, Arcangel trained as a performer. Phasing, virtuosity, atonality, variation, technique, and the database would all be subjects of various Arcangel works notable for their overarching sound component. These include: *Sweet Sixteen* (2006) (phasing); Paganini's *Caprice #5* (2011) (virtuosity); *Drei Klavierstücke op. 11* (2009) (atonality); *A Couple Thousand Short Films About Glenn Gould* (2007) (variation); and *The AUDMCRS Underground Dance Music Collection of Recorded Sound* (2011–12) (database). The idea of data compression and decay, while frequently associated with the format of the JPEG as a tool for digital image conversion, is also a musical term. It forms the basis of *Untitled (After Lucier)* (2006), a video and sound loop that continually compresses and degrades the 1964 TV broadcast of the Beatles on the *Ed Sullivan Show*. The work pays homage to composer Alvin Lucier's *I Am Sitting in a Room* (1969), an early experimental sound piece in which Lucier records himself reading a short text and then plays it back and re-records it again and again, degrading the recording over time.[21]

Similarly, Arcangel notes that his modified video game *Super Slow Tetris* (2004) could be considered an homage to the composer and filmmaker Tony Conrad.[22] Although Arcangel was born on the heels of Buffalo's moment of experimentation and collaboration in the visual arts, film and video, performance, literature, and music, to which Conrad was central, it could be argued that there were some impressions by proximity.[23] Arcangel's *Personal Film* (2008) is a fake structural film—and perhaps a nod to Conrad's *Flicker* (1965)—composed of stock digital video rendered using a certain filter on iMovie and then sent out to be transferred to 16mm film format. As critic and curator Ed Halter recounted in an interview with Arcangel: "You either introduce a ridiculously enormous and therefore pointless amount of work into it, or you reduce the work by using automation, or defaults, or outsourcing. So you either extend the amount of work to an enormous extent that makes it absurd, or you reduce it to nothing which undercuts its legitimacy."[24] Either way, the system employed (or exploited) to reach the proposition is significant.

Cory Arcangel, *Untitled (After Lucier)*, 2006 (still).
Single-channel video loop, black and white, sound,
computer, video projector, and artist software,
dimensions variable. Courtesy the artist

DOING ASSEMBLY: THE ART OF CORY ARCANGEL

Notation in music, in some respects, parallels code in computer programming. This relationship is suggested in Arcangel's recent releasing of open-source projects like *Pizza Party* in the guise of stripped-down pieces of sheet music.[25] Constantly developing systems for distribution, Arcangel is perhaps at this point more interested in new forms of dissemination, telecommunication, and dispersion, than in new and heavily consumer-marketed technologies. We are perhaps seeing a shift in focus necessitated by the speed with which today's newest devices get introduced; we have yet to see Arcangel's interpretation of Google Glass, for instance. Instead, the mode of distribution is tantamount to the medium employed.

Recent examples of new modes of circulation and, by extension, entrepreneurship beyond code zines include the artist's recent installation of his vinyl techno collection (*The AUDMCRS Underground Dance Music Collection of Recorded Sound*) at the Carnegie Public Library in Pittsburgh (2012); his book contract with Penguin to release a novel (2014); Title TK's heterogeneous tour schedule (ongoing); the release of Arcangel Surfware (2014); and his stewardship of a digital recovery project involving Andy Warhol's drawings on the Amiga computer from 1985 (2012–14). Earlier examples of Arcangel's dispersals include the free Wi-Fi network installed as part of his 2010 solo exhibition at the Whitney Museum, his takeover of webpages simultaneous to exhibitions like one at MoCA, North Miami, in 2010 or in lieu of an exhibition such as he did for the small artist-run gallery New Jerseyy in Basel in 2010. There are no doubt countless other examples overlooked here, including Arcangel's way of distributing his trademark software as individually ripped DVDs that visitors to his exhibitions may pull from a vertical spool.

THE ART OF SUBVERSION, MODIFICATION, AND THE READYMADE

If various Minimalist and Conceptualist precedents are a continuous source of inspiration for Arcangel, so is the artwork of net.art duo JODI. Based in Amsterdam, JODI, or JODI.org, comprises artists Joan Heemskerk and Dirk Paesmans, pioneers in many forms of digitally based artworks and, at one time, specifically in the realm of modified video game architectures that focused on the breakdown of any and all qualities and characteristics of the games' interfaces. This deconstructive approach mirrors JODI's modifications of its own website (1995–ongoing), which remains in a state of constant discord, where lines of code take the place of normal surface design such that the effect is at

Cory Arcangel, *The AUDMCRS Underground Dance Music Collection of Recorded Sound*, 2011–12. Collection of 839 trance LPs and catalogued in Machine Readable Cataloging standard, dimensions variable. Installation view: "Cory Arcangel: Masters," Carnegie Museum of Art, Pittsburgh, November 3, 2012–January 27, 2013. Courtesy the artist. Photo: Tom Little

Cory Arcangel, *Data Diaries*, 2003 (screen capture). Website, historically accurate screen capture created using bwFLA: Emulation as a Service, University of Freiburg. Courtesy the artist

once confounding, nonsensical, and extreme. Arcangel's *Totally Fucked* (2003), a video mod featuring Mario hopelessly turning his head back and forth on a lone cube amid a sea of blue screen with nowhere to go, is in synch with the anarchic efforts of JODI, who turns operating systems against themselves. Speaking around the time of its inclusion in documenta X, JODI explained the way that art can become naturalized. As interventionists into both the systems and codes of the art experience as well as that of technology, the duo insists: "Media art is always on the surface. You have to get people very quickly. You need to give them a karate punch in the neck as soon as possible."[26]

Arcangel's *Data Diaries* (2003) is indebted to JODI's tactics. By tricking the program QuickTime into reading one day's worth of random-access memory data as a video file, Arcangel transformed the forgotten trail of activity on his

personal computer into beautiful colors and bouncing pixels across thirty-one separate videos, one for every day of the month of January 2003, when the work was made.[27] The work is an assisted readymade transforming what hides inside every computer and giving pause to what we take for granted such that we can find new ways to see. Arcangel's computer readymades embody none of the indifference of Duchamp. They seek to reveal and challenge the technological systems employed in their making. As such, Arcangel's computer readymades each deal with a different break in the system in an effort to expose the qualities, characteristics, and conditions of the given technology: plasma burn (*Hitachi P42H01U Plasma Burn* [2007], et al.); keystoning (*2 Keystoned Projectors* [2007]); the scanner (*Squire* [2007]); the projector (*Change Bulb* [2008]); game interface (*Self Playing Bowling* [2008], et al.); visual display (*Video Ravings* [2003] and *Colors* [2006]); compression (*Total Asshole Compression* [2004]); Google search (*Dooogle* [2004]); the color gradient in Photoshop (*Gradients* by various titles [2007–ongoing]); and the download (*Untitled Translation Exercise* [2006]). During an artist panel led by curator Michael Connor at Electronic Arts Intermix in 2012, special guest JODI sat on stage with Arcangel. Once Connor turned the conversation over to Heemskerk and Paesmans, a corrupted and faulty Power-Point presentation led to awkward stirs among the crowd, reaching a crescendo when a water glass "accidentally" fell from the panel table and shattered on the ground. Arcangel's earlier précis: "Start a lecture with almost no battery left on my laptop, and end when the computer runs out of power," again certainly owes its agitprop to JODI's mastermindery of subversion.

Yet where the two diverge is significant. JODI comes out of the net.art movement influenced by hacker culture that promoted a networked community of practitioners. With the spread of social media under web 2.0, JODI's vision for the network has been instrumentalized, and corporatized to boot. Arcangel and JODI are quick to recognize this profound shift. Take for instance Arcangel's *Dooogle*, a software emulator that altered Google search so that any search term entered would turn up threads concerning the late 1980s and early 1990s television series *Doogie Howser, MD*, starring Neil Patrick Harris. The website ran from 2004 through most of 2011 when, due to deprecation because of Google upgrades, Arcangel chose to cache the results. Theoretically, memes operate and exist as the lowest common denominator of culture, requiring little of their audience in terms of attention, participation, and feedback. Arcangel is doggedly meme-conscious. *Dooogle* shows this, as do the top-ten lists of the internet (*The Year of the Internet* [2005–06]) that he started with the artist Michael Bell-Smith at about the same time as *BuzzFeed* began offering all of its aggregated content in short digestible list form. He made a super-cut cat video in 2009 (*Drei*

Klavierstücke op. 11) based on the eponymous composition by Arnold Schoenberg and released it on the heels of Keyboard Cat's virality and spoofing in popular culture. He probably would have finished it sooner if the software necessary to pull the notes from existing YouTube videos—Gould Pro, which Arcangel designed—did not also need to be "auditioned" note-by-note before making the final cut.

A BUBBLE BURSTS AGAIN

In 2008, Arcangel received his first large-scale private commission for an artwork from a company called Greenwich Street Capital (GSC) Group, a private equity firm that kept offices on 7th Avenue in Manhattan. For the work, he snapped a photograph of trees in Central Park and used Photoshop to blow up its green pixels until the size of a single pixel matched the size of a US dollar bill. The now massive, overblown file of a blurry pixelated landscape became the repeating pattern covering the walls of GSC's chrome and glass offices, subliminally greeting investors with the promise of greener pastures. The work was left untitled.

Today, the fate of GSC embodies a well-known story. A popular and profitable strategy of investing in mounting corporate debt led to the accrual of investments of mortgages in the subprime, and for a brief moment, the partners of GSC were on top. They nabbed some new lenders, cashed big checks, and expanded. Then the housing and credit bubbles burst and the crash of 2008 left GSC unstable and filing Chapter 11 a short two years later. The financial group Black Diamond purchased GSC's remaining assets in 2011, leaving the status of Arcangel's work more or less in limbo. He then created a secondary work as a kind of elegy to the untitled commission. This new work, *et al.* (2011), a collection of documents, chronicles GSC's legal filings as debtors and the auctioning of its assets, including presumably the wallpaper installation in the offices on 7th Avenue. As a vendor for the company, and hence a rightful witness to the bankruptcy proceedings, Arcangel received confidential copies of the legal paper trail. The collection of letters, including the stamped envelopes they came in, scanned and archived by Arcangel and his assistants, constitutes a deadpan Conceptualist work with nods to Hans Haacke's *Shapolsky et al. Manhattan Real Estate Holdings, a Real-Time Social System, as of May 1, 1971* (1971). The original GSC commission wormed its way through the membrane of the housing bubble that distended the US economy, and by extension that of the world, through most of the 2000s, while being both complicit in and eventually a victim of that bubble just the same. Equally so, the work dovetailed with Arcangel's then-concurrent investigations

Cory Arcangel, Untitled GSC Commission, 2007.
Back-lit LED dura-trans film. Courtesy the
artist and Jimmy Cohrssen Photography. Photo
© Jimmy Cohrssen Photography

into image compression such that the *ex post facto* commission has come to signify an unexpected double entendre, sealed with dual meanings of compression in terms both technological and financial.

It is important to note that 2008 marks not the first, but the second major transformation to impact Arcangel and his contemporaries, who had already survived the dot-com crash of 2000. The fallout from this earlier, and arguably more significant, break led to a partiality for the web marked by a new standard—one found at a safe, relative distance to its circulating economy, armed with a critical eye toward its supposed panacean powers. Artists of the '00s entered into a milieu quickly being redefined by the imminent alteration of the digital-social sphere caught up in a sweep of change as user-generated content took hold under web 2.0. Through an early and quick embrace of new technologies, especially those of the web, Arcangel became a leader in the redefinition of what art is, opening up the man–machine exchange as a territory for further mining. That internet culture inculcated an amorphous, uncentered, unspecific so-called movement known as the ever-shifting term postinternet is no surprise. Whereas many of the artists associated with the neologism are glommed together—rightly or wrongly—because of overarching aesthetic sensibilities that latch onto the modes of rampant corporate branding and commercialization, Arcangel is distinct in that his work operates less in a materialist realm. That is not to say that this artist avoids making objects, but importantly, when his works arrive on the internet, or in the gallery or museum context, they typically surround themselves with a web of systems that activate their display. Interested in the social and, increasingly, the economic, and well versed in the technocratic, Arcangel's work is predominantly systems-oriented. It depends on the readymade, but it finds meaning through its activation—through aggregation, participation, and circulation.[28]

If telecommunication can be defined as "a process of turning objects into mobile signs,"[29] then Arcangel is a telecommunicator. As an astute purveyor of this culture of just-becoming, one that serially turns objects into signs, Arcangel is equally aware of a culture with qualities at once generative, meme-based, and recursive. His work builds itself on the systematized practices of Minimalist and Conceptualist artists and musicians, yet is set against the wildly provisional nature of the internet and new technology. Taking steps beyond the subversions, deconstructions, and hackerisms of pioneering groups like JODI, his work advances Marshall McLuhan's claims that "the medium is the message" and, in that way, tracks developing techno-aesthetic protocols and how the technologically deterministic conditions of our time prescribe the way we think and behave. While distinct in character, look, and feel, the work is nonetheless connected

to social practice, relational aesthetics, and socially engaged artworks that have steered critical conversations around art since the 1990s.

FROM SYSTEMS THEORY TO MEMES

In 1970, curator and critic Jack Burnham curated an exhibition featuring what he called "systems art" at New York's Jewish Museum. Titled "Software," the exhibition included works by John Baldessari, Robert Barry, Hans Haacke, Nam June Paik, and Lawrence Weiner, among others. The techno-utopianism of Burnham's curatorial and critical propositions, transmitted through a series of essays in *Artforum* like "System Esthetics" from 1968, while forward-thinking at the time, anticipated an art world immersed in solidly technical pursuits like engineering and industry. According to art historian Caroline Jones, who has followed Burnham's predictions up through today, what resulted instead were artworks that pursue "the social and electronic protocols that govern our world." Today's "system artworks," according to Jones:

> dialectically reject or critically torque the virtual ideologies of the In-
> ternet to *materialize* [emphasis the author's] the links that join archival,
> research-driven, process-oriented, labor-intensive, recursive, informa-
> tional, social, and communicational aspects of art.[30]

Isolating the internet's significance as a subject of inquiry over its relevance as a medium opens up Arcangel's practice as a serious study on cultural trans-missions, memetics, and social systems. It places Arcangel's works well within the trajectory of process or systems-oriented art that at the same time con-stantly looks to new forms of dissemination. The new media theoretician Lev Manovich puts it into perspective when he notes that the internet is an agent of modernization enabling participation in global consumer culture, yet, at the same time, "the Internet is not a single medium."[31] It is made up of old and new mediums, thus putting its coherence in question. Further complicating Arcangel's use of the internet is the very heterogeneous way that information and meaning are aggregated in the work. As an ensemble, Arcangel's work is multifarious. It takes distinct forms, it traces differing modes of communication, and it opens up new channels for exchange. As such, a consideration of these evolving processes is pertinent to any study of Arcangel's work.

Arcangel's influence on art-making in the early twenty-first century is wide-spread. As machines and devices play more and more of a role in our lives, Arcangel

invites us into conversations about what it all means. A dogged belief in access for all has led to the unique democratization of his art; this in itself has redefined what art is in the early twenty-first century. Yet his early embrace of the internet transformed the way we think about and look at artwork from the get-go. To be a student of Arcangel's practice requires one to look outside of known territories for art, between the culture of the mainstream and the idiosyncrasies of the web, the dominance of the user and the changing role of the artist in society, between participant and passive consumer.

We consume. We copy and repeat. We get corrupted and lose our data, only to abandon ourselves until our profiles are reborn. These techno-aesthetic strategies are embedded in the broadband, networked internet culture that today dominates in the developed world. That cell phone you are carrying tells the story. Socially speaking, we adopt these methods because there is little other way. There is a dwindling number among us who resist the networked offerings of Google's empire, and those who do ultimately find themselves hopelessly out of the loop. The alternative is a broken, forgotten, or obsolete world where frustrations lurk around every corner. Within the many interfaces and flows of information that constitute our lives, these strategies become hard to untangle from one another. Arcangel, the artist-fugitive, the proponent of dispersal and contagion, aware of our limited attention, but nonetheless asking for our participation, sees the limits of our world and ushers us into the next.

. .

This essay was commissioned in 2014 for the present volume.

. .

NOTES

1. This is not to say that art and technology disappeared, but that their funding and the course of their representation in the form of departments within major institutions diminished. Nonetheless, leading digital arts groups like Rhizome, the New York tech-arts organization Eyebeam Art + Technology Center, and Ars Electronica Center in Linz, Austria, among others, continued to realize countless commissions of digital artworks and continued conversations in the digital arts.

2. Harvestworks originally began as an organization that offered public access to a synthesizer studio where nonprofessionals could utilize the technology before it was publicly available.

3. Around 2012, Arcangel released the first version of a pseudo-catalogue raisonné, a database of all known works by the artist dating back to 1987 accompanied by short textual descriptions and a representative image. The book, meant for researchers, was given to the author as a printed and bound binder in February 2012.

4. Some notable early online portals for Arcangel's work included turbulence.org and the New York Digital Salon. In works not immediately built and released on the web, Arcangel has consistently blogged about them on his website, both a clearinghouse and an essential (public) database for all projects, known as Cory Arcangel's Official Portfolio Website and Portal: <http://www.coryarcangel.com> (accessed Aug. 31, 2014).

5. Arcangel got his start curating video and performance programs notably with Seth Price at Anthology Film Archives in 2003. In 2004, with his sister Jamie Arcangel, he curated an exhibition for Foxy Productions called "The Infinite Fill Show." Participating artists were asked to use the 1984 MacPaint software, a precursor to Adobe Photoshop, to create a work. In 2005, Arcangel curated a program and released an accompanying floppy disk called *Low Level All Stars*, a collection of the best Commodore 64 intros taken from various cracking groups, made in collaboration with Radical Software Group.

6. Ricardo Miranda Zúñiga, "Post-Teen Beat Interview with Cory Arcangel," *North Drive Press* no. 1 (2004): n.p.

7. In 2013, Title TK released its debut "album" *Rock$*, a printed transcription of the group's private banter packaged in an LP sleeve.

8. Here I am indebted to ideas of dispersion proposed by Seth Price in "Dispersion," reprinted in this volume.

9. The terms "contagious media," or media that employs viral techniques, was coined and promoted by The Contagious Media group founded by Arcangel's friend Jonah Peretti roughly around 2004. A number of once-collaborators and like-minded peers of Arcangel would move into successful commercial ventures. For instance, Peretti founded *BuzzFeed*, the popular online news media company.

10. Arcangel initially posted the work online accompanied by a technical tutorial to guide in replicating the modification, contributing to its "enthusiastic reception both online and offline." Ruba Katrib, *Cory Arcangel: The Sharper Image* (North Miami: Museum of Contemporary Art, 2010), 11.

11. The number of profiles on the thirty-six-year-old is only surpassed by the incredible number of online and printed interviews to which Arcangel agrees to participate.

12. For a discussion on artworks that challenge ideas of interactivity, see Julian Stallabrass, "Interactivity," in *Internet Art: The Online Clash of Culture and Commerce* (London: Tate Publishing, 2003), 60–67.

13. Despite what the name implies, web 2.0 is not a new version of the world wide web, but rather a change in user experience marked by the transformation of web functions, notably evident in more active exchanges between users, commenting on social media, and user-generated content.

14. Cory Arcangel and Dara Birnbaum, "Do It 2," *Artforum* (March 2009): 196.

15. The collection of tweets edited and selected by Arcangel was published as a book with Penguin in 2014.

16. A notable net.art project to pursue e-commerce strategies was launched in 2002 in the wake of the dot-com crash, when London-based artists Jon Thompson and Alison Craighead initiated their Dot-Store, a collection of goods offered online. Merchandise included, notably, a set of tea towels printed with the Google search results for the queries: "Please Help Me," "Is Anybody There?," and "Can you hear me?"

17. Online purchases can be made through a separate website: <http://arcangelsurfware .biz/> (accessed Aug. 1, 2014).

18. Another notable comparison here is in the work of Seth Price, who with Tim Hamilton, released his own line of clothing during dOCUMENTA (13) in 2012. The military-themed line of hoodies, cloaks, and ponchos were emblazoned with the logos of FDIC, UBS, Capital One, and the patterns found inside business envelopes.

19. The Warhol comparison has been noted by Andrea K. Scott, "Futurism," *New Yorker*, May 30, 2011, 33. Arcangel's work was included in the traveling exhibition originated at the Metropolitan Museum of Art titled "Regarding Warhol: Sixty Artists, Fifty Years" (2012). Arcangel is a self-described Warhol acolyte, making an early video mod of *Hogan's Alley* called *I Shot Andy Warhol* (2002) and more recently participating (alongside the author) in the digital recovery project of Warhol's Amiga drawings as chronicled in an online documentary: <http://www.nowseethis.org/invisiblephoto/posts/108> (accessed Aug. 1, 2014). For comparisons to Jeff Koons and Richard Prince see Roberta Smith, "A Muse in the Machine: Click. Create," *New York Times*, May 27, 2011, C21. Smith writes: "The pieces on view are full of savvy echoes of early video art and structuralist film; kinetic, Conceptual and Pop art and their current derivatives; abstract painting; and, above all, appropriation art—all of it often updated by his generation's democratic attitude toward information sharing."

20. In response to a question about the influence of John Cage, Arcangel states: "I remember going to class and kids were rolling dice in the hallways. He was that prevalent. The way I look at it is that anything you do, you're indebted to Cage. It's not necessarily like love. It's kind of like, you get up in the morning and you brush your teeth. It's just there." "Profile: Cory Arcangel," interview with Cathleen Chaffee, *Contemporary* 84, 2006, 29.

21. Arcangel made another work dealing with compression, *Total Asshole Compression* (2004), programmed by Radical Software Group. It enlarged the size of a file that passed through it, doing the opposite of then-popular StuffIt or Zip programs.

22. Interview with Chaffee, 28.

23. This has been argued by the author in a text accompanying Arcangel's exhibition "Masters" (2012). Tina Kukielski, "Cory Arcangel: Masters" (Pittsburgh: Carnegie Museum of Art, 2012–13), 15–16.

24. Ed Halter, "Get It? An Interview with Cory Arcangel," *Rhizome* journal, Dec. 24, 2008, <http://rhizome.org/editorial/2008/dec/24/get-it-an-interview-with-cory-arcangel-on -comedy/> (accessed Sept. 1, 2014).

25. Arcangel put out *The Making of Super Mario Clouds*, assuming the style of an instruction manual, in 2005. He released a video of the same name and subject a year earlier. The recent set of small, zine-like publications of his code all fall under the title *The Source* and were supported by a Creative Capital grant.

26. Tilman Baumgärtel, "Interview with Jodi. We Love Your Computer: The Aesthetics of Crashing Browsers," *Telepolis*, October 1997, <http://www.heise.de/tp> (accessed Aug. 31, 2014).

27. *Data Diaries* is still viewable in its original online format: <http://www.turbulence.org /Works/arcangel/> (accessed Aug. 10, 2014).

28. David Joselit considers the usefulness of the aggregator as a model for contemporary art in a global sphere. In finding comparisons to conceptualist projects from the 1960s to the 1990s, Joselit concludes: "The most pervasive, global, dialects of the present moment, however, proceed from a different syntactic model: that of the aggregator." David Joselit, "On Aggregators," *October* no. 146 (Fall 2013): 11–12.

29. New media theorist Lev Manovich addresses modernization by comparing Walter Benjamin's writings on film to Paul Virilio's assessment of telecommunication. He states that both theories advanced the continual modernizing mode of "turning objects into mobile signs," concluding presciently in 2000 that "the signs themselves now exist as digital data, which makes their transmission and manipulation even easier." Lev Manovich, *The Language of New Media* (Cambridge, MA, and London: MIT Press, 2000), 173–74. By extension, Hito Steyerl's concept of the "poor image" advances Manovich's claims about transmission, manipulation, and circulation. Hito Steyerl, "In Defense of the Poor Image," *e-flux journal* 10, November 2009, <http://www.e-flux.com/journal/in-defense-of-the-poor-image/> (accessed Sept. 1, 2014).

30. Caroline Jones, "System Symptoms," *Artforum* (Sept. 2012): 113, 116, <http://artforum.com/inprint/issue=201207&id=32014> (Aug. 10, 2014).

31. Manovich suggests this point in his seminal book *The Language of New Media* and provides further elaboration in an interview originally published in *Mania* magazine and available online at: <http://www.uoc.edu/artnodes/espai/eng/art/manovich_entrevis1102/manovich_entrevis1102.pdf> (accessed Aug. 27, 2014).

DISPERSION

Seth Price

The definition of artistic activity occurs, first of all, in the field of distribution.
—Marcel Broodthaers

One of the ways in which the Conceptual project in art has been most successful is in claiming new territory for practice. It's a tendency that's been almost too successful: today it seems that most of the work in the international art system positions itself as Conceptual to some degree, yielding the "Conceptual painter," the "DJ and Conceptual artist," or the "Conceptual web artist." Let's put aside the question of what makes a work Conceptual, recognizing, with some resignation, that the term can only gesture toward a thirty-year-old historical moment. But it can't be rejected entirely, as it has an evident charge for artists working today, even if they aren't necessarily invested in the concerns of the classical moment, which included linguistics, analytic philosophy, and a pursuit of formal demate-rialization. What does seem to hold true for today's normative Conceptualism is that the project remains, in the words of Art & Language, "radically incomplete": It does not necessarily stand against objects or painting, or for language as art; it does not need to stand against retinal art; it does not stand for anything certain, instead privileging framing and context, and constantly renegotiating its relationship to its audience. Martha Rosler has spoken of the "as-if" approach, where the Conceptual work cloaks itself in other disciplines (philosophy being the most notorious example), provoking an oscillation between skilled and de-skilled, authority and pretense, style and strategy, art and not-art.

Duchamp was not only here first, but staked out the problematic virtually single-handedly. His question "Can one make works which are not 'of art'" is our shibboleth, and the question's resolution will remain an apparition on the

horizon, always receding from the slow growth of practice. One suggestion comes from the philosopher Sarat Maharaj, who sees the question as "a marker for ways we might be able to engage with works, events, spasms, ructions that don't look like art and don't count as art, but are somehow electric, energy nodes, attractors, transmitters, conductors of new thinking, new subjectivity and action that visual artwork in the traditional sense is not able to articulate." These concise words call for an art that insinuates itself into the culture at large, an art that does not go the way of, say, theology, where while it's certain that there are practitioners doing important work, few people notice. An art that takes Rosler's as-if moment as far as it can go.

Not surprisingly, the history of this project is a series of false starts and paths that peter out, of projects that dissipate or are absorbed. Exemplary among this garden of ruins is Duchamp's failure to sell his Rotorelief optical toys at an amateur inventor's fair. What better description of the artist than amateur inventor? But this was 1935, decades before widespread fame would have assured his sales, and he was attempting to wholly transplant himself into the alien context of commercial science and invention. In his own analysis: "error, one hundred percent." Immersing art in life runs the risk of seeing the status of art—and with it, the status of artist—disperse entirely.

These bold expansions actually seem to render artworks increasingly vulnerable. A painting is manifestly art, whether on the wall or in the street, but avant-garde work is often illegible without institutional framing and the work of the curator or historian. More than anyone else, artists of the last hundred years have wrestled with this trauma of context, but theirs is a struggle that necessarily takes place within the art system. However radical the work, it amounts to a proposal enacted within an arena of peer-review, in dialogue with the community and its history. Reflecting on his experience running a gallery in the 1960s, Dan Graham observed: "if a work of art wasn't written about and reproduced in a magazine it would have difficulty attaining the status of 'art'. It seemed that in order to be defined as having value, that is as 'art', a work had only to be exhibited in a gallery and then to be written about and reproduced as a photograph in an art magazine." Art, then, with its reliance on discussion through refereed forums and journals, is similar to a professional field like science.

What would it mean to step outside of this carefully structured system? Duchamp's Rotorelief experiment stands as a caution, and the futility of more recent attempts to evade the institutional system has been well demonstrated. Canonical works survive through documentation and discourse, administered by the usual institutions. Smithson's *Spiral Jetty* (1970), for example, was acquired by (or perhaps it was in fact "gifted to") the Dia Art Foundation, which discreetly

Boëtius à Bolswert, engraving for *Pia Desideria* by
Herman Hugo, 1st edition (Antwerp: Hendrick
Aertssens, 1624)

mounted a photograph of the new holding in its Dan Graham–designed video-café, a tasteful assertion of ownership.

That work which seeks what Allan Kaprow called "the blurring of art and life," work which Boris Groys has called biopolitical, attempting to "produce and document life itself as pure activity by artistic means," faces the problem that it must depend on a record of its intervention into the world, and this documentation is what is recouped as art, short-circuiting the original intent. Groys sees a disparity thus opened between the work and its future existence as documentation, noting our "deep malaise towards documentation and the archive." This must be partly due to the archive's deathlike appearance, a point that Jeff Wall has echoed, in a critique of the uninvitingly "tomb-like" Conceptualism of the 1960s.

Agreement! A paragraph of citations, a direction, the suggestion that one is getting a sense of things. What these critics observe is a popular suspicion of the archive of high culture, which relies on cataloguing, provenance, and authenticity. Insofar as there is a popular archive, it does not share this administrative tendency. Suppose an artist were to release the work directly into a system that depends on reproduction and distribution for its sustenance, a model that encourages contamination, borrowing, stealing, and horizontal blur. The art system usually corrals errant works, but how could it recoup thousands of freely circulating paperbacks?

It is useful to continually question the avant-garde's traditional romantic opposition to bourgeois society and values. The genius of the bourgeoisie manifests itself in the circuits of power and money that regulate the flow of culture. National bourgeois culture, of which art is one element, is based around commercial media, which, together with technology, design, and fashion, generates some of the important differences of our day. These are the arenas in which to conceive of a work positioned within the material and discursive technologies of distributed media.

Distributed media can be defined as social information circulating in theoretically unlimited quantities in the common market, stored or accessed via portable devices such as books and magazines, records and compact discs, videotapes and DVDs, personal computers and data diskettes. Duchamp's question has new life in this space, which has greatly expanded during the last few decades of global corporate sprawl. It's space into which the work of art must project itself lest it be outdistanced entirely by these corporate interests. New strategies are needed to keep up with commercial distribution, decentralization, and dispersion. You must fight something in order to understand it.

Mark Klienberg, writing in 1975 in the second issue of *The Fox*, poses the question: "Could there be someone capable of writing a science-fiction thriller

based on the intention of presenting an alternative interpretation of modernist art that is readable by a nonspecialist audience? Would they care?" He says no more about it, and the question stands as an intriguing historical fragment, an evolutionary dead end, and a line of inquiry to pursue in this essay: the intimation of a categorically ambiguous art, one in which the synthesis of multiple circuits of reading carries an emancipatory potential.

This tendency has a rich history, despite the lack of specific work along the lines of Klienberg's proposal. Many artists have used the printed page as medium; an arbitrary and partial list might include Robert Smithson, Mel Bochner, Dan Graham, Joseph Kosuth, Lawrence Weiner, Stephen Kaltenbach, and Adrian Piper, and there have been historical watersheds like Seth Siegelaub and John Wendler's 1968 show "XeroxBook."

The radical nature of this work stems in part from the fact that it is a direct expression of the process of production. Market mechanisms of circulation, distribution, and dissemination become a crucial part of the work, distinguishing such a practice from the liberal-bourgeois model of production, which operates under the notion that cultural doings somehow take place above the marketplace. However, whether assuming the form of ad or article, much of this work was primarily concerned with finding exhibition alternatives to the gallery wall, and in any case often used these sites to demonstrate dryly theoretical propositions rather than address issues of, say, desire. And then, one imagines, with a twist of the kaleidoscope things resolve themselves.

This points to a shortcoming of classical Conceptualism. Benjamin Buchloh points out that "while it emphasized its universal availability and its potential collective accessibility and underlined its freedom from the determinations of the discursive and economic framing conventions governing traditional art production and reception, it was, nevertheless, perceived as the most esoteric and elitist artistic mode." Kosuth's quotation from *Roget's Thesaurus* placed in an *Artforum* box ad, or Dan Graham's list of numbers laid out in an issue of *Harper's Bazaar*, were uses of mass media to deliver coded propositions to a specialist audience, and the impact of these works, significant and lasting as they were, reverted directly to the relatively arcane realm of the art system, which noted these efforts and inscribed them in its histories. Conceptualism's critique of representation emanated the same mandarin air as did a canvas by Ad Reinhardt, and its attempts to create an Art Degree Zero can be seen as a kind of negative virtuosity, perhaps partly attributable to a New Left skepticism toward pop culture and its generic expressions.

Certainly, part of what makes the classical avant-garde interesting and radical is that it tended to shun social communication, excommunicating itself

Jean Ignace Isidore Gérard (Grandville), "Literature
being reeled off and sold in chunks," 1844

"Literature being reeled off and sold in chunks"—Grandville, 1844.

through incomprehensibility, but this isn't useful if the goal is to use the circuits of mass distribution. In that case, one must use not simply the delivery mechanisms of popular culture, but also its generic forms. When Rodney Graham releases a CD of pop songs, or Maurizio Cattelan publishes a magazine, those in the art world must acknowledge the art gesture at the same time that these products function like any other artifact in the consumer market. But difference lies within these products! Embodied in their embrace of the codes of the culture industry, they contain a utopian moment that points toward future transformation. They could be written according to the code of hermeneutics:

> Where we have spoken openly we have actually said nothing. But where we have written something in code and in pictures, we have concealed the truth...

Let's say your aesthetic program spans media, and that much of your work does not function properly within the institutionalized art context. This might include music, fashion, poetry, filmmaking, or criticism, all crucial artistic practices, but practices which are somehow stubborn and difficult, which resist easy assimilation into a market-driven art system. The film avant-garde, for instance, has always run on a separate track from the art world, even as its practitioners may have been pursuing analogous concerns. And while artists have always been attracted to music and its rituals, a person whose primary activity was producing music, conceived of and presented as Art, would find "art world" acceptance elusive. The producer who elects to wear several hats is perceived as a crossover at best: the artist-filmmaker, as in the case of Julian Schnabel; the artist as entrepreneur, as in the case of Warhol's handling of *Interview* magazine and the Velvet Underground; or, as with many of the people mentioned in this essay, artist as critic, perhaps the most tenuous position of all. This is the lake of our feeling.

One could call these niches "theatrical," echoing Michael Fried's insistence that "what lies between the arts is theater...the common denominator that binds...large and seemingly disparate activities to one another, and that distinguishes these activities from the radically different enterprises of the Modernist art." A practice based on distributed media should pay close attention to these activities, which, despite lying between the arts, have great resonance in the national culture.

Some of the most interesting recent artistic activity has taken place outside the art market and its forums. Collaborative and sometimes anonymous groups work in fashion, music, video, or performance, garnering admiration within the art world while somehow retaining their status as outsiders, perhaps due to

Ouroboros, engraving for *Donum Dei* by Abraham
Eleazar (Erfurt, Germany: 1735)

their preference for theatrical, distribution-oriented modes. Maybe this is what
Duchamp meant by his intriguing throwaway comment, late in life, that the artist
of the future will be underground.

If distribution and public are so important, isn't this, in a sense, a debate
about "public art"? It's a useful way to frame the discussion, but only if one un-
derlines the historical deficiencies of that discourse and acknowledges the fact
that the public has changed.

The discourse of public art has historically focused on ideals of universal ac-
cess, but, rather than considering access in any practical terms, two goals have
been pursued to the exclusion of others. First, the work must be free of charge
(apparently economic considerations are primary in determining the divide be-
tween public and private). Often this bars any perceptible institutional frame that

would normally confer the status of art, such as the museum, so the public art-work must broadly and unambiguously announce its own art status, a mandate for conservative forms. Second is the direct equation of publicness with shared physical space. But if this is the model, the successful work of public art will at best function as a site of pilgrimage, in which case it overlaps with architecture.

The problem is that situating the work at a singular point in space and time turns it, a priori, into a monument. What if it is instead dispersed and repro-duced, its value approaching zero as its accessibility rises? We should recognize that collective experience is now based on simultaneous private experiences, dis-tributed across the field of media culture, knit together by ongoing debate, pub-licity, promotion, and discussion. Publicness today has as much to do with sites of production and reproduction as it does with any supposed physical commons, so a popular album could be regarded as a more successful instance of public art than a monument tucked away in an urban plaza. The album is available every-where, since it employs the mechanisms of free market capitalism, history's most sophisticated distribution system to date. The monumental model of public art is invested in an anachronistic notion of communal appreciation transposed from the church to the museum to the outdoors, and this notion is received skeptically by an audience no longer so interested in direct communal experience. While instantiated in nominal public space, mass-market artistic production is usually consumed privately, as in the case of books, CDs, videotapes, and internet "con-tent." Television producers are not interested in collectivity, they are interested in getting as close as possible to individuals. Perhaps an art distributed to the broadest possible public closes the circle, becoming a private art, as in the days of commissioned portraits. The analogy will only become more apt as digital dis-tribution techniques allow for increasing customization to individual consumers.

The monumentality of public art has been challenged before, most success-fully by those for whom the term "public" was a political rallying point. Public artists in the 1970s and 1980s took interventionist praxis into the social field, acting out of a sense of urgency based on the notion that there were social crises so pressing that artists could no longer hole up in the studio, but must directly engage with community and cultural identity. If we are to propose a new kind of public art, it is important to look beyond the purely ideological or instrumental function of art. As *Art-Language* noted, "radical artists produce articles and exhi-bitions about photos, capitalism, corruption, war, pestilence, trench foot and is-sues." Public policy, destined to be the terminal as-if strategy of the avant-garde! A self-annihilating nothing.

An art grounded in distributed media can be seen as a political art and an art of communicative action, not least because it is a reaction to the fact that the

Seth Price, *Puppy, after Jeff Koons*, 2001

merging of art and life has been effected most successfully by the "consciousness industry." The field of culture is a public sphere and a site of struggle, and all of its manifestations are ideological. In *Public Sphere and Experience*, Oskar Negt and Alexander Kluge insist that each individual, no matter how passive a component of the capitalist consciousness industry, must be considered a producer (despite the fact that this role is denied them). Our task, they say, is to fashion "counter-productions." Kluge himself is an inspiration: acting as a filmmaker, lobbyist, fiction writer, and television producer, he has worked deep changes in the terrain of German media. An object disappears when it becomes a weapon.

The problem arises when the constellation of critique, publicity, and discussion around the work is at least as charged as a primary experience of the work. Does one have an obligation to view the work firsthand? What happens when a

more intimate, thoughtful, and enduring understanding comes from mediated discussions of an exhibition, rather than from a direct experience of the work? Is it incumbent upon the consumer to bear witness, or can one's art experience derive from magazines, the internet, books, and conversation? The ground for these questions has been cleared by two cultural tendencies that are more or less diametrically opposed: on the one hand, Conceptualism's historical dependence on documents and records; on the other hand, the popular archive's ever-sharpening knack for generating public discussion through secondary media. This does not simply mean the commercial cultural world, but a global media sphere which is, at least for now, open to the interventions of noncommercial, nongovernmental actors working solely within channels of distributed media.

A good example of this last distinction is the phenomenon of the "Daniel Pearl Video," as it's come to be called. Even without the label PROPAGANDA, which CBS helpfully added to the excerpt they aired, it's clear that the 2002 video is a complex document. Formally, it presents kidnapped American journalist Daniel Pearl, first as a mouthpiece for the views of his kidnappers, a Pakistani fundamentalist organization, and then, following his off-screen murder, as a cadaver, beheaded in order to underline the gravity of their political demands.

One of the video's most striking aspects is not the grisly, though clinical, climax (which, in descriptions of the tape, has come to stand in for the entire content), but the slick production strategies, which seem to draw on American political campaign advertisements. It is not clear whether it was ever intended for TV broadcast. An apocryphal story indicates that a Saudi journalist found it on an Arabic-language website and turned it over to CBS, which promptly screened an excerpt, drawing heavy criticism. Somehow it found its way onto the internet, where the FBI's thwarted attempts at suppression only increased its notoriety: In the first months after its internet release, "Daniel Pearl video," "Pearl video," and other variations on the phrase were among the terms most frequently submitted to internet search engines. The work seems to be unavailable as a videocassette, so anyone able to locate it is likely to view a compressed datastream transmitted from a hosting service in the Netherlands (in this sense, it may not be correct to call it "video"). One question is whether it has been *relegated* to the internet, or in some way created by that technology. Does the piece count as "info-war" because of its nature as a proliferating computer file, or is it simply a video for broadcast, forced to assume digital form under political pressure? Unlike television, the net provides information only on demand, and much of the debate over this video concerns not the legality or morality of making it available, but whether or not one should choose to watch it—as if the act of viewing will in some way enlighten or contaminate. This is a charged document

دانيال بيرل اليهودي

freely available in the public arena, yet the discussion around it, judging from numerous web forums, bulletin boards, and discussion groups, is usually debated by parties who have never seen it.

This example may be provocative, since the video's deplorable content is clearly bound up with its extraordinary routes of transmission and reception. It is evident, however, that terrorist organizations, alongside transnational corporate interests, are one of the more vigilantly opportunistic exploiters of "events, spasms, ructions that don't look like art and don't count as art, but are somehow electric, energy nodes, attractors, transmitters, conductors of new thinking, new subjectivity and action." A more conventional instance of successful use of the media-sphere by a nonmarket, nongovernment organization is Linux, the open-source computer operating system that won a controversial first prize at the digital art fair Ars Electronica. Linux was initially written by one person, programmer Linus Torvalds, who placed the code for this "radically incomplete" work online, inviting others to tinker, with the aim of polishing and perfecting the operating system. The internet allows thousands of authors to simultaneously develop various parts of the work, and Linux has emerged as a popular

and powerful operating system and a serious challenge to profit-driven giants like Microsoft, which recently filed with the US Securities and Exchange Commission to warn that its business model, based on control through licensing, is menaced by the open-source model. Collective authorship and complete decentralization ensure that the work is invulnerable to the usual corporate forms of attack and assimilation, whether enacted via legal, market, or technological routes (however, as Alexander Galloway has pointed out, the structure of the world wide web should not itself be taken to be some rhizomatic utopia; it certainly would not be difficult for a government agency to hobble or even shut down the web with a few simple commands).

Both of these examples privilege the internet as medium, mostly because of its function as a public site for storage and transmission of information. The notion of a mass archive is relatively new, and a notion which is probably philosophically opposed to the traditional understanding of what an archive is and how it functions, but it may be that, behind the veneer of user interfaces floating on its surface—which generate most of the work grouped under the rubric "web art"—the internet approximates such a structure, or can at least be seen as a working model.

With more and more media readily available through this unruly archive, the task becomes one of packaging, producing, reframing, and distributing; a mode of production analogous not to the creation of material goods, but to the production of social contexts, using existing material. Anything on the internet is a fragment, provisional, pointing elsewhere. Nothing is finished. What a time you chose to be born!

An entire artistic program could be centered on the rerelease of obsolete cultural artifacts, with or without modifications, regardless of intellectual property laws. An early example of this redemptive tendency is artist Harry Smith's obsessive 1952 *Anthology of American Folk Music*, which compiled forgotten recordings from early in the century. Closer to the present is my own collection of early video game soundtracks, in which audio data rescued by hackers and circulated on the web is transplanted to the old media of the compact disc, where it gains resonance from the contexts of product and the song form: take what's free and sell it back in a new package. In another example, one can view the entire run of the 1970s arts magazine *Aspen*, republished on the artist-run site ubu.com, which regularly makes out-of-print works available as free digital files. All of these works emphasize the capacity for remembering, which Kluge sees as crucial in opposing "the assault of the present on the rest of time," and in organizing individual and collective learning and memory under an industrialist-capitalist temporality that works to fragment and valorize all experience. In

Seth Price, *After an anonymous cameo, circa 18th century*, 2001

these works, resistance is to be found at the moment of production, since it figures the moment of consumption as an act of reuse.

It's clear from these examples that the readymade still towers over artistic practice. But this is largely due to the fact that the strategy yielded a host of new opportunities for the commodity. Dan Graham identified the problem with the readymade: "instead of reducing gallery objects to the common level of the everyday object, this ironic gesture simply extended the reach of the gallery's exhibition territory." One must return to *Fountain*, the most notorious and most interesting of the readymades, to see that the gesture does not simply raise epistemological questions about the nature of art, but enacts the dispersion of objects into discourse. The power of the readymade is that no one needs to make the pilgrimage to see *Fountain*. As with Graham's magazine pieces, few people saw the original *Fountain* in 1917. Never exhibited, and lost or destroyed almost immediately, it was actually created through Duchamp's media manipulations— the Stieglitz photograph (a guarantee, a shortcut to history), the *Blind Man* magazine article—rather than through the creation myth of his finger selecting it in the showroom, the status-conferring gesture to which the readymades are often reduced. In *Fountain*'s elegant model, the artwork does not occupy a single position in space and time; rather, it is a palimpsest of gestures, presentations, and positions. Distribution is a circuit of reading, and there is huge potential for subversion when dealing with the institutions that control definitions of cultural meaning. Duchamp distributed the notion of the fountain in such a way that it became one of art's primal scenes; it transubstantiated from a provocative objet d'art into, as Broodthaers defined his *Musée des Aigles*, "a situation, a system defined by objects, by inscriptions, by various activities."

The last thirty years have seen the transformation of art's "expanded field" from a stance of stubborn discursive ambiguity into a comfortable and compromised situation in which we're well accustomed to conceptual interventions, to art and the social, where the impulse to merge art and life has resulted in lifestyle art, a secure gallery practice that comments on contemporary media culture, or apes commercial production strategies. This is the lumber of life.

This tendency is marked in the discourses of architecture and design. An echo of Public Art's cherished communal spaces persists in the art system's fondness for these modes, possibly because of the Utopian promise of their appeals to collective public experience. Their "criticality" comes from an engagement with broad social concerns. This is why Dan Graham's pavilions were initially so provocative, and the work of Daniel Buren, Michael Asher, and Gordon Matta-Clark before him: these were interventions into the social unconscious. These interventions have been guiding lights for art of the last decade, but in much the same way that

quasi-bureaucratic administrative forms were taken up by the Conceptualists of the 1960s, design and architecture now could be called house styles of the neo-avant-garde. Their appearance often simply gestures toward a theoretically engaged position, such that a representation of space or structure is figured as an ipso facto critique of administered society and the social, while engagement with design codes is seen as a comment on advertising and the commodity. One must be careful not to blame the artists; architecture and design forms are all-too-easily packaged for resale as sculpture and painting. However, one can still slip through the cracks in the best possible way, and even in the largest institutions. Jorge Pardo's radical *Project*, an overhaul of Dia's ground floor, which successfully repositioned the institution via broadly appealing design vernaculars, went largely unremarked in the art press, either because the piece was transparent to the extent of claiming the museum's bookstore and exhibiting work by other artists, or because of a cynical incredulity that he gets away with calling this art.

A similar strain of disbelief greeted the construction of his own house, produced for an exhibition with a good deal of the exhibitor's money. It seems that the avant-garde can still shock, if only on the level of economic valorization. This work does not simply address the codes of mass culture, it embraces these codes as form, in a possibly quixotic pursuit of an unmediated critique of cultural conventions.

An argument against art that addresses contemporary issues and topical culture rests on the virtue of slowness, often cast aside due to the urgency with which one's work must appear. Slowness works against all of our prevailing urges and requirements: it is a resistance to the contemporary mandate of speed. Moving *with* the times places you in a blind spot: if you're part of the general tenor, it's difficult to add a dissonant note. But the way in which media culture feeds on its own leavings indicates the paradoxical slowness of archived media, which, like a sleeper cell, will always rear its head at a later date. The rearguard often has the upper hand, and sometimes *delay*, to use Duchamp's term, will return the investment with massive interest.

Let's not overreach. The question is whether everything is always the same, whether it is in fact possible that by the age of forty a person has seen all that has been and will ever be. Must I consult art to understand that identity is administered, power exploits, resistance is predetermined, all is shit?

> To recognize...the relative immutability of historically formed discursive artistic genres, institutional structures, and distribution forms as obstacles that are ultimately persistent (if not insurmountable) marks the most profound crisis for the artist identified with a model of avant-garde practice.

Albrecht Dürer, *Melencolia I*, 1514. Engraving,
9 ½ × 7 ⅜ in. (24 × 18.5 cm)

So the thread leads from Duchamp to Pop to Conceptualism, but beyond that we must turn our backs: a resignation, in contrast to Pop's affirmation and Conceptualism's interrogation. Such a project is an incomplete and perhaps futile proposition, and since one can only adopt the degree of precision appropriate to the subject, this essay is written in a provisional and exploratory spirit. An art that attempts to tackle the expanded field, encompassing arenas other than the standard gallery and art world circuit, sounds utopian at best, and possibly naïve and undeveloped; this essay may itself be a disjointed series of naïve propositions lacking a thesis. Complete enclosure means that one cannot write a novel, compose music, produce television, and still retain the status of Artist. What's more, artist as a social role is somewhat embarrassing, in that it's taken to be a useless position, if not a reactionary one: the practitioner is dismissed as either the producer of overvalued decor, or as part of an arrogant, parasitical, self-styled elite.

But hasn't the artistic impulse always been utopian, with all the hope and futility that implies? To those of you who decry the Utopian impulse as futile, or worse, responsible for the horrible excesses of the last century, recall that each moment is a Golden Age (of course the Soviet experiment was wildly wrongheaded, but let us pretend—and it is not so hard—that a kind of social Dispersion was its aim). The last hundred years of work indicate that it's demonstrably impossible to destroy or dematerialize Art, which, like it or not, can only gradually expand, voraciously synthesizing every aspect of life. Meanwhile, we can take up the redemptive circulation of allegory through design, obsolete forms and historical moments, genre and the vernacular, the social memory woven into popular culture: a private, secular, and profane consumption of media. Production, after all, is the excretory phase in a process of appropriation.

..

"Dispersion" by artist Seth Price was first published as a freely downloadable PDF in 2002. A mock manifesto that wends through the history of conceptual approaches to media, "Dispersion" addresses the longstanding question of how an artist might exist outside the confines of the art world, tentatively proposing that an answer might lie in the distribution networks of mass culture, including the internet. Price reedited and worked on the open-ended essay until officially finishing it in 2008. Outside of the PDF, the piece has also taken other forms, such as CD-ROM, and as text printed onto his large-scale sculptural work *Essay with Knots* (2008). This reprinting preserves Price's unique style and voice, though it does not utilize the same formatting or include the full suite of images found in the 2008 PDF version.

..

Alexander R. Galloway

"HOW WE MADE OUR OWN 'CARNIVORE'" (2002)

Disobedience to authority is one of the most natural and healthy acts.
—Hardt and Negri, *Empire*

Ethernet was built by Robert Metcalfe at Xerox PARC in the early 1970s. But the concepts behind Ethernet were invented at the University of Hawaii a few years earlier. Scientists in Hawaii faced a unique problem: How to network different campuses, each on different islands separated by water.[1] The solution was to use the free airwaves, to transmit data through the air, or "ether," using radio. There were no wires. Like a radio station, each node sent messages broadly over the sea to other islands. A protocol was developed to avoid collision between simultaneous communications. Ever since, Ethernet has been based on an open transmission model. The protocol translated well to wire-based networks too, and is now the most widely used local networking protocol in the world.

Since Ethernet is based on an open broadcast model, it is trivial for listeners to make themselves "promiscuous" and eavesdrop on all communications, not simply those specifically addressed to them. This technique is called packet-sniffing and has been used by systems administrators and hackers alike for decades. Ethernet, sniffers, and hacking are at the heart of a public domain surveillance suite called *Carnivore* developed by RSG and now used in a civilian context by many artists and scientists around the world.

Hacking

Today there are generally two things said about hackers. They are either terrorists or libertarians. Historically the word meant an amateur tinkerer, an autodidact

who might try a dozen solutions to a problem before being rewarded by any success.[2] As Bruce Sterling writes, the term hacker "can signify the free-wheeling intellectual exploration of the highest and deepest potential of computer systems."[3] Or as Steven Levy glowingly reminisces of the original MIT hackers of the early sixties, "they were such fascinating people. [...] Beneath their often unimposing exteriors, they were adventurers, visionaries, risk-takers, artists…and the ones who most clearly saw why the computer was a truly revolutionary tool."[4] These types of hackers are freedom fighters, living by the dictum that data wants to be free.[5] Information should not be owned, and even if it should, non-invasive browsing of such information hurts no one. After all, hackers merely exploit pre-existing holes made by clumsily constructed code.[6] And wouldn't the revelation of such holes actually improve data security for everyone involved?

Yet after a combination of public technophobia and aggressive government legislation the identity of the hacker changed in the US in the mid to late eighties from do-it-yourself hobbyist to digital outlaw.[7] Such legislation includes the Computer Fraud and Abuse Act of 1986 which made it a felony to break into federal computers. Hackers were deeply discouraged by their newfound identity as outlaws, as exemplified in the famous 1986 hacker manifesto written by someone calling himself The Mentor:[8] "We explore…and you call us criminals. We seek after knowledge…and you call us criminals."[9] Because of this semantic transformation, hackers today are commonly referred to as terrorists, ne'er-do-wells who break into computers for personal gain. By the turn of the millennium, the term hacker had lost all of its original meaning. Now when people say hacker, they mean terrorist.

Thus, the current debate on hackers is helplessly throttled by the discourse on contemporary liberalism: should we respect data as private property, or should we cultivate individual freedom and leave computer users well alone? Hacking is more sophisticated than that. It suggests a future type of cultural production, one that RSG seeks to embody in *Carnivore*.

Collaboration

Bruce Sterling writes that the late twentieth century is a moment of transformation from a modern control paradigm based on centralization and hierarchy to a postmodern one based on flexibility and horizontalization:

> For years now, economists and management theorists have speculated that the tidal wave of the information revolution would destroy rigid, pyramidal bureaucracies, where everything is top-down and centrally controlled. Highly trained "employees" would take on greater autonomy,

being self-starting and self-motivating, moving from place to place, task to task, with great speed and fluidity. "Ad-hocracy" would rule, with groups of people spontaneously knitting together across organizational lines, tackling the problem at hand, applying intense computer-aided expertise to it, and then vanishing whence they came. [10]

From Manuel Castells to Hakim Bey to Tom Peters this rhetoric has become commonplace. Sterling continues by claiming that both hacker groups and the law enforcement officials that track hackers follow this new paradigm: "they all look and act like 'tiger teams' or 'users' groups." They are all electronic ad-hocracies leaping up spontaneously to attempt to meet a need."[11] By "tiger teams" Sterling refers to the employee groups assembled by computer companies trying to test the security of their computer systems. Tiger teams, in essence, simulate potential hacker attacks, hoping to find and repair security holes. RSG is a type of tiger team.

Hackers are autonomous agents that can mass together in small groups to attack specific problems. Hackers embody a different organizational management style (one that might be called "protocological"). In this sense, while resistance during the modern age forms around rigid hierarchies and bureaucratic power structures, resistance during the postmodern age forms around the protocological control forces existent in networks.

Coding

In 1967 the artist Sol LeWitt outlined his definition of Conceptual art:

> In conceptual art the idea or concept is the most important aspect of the work. When an artist uses a conceptual form of art, it means that all of the planning and decisions are made beforehand and the execution is a perfunctory affair. The idea becomes a machine that makes the art.[12]

LeWitt's perspective on Conceptual art has important implications for code, for in his estimation Conceptual art is nothing but a type of code for artmaking. LeWitt's art is an algorithmic process. The algorithm is prepared in advance, and then later executed by the artist (or another artist, for that matter).

How can code be so different than mere writing? The answer to this lies in the unique nature of computer code. It lies not in the fact that code is sub-linguistic, but rather that it is *hyper*-linguistic. Code is a language, but a very special kind of language. *Code is the only language that is executable.* As Kittler has pointed out, "[t]here exists no word in any ordinary language which does what it says. No description of a machine sets the machine into motion."[13] So code is

the first language that actually does what it says—it is a machine for converting meaning into action. Code has a semantic meaning, but it also has an enactment of meaning.

Dreaming

Fredric Jameson said somewhere that one of the most difficult things to do under contemporary capitalism is to envision utopia. This is precisely why dreaming is important. Deciding (and often struggling) for what is possible is the first step for a utopian vision based in our desires, based in what we want.

This visionary tone is exactly what Jameson warns is lacking in much contemporary discourse. The relationship between utopia and possibility is a close one. It is necessary to know what one wants, to know what is possible to want, before a true utopia may be envisioned.

One of the most important signs of this utopian instinct is the hacking community's anti-commercial bent. Software products have long been developed and released into the public domain, with seemingly no profit motive on the side of the authors, simply for the higher glory of the code itself.

However, greater than this anti-commercialism is a pro-protocolism. Protocol, by definition, is "open source," the term given to a technology that makes public the source code used in its creation. That is to say, protocol is nothing but an elaborate instruction list of how a given technology should work, from the inside out, from the top to the bottom, as exemplified in the RFCs, or "Request For Comments" documents. While many closed source technologies may appear to be protocological due to their often monopolistic position in the marketplace, a true protocol cannot be closed or proprietary. It must be paraded into full view before all, and agreed to by all. It benefits over time through its own technological development in the public sphere. It must exist as pure, transparent code (or a pure description of how to fashion code). If technology is proprietary it ceases to be protocological.

This brings us back to *Carnivore*, and the desire to release a public domain version of a notorious surveillance tool thus far only available to government operatives. The RSG *Carnivore* levels the playing field, recasting art and culture as a scene of multilateral conflict rather than unilateral domination. It opens the system up for collaboration within and between client artists. It uses code to engulf and modify the original FBI apparatus.

Carnivore Personal Edition

On October 1, 2001, three weeks after the 9/11 attacks in the US, the Radical Software Group (RSG) announced the release of *Carnivore*, a public domain riff

on the notorious FBI software called DCS1000 (which is commonly referred to by its nickname "Carnivore"). While the FBI software had already been in existence for some time, and likewise RSG had been developing its version of the software since January 2001, 9/11 brought on a crush of new surveillance activity. Rumors surfaced that the FBI was installing Carnivore willy-nilly on broad civilian networks like Hotmail and AOL with the expressed purpose of intercepting terror-related communication. As Wired News reported on September 12, 2001, "An administrator at one major network service provider said that FBI agents showed up at his workplace on [September 11] 'with a couple of Carnivores, requesting permission to place them in our core.'"[14] Officials at Hotmail were reported to have been "cooperating" with FBI monitoring requests. Inspired by this activity, the RSG's Carnivore sought to pick up where the FBI left off, to bring this technology into the hands of the general public for greater surveillance saturation within culture. The first RSG Carnivore ran on Linux. An open source schematic was posted on the net for others to build their own boxes. New functionality was added to improve on the FBI-developed technology (which in reality was a dumbed-down version of tools systems administrators had been using for years).

The initial testing proved successful and led to more field-testing at the Princeton Art Museum (where Carnivore was quarantined like a virus into its own subnet) and the New Museum in New York. During the weekend of February 1, 2002, Carnivore was used at Eyebeam to supervise the hacktivists protesting the gathering of the World Economic Forum.

Sensing the market limitations of a Linux-only software product, RSG released *Carnivore Personal Edition* (*CarnivorePE*) for Windows on April 6, 2002. *CarnivorePE* brought a new distributed architecture to the Carnivore initiative by giving any PC user the ability to analyze and diagnose the traffic from his or her own network. Any artist or scientist could now use *CarnivorePE* as a surveillance engine to power his or her own interpretive "Client." Soon Carnivore Clients were converting network traffic to sound, animation, and even 3-D worlds, distributing the technology across the network. The prospect of reverse-engineering the original FBI software was uninteresting to RSG. Crippled by legal and ethical limitations, the FBI software needed improvement not emulation. Thus *CarnivorePE* features exciting new functionality including artist-made diagnostic clients, remote access, full subject targeting, full data targeting, volume buffering, transport protocol filtering, and an open source software license. Reverse-engineering is not necessarily a simple mimetic process, but a mental upgrade as well. RSG has no desire to copy the FBI software and its many shortcomings. Instead, RSG longs to inject progressive politics back into

a fundamentally destabilizing and transformative technology, packet sniffing. Our goal is to invent a new use for data surveillance that breaks out of the hero/ terrorist dilemma and instead dreams about a future use for networked data.

.........

EXCERPT FROM "'CARNIVORE PERSONAL EDITION': EXPLORING DISTRIBUTED DATA SURVEILLANCE" (2006)

Criticism of the work

Carnivore has benefited from a reasonable amount of public discussion. There have been two main threads of criticism thus far of the work.

The first criticism is that Carnivore is an opportunist project whose notoriety has benefited more from hype than from actual substance. This line of criticism attacks the project as being too "slick" and for having a commercial-looking GUI design, as well as trying to piggy-back on contemporary social themes that are considered hip or timely such as data surveillance. I consider this criticism to be without merit. Data surveillance and privacy are two of the most pressing themes in society today, particularly in recent years as tracking technologies have proliferated both in the commercial and governmental sectors. Further, the commercial style of the work was a deliberate attempt to escape the ghetto of so-called political art and intervene in culture on a much broader scale.

The second criticism might be called the "screensaver" critique articulated by Andreas Broeckmann[15] and others. This approach claims that the various Carnivore clients merely resemble screensavers and don't achieve any level of aesthetic innovation or political nuance. This criticism claims that the potential for Carnivore to be steadfastly critical of the FBI or other data snoops has been diluted and sidetracked toward data visualization projects that lack commentary or critique. I also consider this criticism to be invalid, as it is both misdirected and inaccurate. First, the criticism is misdirected because it confuses specific Carnivore clients with the entire project itself (which is composed of the engine, CarnivorePE, plus an unlimited number of clients that use the engine). I can imagine a compelling critique of specific clients based on this anti-screensaver rationale, but since CarnivorePE imposes no restriction on how the data shall be visualized (or even that it should be visualized), it is misdirected to say that Carnivore as a project falls short in this regard. Second, the criticism is inaccurate because I consider there to be something profound in taking a mystified, obfuscated technical apparatus such as a data network, and unmasking it in order to make it visible. This is one of the fundamental methods in the areas of ideology

critique or apparatus critique (in cinema studies, for example), which I endorse and consider to be at play in Carnivore as well. Screensaver or not, Carnivore still denudes a hitherto obfuscated apparatus, and this is a fundamentally valuable process.

The work has thus far not been criticized on legal grounds. To my knowledge, packet sniffing is illegal in the U.S. if it is covert or unauthorized. But non-covert uses of packet sniffers, for example when a network administrator uses tcpdump to diagnose a network outage, are legal. This was one of the reasons that prompted the decision to shift from a client-server architecture to a distributed architecture: the potential for abuse is diminished when the sniffer engine and the client both reside at the fringes of the network rather than at centralized hubs. Thus far there has also been a general lack of criticism from the mainstream internet public. Judging from unsolicited email and anecdotal comments on Slashdot and elsewhere, most internet users are supportive of the project.

Surprisingly, and to my relief, there has been a complete lack of correspondence from the FBI or other government representatives.

Summary
As I have hoped to convey, Carnivore is an attempt to explore a "third way" for data surveillance that is neither threatening nor liberating. This was achieved first by making the software distributed rather than centralized, and second by uncoupling the surveillance engine from the interpretive clients thereby hindering the act of interpretation as little as possible. By pulling back the veil of secrecy surrounding networks, Carnivore allows non-scientists to explore network data traffic more easily. The various Carnivore clients written to date have resulted in entirely novel ways for visualizing and interpreting data traffic and in doing so start to move beyond the somewhat limited consideration of data surveillance as it has existed thus far in the public imagination.

..

Conceived by the collective Radical Software Group, Carnivore, as described on its website, "is a Processing library that allows you to perform surveillance on data networks. Carnivore listens to all internet traffic (email, web surfing, etc.) on a specific local network. Using Processing you are able to animate, diagnose, or interpret the network traffic in any way you wish." These two texts were written by Alexander R. Galloway, a founding member of Radical Software Group, in 2002 and 2006. They were brought together in the current configuration for this volume but are otherwise preserved in their original forms.

..

NOTES

1. The system at the University of Hawaii was called ALOHAnet and was created by Norman Abramson. Later the technology was further developed by Metcalfe and dubbed "Ethernet."

2. Robert Graham traces the etymology of the term to the sport of golf: "The word 'hacker' started out in the 14th century to mean somebody who was inexperienced or unskilled at a particular activity (such as a golf hacker). In the 1970s, the word 'hacker' was used by computer enthusiasts to refer to themselves. This reflected the way enthusiasts approach computers: they eschew formal education and play around with the computer until they can get it to work. (In much the same way, a golf hacker keeps hacking at the golf ball until they get it in the hole.)," <www.robertgraham.com/pubs/hacking-dict.html>.

3. Bruce Sterling, *The Hacker Crackdown*, p. 51. Bantam, New York, 1992.

4. Steven Levy, *Hackers: Heroes of the Computer Revolution*, p. ix. Anchor Press/Doubleday, New York, 1984.

5. This slogan is attributed to Stewart Brand, who wrote that "[o]n the one hand information wants to be expensive, because it's so valuable. The right information in the right place just changes your life. On the other hand, information wants to be free, because the cost of getting it out is getting lower and lower all the time. So you have these two fighting against each other." See "Whole Earth Review," p. 49, May 1985.

6. Many hackers believe that commercial software products are less carefully crafted and therefore more prone to exploits. Perhaps the most infamous example of such an exploit, one which critiques software's growing commercialization, is the "Back Orifice" software application created by the hacker group Cult of the Dead Cow. A satire of Microsoft's "Back Office" software suite, Back Orifice acts as a Trojan Horse to allow remote access to personal computers running Microsoft's Windows operating system.

7. For an excellent historical analysis of this transformation see Sterling's *The Hacker Crackdown*.

8. While many hackers use gender neutral pseudonyms, the online magazine "Phrack," with which The Mentor was associated, was characterized by its distinctly male staff and readership. For a sociological explanation of the gender imbalance within the hacking community, see Paul Taylor, *Hackers: Crime in the Digital Sublime*, pp. 32–42. Routledge, New York, 1999.

9. The Mentor, "The Conscience of a Hacker," *Phrack*, vol. 1. no. 7, tile 3, <www.lit.edu/
-beberg/manlfesto.html>.

10. Sterling, *The Hacker Crackdown*, p. 164.

11. Ibid.

12. Sol LeWitt, "Paragraphs on Conceptual Art," in Alberto, et al., eds., *Conceptual Art: A Critical Anthology*, p. 12. MIT Press, Cambridge, 1999. Thanks to Mark Tribe for bringing this passage to my attention.

13. Friedrich Kittler, "On the Implementation of Knowledge—Toward a Theory of Hardware," in *nettime*, <www.nettime.org/nettime.w3archive/199902/msg00038.html>.

14. For an interesting commentary on the aesthetic dimensions or this fact see Geoff Cox, Max McLean, and Adrian Ward, *The Aesthetics of Generative Code*, <sidestream.org/papers /aesthetics/>.

15. Andreas Broeckmann (2002) "Re: <nettime> How We Made Our Own 'Carnivore'" Nettime, <http:// www.amsterdam.nettime.org/Lists-Archives/nettime-l-0206/msg00114. html> (accessed Aug. 27, 2005).

Raqs Media Collective

Once, not so long ago, on a damp, rainy afternoon in Paris, a stroll took us across the Avenue d'Iéna, from contemporary art to ancient and medieval oriental art, from the Palais de Tokyo to the Musée Guimet. There, standing in front of a frieze from the Banteay Srei temple in Cambodia's Siem Reap province, now located at the far end of the ground-floor section of the Guimet's permanent collection, we felt the sharp edge of estrangement in something that also felt downright familiar.

The Banteay Srei frieze narrates a story from the *Mahabharata*, a Sanskrit epic. The story is of two brothers, the demons Sunda and Upasunda, whose tussle over the attentions of Tilottama, an *Apsara*—a heavenly courtesan sent by the gods to destroy them with jealousy—was the cause of their downfall. Like most others who grew up listening to stories in India, we knew it well, even if only as an annotation to the main body of the epic. But it wasn't the details of the story that intrigued us that afternoon, or the carved contours of Sunda and Upasunda's rage, or even the delicacy of the depiction of Tilottama's divisive seduction. Instead, standing before these stone images, made in a region roughly 3,500 miles to the east of where we live, in Delhi, and exhibited in a museum roughly 6,500 miles to the west of our current location, we felt compelled to think again about distance and proximity, and about how stories, images, and ideas travel.

The story of Sunda, Upasunda, and Tilottama was probably first told around 200 BC in the northwestern part of the South Asian subcontinent. Between the first telling of the story and the carving of the frieze in a clearing in the forests of Siem Reap circa 967 CE lay a little more than a thousand years and an eastward journey of a few thousand miles. Between its carving and our sudden encounter with it in Paris, there lay a little more than another millennium and a westward journey halfway across the world. These intervals in time and space

were overlaid by an elaborate circuit that encompassed travel, conquest, migration and settlement, wars and violence, the clearing of forests, the quarrying of stone, slavery and indenture, skilled artisans, the faces and indiscretions of the men and women who would become the inspiration for jealous demons and divine courtesans, a few thousand years of history, the crossing of oceans, the rise and fall of several empires across different continents, and the repeated telling and forgetting of a minor story.

Contemporaneity, the sensation of being in a time together, is an ancient enigma of a feeling. It is the tug we feel when our times pull at us. But sometimes one has the sense of a paradoxically asynchronous contemporaneity—the strange tug of more than one time and place. As if an accumulation, or thickening, of our attachments to different times and spaces were manifesting itself in the form of some unique geological oddity, a richly striated cross section of a rock, sometimes sharp, sometimes blurred, marked by the passage of many epochs.

Standing before Sunda, Upasunda, and Tilottama in the Musée Guimet, we were in Siem Reap, in Indraprastha (an ancient name for Delhi, in whose vicinity much of the *Mahabharata* story is located), in New Delhi, in nineteenth-century Paris, and in the Paris of today. We were in many places and in many times. Sometimes art, the presence of an image, moves you. And you find yourself scattered all over the place as a consequence.

How can we begin to think about being scattered? Collections of objects from different parts of the world are indices of different instances of scattering. The minor encounter that we experienced in the Musée Guimet is one kind of scattering. It taught us that sometimes we encounter familiarity in the guise of strangeness and then suggested that we learn to question the easy binary shorthand of the familiar and the strange as a way of thinking about ourselves, others, and the world. It suggested the possibility of other less polarized and more layered relationships between cultural processes. But this is not the only possible kind of scattering provoked by the presence of images and stories that echo the familiar in uncanny ways.

An increased intensity of communication creates a new kind of experiential contagion. It leads to all kinds of illegitimate liaisons between things meant to be unfamiliar. The first thing that dissolves under the pressure of this promiscuous density of contact across space is the assumption that different degrees of "now" are obtained in different places, that Delhi or Dar es Salaam are somehow less "now" than Detroit. The "nows" of different places leach into one another with increasing force. The realities of different contemporaneities infect one another. This condition generates active estrangement, a kind of nervous expulsion, a gladiatorial repulsion scripted through an orientation of either contempt or homage.

Why contempt and homage? They permit the automatic assumption of a chasm between the beholder and the object of contemplation. The tropes of contempt and homage are an optic through which some perennially survey others and then evaluate them along an axis, where the production of estrangement has to be resolved in terms of either positive or negative regard. The "survey" mode of understanding the world presumes a stable cyclopean and panoptic center of surveillance to which the gaze can never adequately be returned, ensuring that a meeting of visions will never take place on equal footing.

Like Sunda and Upasunda fighting over Tilottama, the more that different parts of the world come to be aware of one another's desires, the more disputes there are over who can access the contemporaneity that both desire—the part of the world that has more confidence in itself or the one that has more of the élan of the "Other." Key to this conflict of perceptions is a refusal to recognize that, like the sudden appearance of a Sanskrit story in a Khmer frieze in a Parisian museum to a collective of practitioners from Delhi, the relationships between familiarity and estrangement are comprised of many folds and cracks in space and time. Estrangement is only familiarity deferred, or held in abeyance.

Rather than recognize the fact that familiarity and estrangement are only two non-distinct and contiguous instances of cognitive and affective transfer, this tendency to resolve the unfamiliar into the binary of the "like" and the "alien" needs constant mechanisms of reinforcement. The duality of contempt and homage is one such mechanism. In the first instance (contempt), the object of the survey is pinned down in taxonomic terms, explained away to require no further engagement, making impossible the blurring of the distinction between the surveyor and the surveyed. In the second (homage), the object is exalted beyond the possibility of an engagement. In either case, a difference, once identified, becomes a factor of cognitive and affective excision. This forecloses the possibility of recognizing that what is identified and estranged may in fact be disturbingly similar to what is familiar, even though it may be located in realities that are difficult to translate with coherence or consistency. It is the inability to recognize the face of a stranger when you look at your own reflection.

The amalgam of the sensations of familiarity and estrangement evokes a new register of a tense accommodation, a hospitality to the presence of the "strange" that is not without attendant unease for the "familiar." In the end, this may guarantee the disavowal of mutual antipathy and the cultivation of some sort of cohabitation. We can change the framework of the story on the Banteay Srei frieze. Sunda and Upasunda can both survive by agreeing to stay within the framework of a generous but awkward polyandry. They can do this by learning to negotiate with Tilottama's claims on both their desires and by displaying a little more effort at being open to unpredictable encounters.

What does a little more encountering do in the domain of contemporary art? An assessment of the amplitude of signals and the intensity of contact that mark our world today is still waiting to be made. One of the ways in which this could be undertaken would be for us to try to account for the implications of the growth in internet-based connectivity on a global scale. The internet as we know it today is barely a decade-and-a-half old, and its expansion can be dated to as late as the mid-1990s. Curiously, the expansion of the internet and the recent expansion of the number of biennials have been coincident with each other.

In 2005[1] it was estimated that 15.8 percent of the world's population, or over one billion people, have some kind of regular internet access. A majority of internet users live in North America, Europe, Australia, New Zealand, and parts of East Asia (South Korea, Hong Kong, Taiwan, Japan, and Singapore). World internet usage grew by an estimated 147 percent from 2000 to 2005, and the highest growth rates were in Africa, Asia, the Middle East, and Latin America. Chinese is the second most used language on the internet, and a country like India experienced a growth of 420 percent in internet usage, from five million people in 2000 to twenty-six million in 2005. It means that some twenty-six million people in India (through labor, education, correspondence, and entertainment) employ, use, and rely on a medium that enables an exceptional level of global reach. Actual figures for internet usage are probably significantly higher, as most people in India and other similar societies tend to go online not from the computers they own (since not many people "own" computers) or even computers they might access at work, but from street-corner cybercafés. No other platform of communication in world history can claim that it has attracted the attention of 15.8 percent of the world's population in the span of ten years.

Ten years is a very short time in the history of culture. It is the span between three documentas or roughly the time between the founding of the European biennial, Manifesta, and its fifth edition. If internet usage continues to grow, at least at this rate, for the next twenty years, approximately 75 percent of the world's population will have initiated a deeply networked existence in the time it takes to produce the next four documentas. Nothing has prepared us for the consequences of this depth and density of communicative engagement at a global scale. And unlike previous expansions in communicative capacity (print, radio, cinema, television), this time, with the internet and new digital devices, we see readers who are also writers and editors, users who are also producers, and viewers who are also, at least potentially, creators, entering a global space of cultural production.

While it would be simplistic to argue for a cause-and-effect relationship between the expansion of the constituencies served by the internet and the growth

in number of biennials and other international art events, it would be equally facile to dismiss the implications of the emergence of this vast augmentation in global communications for the contemporary art scene. What are these implications? First, that the discursive communities around contemporary art, like the discursive communities in science or politics, are poised to undergo a significant transformation. Second, an increasing diversity of positions vis-à-vis the role of authorship, creativity, and intellectual property in the actual domain of global cultural practice are challenging the notions of bounded authorship that have dominated the concept of art production in the recent past. Both of these formulations need some elaboration.

The discursive framework of contemporary art, like any other domain of thought and practice today, can no longer be viewed as something that occurs only among an exclusive cognoscenti of curators, practitioners, theorists, and critics residing in Europe and North America. Discursive networks can afford to practice an exclusionary mode of existence only at the risk of their own obsolescence. Every node in such a network survives only if it is able to affect a critical mass of new connectivities and be a conduit for new information about a very rapidly changing world.

In politics, it is impossible to conceive of a discursive framework that does not include an active interest in what is going on in the majority of the world. The realities of the Middle East, South America, Eastern Europe, sub-Saharan Africa, and Central, South, and East Asia affect what happens in Europe and North America profoundly. The networks of global finance and trade or even of distributed production that characterize the world economy today would not exist as they do without the internet. Similarly, the global production and dissemination of news is deeply tied into the substance of everyday politics. It is impossible to separate domestic politics in any major Asian or European country from, say, what is happening in Iraq today. To say this is to state the obvious.

But what is obvious in a discussion of the economy, the media, or politics is somehow seen as novel or esoteric in the realm of culture. This prevailing surprise about the fact that the "contemporary" is also "transterritorial," that "now" is "elsewhere" as much as it is "here," or that it is as "strange" as it is "familiar," is one of the symptoms of the lag in the levels of informed discussion between the domains of culture and of political economy. However, while it may still be possible for some to argue, from a perspective that privileges the present state of affairs, that a globalization of contemporary culture may imply an attempt to impose a specifically Western modernist agenda on a global scale due to the inequalities in articulative capacity, it would be impossible to sustain this argument in the long term. The momentum generated by different processes of

cultural articulation set in motion in various local contexts all over the world indicate a reality of densely networked yet autonomous tendencies, movements, genres, styles, and affinities that are far more complex than those for which the discourse of Westernization allows. Even a cursory glance at the crosscurrents of influence in global popular culture, in music, film, cuisine, fashion, literature, gaming, and comics, reveals the inner workings of this web. We are in a world where cinema from Mumbai, *manga* from Tokyo, music from Dakar, literature from Bogotá, cuisine from Guangzhou, fashion from Rio de Janeiro, and games from Seoul act as significant global presences, rivaling, and occasionally over-shadowing, the spread and influence of their European and North American an-alogues. The trends in contemporary art practice and exhibition can, in the end, only be an echo of this banal generality of the everyday life of global cultural traffic and transaction.

The growing presence of art practitioners and works from outside Europe and North America within major European and North American exhibitions, and the realization that there are non-Western histories of modernity, have had two ancillary effects. They have demonstrated that these practices, practitioners, and their histories have a significant global perspective, speaking to the world from their own vantage points, as they have done for a while. These two realities also have created pressure within non-Western spaces and by non-Western prac-titioners, curators, and theorists to lay claim to a global cultural space through the founding of contemporary art institutions, networks of practitioners, and exhibition circuits. One implication of these conditions has been the prolifer-ation of biennials and other international exhibitions of contemporary art in spaces outside Europe and North America and a corresponding increase in the discourse generated through and around contemporary art in these areas.

Another implication has been the nascent presence of the curator and the critic of contemporary art in Asia, Africa, and Latin America or the curator and critic who finds him- or herself located within or at a tangent to new Asian, African, and Latin American diasporas in Europe and North America. At first, this new curator may be someone who seems to speak only to and for his or her place of origin. He or she then may be perceived as working with other curators and artists within specific regional (but transnational) settings or with peers in similar contexts elsewhere in the world. Eventually, this person will be seen as laying a claim to working with artists from everywhere, including Europe and North America. These claims, as and when they occur (and some are indeed oc-curring even now), will be based not on the operation of affiliations based on geopolitics, geography, and location, but on elective affinities of interest, taste, curiosities, methodologies, and concerns.

This will coincide with the rise of institutional and noninstitutional structures, spaces, and networks in contemporary art that have significant presences outside Europe and North America. These entities will become forums for discussion and exhibition as well as fulcrums that enable the leveraging of transregional contexts for collaboration and curating. The idea that contemporary art has to have a central location that privileges a particular history or cultural framework will erode, giving way to the idea that contemporaneity is best expressed within the logic of a flexible and agile network that responds to emergences and tendencies on a global scale. This means that the logic of spatial and cultural distance that operated as a perennial handicap to the non-Western curator, practitioner, or theorist is unlikely to remain of much significance. Likewise, the European or North American artistic practitioner or curator will be increasingly called upon to demonstrate his or her relevance in a multi-polar world where European or North American origins or location will no longer operate as an automatic set of credentials. In a world that grows increasingly used to being networked, curators and artists from different spaces will work together and in each other's spaces, as a matter of course. In their everyday practices, they will question, challenge, and subvert stable identifications of spatiality and cultural affiliation. This will not necessarily mean better or worse art or discourse; what it will mean is that the terms "global" and "contemporary" will resonate in a host of different ways, so as to indicate the active presences of hitherto absent, silent, or muted voices and expressions.

The challenge to the notion of bounded authorship as a result of the expansion of a global platform like the internet is perhaps of deeper significance for contemporary art, even if it is at the moment less visible. The internet has set in motion peer-to-peer networks and online communities that do more than share cultural intelligence: they also begin to occasionally collaborate on the making of things and of meaning, often at a global scale, in a way that is at variance with mainstream protocols of intellectual property. This is most clearly visible in the global open-source communities, but the influence of the "open-source" idea has ramifications beyond software. This tendency is increasingly audible in the domain of a new global musical sensibility based on file-sharing, remixing, and recycling of extant musical material, with scant regard to the admonitions of the protectors of intellectual property or cultural purity. It is also present in peer-to-peer networks founded by scientists, legal scholars, philosophers, historians, and other social scientists who have used the internet to establish a new intellectual common that gains strength through regular usage, participation, and contribution, often in direct opposition to the hierarchies prevalent in institutionalized academic and intellectual life. These new communities of research and reflection are rapidly establishing today's bridgeheads of inquiry, free from

the inherent conservatism founded on concerns for proprietary or commodifiable utility that ties production in academic institutions and research spaces to "safe" areas of inquiry through the instruments of intellectual property. Increasingly, these "open" spaces are the ones where science, philosophy, and social theory are "hot" and more responsive to the world around them.

By foregrounding an emphasis on the common and other forms of collaboration or non-property or anti-property arrangements, open-source practitioners and theorists (be they in software, music, science, or the humanities) have initiated a profound turbulence in the cultural economy. The domain of contemporary art cannot remain immune to this turbulence, which exists all around it. It is perhaps only a matter of time before the ethic of sharing, collaboration, and "commoning" becomes commonplace within contemporary art, just as it has in other domains of culture. It is already visible, in a nascent sense, in numerous curatorial collaborations and artist-practitioner-technician-curator-theorist networks that transcend borders and disciplinary boundaries, that give new twists to the "publicness" of public art projects, and that raise vexed questions concerning the "ownership" of the ephemeral and networked works and processes that they generate. The increasingly dense, cross-referential nature of practices within contemporary art also points in this direction, leading us to think of the space of contemporary art not as a terrain marked by distinct objects, but as one striated by works that flow in and out of one another or cohabit a semantic territory in layers of varying opacity. Crucially, a liberality of interpretation about what constitutes intellectual property and what devolves to the public domain will be central to defending the freedom of expression in art. Art grows in dialogue, and if intellectual property acts as a barrier to the dialogue between works, then it will meet with serious challenges that arise from the practices of artists and curators.

All this cannot happen without conflict and disruption. The domain of the sign is the playing field of a new cultural economy, where the generation of value hinges on an adherence to the principles of intellectual property. However, increasingly, practices that are at variance with the principles of property in culture for a variety of ethical, social, intellectual, aesthetic, and pragmatic reasons have perforated this domain. The likely consequence of all this is that the tasteful tranquility that marked the enterprise of aesthetic contemplation will find itself besieged by disputations, legal suits, accusations of copyright infringement, and intense, invasive scrutiny by holders of intellectual property. Making art will increasingly be about forging new legal concepts and creating new economies of usage, ownership, and participation. Making and exhibiting art will be about fashioning politics, practicing a new economics, and setting precedents or challenges in law.

The existence of contemporary art is ultimately predicated on its practitioners' conditions of life. The myriad daily acts of practicing, reading, inscribing, interpreting, and repurposing the substance of culture, across cultures, constitute these conditions of life. These acts, in millions of incremental ways, transpose the "work" of art to a register where boundedness, location, and property rest uneasily. The work of art, the practitioner, the curator, the viewer, and the acts of making, exhibiting, and viewing all stand to be transformed. All that is familiar becomes strange; all that is strange becomes familiar.

..

"Digressions from the Memory of a Minor Encounter" by the Raqs Media Collective was originally published in *The Manifesta Decade: Debates on Contemporary Art Exhibitions and Biennials in Post-Wall Europe* (MIT Press, 2006).

..

NOTES

——

1. Data Source: <http://www.worldbank.org/> (accessed Sept. 15, 2014).

Alice Ming Wai Jim

There is an advantage to having visited *RMB City* (2008–11)—the online fantasy world created in Second Life (SL) by Beijing-based artist Cao Fei—when appreciating her "slightly different version" of it as a one-person-game art installation grimly titled *Apocalypse Tomorrow: Surf in RMB City* (2011). The title screen invites audiences to step on a bright orange skimboard (a surfboard without fins) to guide the on-screen avatar, "an intrepid meditating monk," through a post-disaster floodscape filled with obstacles that turn out to be the remnants of the submerged, once-famous *RMB City* sometime in the future. Marking the culmination of the *RMB City* project, *Apocalypse Tomorrow* premiered in the group exhibition "Real Virtuality" at New York's Museum of the Moving Image in January 2011, about the same time Cao Fei announced intentions to power down *RMB City*'s operations. While both are stand-alone works, experiencing *RMB City* and *Apocalypse Tomorrow* in the same time-space cosmos of a gallery fortuitously exults both as perfect bookends for the numerous artworks, interactive exhibitions, and events that Cao Fei's art in Second Life has spawned over the last three years. From platform to surfing game, the incredible scope of the project has brought critical attention to an expanding cultural brokerage between the art world, the internet and its virtual economies, and the role gaming and social media can play in questioning these developments as well as its own.

Over the last decade, Cao Fei has gained a prominent place at the forefront of a generation of artists interested in combining game modding with the latest display, social networking, and web 2.0–enabled technologies to create online participatory media projects. Second Life, launched in 2003 by Linden Lab, is the three-dimensional virtual universe of different user-created worlds, with its own money exchange (the Lindex) and currency, inhabited by over twenty million self-customized user-avatars called "residents" who communicate through

instant messaging. Membership is free to the public common spaces, but with Linden dollars converted from real US dollars, residents can purchase land and the goods and services to build up and privatize their virtual homes and businesses. Opened to the public in 2009, Cao Fei's whimsical *RMB City* is arguably the most widely acclaimed SLart (art in Second Life) project in both SL and RL (Real Life) art worlds.

RMB City is an online art community, platform, and concept piece designed as "an experiment exploring the creative relationship between real and virtual space, and is a reflection of China's urban and cultural explosion."[1] Seen from a bird's-eye view (as all avatars in SL have the ability to fly and teleport), *RMB City* is a chaotic themeparkization of overabundant socialist, communist, and capitalist icons and architectural landmarks associated with Chinese cities then and now, along with every fathomable aspect of material culture extolling the excesses of capitalism that, according to Cao Fei, "made China, my country, such a syncretic experimental place."[2] Indeed, a literal translation of its title, drawing from the abbreviation of the Chinese unit of currency, *Renminbi* ("people's money"), could read simply as "money town." Now deserted by the online art community that used to inhabit and maintain it, *RMB City* still exists on the Creative Commons Kula Island in SL.

Cao Fei's first explorations of the SL community began in 2006, when she, as her avatar, China Tracy, then an armor-clad, platinum-blond cyberpunk approaching Barbie-Doll proportions, directed a three-part machinima about her in-world experiences over a period of six months. Machinima is filmmaking in a virtual environment using interactive three-dimensional video game engines to render computer-generated imagery (CGI) in real time. Interactive screen spaces of the virtual worlds in SL act as portals enabling one to become a part of the media image rather than just a watcher. Yet the desire to control the generative outcomes of platforms is a constant factor when producing machinima in synthetic worlds. As Cao Fei put it, "I was directly recording myself as I moved through Second Life, but as I'm watching myself, I'm also controlling myself; I'm simultaneously director and actor. But I enjoy exploring everything and not knowing what will happen in the next step. A lot of the process is waiting for something to happen, and I didn't try to make something fake." Edited down to twenty-eight minutes, the resulting cyber epic, *i-Mirror* (2007), premiered at the 52nd Venice Biennale as part of the Chinese Pavilion exhibition, but in its own temporary China Tracy Pavilion on-site and in SL.[3] The virtual documentary chronicles Cao Fei's encounters ("part real, part role playing") with SL's surreal terrains, subcultures, and players, including her love affair with a young blond Chinese avatar that she later discovers is actually a sixty-five-year-old American in real life.

Role-playing (or taking on a pretend persona), urban youth culture, and dreamscapes are subjects that Cao Fei, as part of a new younger generation the media has coined "New New Human Beings" or *Xin Xin Ren Lei*, has long explored—not only the rapid urbanization of Guangzhou where she was born and raised, but also pop culture from manga and anime to American rap and breakdancing, Chinese TV dramas, and digital entertainment downloads.[4] Illustrious examples include *Hip Hop* (2003), an upbeat video of regular city people, such as a clerk, a construction worker, and a police officer in Guangzhou, Fukuoka, and New York performing hip hop scenes, and *COSPlayers* (2004), a video and photographic series starring real-life Chinese "costume players," fantasy realm–obsessed youth who dress up as their favorite manga, anime, or game characters. With signs of Guangzhou's high-speed urbanism and the socioeconomic upheavals associated with post-planning as their backdrop, the teenagers theatrically roam the city by day as urban superheroes, but by night, at home in small working-class living quarters and with their aging parents, they brood under a heavy cloud of depression, self-alienation, and ennui. Less morose, *Whose Utopia* (2006–07), produced during the Sieman's Art Program where she conducted a six-month residency called *What are you doing here?*, is a surreal three-part video of employees at the Osram lightbulb factory in Foshan, Guangdong Province, acting out their hopes and aspirations in their workplace as ballet dancers and rock stars.

In the virtual realm, however, the body images that users create for their avatars, Christine Liao writes, "usually do not mirror their physical body but are accumulations of imagination and desires…. Because avatars carry information about personal desires and cultural experiences, avatars do not represent the dream of cyberspace as a space without stereotype of human and discrimination."[5] While SL as a cultural interface offers abundant possibilities for identity play, "the visual culture of avatars has certain limitations and adheres to particular aesthetics, especially Western aesthetics."[6] Cao Fei also notes a further distinction: "For cosplayers, they put on different costumes in their real life, but they're conscious of playing a game. When you're online in a totally new world, your physical self is more invisible, and it's your inner self that's revealed."[7]

The initial melancholic urban drifting of China Tracy during the making of *i-Mirror* in the great number of Western-style contexts that tend to dominate in SL (HiPiHi, the Chinese version of SL, was not released until 2008) led Cao Fei to create *RMB City* as her "own city utopia," which would virtually reflect her cultural gaze back at herself and to which she could feel a sense of belonging. *RMB City*, Cao Fei notes, "is a Chinese city, but it mixes the different elements of China. I'm very interested in the city as an organism and have done a lot of research on cities in the Pearl River Delta, and I'm hoping I can use my knowledge

to build a Second Life version of my vision of the Chinese city today."[8] The resulting monuments and signature high-rises in Cao Fei's new "virtopia" (Virtual Utopia) clearly call up the major cities of Beijing, Shanghai (especially Pudong New Area, a designated Special Economic Zone), and Hong Kong, one of China's two Special Administrative Regions.[9]

With Cao Fei's "Slebrity" avatar China Tracy (now with long black hair twisted into small Princess Leia buns) as participant-observer, resident-tourist, and philosopher-guide, *RMB City* has hosted over a dozen in-world activities, in all seriousness to the absurd, that have ranged from the 2009 opening live performance piece *Master Q's Guide to Virtual Feng Shui*, by Guangzhou-based artist Huang He; to the machinima *Live in RMB City* (2009) on the first steps and existential questions in SL of China Tracy's newborn son China Sun (as in real life); to the unveiling of the Guggenheim Museum in *RMB City*; to a Naked Idol in an *RMB City* beauty contest in 2010 for SL avatars; to five mayoral inauguration ceremonies inducting well-known figures in the art world such as longtime collector and patron of contemporary Chinese art Uli Sigg (SL: UliSigg Cisse), Jerome Sans (SL: SuperConcierge Cristole), then Director of the Ullens Center for Contemporary Art (UCCA) in Beijing from 2008 to 2011, and the Guggenheim Museum's Senior Curator of Asian art, Alexandra Munroe (SL: Supernova Sibilant). As a laboratory, *RMB City* has also experimented with hybrid productions that combine SL and RL performances, such as the post–Hurricane Katrina project *NO Lab in RMB City* (2008) in collaboration with Hong Kong–based MAP OFFICE (Gutierrez + Portefaix) that premiered at Prospect.1 New Orleans. In the live mixed-reality performance *RMB City Opera* (2009) for Artissima 16 in Turin, Italy, virtual and real performers interact with one another in real time, inspired by the revolutionary propaganda model operas, or *Yang Ban Xi*, developed during China's Cultural Revolution (traditional operas were banned by Mao Zedong's wife Jiang Qing).

Developed by Cao Fei and Vitamin Creative Space in Guangzhou, *RMB City* is not just an Asian island city in SL, it is also a product of the international art world network that sees a primary investment in contemporary Chinese art. The virtual realm had been under construction for almost two years between 2006 and 2008 before it found an institutional partner in the Serpentine Gallery. From its *City Planning* stage to the involvement of investors and institutions as collaborators to purchase usage of the buildings in SL and program events and activities in them, *RMB City* mimicked the structures of real-world real estate, urban planning, and art ecologies. Indeed its "advanced preview and sale" at Lombard-Fried Projects in New York in 2007 emphatically corroborated the art world's interest and readiness in staking out virtual real-estate developments in a most spectacular way: basically by the buying and selling of virtual gallery

space in *RMB City*, payable in real-world cash. The Chelsea gallery had provided China Tracy, as "Chief Developer," with real-life retail space for a *RMB City* leasing office and showroom complete with neon signs, futuristic scale models, and a billing slogan: "My City is Yours, Your City is Mine." According to the press release, the public was "invited to view an *RMB City* model, preview videos, promotional materials, and detailed *RMB City* photographs and go online via laptops providing real-time links to the city under construction in Second Life." *RMB City*, packaged as a real-estate agency, was restaged for the 10th Istanbul Biennial in 2007. At its "Investors' World Premiere" at Art Basel Miami Beach earlier in 2007, available for purchase in addition to the promotional aerial survey video *RMB City: A Second Life City Planning* (2007) were *RMB City* hardhats and booklets explaining that special "units of RMB City will be sold to collectors and investors, and all sales profits will contribute to the RMB City Foundation for further construction, operation and development of the City in the coming two years." The marketing campaign obviously worked. For an artwork that's nowhere, this cyber art island allegedly fetched one hundred thousand US dollars from an unidentified collector at the art fair for one particularly pricey virtual plot.[10]

While *RMB City* was envisioned from the onset as a two-year residency in virtual space for the artist and her peers and collaborators, it became clear over time that what began as an fictional witnessing of China's feverish rate of urbanization became a contradictory site of political contestation regarding the city's futurities. Writing in reference to *RMB City*, Ceren Erdem observes: "Living in a Chinese city today, it is impossible to escape and become isolated from the forceful production of urban fiction. The best way to negotiate a space of personal freedom within it is perhaps to appropriate this as a given condition and exaggeratedly utilize it to an excessive degree, exposing its overabundance and even absurdity to the public gaze."[11] *RMB City*'s virtual skyline is crowded with the cantilevered prow and perforated metal skin of Bernard Tschumi's West Diaoyutai Tower and Rem Koolhaas and Ole Scheeren's CCTV building, both from Beijing, suspended in midair from construction cranes that compete for vertical footprints. On the end of one of them, a giant floating panda (the city's "love center") is dangerously close to getting spiked by Jiang Huan Cheng's Oriental Pearl TV Tower from Shanghai that shoots up from the central business district and among dream factory chimneys spouting fiery, black smoke. None of this seems however to deter the airy meanderings of the national flag, held up, if not led, by its stars. Lower down, rotating a gigantic Ferris wheel like a parasol, the *Monument to the People's Heroes* overlooks Tiananmen Square, which has become one of the many infinity pools in Shanghai hotels, but public here and possibly filled by the water from the Three Gorges reservoir that is gushing into huge

toilets on the container piers of the Pearl River Delta below only to be flushed as sewage into an ocean of floating Red Army soldiers and Mao statues. Low-flying planes glide over super malls as well as dilapidated houses and street markets, a marooned Feilan Temple, the Grand National Theater in Beijing, and the rusted steel structure of Beijing's Olympic Stadium, aka Bird's Nest. The slick animation of this 3-D world is "very colourful and very perfect," but beyond that, already signs of the dystopic underbelly of a future China in late-capitalist development seep up through the sand in this world and in real life.[12]

In fact it is precisely the luxury goods and properties of *RMB City* alongside the relics of its hubristic downfall bobbing up and down between ocean swells that the avatar monk in *Apocalypse Tomorrow* has to circumnavigate. Surfing free-style, the monk in fact seems to glide just as easily through giant designer handbags by Louis Vuitton and Marc Jacobs playfully occupied by marine life, pseudo trademark logos of multinationals, a menacing Mecha super robot, seated Buddha sculptures, and the Statue of Liberty, as he does passing motley survivors waiting it out on raft-sized MacBooks and iPads (Panda has hitched a bicycle ride) and a boat full of dynastic characters brandishing a "Fair Pay for Deity!!!" sign. The monk dodges falling RMB factories, shopping carts and UFOs only be taken by a swirling maelstrom to the bottom of the ocean where I. M. Pei's Bank of China from Hong Kong lies next to KTV among the ruins. A wheel-propelled net, a gravity-defying upward-flowing waterslide, and the national flag-cum–magic carpet gently pulled along by cranes come to the rescue at highly auspicious moments.

Compared to the bright, color-saturated qualities of the *RMB City* virtual utopia, the animated game world of *Apocalypse Tomorrow: Surf in RMB City*, despite its title, is relatively restrained and decidedly low-tech and retro in feel, with its pastel palette combination of freehand drawings and Flash animation. In contrast to the former's light-hearted yet punchy electronic music, the latter's surf "journey of self-cultivation" is set to two serene fifteenth-century compositions (*Chunxiao Yin* [Spring Dawn] and *He Wu Dongtian* [Cranes Dance], both "in a Grotto-Heaven") performed by a Chinese silk-string zither (*guqin*), interrupted only by coin sound effects each time the monk successfully avoids collision, which is almost always. The technological downsizing, however, is only on the surface.

Designed in Flash Surf, *Apocalypse Tomorrow* is a video game projected onto a curved screen with a custom body board Wii remote interface. If machinima is an example of not only emergent gameplay but also game art modding, this specially designed Flash Surf game operates more like a mind-surf simulator that induces a state of meditation to free the mind of worldly desires rather than to

improve reflexes and reaction time in riding the waves. Typical surfing video games demand a lot more physical athleticism. In billowing white robes and a topknot, the practically armless monk, who is seen only from the back, doesn't attempt any sort of fancy maneuvers or ever wipes out, even when caught in a maelstrom, rather he just seems to drift. Although there is a point counter, as with most artist-made video game mods, gameplay isn't really the point: the avatar at no time perishes, there are no levels, and the game never really ends. As the game description indicates, "the monk-avatar, his heart at ease, constantly overcomes the obstacles but never reaches anything resembling a final destination." In effect, the monk, much like a white chess bishop, and by extension *Surf in RMB City*, is intended to guide the player through "a fully conscious drama where each player picks her own paths," revealing more about the player than the game. Unlike China Tracy's excursion through Second Life, the solitary monk is not interested in staking out territory and picks up neither company nor things, perhaps adding credence to how one that is divested of desire and expectancy (technically) never dies.

Cao Fei's SL art emphasized the roles played by various stakeholders—as art collectors, art institutions, and land developers—as not only observers but denizen-participants in the formation of *RMB City* as a new transnational urban space. It is, however, only a microcosmic portion of the possibilities as well as the ironies of the introduction of virtual worlds to real-life populations where the economic disparity is so great that concepts such as soft capital and virtual goods, marketed brands, and property traded by only those with excess income are simply irrational to citizens, save for the most imaginative. Yet this wide-ranging new media artwork has crucially enabled the possibility of a counter-worlding to China's ostensibly overzealous and unsustainable industrialization in real life, precisely by playing up and ultimately washing away cumulative consumerist practices. Considering the efficacious advances in technology-enabled media art to inculcate new publics into patterns and practices of its own consumption, this endeavor seems all the more pressing in the present as well as the future. "Contemporary consumer society created people who live for consumer products, who spend money on consumer products, or those who are the products," Cao Fei states, "whereas contemporary art focuses more on overlooking, epitomising, reflecting, and judging consumerism, making us reflect on questions like where we come from and where we will go."[13]

In the wake of natural disasters from tsunamis to earthquakes and ongoing worldwide conflicts and wars, *Apocalypse Tomorrow* seems a critically apt ending for *RMB City*, sunk under the weight of its own excess. It can be understood to emerge out of the broader contradictions of gaming, user-created content, and

social media that would parody relationships between China's state capitalism and free market economies, global capitalism and media democracy, civic politics and human rights, and the art market's relationship to the virtual economies of an art world online. One of the most poignant yet disturbing animated sequences in *Apocalypse Tomorrow* is of line drawings of the World Trade Center twin towers cut in half by a plane-shaped bird, toppling over in such a way as to resemble Beijing's CCTV tower. If there is a further haunting to account for, it is the trauma of reactive world wars of counterterrorism, terror, and extreme fundamentalisms in late global capitalism.

From beginning to end, Cao Fei's *RMB City* has been both "a process of continuous 'remaking' to allow constant inventions and participations of other people" and a site of "collective sharing and creation," according to curator Hou Hanru.[14] The city platform prompted if not compelled audiences to play a role (or as many and in as many different ways as possible) in the characterization and production of "virtual" "world spaces" (from online gaming to social media) as generative resources for political engagement in real life and vice-versa. The endgame is not the point. Rather the revelation is, like the post-apocalyptic monk, as virtual avatars and in real life: either steer in the direction you want to go, or end up adrift in the current.

"The Different Worlds of Cao Fei" by Alice Ming Wai Jim was commissioned by *Yishu Journal of Contemporary Chinese Art* and first published in 2012.

NOTES

1. *RMB City* website, <http://rmbcity.com>.

2. Davide Quadrio, "A Dramatic 'Second Life' for Cao Fei," *Flash Art* 63:270 (January/February 2010): 38.

3. Cao Fei exhibited with Shen Yuan, Yin Xiuzhen, and Kan Xuan in "Everyday Miracles: Four Woman Artists in the Chinese Pavilion" (2007), curated by Hou Hanru, as the youngest member of the group.

4. Hou Hanru, "Cao Fei: A Cosplayer Recounts Alternative Histories," *Art iT* 15 (Spring/Summer 2007): 59–62.

5. Christine L. Liao, "Avatars, Second Life, and New Media Art: The Challenge for Contemporary Art Education," *Art Education* 61:2 (March 2008): 89.

6. Ibid.

7. Samantha Culp, interview with Cao Fei, *Artkrush* (February 2008) <http://artkrush
.com/160442> (now defunct); <http://archive.samanthaculp.com/2008/02/portfolio
/interview-cao-fei-artkrush-feb-2008/>.

8. Ibid.

9. Zhang Anding (SL: Zafka), "Here Comes Metaverse: a New Existential Manifesto," *RMB
City: Cao Fei/SL Avatar: China Tracy*, ed. Hu Fang and Cao Fei (Guangzhou: Vitamin Creative
Space, 2008).

10. Chin-Chin Yap, "The Virtual Muse and Her Taxman," *ArtAsiaPacific* 58 (March/April
2008): 87.

11. Ceren Erdem, "RMB City: Spectatorship on the Boundaries of the Virtual and the Real,"
Interventions Journal 2 (January 2012), <http://interventionsjournal.net/2012/01/26
/rmb-city-spectatorship-on-the-boundaries-of-the-virtual-and-the-real/> (accessed March
12, 2012).

12. Ibid.

13. Christina Ko, "Patron Taint," *Prestige* 29 (May 2011): 261.

14. Hou Hanru, "Notes on Cao Fei's *RMB City*," artist's website, February 27, 2011, <http://
www.caofei.com/texts.aspx> (accessed March 12, 2012); Hou Hanru, "Politics of Intimacy:
On Cao Fei's Work," *Cao Fei: Journey* (Frac Ile-de-France; Le Plateau & Vitamin Creative Space,
2008), 50.

Discussants: Cory Arcangel, Michael Bell-Smith, Michael Connor,
Caitlin Jones, Marisa Olson, and Wolfgang Staehle
Moderator: Lauren Cornell

"Net Aesthetics 2.0" is an ongoing discussion series initiated by Rhizome that has culminated in three panels to date—in 2006, 2008, and 2013—all of them born from an urgency to frame the ways internet art has evolved in light of broader changes in art and society. While internet artists of the 1990s and early 2000s generated intense, self-reflexive debate about the nature, politics, and practices of art online (often on Rhizome's own mailing lists, in keeping with the medium's fledgling stage), later inflections on the form were articulated in more distributed, looser ways. "Net Aesthetics" formed generative referendums that accrued with each session and sparked lively conversation online, helping artists and curators find the language to further develop and share their work.

Held just two years apart and in New York City, first at Electronic Arts Intermix and later at the New Museum, the first two "Net Aesthetics" panels can be seen as close kin—linked in time, space, and community. Both discussed evolving practices that responded to the rapid transformation of art engaged with the internet following the burst of the dot-com bubble, how this extant work engaged an emergent "social web," and the latter's attendant economic and interpersonal repercussions and effects. The third panel, "Post-Net Aesthetics," held at the ICA, London, highlighted that city's rich contribution to and perspective on a more global discourse. It also provided one of the earliest public discussions of the label "postinternet," which has, by 2014, become a widespread and much-contested term in art world parlance.

Crystallizing the role that Rhizome could play, both as a natively networked institution and one in conversation with particular segments of artist communities, these conversations operated like testing grounds, offering up terms such as "art after the internet," "digital folk art," "surf clubs," and "postinternet," that captured ideas and practices in-progress. The brief excerpts that follow are

glimpses into these broad and far-ranging conversations, with each participant represented by only a few key remarks.

—Heather Corcoran, Executive Director of Rhizome, 2012–present

LAUREN CORNELL: Hi everyone, thanks for coming. Next fall is Rhizome's ten-year anniversary, and with that threshold in mind, I organized this panel to explore how internet art has evolved over its first decade. Rhizome started out as a mailing list in 1996, and at that time it was home, like other mailing lists in internet communities such as The Thing and Nettime, to some of the first artists who were experimenting with work online. The net of course was a very different place then. It was, as Olia Lialina has written, a much thinner network of pages across which some of the first signs of personal expression and e-commerce were beginning to flower. It was a very exciting time, and because of the newness of it all, also very awkward and very slow; everything was very much under construction. Now, ten years later, things have obviously changed. The internet is now a mass medium and a much more complex, populist, and sophisticated place to work and to respond to. I invited four artists [and one curator, Michael Connor] this evening who all take very different approaches to working with the net, and I'm hoping that through their presentations you'll get an idea of the breadth of work that's being made with the net now.

CORY ARCANGEL: Since this in an internet art panel, I thought I would concentrate on some things I make that deal with the internet. I tend to do three things: I make a lot of stuff for the internet, and some stuff for the galleries, and also some stuff for cinema-style film and video screenings. When I make something, there's always this question: "Well, where does it belong?" I'm going to show you a couple of things, and talk about where they belong.

Four years ago, I was just making lots of stuff and there weren't so many exhibition opportunities. At the time I was making abstract computer art, which is probably why there weren't so many exhibition opportunities. This project, which some of you might know, or not, is called *Super Mario Clouds* [Arcangel plays the video on the screen]; but what a lot of people may not know is that I made it for the internet because I had no chance of showing anything in galleries at that point. It was just a website about how I took apart this Nintendo cartridge and took everything away from the game Super Mario Brothers except for the clouds. This was my first project made for the internet. I wanted to make something that was "meme-able," something that would replicate itself. I wanted to make a webpage about a project that people would never have to see to know what it was. The point of the work wasn't necessarily the work; the point

of the work was showing people that I did it and explaining how it was done. I had all the commentary about source code as a kind of explanation of how I made it. The work was really internet artwork. And then later people were like "Well, do you want to show this in a gallery?" And I was like "Yeah! Cool." And then it became a whole different work because I started doing installations with it.

More recently, now that I've got my new blog, I've gotten really into doing stuff just for the internet. Here's a project [points to an image projected onto the screen] that I did in collaboration with Eyebeam Research and Development called *Pizza Party*. It's a hack of the Domino's website, where you can order pizza over the command line. It's a program that anyone can download and use to order pizza. This is a website called *Dooogle* [pulls up another image], which is pretty simple. It's just like Google except it only searches for Doogie Howser no matter what you type into it. It was remarkably unsuccessful. If you look at the stats, like four people have looked at it this month. [Arcangel is corrected by an audience member.] Forty? Ok, great. That's me, probably. This is a new one [points to another projected image] that I just made, a piece called *Sailing*. This one isn't so pop I guess. It's the song "Sailing" by Christopher Cross in Arabic. Maybe we can just have a moment with this.

MICHAEL BELL-SMITH: I'm making videos that are influenced in some degree by an art context or an art historical sense, but in other respects are really heavily influenced by what people are doing on the internet, that may or may not be art or have anything to do with art. Maybe somewhere in between. First of all, my video *Continue 2000* is something that I haven't put on the internet, and I don't know if I will put on the internet, but it definitely has a lot to do with the internet, for me at least. It's heavily influenced by a few different threads of what, for lack of a better word, I'm going to call "internet folk art," things that people are doing on the internet and maybe not necessarily identifying as art, but that are popular visual practices. Some of these are the memes that Cory was talking about. One thing that influenced *Continue 2000* is animated GIFs. An animated GIF is a really simple file format on the internet that provides for little animations. A lot of things are appealing to me about animated GIFs; one is this looping, these very simple building blocks of animation. Here are a few animated GIFs that are taken from the anime in *Ranma 1/2* [gesturing to the screen]. They're really short and they're looping and they focus on really minimal gestures of animation. That's one thing that definitely influences me.

Another couple of things I want to talk about are pixel art and sprite animation. Pixel art is really popular in signatures and in avatars and online identities that people use for different message boards on the internet. You have your little image that represents your identity. Things like this will be really commonly

used to represent: "I'm Mike, I'm posting on this Star Wars message board about episode two or whatever, and this is how I identify myself, with these two people running with these lines." So it's a kind of common pop folk art internet thing that exists in that context, and I'm using some aesthetics of it in a different context.

Sprites are building blocks of early video games, before all video games were 3-D. One thing that's interesting about video games becoming far more sophisticated simultaneously with a few different technological advances is that now there are all these people on the internet ripping sprites from old video games. For instance, here we have some sprites from a fighting game [points to a projected image]. People on the internet are essentially just capturing sprites frame-by-frame from video games, and they're using them to reconstruct their own narratives. They're using the building blocks of what originally were commercial video games and years later using them again as building blocks for their own animations. This is an example of such an animation, where someone has taken these old sprites and recast them in a different context to create their own narrative about Michael Jackson and his moonwalker guys ruling the universe. In this case, a kid from Japan has gone online, hunted down all these different sprites, and used them to animate his own narrative using these building blocks. Obviously he didn't draw any of this stuff. The majority of this is sucked from different video games, but he's using it to define his own little narrative here, which goes on and on and on. So that's something that definitely I think is a really interesting movement in this internet folk art stuff and something that I definitely am influenced by in the work that I do.

The other video that I want to show is quite a bit different. This one is a piece I did that uses R. Kelly's *Trapped in the Closet* video as its source material. R. Kelly released this song cycle called *Trapped in the Closet*, which is basically a pop song that comes in different parts, this kind of cyclical pop song. It tells this ongoing story in a pulpy, soap opera-y way. One thing I found really remarkable was that all the parts have the exact same melody and cadence, even though at the time that I made this piece there were five parts out, and now there are twelve parts out, at least as far as I know. What I decided to do was play all of them at the same time, on top of each other. The basis for this idea came from mash-ups, which are when two songs are blended together to create a new composition, and often that revolves around syncing time. All these songs from *Trapped in the Closet* are essentially the exact same song but represent different points in this narrative, so my idea was to take them and lay them all on top of each other. We'll just watch an excerpt of this. It's kind of painful; it goes on like this for a while. While this definitely has precedents in an art world context and the history of video art and appropriation, it also definitely has one foot in the world of

mash-ups and responds to media enabled by file-sharing, and kids with computers who suddenly have access to all these media and can comment on it however they see fit.

MARISA OLSON: I actually had a breakthrough the other day and realized that the whole reason that I do all the crazy stuff that I do is that I'm really interested in communication, the way that people choose to express themselves, and the technologies of this communication, or what people in the days of Plato and Socrates called *techne*, which is this fine balance between utilitarianism and artistry. Everything that I do unfolds from my major, hardcore obsession with pop music and cultural distributive communication technologies. I'm going to toggle back and forth between video and internet because some of the internet art that I make is on the internet, and some is after the internet. Here's something that I made after the internet. It's called *moiMovies*.

CORNELL: What do you mean by "after the internet"?

OLSON: Well, I spend a lot of time online and I like Friendster, I like Myspace, I like MP3s, I like email. So a lot of the stuff that I make is the result of my drag-and-drop file addictions and that sort of thing. In this project, *moiMovies,* I took images that were on my computer because I had used them in my Friendster profile back in the day, and I combined them with sound clips that were on my computer from my *American Idol* blog. I was also interested in home-movie software like iMovie and how it tries to enforce this convention of nostalgia in the little techniques that are built into the software. But I wanted to think about nostalgia for stupidity or decay or boredom, or something like that. So I made this.

MICHAEL CONNOR: I thought I would, at this point, reintroduce the narrative of this panel, which is probably up for some debate, because I think the implied narrative when you say "2.0" is that we're experiencing some kind of rebirth, and then the artists presenting here in some way represent this rebirth of the internet. If this is the case, the narrative that we can take as our starting point is that in the mid- to late '90s, internet art experienced a boom that geared the dot-com boom, and these two booms culminated in 2001 with exhibitions of internet art in major museums all over the world like SFMOMA and the Whitney. Subsequently, curators didn't want to touch this area for several years, until more recently when it became credible again to talk about showing internet art in your gallery or museum. That narrative is true, and it's untrue. One thing that I think is kind of interesting about the narrative is that I remember that, in 2002, there

was this feeling of disillusionment with the web. We'd been through these years of the internet experiencing the camp of "content is king, and you can sell your content to make a lot of money." And other people were preaching a different story: "content is king" versus "information wants to be free." In 2002, Bruce Sterling wrote an article called "Information Wants to be Worthless." I really loved that title and I thought it was a really great third way, a rebirth of the idea that the computer was a liberating device that we could use for individual expression.

The four people that we've seen present today all seem to have an element of anthropology in what they're doing. I would say that Marisa, Cory, and Michael [Bell-Smith] are participant-observers in this great game of user-generated content, whereas Wolfgang perhaps has a more detached and objective approach with his livestream cameras and more photorealistic depictions of reality. But all of you are inspired by the idea of the internet as a means for understanding some glimpse of the psyche or an anthropology of ourselves. At what point do you draw the line between what people are doing on the internet, that is your source of inspiration, and work that you are making and calling art?

WOLFGANG STAEHLE: Well, I'm not really following what's going on on the internet. I'm not really reading blogs; I'm not downloading MP3s all the time; I'm just using it as a tool. Basically, for projects involving a live camera feed, I just want to get my pictures to the gallery as quickly as possible, and the internet is fast, so I use it. It updates quickly so it's always fresh, and that's why I use it, but I'm not really following internet culture. I mean I follow it, obviously, with all my work with The Thing, but after that, I don't know. After ten years of immersion in it, I needed to get out because I felt fried; I felt like I had my head stuck in a microwave oven. I needed to get out and slow down and reflect on where I'm going and what it is to be alive, instead of wasting my time in simulation games all the time.

ARCANGEL: It's a really important question. All this stuff out there made by all these people is probably better than the stuff I'm making. How do you deal with that? That's one part of the question, and the second part of the question is where do I fit in with that, because essentially I'm doing the same thing that they are. As an artist, what is my role on the internet? The first part is like a daily battle. I call it the fourteen-year-old Finnish-kid syndrome. Basically there are people doing things on the internet right now that are above and beyond. I will see stuff daily and think, Oh my God, that's the greatest thing I've ever seen in my life, and in an art context it could work. It's this kind of age-old folk art thing. I think of it as a real benefit, as someone who's making work right now, because I not only have this community of friends that I trust and we're always bouncing projects

around, but I also have this global community that inspires me on a daily basis, and that I have to keep abreast of. In a way, my daily battle is just to try to, when I make something, make sure that it not only fits in an art context but that it also fits in online. Generally when I put something on my blog, no one knows that I'm an artist. As soon as it gets copied and pasted to another blog, I cease to become an artist. It just becomes another piece of information on the net. And so I like to do both.

CAITLIN JONES: I have another question about the issue of nostalgia. You guys keep talking about folk art, or I like to call it "internet outsider art." I think, except for Wolfgang's Postmasters site, almost all the sites you guys showed us were not things we recognize from the internet in 2006. They're things that we recognize from the internet in maybe 1999 or 2000, animated GIFs and garish colors and things like that. So this question is for all of you, but Cory, we've talked about this in the past in terms of your Nintendo pieces, and you were fairly adamant that those works are not about nostalgia—that they're about the fact that because you could get cheap computers that were easy to program, you therefore used them. But it seems to me your internet work is a lot about nostalgia. You're kind of obsessed with this early amateur web, the sort of "Welcome to my Homepage" kind of thing, and I think Michael [Bell-Smith], a lot of your work relates to that too, and Marisa you actually brought up the term nostalgia. So I wonder if you guys could talk about your relationship to nostalgia.

ARCANGEL: It's just easier to step back a little bit, because it's just so hard to keep up. Like I'm on Myspace now and I do not know what it means. And I know that in two years I'll know what it meant. It's just easier.

JONES: I think it also could be read from an art historical perspective, possibly as a rejection of the slick and corporate takeover of the internet space. Maybe I'm totally projecting onto you, but that was a time when people were really getting excited about the internet and putting pictures of their cat online and doing all this stuff, which maybe we still can—it's not that it's not there; it's just harder for anybody to find now.

CORNELL: I would also say that the appropriation of older material is a means to participate, and that there's no "anti" in it. Something that I was thinking about after all of the presentations is just how sort of ridiculous the web has become. It leaves people in a paradoxical position where you celebrate it and critique it at the same time. I think that that sort of gesture is in a lot of the work

we've seen today. To backtrack for a second—something that was interesting to me when I titled this panel "Net Aesthetics 2.0" was to think about how artists used things like blogs or Flickr or del.icio.us or these software services that are more recent to the web. Marisa, you use those materials in your work, and some of the other artists do too. Could you speak for a minute about why you use blogs in particular in your work, and how that format suits it?

OLSON: Yeah, I love blogs, and I love them for a few different reasons. They're easy to get. You can come to one for the first time (if anybody's still doing that) and understand the structure and rules of it. They're so self-reflexive in terms of all the little points on them that say "Hey, I'm a diary entry and this is what day I was made and what time I was made." I'm interested in the crossover between the tropes or the conventions or the rules that are specific to autobiographical narratives, and those that are specific to writing for blogs. I like to exploit that a little bit. I also feel like blogs are a great place for happenings, to revive an old word, in the sense of time-based performances that are socially specific.

BELL-SMITH: To return to something we talked about a moment ago, I think one thing that's really nice about the internet is that it is a space now where you can put things online without a degree of consequence or—this is going to sound ridiculous—it's a little bit of a safer space. I know personally I use the internet as a sketch pad for certain things. I'll put something out there, thinking it's just something I made in an afternoon, and then a lot of people respond to it, and as a result I take it more seriously or rethink the way I was looking at it.

· ·

This conversation was part of an ongoing set of discussions conducted over a number of years. For part 2, "Net Aesthetics 2.0 Conversation, New York City, 2008," see page 285. For part 3, "Post-Net Aesthetics Conversation, London, 2013," see page 413.

· ·

CAITLIN JONES: Oliver, the first time we worked together was through "Character Reference," a show I organized at Bryce Wolkowitz Gallery in 2007. After recently Googling it (the exhibition was seven years ago), I found this bio that I believe I wrote for you:

> Vienna based Oliver Laric works in video, audio, painting and photography as well as fashion and publishing. At this point not widely known in the art world, his numerous videos, which have been widely viewed on YouTube, have garnered him enormous popularity on the Internet.

I find this bio quite telling. At the time, you weren't identifying yourself as an artist specifically engaged with the internet, but your video *787 Cliparts* (2006) was very popular online and brought you to the attention of art audiences and curators like myself. How much did the viral success of that video influence your future work?

OLIVER LARIC: Your invitation to take part in that show was the first email I had ever received from a curator. The work went from website to exhibition space, not from exhibition space to website. The majority of the responses I had to the video came from people who had seen it online, including your invitation. This experience made me realize that the work on my website is the real thing. I don't feel like I need to make a choice between museum or website. Both can act as legitimate spaces of primary experiences.

JONES: The importance of "primary experience" is a useful segue into vvork .com—a website that the two of you, along with Christoph Priglinger and Georg Schnitzer, ran from 2006 until 2012. A six-year accumulation of blog

posts consisting purely of images of artworks, annotated simply with title, date, artist name, and materials used. How did you develop VVORK?

LARIC: Before VVORK we were working on a print magazine that was published within other print magazines. We did not have any printing costs, but still had to negotiate for space in publications. When we discovered blogs it seemed too good to be true—that you could have an audience with little geographical restrictions and minimal costs. We were interested in having an independent platform for ourselves and others, particularly for artists underrepresented in the more established publications. We posted the works of students and artists at the beginning of their career next to the works of established artists, often featuring artists' personal documentation or images that did not depend on the gallery as a backdrop. The focus was on the single work, not the CV, and how that work changes when brought into dialogue with another work.

JONES: For a long time I thought the audience for VVORK was a small community of "internet-aware" artists and curators, but I later realized that its reach had massively grown—artists and curators who weren't interested in the internet as a place of production were referring to the website as a resource and, through their research, were introduced to issues surrounding the distributive nature of the web. I'm curious how you saw VVORK functioning in a broader context. Was it an artwork? A curatorial project? A forum for your own research? Something else completely?

LARIC: We saw VVORK as an exhibition that happened to go on for nearly seven years. The exhibition was constantly changing with each work added. As we started tagging works with descriptive technical terms, it also became a searchable database, which is still accessible today.

ALEKSANDRA DOMANOVIĆ: We had over twenty thousand daily visitors at our peak, which is not small. But we never really knew how much curators were looking at it. Usually it was artists who wrote to us, saying how much they liked the site, or how they got offered a show because a curator spotted them on VVORK. That was an indicator to us, but not so many curators got in touch that way. I am still surprised when I meet people (curators and artists that I never thought spend time online) who tell me they were following us.

VVORK and the kind of logic around it influenced the way I made art. I realized that many of my own projects had the same methodology of researching (surfing), finding the right combinations, archiving, and finally redistributing.

VVORK

After almost 7 years and 5.313 posts, we are ending our daily activity.
Our Archive as well as Index, Search and Projects overview will remain online.
Thank you for your support.

Aleksandra, Christoph, Georg and Oliver

12. 12. 2012

Aleksandra Domanović, Christoph Priglinger,
Georg Schnitzer, and Oliver Laric, vvork.com,
2006–12 (screen capture). Website

JONES: Right, I remember that when you started working on *Turbo Sculpture* (2010) it appeared in a number of forms. Do you see that work, and others like *Untitled (19:30)* (2010–11), as coming out of your VVORK processes?

DOMANOVIĆ: Actually *Turbo Sculpture* evolved out of a blog post. It was originally an essay commissioned by *Art Fag City* (another contemporary of VVORK), and only later did I turn it into a video essay. This video still uses the web as a source. It talks about the phenomenon of erecting monuments to Western media celebrities in the Balkans. I found all the material, text, and images for it online and just collaged them together. Later on, when I could not find what I needed online, I had to get it elsewhere. Whether it was having to circulate to all the national capitals of former Yugoslavia to collect TV idents for *Untitled (19:30)* or to the South of Germany to a specialized manufacturer for some of my sculptures, my work necessitated a wandering path. *Untitled (19:30)* became an openly accessible TV-news ident archive and a collection of remixes that continues to grow and is still updated. I see the website nineteenthirty.net as a backbone

to the project; besides that, the work has many manifestations. It is a video, a vinyl record, a party. And my sculptures are distributed online via documentation.

JONES: I sometimes think of VVORK (and both of your independent practices), as being a generational gateway for people to think about the web as a space to experience art (beyond just internet art per se) and to examine the complications that arise from the virtual experience of art objects. It spoke a language that tied it to projects that people were familiar with—not only the historical work of Walter Benjamin or John Berger's *Ways of Seeing*, but also Seth Price's "Dispersion"— that were similarly addressing the multi-format access we have to art. Through VVORK, you drew attention to the relationship between the experience of "the real thing" and a document of the real thing online.

This was particularly interesting to me because, previously, curators and artists using the web (myself included) were focused on how to translate online projects into physical spaces, but VVORK did the opposite. It took physical objects and translated them online, in the form of photographic documentation. This deliberately complicated and called into question the idea you just mentioned of the "primary experience."

DOMANOVIĆ: This question first came up when we did our first "real life" show called "Bad Beuys Entertainment, Boling, Bruno, Chisa & Tkacova, collectif_fact, Matsoukis, Mirza, Prévieux, Rungjang, Zucconi" in 2007 at Gallery West in The Hague. A talk was organized for the opening, and there was a teacher from the Rietveld Akademie in the audience who told us that he advises his students to not look at VVORK but to go and see artwork live. It was at that point that I had a slight epiphany: I realized that it did not make a difference to me at all. I had seen so much work online that these two worlds were already twirled together in my head. It was more like one kind of presence augmenting the other, and reversed. Like photography transformed subjects into objects, maybe the internet transforms objects into subjects.

LARIC: We were more interested in a leveling than a distinction between the two—more about the "and" than the "or," the wave and the particle, not the wave or the particle. We think of the different states as equally valid experiences without a predetermined hierarchy. The value of the experience is negotiable and constantly changing. I haven't seen some of my favorite artworks, movies, or plays, nor have I read some of my favorite books, such as Cervantes's *Don Quixote*, but my imagination of Don Quixote continuously influences my work.

JONES: Can you describe your 2009 exhibition "The Real Thing" at MU Eindhoven, which addressed this question of "primary experience" directly in a physical gallery context?

LARIC: The show borrows its title from a short story by Henry James in which an artist prefers the represented over the real. We share this affinity and in many instances perceive the secondary experience as primary. For example there was a selection of artworks that could function without their physical embodiment, such as John Baldessari's *Throwing Three Balls in the Air to Get a Straight Line (Best of Thirty-Six Attempts)* (1973). Of course we asked Baldessari if he agreed to take part with the title. Further examples include Claude Closky's *The First Ten Numbers Classified in Alphabetical Order (English version)* (1989) and Cory Arcangel's *Super Slow Tetris* (2004). Gelitin's temporary balcony mounted on the World Trade Center in 2000, titled "The B-Thing," was exhibited in the form of the *New York Times* article "Balcony Scene (Or Unseen) Atop the World; Episode at Trade Center Assumes Mythic Qualities," published on August 18, 2001. And there was also Matthieu Laurette's "Selected Works Currently On Display Elsewhere" (1993–2006/present), which presented an overview of works exhibited at other venues during the time frame of the exhibition.

JONES: I remember when I read about the show I thought, "I wish I could go see that," and then laughed when I realized I didn't at all need to. Both the exhibition and my personal realization—which was promoted by the exhibition—addressed, very succinctly, the notion of experience and representation.

The broad-based popularity of VVORK preemptively undermines the point that Claire Bishop's "Digital Divide" article makes about the reluctance for contemporary art at large to address the "digital." The article, though controversial for its dismissal of the rich and vibrant history and discourse around art and technology as a "specialized field," did locate a significant blind spot.

You both have always made work about what it means to create and distribute art digitally, and you've done it with feet in both a contemporary art context and the "specialized field" of the internet—VVORK is only one example of this. Neither of you are programmers or hackers, but your work shows a literacy around digital technology. Can you talk a bit about how you approach working with technology?

DOMANOVIĆ: For me, not being intimidated by technology was already enough to give it a try. Back when we started VVORK, I remember artists (at least in

Oliver Laric, *Versions (Missile Variations)*, 2010.
Airbrush on Dibond, 27 ½ × 39 ⅜ in (70 × 100 cm)
each. Courtesy the artist

Europe) being snobbish and skeptical toward anything online, especially other artists having websites. Now all of these artists have a website with a carefully packaged CV and a copyright symbol somewhere at the bottom. That is not what the internet was to me. To me it was more of an active space, a discussion—I did not use the web passively, it was a place of engagement. It meant new possibilities and new friendships. I experienced working online as something very real with material consequences. But it was a different landscape seven or eight years ago. Now I feel my concentration span shortening due to social media, and I love to meet people in real life if possible.

Digitality is our air now. It is not separate or separable from the world in which we live and move. And I guess this is still amazing to me and worth exploring, because I find it has profound effects on everything. Generations to come will probably find digitality ubiquitous and not so interesting, but to me it's like the thing that makes the world interesting. I think I've just always had an affinity for it. I always liked science fiction and preferred video to painting. Though I have to admit that this could be a learned preference and not just intuitive.

The subjects in my work are various and the pieces themselves may take on multiple manifestations, but most of them have a digital presence in one way or another. This can be through a PDF document, a 3-D file, a blog post, a video. And I suppose I try to be conscious of that in my work.

LARIC: For me, maybe it's less about technology and more about urgency. I'm surprised how long the influence of technology has been marginalized in

exhibitions. The first time I went to the Venice Biennale in 2007, I wondered where the internet was. Have you heard of the song "Used to Be" by The Dream? The lyrics go: "You used to be anti-internet, but now you constantly blogging and shit."

JONES: Both of your work references or utilizes the internet in many ways, for example, as a resource, a distribution hub, or as the thematic basis for sculptural objects. Work that shows this internet awareness is being referred to as "postinternet." What do you think about this term?

DOMANOVIĆ: I identify with the type of work that you are describing, but I am not crazy about the term. Though I have to admit that I am getting less and less repulsed by it. I remember that the time "postinternet" came into currency was a time when I started working with a gallery. And there was hype around it, so many artists jumped on the bandwagon, and some of them had a very superficial interest in it, as did some curators and gallerists. So that is why it's hard to identify with completely. I did not take the term seriously at the beginning, but now it looks like it's here to stay.

LARIC: The term does not feel right, but it has become ubiquitous. There are other examples of less-than-ideal terminology and nomenclature that scenes and subcultures have become accustomed to, such as Krautrock, Spaghetti Western, or Jungle.

Maybe an alternative would be to use a retronym; the acoustic guitar only became acoustic after the invention of the electric guitar. "Preinternet art" could describe anything before the internet. Now we are simply dealing with art.

Didn't you mention that the term had already been used in 2004 by Michael Bell-Smith?

JONES: Michael Bell-Smith used it in 2006 in a description of his work that appears on EAI's website: "…through the lens of a post-personal computer, postinternet, post-Google image search age." (Though I honestly don't think he is anxious to claim its origin.) I think the term is a bit of a red herring—with all this time spent debating the provenance and accuracy of the term, discussions about the evolution of the work itself, from net.art to objects in a gallery, have been secondary. In general, 2005 to 2006 was a moment when many people were looking at how the web could appear in the gallery in a non-browser format.

DOMANOVIĆ: Guthrie Lonergan and Cory Arcangel were the ones who used the term "internet aware," which sounds a bit more accurate. Although by this point I am not sure it matters anymore.

VVORK, Nasty Nets, Loshadka, Computers Club, ClubInternet…all these internet "clubs" were all so important and active at that time. Maybe this postinternet conversation/obsession is what happened when all these online clubs closed.

JONES: You're right. Those online communities were really important for connecting artists and curators—across generational lines. Rhizome, too, I think is remarkable in documenting the shifts (and there have been a lot) in internet-based art practices.

I think in almost every essay I write, or interview I do, I end up referring back to Olia Lialina's writing or art practice, so this will be no exception. In her website entry "Net Art Generations" she gets to the heart of these historical shifts more eloquently and authoritatively (given that she has been making incredible art on and about the web since 1996) than I ever could:

> Net art can be divided into more than just two generations like old and new or 1.0 and 2.0. There are at least three, plus one more.
>
> The 1st—Artists working with the Internet as a new medium. Coming from other backgrounds, like film, performance, conceptualism, activism, whatever…
>
> The 2nd—Studied JODI at university…
>
> The Last—Net artists active in between dot.com crash and web 2.0 rise…
>
> The 3rd—Artists working with the www as mass medium, not new medium (04 June 12: If I'm not mistaken a misleading "post-internet" term used for this now)[1]

She goes on to say "All generations, except 'the last' are not necessarily connected to a certain period of time," and then sums up with a quote from the Curator of Digital at the Serpentine Gallery that articulates a new category called "early post-internet": "Most of early post-internet stuff was produced online."[2]

That Olia would draw attention to this particular quote is very important to me. It points to both the futility of trying to pin down "pre" or "post" and the problems that arise when the history of internet art is reframed as postinternet's progenitor.

LARIC: I think the term "postinternet" bothers me less than the incomplete and distorted historicization. Many of the artists who defined the direction are often left out, such as John Michael Boling, Guthrie Lonergan, Kari Altmann, Charles

Broskoski…so many people. Miltos Manetas made a canon of work in the '90s and early 2000s that predicted what artists are doing now. Miltos understood that his paintings were just a necessary by-product of the JPGs that circulated online.

Another example comes from 2013, when someone claimed to be hosting the first-ever online biennial, ignoring more than twenty years of online shows and biennials. The false claim was repeated in various art publications. When I wrote to the organizers to explain that there had been numerous online biennials before 2013, they told me that the precursors don't count because there are no Wikipedia entries about them.

JONES: Didn't you end up making a work about it?

LARIC: Well, I made a work for this biennial titled *An Incomplete Timeline of Online Exhibitions and Biennials* (2013) that was the result of research and interviews with people involved in the early online exhibitions, from 1991 to the present. But then I had to decline to participate because it was not possible to use an HTML file and host text and images separately, only photos of artworks within their format. Michael Connor at Rhizome kindly agreed to host the list, as they had no problem with text and images.

JONES: And this "incomplete" historicization has other implications as well. Oliver, you were on a panel at the 2012 Digital-Life-Design conference organized by Hans-Ulrich Obrist called "Ways Beyond the Internet." The panel included a lot of artists I really admire, but there was only one woman represented, and she wasn't an artist but a critic. Given that Obrist and the Serpentine (where he works) has this major legitimizing stamp for many—obviously this was deeply problematic.

LARIC: The selection was definitely not representative, and unfortunately these all-male constellations happen all too regularly. After the panel in Munich I decided to turn down any invitation to all-male shows. You would assume that this would change for the better, but it seems be getting worse with some of the younger male artists.

DOMANOVIĆ: The online and postinternet scene has always been predominantly male, and from my own experience most of them are nice, although there are some real assholes in there as well. I don't think that this scene is any less or more chauvinist than any other art scene. This is unfortunate as one would hope that all the potential new technologies and the knowledge they bring would have a positive, equalizing effect, but unfortunately the old patterns just keep repeating.

JONES: Both of you eloquently illuminate these cracks and problems in your own work. Like Oliver's "Incomplete List," Aleks, your recent work for the 2014 Glasgow International, titled *Things to Come*, deals pretty specifically with representations of women and their relationships with technology.

DOMANOVIĆ: Yes, and so too does the 2013 exhibition "The future was at her fingertips" at Tanya Leighton. This was the first body of work where I was addressing the subject of women in art, science, and technology directly. Although toward the end of VVORK I was also consciously posting only female artists. That work was less about "women" than about certain kinds of biases that I found present in science and technology, as well as art. I used an object known as the Belgrade Hand—a responsive prosthetic developed in 1963 by Serbian scientist Rajko Tomović of which I made sculptures—as a sort of an emblem to talk about my various interests, most of them having to do with the representation of gender in a technological landscape, the critique of the reification of science and technology, and the aesthetics of medical technology. There were also some narrative interests in science fiction as the Belgrade Hand was used as a prop in a sci-fi film from the '70s. This naturally bled into my following project *Things to Come*. Named after a 1936 sci-fi film, the work set out to explore the history and development of technology through a gender-conscious lens. I ended up commissioning a series of 3-D models of different technological devices mostly from sci-fi cinema, like the Med Pod from *Prometheus* and the Power Loader from *Alien,* and printing them on oversized transparent foils.

JONES: Photography went from being ephemeral to sculptural, video did the same, even performance art. I used to get upset about the "re-objectification" of ephemeral art forms, but now I see it as really truly reflective of our culture. Because you both navigate this territory in such conscious and thoughtful ways, could you maybe speak to how and why you developed this way of working? Oliver, I'm thinking about some of your newer work with 3-D scans where you're literally recreating objects through digital means. Or Aleks, your paper-stack sculptures have made a domain an object.

LARIC: At first I was only showing work on my website, which lent itself well to videos. My interest in making sculptures came with the opportunities to show in physical spaces. Both manifestations are essentially the same work. I'm curious to see an idea morph into different forms. There are some interesting formats that are still underutilized, such as the elevator pitch or the ring tone.

In many cases it's more interesting for me to produce the tools than to produce the work itself. Ideally someone who I don't know and who doesn't know

Aleksandra Domanović, *Mayura Mudra*, 2013.
Laser-sintered PA plastic, polyurethane,
Soft-Touch & brass finish, printed acrylic glass,
61 ⅞ × 11 ⅞ × 11 ⅞ in (157 × 30 × 30 cm).
Courtesy the artist and Tanya Leighton Gallery,
Berlin. Photo: Gunter Lepkowski

me discovers the tools and finds purpose in their use. When I removed the background from a Mariah Carey video to enable a modification of the video, most responses were by fans who would probably care less that an artist did about the technical preparation and facilitation for the videos. In a manner similar to "Lincoln 3D Scans" (2012–ongoing), I assume that the majority of the users downloading the 3-D models are primarily interested in the models, not the story of how they became available. There is simply a need for cheap or free 3-D models without any copyright restrictions. Some of the models have been downloaded over twenty thousand times to date, and I keep encountering them randomly. They don't necessarily remain ephemeral as many have been 3-D printed.

DOMANOVIĆ: Honestly, I probably wouldn't have become an artist if there were no internet. It was a springboard for me. But working online also had its limitations. When I made the first paper stacks, the .yu domain just got abolished from the internet and I was thinking a lot about digital-born content and what happens to it in the long run. The stacks exist in two manifestations, the PDF document and a physical sculpture—the stack of paper with images on the sides. I wanted to have something that I could just email to a gallery and they would then print it out, or anyone could create from the internet. It was never an ideological choice to work online, it just happened, the same way that I now enjoy making physical objects.

JONES: There is this moment when a "new medium" becomes "just another medium." Or as Olia stated, when a new medium becomes a mass medium. It does seem like that is where we are. The radical societal shifts that the internet has ushered in are not a novelty, they are totally normalized. Your work, and the work of others that we've talked about, reflect this sense of new normality.

LARIC: It's possible to make 3-D prints about 3-D printing, but I instead use the technology as just another tool. It would be nice to make videos that work in PAL, HD, 4K, 8K, 16K, and in whatever resolution or logic will follow. That's why I'm drawn to the vector. It's without scale. It can be continuously updated, enlarged, and modified.

DOMANOVIĆ: What I enjoy about this situation is that now I can have conversations with my mom about where she streams her TV series from. Before, I had to download them for her. Many more people can join the conversation. I see the internet, and, more broadly, digital culture, as much more than a medium, because it encompasses everything.

Oliver Laric, *Yuanmingyuan 3D Scans*,
2014. Digital 3-D print, 7 ½ × 2 ¾ × 14 ½ in
(19 × 16.8 × 37 cm). Courtesy the artist;
Tanya Leighton Gallery, Berlin; and
Seventeen, London

Aleksandra Domanović, *Things to Come*,
2014. Installation view: Gallery of Modern Art,
Glasgow International. Courtesy the artist
and Glasgow International. Photo: Alan McAtee

Aleksandra Domanović and Oliver Laric are artists based in Berlin who work together collaboratively and also maintain individual practices. This interview, which took place over email during the summer of 2014, was commissioned for the present volume.

NOTES

1. Olia Lialina, "Net Art Generations," Teleportacia, Nov. 19, 2013, <http://art.teleportacia.org/observation/net_art_generations/>.

2. Ibid.

Paul Slocum

My background was originally in computer programming and music, but in 2003, curators started putting some of my technology projects in art shows, and I began to become part of the new media art scene. Some of the first events I was involved with were the Readme festival (2005), which I was invited to by Alexei Shulgin, and a performance and exhibition with Cory Arcangel at Flux Factory in New York (2003)—there were many others over the next few years. During this time, Lauren Gray and I were performing as Tree Wave, an 8-bit audio/video performance group for which I developed custom software for obsolete computers.

In 2006, Lauren had the idea to open a gallery, and I quickly became involved as it ramped up. We were inspired by spaces in the US and Europe where we had performed that were working in a DIY way to make shows happen, and from the beginning we wanted to have both exhibitions and performances. Dallas had an active art scene when we started, but there was nobody else in the city showing the kind of electronic or new media work I was interested in, so there was little competition for shows. Since Dallas is a major technology hub (Texas Instruments is one of the best-known companies based there, and there's a lot of military contracting), there was an audience that came to us that might not have been going to other galleries.

At the time, we were one of the few spaces in the US with the equipment and expertise to exhibit new media artwork. Exhibiting work created using the internet and evolving computer technologies presented complex problems related to visual fidelity, and many additional practical problems of placing the work in the gallery. In the process of working through these issues, we developed new methods for archiving and displaying new media artwork. At that time, I had personally seen little internet-based work shown in museums or galleries, and

so we had to improvise as we went along. For example, in our very first show we wanted to exhibit Tom Moody's blog as an artwork, so we took screen recordings of his website and showed it off as a looped DVD, which seemed like the most stable arrangement.

We did a more complicated version of this process for a show with Dragan Espenschied and Olia Lialina in order to exhibit *Olia's and Dragan's Comparative History of Classic Animated GIFs and Glitter Graphics* (2007), which was a series of animated GIF diptychs. Getting the best quality transfers took some ingenuity, because my computers were too slow to record the screen without losing frames. I slowed down each GIF to one-tenth of the original speed, recorded the video at that slower rate, and then sped up the video ten times to create the exhibition copies. We had a wide range of mediums and installation challenges, from the hacked video games of Cory Arcangel, Paper Rad, and JODI, to Petra Cortright's YouTube videos and Arcángel Constantini's electromechanical devices. We showed moving images on many display devices, including vintage cathode-ray tube televisions and computer monitors, various LCD screens, projection TVs, travel DVD players, and PalmPilots.

For our two-part exhibition of Kristin Lucas's work, we had a contemplative installation in the front gallery, including video, light box prints, cast rocks and monitors, and laser cut comets. In the second gallery, we showed Kristin's *Refresh* project (2007), where she legally changed her name from Kristin Sue Lucas to Kristin Sue Lucas (the same name) as a kind of reawakening, and the "Before and After" show (2008), where she asked colleagues to produce portraits of her, before and after her name change. For a show that we did with Kevin Bewersdorf and Guthrie Lonergan, Kevin had beach towels, pillows, mouse pads, and coasters onto which he had printed Google search results for things like "pain," "Woodstock," or "Titanic" through Walgreens's online store. Guthrie also worked with stock options of a different kind: his video *Artist Looking at Camera* (2006) compiled clips of visual artists smiling into the camera, all sourced from Getty Images' archive—as they weren't paid for, all of the clips featured Getty's watermark prominently.

"Show #22: YTMND" in March 2009 is one of the most unusual exhibitions the gallery put together. The subject of the show was the online video-sharing community YTMND, curated by myself, but without the active participation of YTMND members. YTMND is a web community, based at ytmnd.com, that reached peak popularity between 2004 and 2007 for creating and sharing early memes in a very specific and simple format: minimal one-page websites that consist of a single image or animation file (often tiled), a short sound loop, and up to three lines of large zoomed text. It had grown to about five hundred

thousand sites by the time we did the show. A brief essay that Guthrie Lonergan wrote for the show captures the sensibility of YTMND really well; he argues for YTMND's "simplicity and elegance" and says "its 'singular focus' format is as sharp as any cultural appropriation in the art world."[1]

Despite the minimal nature of the YTMND aesthetic, it was a technically difficult show. We chose around fifty YTMND sites, and I needed to show almost all of them off of computers, rather than converting them to DVD as we done before, because it was the only way to maintain the resolution of the images. Affordable HD video players were only first becoming available at that time. Although the crowdsourced nature of the exhibition was unprecedented, the exhibition ended up having similarities in look and comic tone to the printed internet images and remixed internet videos of Kevin Bewersdorf and Guthrie Lonergan that we had exhibited previously.

We represented ten artists as a commercial gallery, including JODI, John Michael Boling, Javier Morales, Kevin Bewersdorf, Petra Cortright, Guthrie Lonergan, Dragan Espenschied, and Olia Lialina. Most of these artists had no representation in the US, or anywhere—which at the time really just meant putting their names on the website. We mostly sold things as small-run editions; this involved a contract and two copies of the piece (one for exhibition and one for backup and archiving), usually on DVD, either as data or video depending on the work. We actually had very few collectors, though the ones we had were loyal. The capital that I used to fund the shows largely derived from residuals I earned from writing music for cell phone commercials, and most of that money was later recouped through sales, almost all of which were made through images and videos on our website without the collectors ever visiting the gallery. The first time a collector emailed us about buying work, I thought it was probably a cashier's check scam, but that person ended up being our biggest supporter.

The gallery's physical space closed in 2009, and I moved to New York later that year. The gallery is still functioning in that I am actively working toward placing artwork from the gallery artists into archives and collections, and I update the existing gallery editions as necessary for new video and computer formats. I also have been working on plans to eventually relaunch it in some form as a space, maybe here in New York, or elsewhere. Many of the artists still don't have representation otherwise, so the need is still there.

And/Or Gallery operated in Dallas, Texas, from 2006 to 2009 and showed contemporary art with an emphasis on new media.

NOTES

1. Guthrie Lonergan, "Picture. Sound. Text.," And/Or Gallery (March 2009), <http://www.andorgallery.com/shows/22.html> (accessed Sept. 9, 2014).

"Show #22: YTMND," 2009. Exhibition view:
And/Or Gallery, Dallas. From left:
MercenaryFoxMcCloud, tomahawk.ytmnd
.com, 2006; prairiedogeric10,
rrrrrrrrrrrrrrrrrrrrrr.ytmnd.com, nd;
Netmaster, pencollection.ytmnd.com, 2006;
SlidersRox, holidaysarecoming.ytmnd.com,
2006; thepizzaboy, holybridge.ytmnd.com, 2007;
Inkdrinker, picturesoundtext.ytmnd.com,
2005. Courtesy And/Or Gallery

"Show #22: YTMND," 2009. Exhibition view: And/Or Gallery, Dallas. From left: Max Goldberg, www.yourethemannowdog.com, 2001; various YTMND users and Paul Slocum, YTMND print, 2009. Courtesy And/Or Gallery

Installing "Show #17: Cory Arcangel + Olia Lialina and Dragan Espenschied," And/Or Gallery, Dallas, 2008. From left: Michelle Proksell, Paul Slocum. Courtesy Cory Arcangel

Installing "Show #17: Cory Arcangel + Olia Lialina and Dragan Espenschied," And/Or Gallery, Dallas, 2008. From left: Dragan Espenschied, Olia Lialina, Kevin Bewersdorf. Courtesy Cory Arcangel

Back room of And/Or Gallery during installation
of "Show #17: Cory Arcangel + Olia Lialina
and Dragan Espenschied," 2008. From left: Cory
Arcangel, Dragan Espenschied, Olia Lialina, Kevin
Bewersdorf. Courtesy Michelle Proksell

Dragan Espenschied and Olia Lialina, *Olia's and
Dragan's Comparative History of Classic Animated
GIFs and Glitter Graphics*, 2007. Installation
view: "Show #17: Cory Arcangel + Olia Lialina
and Dragan Espenschied," And/Or Gallery, Dallas,
2007. Courtesy And/Or Gallery

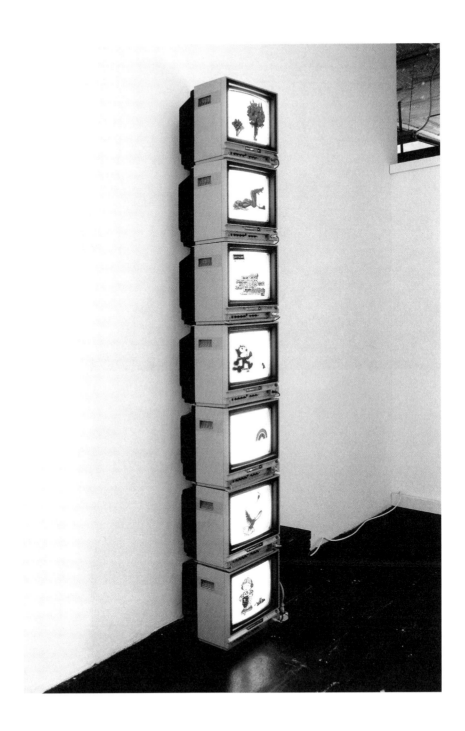

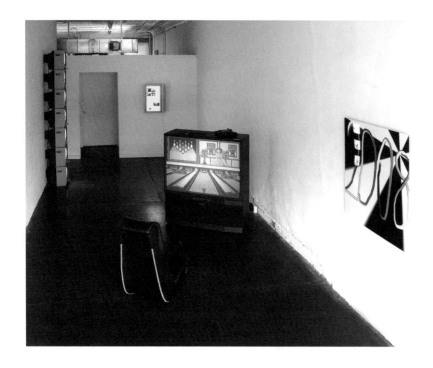

"Show #17: Cory Arcangel + Olia Lialina and
Dragan Espenschied," 2008. Exhibition view:
And/Or Gallery, Dallas. From left: Dragan
Espenschied and Olia Lialina, *Olia's and Dragan's
Comparative History of Classic Animated GIFs
and Glitter Graphics*, 2007; Dragan Espenschied
and Olia Lialina, *Online Newspapers: New York
Edition*, 2008; Cory Arcangel, *Beat the Champ
(Sega Genesis Championship Bowling: Dana)*,
2008; Cory Arcangel, *Photoshop Gradient and
Smudge Tool Demonstration #25*, 2008. Courtesy
And/Or Gallery

Dragan Espenschied and Olia Lialina, *Blingees*,
2007. Installation view: "Show #17: Cory Arcangel
+ Olia Lialina and Dragan Espenschied," And/Or
Gallery, Dallas, 2007. Courtesy And/Or Gallery

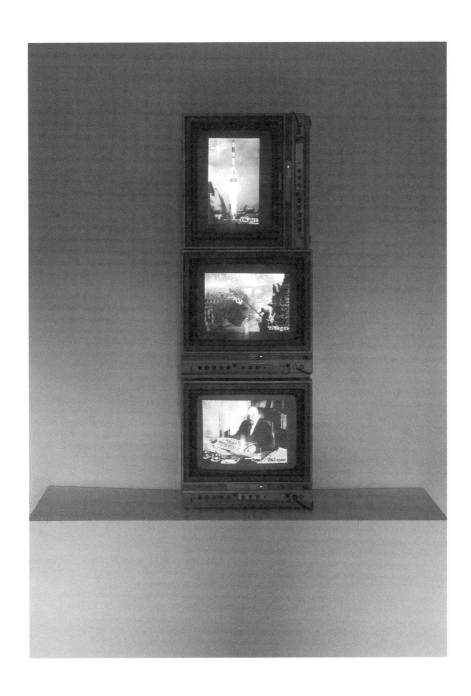

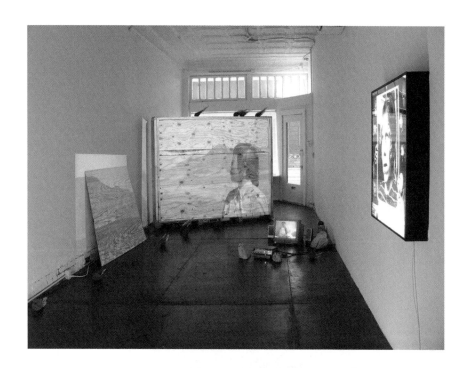

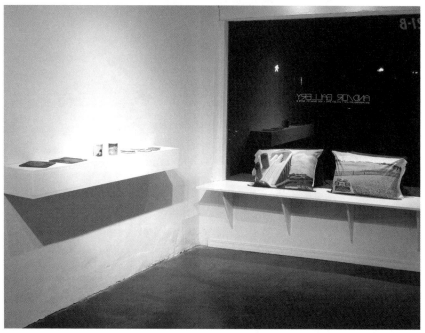

A BRIEF HISTORY OF AND/OR GALLERY

"Show #14: Kristin Lucas," 2008. Exhibition view: And/Or Gallery, Dallas. Works by Kristin Lucas, from left: *Whatever Your Mind Can Conceive*, 2007; *Travel Advisory*, 2007. Courtesy And/Or Gallery

"Show #12: Kevin Bewersdorf + Guthrie Lonergan," 2007. Exhibition view: And/Or Gallery, Dallas. Works by Kevin Bewersdorf, from left: *Google image search results for "pain" printed onto mouse pads by Walgreens.com*, 2007; *Life Mug 1&2*, 2007; *Six various Google image search results printed onto coasters by Walgreens.com*, 2007; *Google image search results for "Titanic" printed on pillowcase by Walgreens.com*, 2007; *Google image search results for "Woodstock" printed on pillowcase by Walgreens.com*, 2007. Courtesy And/Or Gallery

"Show #12: Kevin Bewersdorf + Guthrie Lonergan," 2007. Exhibition view: And/Or Gallery, Dallas. From left: Kevin Bewersdorf, *MaxXimuM Sorrow throw rug*, 2007; Guthrie Lonergan, *Bricks*, 2007; Kevin Bewersdorf, *Commemorative Obelisk*, 2007; Guthrie Lonergan, *2001<<<>>>2006*, 2007; Guthrie Lonergan, *Domain, 2007*; Guthrie Lonergan, *Artist Looking at Camera*, 2006. Courtesy And/Or Gallery

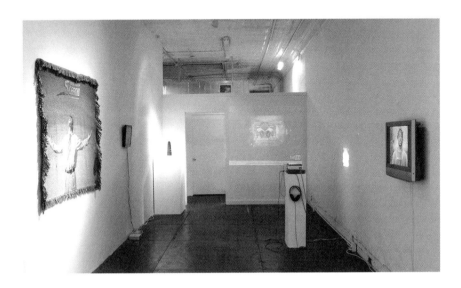

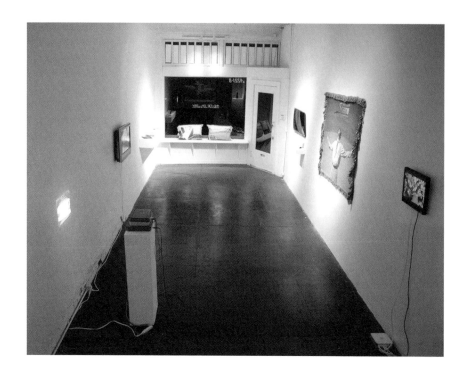

"Show #12: Kevin Bewersdorf + Guthrie Lonergan,"
2007. Exhibition view: And/Or Gallery, Dallas.
From left: Guthrie Lonergan, *Domain*, 2007;
Guthrie Lonergan, *Artist Looking at Camera*, 2006;
Kevin Bewersdorf, *Google image search results for
"pain" printed onto mouse pads by Walgreens.com*,
2007; Kevin Bewersdorf, *Life Mug 1&2*, 2007;
Kevin Bewersdorf, *Six various Google image search
results printed onto coasters by Walgreens
.com*, 2007; Kevin Bewersdorf, *Google image
search results for "Titanic" printed on pillowcase
by Walgreens.com*, 2007; Kevin Bewersdorf,
*Google image search results for "Woodstock" printed
on pillowcase by Walgreens.com*, 2007; Kevin
Bewersdorf, *Calvin peeing on Suffering*, 2007;
Kevin Bewersdorf, *MaxXimuM Sorrow throw rug*,
2007; Guthrie Lonergan, *Bricks*, 2007. Courtesy
And/Or Gallery

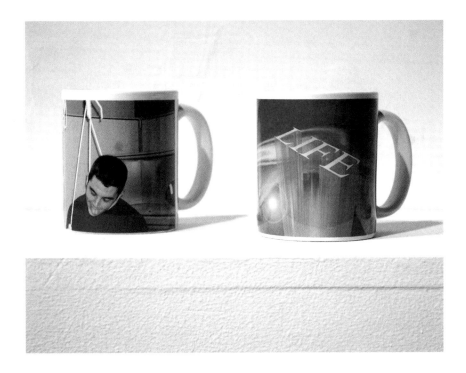

Kevin Bewersdorf, *Life Mug 1&2*, 2007.
Installation view: "Show #12: Kevin Bewersdorf +
Guthrie Lonergan," And/Or Gallery, Dallas,
2007. Courtesy And/Or Gallery

"Show #12: Kevin Bewersdorf + Guthrie Lonergan,"
2007. Exhibition view: And/Or Gallery, Dallas.
From left: Kevin Bewersdorf, *Google image
search results for "pain" printed onto mouse pads
by Walgreens.com*, 2007; Kevin Bewersdorf, *Life
Mug 1&2*, 2007; Kevin Bewersdorf, *Six various
Google image search results printed onto coasters by
Walgreens.com*, 2007. Courtesy And/Or Gallery

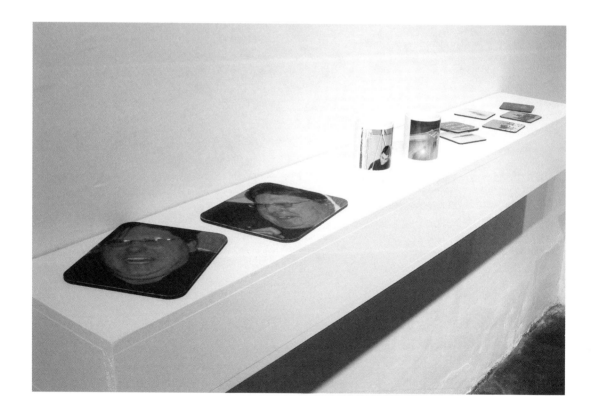

A BRIEF HISTORY OF AND/OR GALLERY

Kevin Bewersdorf, *Google image search results for*
"Titanic" printed on pillowcase by Walgreens.com,
2007. Installation view: "Show #12: Kevin
Bewersdorf + Guthrie Lonergan," And/Or Gallery,
Dallas, 2007. Courtesy And/Or Gallery

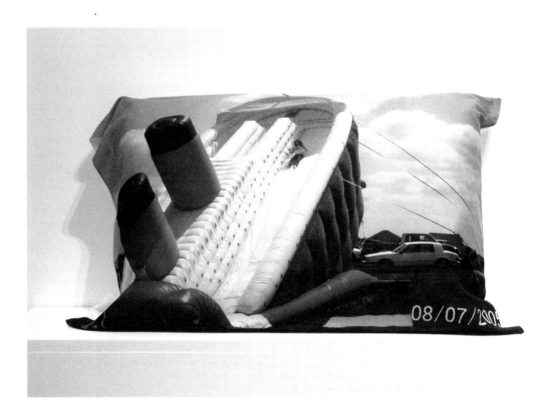

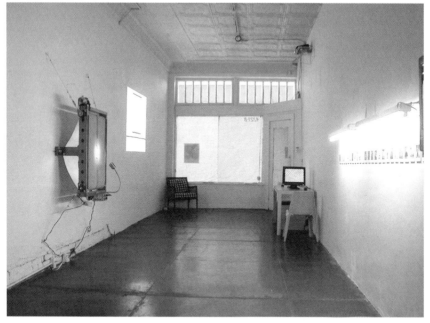

A BRIEF HISTORY OF AND/OR GALLERY

"Show #9: JODI + Arcángel Constantini," 2007.
Exhibition view: And/Or Gallery, Dallas. From
left: JODI, Untitled, 1998; Arcángel Constantini,
SX-70 Polaroids, 2000; Arcángel Constantini,
Zi-Re-Filme, 2006; Arcángel Constantini,
Semimscope, 2005. Courtesy And/Or Gallery

"Show #9: JODI + Arcángel Constantini," 2007.
Exhibition view: And/Or Gallery, Dallas. From
left: Arcángel Constantini, *Semimscope*, 2005;
JODI, *BCD*, 2000; JODI, Untitled, 1998;
Arcángel Constantini, *SX-70 Polaroids*, 2000.
Courtesy And/Or Gallery

Arcángel Constantini, *Zi-Re-Filme*, 2006.
Installation view: "Show #9: JODI + Arcángel
Constantini," And/Or Gallery, Dallas, 2007.
Courtesy And/Or Gallery

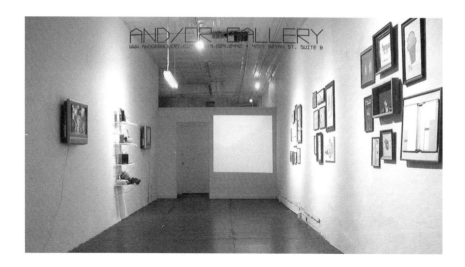

"Show #8: Chad Hopper + John Michael Boling and Javier Morales," 2007. Exhibition view: And/Or Gallery, Dallas. From left: John Michael Boling and Javier Morales, *Body Magic*, 2006; Chad Hopper, various sculptures, 2007; John Michael Boling and Javier Morales, *The Church of the Future*, 2006; John Michael Boling, *Untitled GIF*, 2006; Chad Hopper, various mixed media pieces, 2007. Courtesy And/Or Gallery.

"Show #2: Paper Rad with Cory Arcangel + Chad Hopper," 2006. Exhibition view: And/Or Gallery, Dallas. From left: Chad Hopper, various mixed media pieces, 2005–06; Paper Rad and Cory Arcangel, *Super Mario Movie*, 2005; Paper Rad and Ben Jones, *Facemaker*, 2005; Paper Rad and Cory Arcangel, *Ever Danced With Garf?*, 2004. Courtesy And/Or Gallery

Paper Rad, *Video Comic*, 2004. Installation view: "Show #2: Paper Rad with Cory Arcangel + Chad Hopper," And/Or Gallery, Dallas, 2006. Courtesy And/Or Gallery

A BRIEF HISTORY OF AND/OR GALLERY

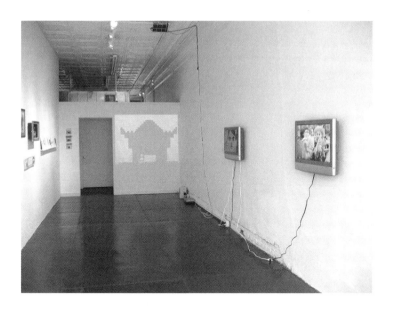

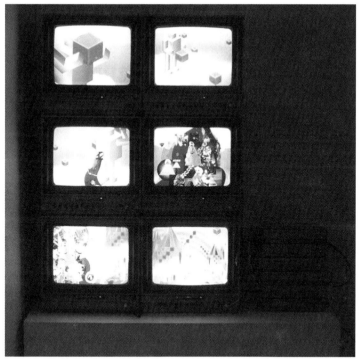

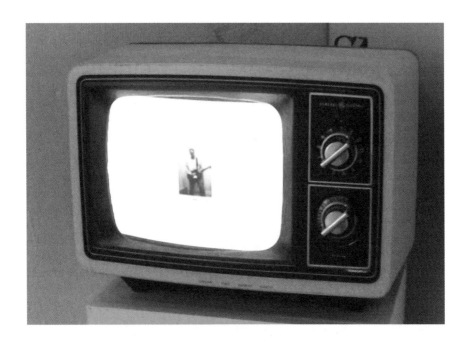

Tom Moody, *Guitar Solo*, 2006. Installation view:
"Show #1: Tom Moody + Saskia Jorda," And/Or
Gallery, Dallas, 2007. Courtesy And/Or Gallery

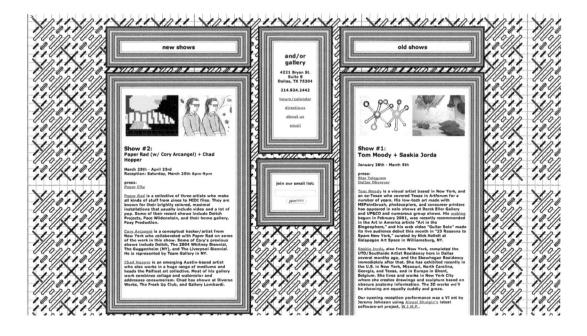

And/Or Gallery website homepage
(screen capture). Archived webpage from 2006.
Courtesy And/Or Gallery

INTERNET EXPLORERS

Ceci Moss

I'm still wondering if the Internet is a representational medium, or whether it will be more about having an experience. Probably the Internet will seem to disappear because of its growing transparency and ubiquity. Then 'Internet artists' will gradually be perceived as 'artists.'
—Harm van den Dorpel, "Interview with Harm van den Dorpel on Club Internet's 'Free Fall,'" Rhizome, October 17, 2008

Within the first ten years of the 2000s, the media landscape underwent a tremendous shift. The internet, in particular, drifted far beyond the screen and the stationary computer work station, finding its way into every aspect of our lives, a process accelerated by advances such as faster bandwidths, smart phones, and social media.

The following brief timeline of product launches is illustrative: 2002, Friendster; 2003, Myspace; 2004, Facebook; 2005, YouTube; 2006, Twitter; 2007, iPhone and Tumblr. An increasingly mobile, networked world arose alongside these developments, resulting in a new phase for contemporary art, one that witnessed artistic practices becoming more fluid, elastic, dispersed, and expanded. Internet artists began to make art *about* informational culture using various online and offline means, no longer determining their practice solely by an online existence. This essay examines a micro-history, from roughly 2005 to 2010, in which an international network of artists, many of them millennials, working on the internet turned their focus to mainstream user-generated content as a form of popular culture following the rise of social media. This anthropological approach to the popular culture of social media subsequently developed into a larger desire to excavate the web's involvement in the everyday, at a moment

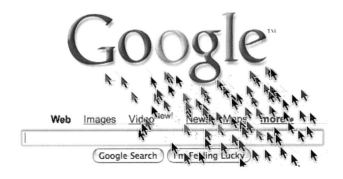

John Michael Boling, *Lord of the Flies*, 2006 (still).
Web-based video. Courtesy the artist

when the internet became more mobile and integrated into daily life. Turning to art practices (such as surf clubs, or artist-run, collaboratively authored blogs for artistic experimentation) and artist-run curatorial platforms active during this short, rapidly paced period, this essay will elaborate a perspective in which self-identified "internet-based artists" simply became "contemporary artists" engaged with a thoroughly informational world and milieu.

The introduction of social media opened the gates for an explosion of user content online. Artists, drawn to the cultural relevance of this material, began to sift, navigate, and respond to everything from Yahoo! Answers to Myspace introductions. During this same period, the experience of browsing became dramatically more self-customized and streamlined, guided by the links shared on one's own social networks, RSS feeds, and Twitter subscriptions, as well as a continually optimized, personalized search. The collaboratively produced artist-run blogs known as surf clubs became a way for artists to develop a visual vocabulary

in conversation, to share the fruits of their searches, and to experiment with those findings in the form of blog posts. Exploring the diverse ephemera of web culture, contributors to these surf clubs created a visual dialogue, scrapbook, and archive of their discoveries online alongside their own creations, such as found YouTube videos and animated GIFs.

In 2006, curator Lauren Cornell organized an online exhibition for Rhizome entitled "Professional Surfer," thus coining the term in a project that boldly considered web browsing an art form, and assembled a few of these websites as works in themselves. The artists/bloggers behind exhibited projects like Supercentral, Cosmic Disciple, Nasty Nets, and Chillsesh—such as Kevin Bewersdorf, Marisa Olson, Joel Holmberg, Guthrie Lonergan, Charles Broskoski, John Michael Boling, Chris Coy, Michael Bell-Smith, and Travis Hallenbeck—approached massive user output like an amateur ethnographer or anthropologist, interpreting this content through a lens cognizant of its cultural weight. A single post to Nasty Nets, for example, often generated a flood of posts and related imagery by its members, such as Michael Bell-Smith's "The post where … we share awesome gradients," which collected animated gradients from all over the web, or Guthrie Lonergan's suite of YouTube videos of users demoing the opening and closing of garage doors. Posts such as these were attempts to draw attention to the artistic merit and value of user content, from the weird to the banal. Another work in the "Professional Surfer" exhibition *Lord of the Flies* (2006) by Nasty Nets member John Michael Boling, but hosted on his own website 53 o's, loops a video depicting an anxious swarm of mouse pointers hovering over the Google search page as a low-fi midi version of the *Twin Peaks* theme song plays. As goofy as it is ominous, the work gets at the underlying desire for information driving the millions of users searching the web every day.

Surf clubs championed the idea that searching was equivalent to making, a form of craft. Artist Kevin Bewersdorf, with the launch of the surf club Spirit Surfers with Paul Slocum in 2007, aimed to push the findings associated with searching into something more significant by reflecting on the spiritual and psychological space of the web. In the *Spirit Surfing* manifesto, he states: "Perhaps finding is making, but finding is not enough."[1] Envisioning his posts as "jewels publicly removed and reset,"[2] Bewersdorf sought to elevate the act of web surfing, and his findings, into something greater—a pathway to a spiritual realm. The quasi-spiritual aspect of the blog was set against the deeply commercial space of the web, and the reality that users produced and consumed content. While others used the web for shopping and entertainment—a group of people Bewersdorf termed "INFObrats"—some turned their attention to the "boons" and "wakes" of the surf, not as customers but as "INFOmonks" who lose themselves in the

infinite horizon of information, or the "INFOspirit." The power was in Spirit Surfers' intention and in the care behind the framing of the group's finds, a gesture that Bewersdorf compared to Joseph Cornell's boxes. While other surf clubs took content found online out of orbit and into a sort of détournement, indexed and cataloged within the context of the blog, Bewersdorf aimed to assemble his finds like beads on a prayer necklace. Bewersdorf asks, What does a surfer seek, what does it mean to find, and what can a frame do?

The "professional surfers" of this period participated in a type of reframing, and reorganization, of their finds, activities informed by the software that regulated these experiences. As users blindly or expertly navigated the web, populating it with comments, animated GIFs, or mash-ups, artists teased out and picked up on their interaction with software, especially its automatic settings, or defaults. In his 2009 text for Rhizome, "After the Amateur: Notes," Ed Halter argues that internet artists absorbing or mirroring mass user-generated content in their work present a different turn, that of the "sub-amateur."[3] Halter was particularly interested in the status of the "amateur" practitioner and how artists have assimilated such a designation over time, from avant-garde cinema to art photography. Unlike the amateur photographer in decades past who aspired toward professionalism, the user is interested in the pure and immediate functionality of his tools, often realized through defaults. Internet artists responding to the user or "sub-amateur" prefer function over form, favoring the "raw instrumentality" of images. For example, Halter points to Petra Cortright's *VVEBCAM* (2007), which features the artist staring blankly at the camera while activating a series of default effects that crowd the screen, such as dancing pizza slices and lightning. The artist's concentrated expression contrasts with the lighthearted nature of the animations, an effect that is both humorous and disarming. As Halter argues, artists like Cortright are specifically attentive to software's functions, a move that draws up the vocabulary and register of these functions as absorbed by the web's mass audience.

While Halter's essay is specifically concerned with how artists adopt the amateur vernacular on the web, his attention to defaults in the essay touches on software's widespread influence on culture itself, the subject of Lev Manovich's 2013 book *Software Takes Command*. Here Manovich argues that the computer's permanent extendibility through software disrupts "medium" by transferring the techniques and interfaces of *all* previous media technologies to software.[4] Drawing a comparison to ecology, Manovich argues that media techniques start acting like a species in shared software environments, interacting, mutating, and making hybrids of themselves.[5] This, in turn, influences how and what users can create in endless combinations, translating software into culture. Manovich's

Marcin Ramocki for Spirit Surfers, *blue explosion*, 2008 (screen capture). Animated GIF. Courtesy the artist

observations on user behavior in *Software Takes Command* in some ways sets the stage for the artistic shifts that occurred in the mid-2000s. While the book focused on how programmers and users were creatively producing or hybridizing new software, many of the internet artists working in the mid-2000s were in turn concentrating on how users navigated these platforms, the default being one example. Some artists—like Ryder Ripps—started programming their own platforms, taking the concept of a surf club in a new direction. Ripps's 2009 project dump.fm is a visual chat room that allows participants to share images from the web, their hard drive, or web cam instantly. As Ripps stated in a blog post for Rhizome, "Dump.fm is a place where content is hyper-transient and used to facilitate connections and induce creativity."[6] More ephemeral, fast-paced, and unwieldy than the standard blog format of a surf club, dump.fm has cultivated a community through visual conversation. In many ways, surf clubs foreshadowed the popular blogging platform Tumblr, which, by the 2010s, became a key part of mainstream web culture as speaking through and with images became a new norm.

Parallel to the surf clubs, a number of compelling artist-initiated online curatorial projects surfaced during the period of 2005 to 2010 that, through selected themes and custom formats, pondered the psychological and philosophical impact of informational overload. These projects were attentive to the drift-like experience of surfing the web and were engineered to complement that environment. From 2008 to 2009, artist Harm van den Dorpel organized exhibitions for Club Internet around loose themes, often with fifteen or more artists. The rotating exhibitions functioned like a surf club in that van den Dorpel viewed exhibiting artists as "members"; however, the site itself was designed as an online gallery, not a blog. These busy, populous shows invited the user to float through the exhibition; for instance "Tag Team," curated by Guthrie Lonergan, riffed on the surf club by asking artists to submit "non-art" links, while in "Reverse Engineering: the Uncurated Reunion," members of Club Internet were asked by van den Dorpel to create a new work on the spot and within a four-hour time frame. The curatorial platform of artists Parker Ito and Caitlin Denny, JstChillin (which operates under the tagline "real without being actual, ideal without being abstract. Time doesn't exist when you're...jstchillin!"), focused the user's attention through bimonthly rotations of single online artworks that reflected on the time and space of the web environment from 2009 to 2011. In lieu of a manifesto or mission statement, Ito and Denny recorded and looped an Instant Messenger conversation titled "An Essay about Chillin'," time-stamped at 3:25 a.m., which considers the metaphysics of web surfing. Accompanied by a choral soundtrack, Ito makes the observation that: "The net is all around us,

an indescribable feeling, soaring, tumbling, freewheeling, through an endless diamond sky." Exemplifying this sense of free-floating space is Mitch Trale's otherworldly virtual environment *Analog Environments* (2009) or Michelle Ceja's *Silicon Velocity* (2009), with its looped, roller coaster–like descent—presented full screen—into a gridded tube. Jacob Broms Engblom and Ryder Ripps's *Stop Internet Time (The Eternal Chill Online)* (2009) is more explicitly contemplative; the website features a video of a slowly melting ice cube next to an animated GIF of hands outstretched whose search button promises to "sooth." A voiceover declares: "The internet is like a well, used but never used up, it is like the eternal void, filled with infinite possibilities."

If Jstchillin contemplated the realities of time spent together online, artists Mark Brown and Kari Altmann's curatorial platform *Netmares/Netdreams* (2007–09) seemed to mine the web's dark subconscious, pointing toward collective fantasies. Begun originally as two separate image blogs—"Netmares" and "Netdreams"—the project developed into a more formal curatorial platform that allowed users to scroll through a curated selection of artworks that seemed to hold together through dream logic. Exhibitions were mysterious; stripped of a descriptive introduction, the artworks were linked in the navigation bar by letter Zs, which would gradually fade in and out. The works themselves were equally cryptic. For example, Damon Zucconi's *Shining (Ghost)* (2006)—which was included in the online exhibition "v 2.0" in 2008 —features an obscured figure in white set in a white room with a strobe light flickering along to an ecstatic techno track; presented in the same rotation was Nathan Hauenstein's animation *Pillars* (2008), which depicts two totem poles advancing and retreating into a black abyss. In an interview with Brian Droitcour for Rhizome, in which Droitcour makes the observation that *Netmares/Netdreams* almost functions as a larger, layered work unto itself, Altmann notes in response that all artworks are increasingly operating as an open structure, stating, "As we've expanded our view of the relationships and voids between everything from databases or networks to dataclouds and holograms, we've arrived at a better realization of the virtual and physical properties inherent in everything. Everything becomes matter, energy, and representation, and is connected to everything else."[7] The dreams and nightmares illuminated in *Netmares/Netdreams* might indicate a collective consciousness or groupthink, but as Altmann suggests, there's a greater, scalable connection holding everything together.

Altmann's observations articulate a perspective that became more widespread during this period, namely that the internet, far from being an isolated medium, was in fact a powerful force filtered into every aspect of life. For many of the same artists within the "professional surfer" cohort, the internet was seen

Ryder Ripps and Jacob Broms Englom, *Stop
Internet Time (The Eternal Chill Online)*, 2009.
Web-based project from Jstchillin.org, October
2009–February 2011. Courtesy the artists

not as the sole platform for the production of a work, but instead as a crucial nexus around which to research, assemble, transmit, and present data, both online and offline. In an often-quoted Rhizome interview from 2008, internet artist and Nasty Nets member Guthrie Lonergan described a move in his practice toward "Internet Aware Art" by saying:

> I'm scheming how to take the emphasis off of the Internet and technology, but keep my ideas intact. Objects that aren't objects. I got a couple of books and a t-shirt in the works. Right now I'm really into text (not visually/typography…just…text…), and lots and lots of lists…. "Internet Aware Art."[8]

Lonergan's statement regarding "Internet Aware Art" can best be understood as works that depend on the internet for their transmission and, in some instances, reflect on that process itself, but do not need to reside completely within that environment, and often go offline. A few weeks after Lonergan's interview was published on Rhizome, artist and Nasty Nets member Marisa Olson echoed a similar shift in an interview with *we make money not art* blogger Regine Debatty, stating:

> There doesn't seem to be a need to distinguish, any more, whether technology was used in making the work—after all, everything is a technology, and everyone uses technology to do everything. What is even more interesting is the way in which people are starting to make what I've called "Post-Internet" art in my own work (such as my *Monitor Tracings*), or what Guthrie Lonergan recently called "Internet Aware Art." I think it's important to address the impacts of the internet on culture at large, and this can be done well on networks but can and should also exist offline. Of course, it's an exciting challenge to explain to someone how this is still internet art…. If that really matters.[9]

For artists and curators at the time, these two interviews expressed a change in how internet artists were approaching their practice in a way that resonated strongly within the community. Under the designation postinternet or internet aware, internet art was not required to be online, but rather referred to art enmeshed within an informational culture, online and off.

The capture and transmission of digital information is now a defining characteristic of our environment, a fact that is apparent all around us, in everything from car design to ATM machines. All art regardless of medium becomes, on some

level, legible as data to computers and a network. Theorist Benjamin Bratton describes the omnipresence of this informational reality as "The Stack," explaining:

> Instead of viewing the various scales of emergent ubiquitous computing technologies as a haphazard collection of individual processes, devices and standards (RFID, cloud storage, augmented reality, smart cities, conflict minerals, etc.), it is more illuminating to model them as components of a larger, comprehensive, meta-technology. The Stack is planetary-scale computation understood as a megastructure. The term "stack" is borrowed from the TCP/IP or OSI layered model of distributed network architecture. At the scale of planetary computation, The Stack is comprised of 7 interdependent layers: Earth, Cloud, City, Network, Address, Interface, User. In this, it is an attempt to conceive of the technical and geopolitical structures of planetary computation as a "totality."[10]

Software is one through-line and mechanism within The Stack, but computation as a whole is shifting everything around us. Given this complex contemporary reality, terminology that references internet artists moving offline suggests much more than internet artists simply making objects, but rather indicates how artists engage the widespread epistemological and ontological change due to the rise of a deeply informational culture.

..

This essay was commissioned in 2014 for the present volume.

..

NOTES

1. Kevin Bewersdorf, *Spirit Surfing* (Brescia: LINK Editions, 2011), 24.

2. Ibid., 23.

3. Ed Halter, "After the Amateur: Notes," Rhizome, April 29, 2009, <http://rhizome.org/editorial/2009/apr/29/after-the-amateur-notes/>.

4. Lev Manovich, *Software Takes Command* (New York: Bloomsbury Academic, 2013), 180.

5. Ibid., 164.

6. Ryder Ripps, "Introducing: Dump.fm," Rhizome, March 5, 2010, <http://rhizome.org/editorial/2010/mar/5/introducing-dumpfm/>.

7. Brian Droitcour, "Turn On, Tune In, Zoom Out: An Interview with Kari Altmann," Rhizome, March 13, 2009, < http://rhizome.org/editorial/2009/mar/13/turn-on-tune-in-zoom-out/>.

8. Thomas Beard, "Interview with Guthrie Lonergan," Rhizome, March 26, 2008, <http://rhizome.org/editorial/2008/mar/26/interview-with-guthrie-lonergan/>.

9. Regine Debatty, "Interview with Marisa Olson," *we make money not art*, March 28, 2008, <http://we-make-money-not-art.com/archives/2008/03/how-does-one-become-marisa.php>.

10. Metahaven, "The Cloud, the State, and the Stack: Metahaven in Conversation with Benjamin Bratton," Tumblr, December 16, 2012, <http://mthvn.tumblr.com/post/38098461078/thecloudthestateandthestack>.

LOST NOT FOUND: THE CIRCULATION
OF IMAGES IN DIGITAL VISUAL CULTURE

Marisa Olson

There is a strain of net.art referred to among its practitioners and those who follow it as "pro surfer" work. Characterized by a copy-and-paste aesthetic that revolves around the appropriation of web-based content in simultaneous celebration and critique of the internet and contemporary digital visual culture, this work—heavy on animated GIFs, YouTube remixes, and an embrace of old-school "dirt-style" web-design aesthetics—is beginning to find a place in the art world. But it has yet to benefit from substantial critical analysis. My aim here is to outline ways in which the work of pro surfers holds up to the vocabulary given to us by studies of photography and cinematic montage. I see this work as bearing a surface resemblance to the use of found photography while lending itself to close reading along the lines of film formalism. Ultimately, I will argue that the work of pro surfers transcends the art of found photography insofar as the act of finding is elevated to a performance in its own right, and the ways in which the images are appropriated distinguish this practice from one of quotation by taking them out of circulation and reinscribing them with new meaning and authority.

The phrase "pro surfer" originated with the founding in 2006 of Nasty Nets, an "internet surfing club," whose members are internet artists, offline artists, and web enthusiasts who were invited by the group's cofounders (of which I was one) to join them in posting to the Nasty Nets website materials they had found online. Many of the contributions were then remixed or arranged into larger compositions or "lists" of images bearing commonality. Soon a number of group "surf blogs" appeared around the net, including Supercentral, Double Happiness, Loshadka, and Spirit Surfers. All share some number of common members, social bonds, or stylistic affinities. There are also a number of "indie surfers" making similar work, some of whom will be mentioned here.

While the artists in this movement have at times debated whether or not they are truly part of a movement, and whether their posts (most of which take

the form of blog entries) are truly art or "something else," there have been a number of movement-like signs. In 2007, we had our own happening in the form of the Great Internet Sleepover—held at New York's Eyebeam and organized by Double Happiness cofounder Bennett Williamson—to which surfers flocked from as far as California, Utah, Wisconsin, Texas, Georgia, Virginia, Rhode Island, and elsewhere. Many pro surfer artists, on their own or in their respective collectives, are being curated into major museum exhibitions and film festivals. Despite such recognition, there have yet to be many significant essays on the movement, and the artists debate the need for anything resembling a manifesto, saying among themselves that they are waiting to hear interpretations from external, critical voices. So I am making a first stab here, knowing full well that I might wipe out.

If we are to consider pro surfer work in relationship to photographic media, we must begin with the concept of *circulation*—the ways in which the images are produced and exchanged, and their currency or value. The images that get appropriated on these sites are at times "cameraless" (i.e., created by software or other lensless tools that nonetheless aspire to optical perspective, typically follow normative compositional rules, and tend to index realism), while others are created with another being behind the aperture, only to be found and appropriated by a surfer. In their re-presentation in a different context—arguably a different economy—the images are taken out of circulation, often without attribution or a hint of origin, unless that is part of the story being told by the artist. Two Nasty Nets members programmed a web-based tool called Pic-See that makes it easier for internet users to plunder images archived in open directories. When the images are reused, they are positioned as quotations; yet authorial status is inscribed by the artist who posts them. Let's consider some examples.

Justin Kemp's *Pseudo Event* (2008) is an assemblage of photos taken at ribbon-cutting events, with each picture lining up perfectly so as to form a continuous red ribbon that stretches across the screen, requiring quite a bit of horizontal scrolling. Similarly, Guthrie Lonergan's *Internet Group Shot* (2006) gathers group photos found online (of teams, coworkers, families, etc.) and collages them together into a larger portrait. In some sense this is a group portrait of internet users. The image unfolds vertically, with the individual components rising up from the herd as one scrolls over. John Michael Boling's *Four Weddings and a Funeral* (2006) culls YouTube videos of just those types of events. The five videos attest to the popularity of this content on the video-sharing websites and add up to a rather clever evaluation of the nature of web-based forms—a common trope in this genre of net.art. Consider Oliver Laric's *50 50* (2007), which pieces together fifty YouTube clips of different people singing the music of hip-hop artist

50 Cent, or Seecoy's *matrYOshki* (n.d.), which nests within itself the same YouTube clip of Russian nesting dolls. These works simultaneously celebrate net culture, critique it, comment on the experience of web surfing, and flex the artist's geek muscles. While not all pro surfers are extreme hackers—in fact many rely on WYSIWYG tools and web 2.0 devices that make DIY code tricks easy—others cleverly exploit html, JavaScript, CSS, and other programming languages (often those dating to the early days of the internet that have since waned in popularity). One such example is Boling's *Marquee Mark* (n.d.), which makes internet-derived images of pop star–cum-actor Marky Mark Wahlberg scroll in a marquee fashion. These practices resemble the art historical use of found photography, but verge on constituting some other kind of practice— something, dare I say, more original.

It should be noted that other artists in this milieu are making images that verge on the sublime, images of which one would never question the originality. These pictures also employ found material—whether it is extant photography or images that were already "fake," i.e., cameraless digital images created to index reality without ever having an analogous relationship to it. These include video game graphics, low-pixel sprites, bitmap illustrations, and other digital renderings. Artists Travess Smalley and Borna Sammak both make collages out of such materials that resemble Jackson Pollock's drip paintings or Kurt Schwitters's collages more than anything as mimetic as Robert Rauschenberg or Richard Hamilton, to whom they clearly owe some degree of creative debt. Petra Cortright's landscape images are deceptively realistic constructions of epic, jankyedged, behemoth mountain ranges that could never truly exist in nature. James Whipple's work often begins with real images of existing spaces, then forces a harmony with the so-called organic shapes of power icons and female body armor found in online, multiplayer video games.

Charles Broskoski's *Cube* (2007) copies and pastes together the scroll bars usually interpreted as "outside" of the internet and uses them to create one of the most pervasive art historical forms—the grid—thus slamming social context back into the domain of modern aesthetics. Paul Slocum's *Time Lapse Homepage* (2003) is a sort of video soundtrack to the evolution of his personal webpage, which is also a record of his ongoing response to working online and experiencing the internet. These meta-commentaries continue the practice of critiquing the internet and greater network culture through its own lenses. Pro surfer Michael Bell-Smith is best known for works like his *Chapters 1–12 of R. Kelly's Trapped in the Closet Synced and Played Simultaneously* (2005), in which he overlapped the web-based episodes of R. Kelly's show to reveal its formal qualities (a significantly "off-line" project directly influenced by the content and experience

of the internet). But like many other pro surfers, Bell-Smith is also engaged in a distinctly social practice, as was the case in his Nasty Nets post entitled "The post where we share awesome gradients." In the post, members of the collective and other readers posted their favorite gradient images. Usually meant to linger as background information on a webpage, these gradients were scraped, collected, and re-presented in celebration of their often overlooked beauty. It is no wonder that in this genre the playlist is the formal model par excellence (see Lonergan's playlist of Myspace users' diaristic YouTube-based "intro videos"; but in this case the artists are frequently playing with other people's property). In this sense, they are not unlike some of our most beloved contemporary photographers. Queue the obligatory art historical references: the Surrealists, the Dadaists, the Pictures Generation, Andy Warhol, Thomas Ruff, and even Gerhard Richter, Christian Marclay, or Tacita Dean, if you want to consider "found" tropes or photo-based painting. The list is long.

Found photography has enjoyed a particularly dubious legacy. Scraped from the dustbins of history, the worlds these images encapsulate already represent a universe other than the one occupied by the discoverer. Whether hailing from a different time or place (or both), discrepancies tend to exist between the intention of the eye of the photo-taking artist and the later viewer. The discrepancy draws on the voyeuristic curiosity of the latter—eyes for which the image may or may not have been intended. The ways in which these eyes might interpret the images recall film theorist Christian Metz's distinction between a viewer's primary identification with the camera and secondary identification with characters, while problematizing the third term of a viewer's relationship to the artist, particularly when the viewer steps in to appropriate the image.

These relationships are distinctly marked by the question of the photo's content, which is in turn overdetermined by the circulatory patterns of found photos. Some of the earliest images we have of this nature are those eerie photographic studies from mental institutions that sought to link physiognomy and psyche with mug shots that presaged racial profiling in their linking of a suspect's silhouette with a predisposition toward deviance. Whether we're talking about Ishi or Salpêtrière patients or those forever interned at the Mütter Museum, these indices of abnormality spliced *vérité* and constructed horror in their archiving of impending disaster, perhaps kicked off by the snap of the aperture. These bodies were taken out of circulation in the economy of signs to which they belonged—in effect taxonomized like a beloved stuffed pet—in order to be preserved. The same can be said of the family photos that now populate the "found" genre and that signify death by alluding to the inevitable passing of time. These images circulate in excess. Their value may be the inverse of

one predicated on scarcity, but they stand in a position of contrast to proper "Art Photography."

Despite existing mostly as unique prints, the distribution of found photos is far less restrictive than limited-edition prints, which tend to be just as controlled with regard to reproduction as they are with regard to form and content. The copyrighted image acquires more cultural currency in correlation to its increased monetary value, yet the priceless snapshot is the one that floats freely. The author's right to control the image, to claim ownership of it as an object or a product of his or her mind or labor, is theoretically ceded when it's tossed into the bin, whether at a garage sale or a photo fair.

This is where we can begin drawing analogies to the internet. When an image is uploaded, presumably any person with any intent can access it. We know this because, in these days of perpetual political paranoia, a new form of technophobia related to identity theft skews most cultural commentary related to the posting of photos on social networks and other public sites. Nonetheless, the correlation between *vérité* and free circulation persists: the photos that truly represent mainstream life (in all its absurdities), that truly reflect those spectacles that we fantasize about producing and witnessing, are the ones left out there to be found, floating sans watermark. This accounts for their popularity among artists and nonartists alike. Make no mistake, found photos are enjoying celebrity status on the internet among surfers—pro, indie, and amateur. Those split-second bloopers, acts of conspicuous consumption, and diaristic elevations of otherwise banal moments found on sites with names like FAIL (failblog.org) and Ffffound (ffffound.com) comprise the backbone of contemporary digital visual culture. They are the vertebrae of a body we otherwise seek to theorize as amorphous. We tend to overlook this proliferation of images, considering it as somehow anomalous and not yet part of the master narrative of network conditions.

Rosalind Krauss argues that while there are many spaces and contexts in which photos live, the wall of the gallery is the primary discursive space of the photo. But the leap to digital form prompts us to consider not only the vertical plane of the webpage as the new home of photographic media. (Indeed, how many of the world's photos are even printed anymore?) We are also led to consider the relationship between taxonomy à la the stuffed-pet metaphor and taxonomy à la the digital archive. In so many ways, the archive has become the dominant mode of not only photographic presentation, but also of its production. This was true of August Sander and Walker Evans, and it was picked up and modified by Ed Ruscha and John Baldessari. The work of pro surfers continues to indulge our impulse toward order, whether images are produced from

the get-go as one of a series, remixed according to database aesthetics (to exploit an early net.art catchphrase), or folded into a list and presented as a sort of pre-contextualized readymade. The history of photography makes clear that this is a common practice, but what we must ask ourselves now is whether these are, in fact, still readymades or whether the degree to which they are altered makes them something else.

Montage theory argues in favor of "something else." In the famous "Kuleshov Effect," named for film theorist Lev Kuleshov, linked shots add up to something greater than the sum of their parts, dialectically constructing a narrative by way of association. These same terms can clearly be used to describe the representational strategies at play in the aforementioned pro surfer work samples. But the resemblances also extend to the social life of this creative community. In "The Principles of Montage," Kuleshov discusses the period in the nascent stages of Soviet cinema in which he and his comrades attempted to discern "whether film was an art form or not."[1] Kuleshov argues that, in principle, "every art form has two technological elements: material itself and the methods of organizing that material."[2] Kuleshov and his peers felt that many aspects of filmmaking—from set design and acting to the very act of photography—were not specific to the medium. Nevertheless, he argues, "The cinema is much more complicated than other forms of art, because the method of organization of its material and the material itself are especially 'interdependent.'"[3] In specific opposition to his examples of sculpture and painting, Kuleshov describes a medium in which the very structure, indeed the very structuring context (its machines and process—in short, its apparatuses), is responsible for not only the production of signifiers, but also the signification itself. This insistence on the "complicated" role of apparatuses foreshadows later critical insistence on the interdependence between the content and the hardware and software *organizing* the content of a work of new media art, and certainly in the work of the art hack, by virtue of its signification through re-sequencing.

When we apply this logic to the practices and products of pro surfers, we see that they are engaged in an enterprise distinct from the mere appropriation of found photography. They present us with constellations of uncannily decisive moments, images made perfect by their imperfections, images that together create portraits of the web, diaristic photo essays on the part of the surfer, and images that certainly add up to something greater than the sum of their parts. Taken out of circulation and repurposed, they are ascribed with new value, like the shiny bars locked up in Fort Knox.

It was once argued that collage was the most powerful tool of the avant-garde, that it was a literalization of the drive to reorganize meaning. Now that it has become a mainstream practice, its authority has become virtually

endangered. New media often suffers the fate of receiving inadequate criticism, and this is particularly true of internet-based work. Because these artists are practicing within a copy-and-paste culture in which images, sound files, videos, and even source code are lifted and repurposed, the work is often dismissed as derivative. (My Rhizome colleague Lauren Cornell and I attempted to address this fact when we co-curated the New Museum exhibition "Montage" in 2008.) Despite the implied claim that anything derivative is incapable of signifying on its own, the representational practice upon which this work hinges—montage—is by definition an act of bringing meaning to something. It borrows the techniques of collage—namely piecing together fragments, objects, and ideas in what Roland Barthes might call a "tissue of quotations"—to create new valences. This is not so much derivative as dialectical. Each "lifted" piece is put in conversation with the other, so that the combination creates a third (or fourth or fifth) "term."

Despite the fact that the art world has flourished after decades of Pop art and other recitations, the label "derivative" becomes a blockade, denying artists entrée to a shared discourse, or denying the radical potential of their montage-based practices.

A few years ago, respected new media curator and self-described "former photo boy" Steve Dietz wrote an essay entitled "Why Have There Been No Great Net Artists?" The essay was inspired by the semi-rhetorical question asked by Linda Nochlin in her legendary essay "Why Have There Been No Great Women Artists?" Dietz summarizes the quandary posed by Nochlin and invokes the same paradox in his own. The immediate answer is that of course there have been great female artists and great internet artists. The second response is to say that the question is incorrectly framed. Not all female artists are the same (we are not a category!), and the same can be said of internet artists whose work now takes on a variety of forms and contents—just like photography! But the deeper issue here is art history's compulsion toward recursion. The history that repeats itself is one written by archetypical, old, white dudes (as Paris Hilton so poignantly described John McCain in a recent web video) who tend to leave the ladies out of the yearbooks of their self-perpetuated boys' clubs. The same could very easily happen with net.art.

There are artists I respect whose work couldn't be adequately described within my assigned word count, artists who might take issue with my interpretation of their work, and artists who may see the field moving in entirely different directions. But if we are to be taken seriously, we must take a considered look at our playlists and think about our favorite artists' favorite artists. We must learn and assert our own art history, so that in the near future, we will be found in those yearbooks.

"Lost Not Found: The Circulation of Images in Digital Visual Culture" by artist Marisa Olson was first published in *Words Without Pictures* (Aperture/LACMA, 2010), coedited by Charlotte Cotton and Alex Klein.

NOTES

1. Lev Kuleshov, "The Principles of Montage," in *Kuleshov on Film: Writings of Lev Kuleshov*, trans. and ed. Ronald Levaco (Berkeley and Los Angeles, CA: University of California Press, 1974), 186.

2. Ibid., 188.

3. Ibid.

Guthrie Lonergan

This is going to be somewhere between a lecture and a screening. I'm going to talk a lot at the beginning and then show some stuff and then talk while I show some more stuff. Basically I will be showing you what I like and talking about why I like it. I don't really know much about art. I'm just going to try to explain why I like the things I'm showing.

I wanted to say up front that I'm a little embarrassed that, after making this lecture, I realized I included all male artists. This is something that bothers me about internet art—that it's still very much male-dominated. So this is a problem we're going to have tonight, and in general. So just keep that in mind.

A PERSONAL JOURNEY TO THE WWW

Music used to be my life, not the internet. I spent my youth listening to music and started recording myself on a four-track tape recorder when I was about ten. But as "music" became MP3s that I listened to on my computer in iTunes, I stopped caring about it the way I used to, because it wasn't very exciting anymore. I know a lot of people complain about MP3s being inferior to CDs, and CDs being inferior to vinyl records, etc., because of sound quality, or album art, but this argument misses the bigger picture of music on the internet. The fluidity of MP3s, the instant free downloading, and the infinite information about bands and genres made music too quick and worthless to me. I started to treat it like garbage.

Music had become just one arm of a larger entity that encompassed all mediums. And as music got sucked into the internet, I got sucked in along with it. I gave

Guthrie Lonergan, excerpt from webpage presen-
tation for "We Did It Ourselves" lecture
at Light Industry, 2009 (screen capture). Image
of HTML webpage. Courtesy the artist

myself over to this greater power so I could investigate what truly moves me now, and why. Did this amazing thing—music—just get ruined? Or was something else going on? What I realized was, yes, of course something else is going on: the internet is an equalizing force, and I think that this "equalizing" was what took the magic out of music for me and ultimately transformed all mediums. At this point we're pretty familiar with what this equalizing means. First of all, the net is interactive, and now of course there are Do-It-Yourself tools so that anyone can participate. And second, since everything's presented on the same platform, there isn't usually the same hierarchy that there is in television or the art world.

Strangely, this equalizing sounds a lot like what excited me about the music that dominated my youth: music that I felt that I (or anyone) could do because the songs weren't difficult to make and it was recorded and distributed relatively cheaply, separate from mainstream pop culture. But the internet is an insanely accelerated version of this process and what it leads to is this: when you see the most amazing thing you've ever seen *every single day*, amazing things aren't amazing anymore. This banality has become the thing that excites me, and it's also what I continue to struggle with and try to understand.

I first started to understand the shift in my own interests through sharing links on the community bookmark website del.icio.us; as I participated, I became part of a smaller community within the larger del.icio.us community. I'm not refer-ring to any particular surf club,[1] but rather a casual group of people who seemed excited about similar types of websites. Over the course of the past five years or so, we collectively developed a loose taste for certain qualities in found material, much of which included homemade examples of normal people participating in this DIY internet thing. To clarify, I'm not talking about "viral" stuff, like LOLcats. What I am talking about are things that are ultimately never "catchy" or engag-ing enough to a mass audience to ever become viral.

Being involved in this community, I really came to like the idea of the inter-net surfer: someone who surfs through this enormous amount of information, finds stuff he or she likes, and bookmarks it. In 2006, I did a series of perfor-mances where I would surf the internet in public and show these websites to an audience that was typically made up of mostly artists working in conventional mediums—painters, etc. I'm going to show you some highlights from that.

Dr. Soda Page

This is a webpage found by John Michael Boling,[2] who is an avid Diet Coke drinker. This [The (Not Very) Authoritative Doctor Soda Page] is a very simple, plain website where this guy has tried a bunch of different Dr. Pepper knock-offs—generic sodas that you can buy at Walmart. He created a small database that presents a photograph, tasting notes, and the "natural habitat" of each soda. He includes descriptions such as: "Robitussin-y nose" and "inadequate bubbles." The straightforwardness of this website is what I'm attracted to, and the focus on these generic sodas, and how the dullness of the design echoes the dullness of the content. I'm really drawn to generic soda because it's funny to think: if Coca Cola is the epitome of mass culture, then what does generic soda represent?

Super Soaker Collection

This is Chris Reid's Super Soaker Collection. I really like how he presents this collection—how he uses multiple angles—on this simple webpage. He also has an Excel spreadsheet where he catalogs all of his toy guns. In the inventory, he lists their condition; some are listed as "missing." There is something endearing about this, even though it's over-indulgent consumerism or something.

Nolon

This is a video that I found on Google Video about four years ago, right when internet videos started to get going—the video is still up. It's just a guy in a bathroom. There's no sound. It's nice how his personality comes through. He's just a guy filming himself in the bathroom.

My Most Boring Dreams

This is a website where this guy has attempted to make a primitive blog of a dream journal, but it's a rather unsuccessful blog because there are only three entries and it's vague when they happened as no precise years are noted. But I really like this just as a perfect, isolated little thing. Let me read a couple.

> From the night of April 29 to April 30.
>
> I dreamt I went out to get a few cartons of RainBlow [sic] gum. I went to Rainbow Foods, knowing they wouldn't have it (Target carries the milk-carton type cartons of these, while Rainbow does not). When I got there, they surprisingly did have it, but they only had vanilla flavored. I had never seen vanilla flavored before. The cartons of vanilla flavored were $5.69 each, so I just bought one of the smaller bags of it that they had, for $3.69. I brought it home and my wife was surprised that there was a vanilla flavor, and that it was so expensive.
>
> There was another part. A woman in the grocery store asked me for some help. I followed her down an aisle, where she showed me some kind of spread to put on crackers. The fat content was 2 mg / serving, and she wanted to know if that was a lot. I said it was very low fat, and she should go ahead and buy it
>
> Sometime between 1998-present
>
> I dreamt I went to a newspaper machine, the regular kind you see on street corners, to buy a Sunday newspaper. I put in my change and bought the newspaper. I opened it up, and found that it had not one, but two 'TV Guide's [sic] in it.

I don't remember how I ran into this website, but I figured out the guy's email address and wrote him some fan mail; he wrote me back and said "Hi, you know, I haven't had any dreams that boring for a while now, and I'm kind of disappointed. Glad you enjoy the ones that are there, and thanks for the email! When I have more boring dreams I will post them."

I forgot to show you this, which is related to The (Not Very) Authoritative Dr. Soda Page. This is the Wikipedia entry for Dr. Thunder, which is a generic Dr. Pepper knockoff. I just really love this Wikipedia uploaded picture, which looks like a shitty cell phone picture.

DEFAULTS

So what is the thread here? Why am I excited about these websites in particular? On the internet, DIY is very much mainstream. It's not alternative and it's not a subculture, the way it's thought of in music. I love the idea of the computer as a tool that most people use every day. Computers are used at work and for daily activities and they're where we go when we're bored. Looking at these websites that we're bookmarking, we're starting to find meaning, and maybe beauty, in this banality.

Things on the internet that I found meaningful were all technically unimpressive. I found myself attracted to this internet DIY content, not only because it came out of banality, but because the aesthetic was boring and slow-paced. It's "minimal-janky" as opposed to "minimal-sleek," or "iPod-minimal," or Minimalism. We shouldn't confuse this with lo-fi, because it's more about leaning into the easiness of computers and letting the computer do the work. This is a different attitude from punk. The websites I was attracted to never completely look like crap, because there was always an antiseptic, corporate foundation to the material. Certain defaults in the software are always present, and I found myself attracted to these defaults.

HACKING VRS. DEFAULTS CHART

This is a chart that I made in early 2007 that identifies two different approaches to, or attitudes about, using the internet and making internet art. I'm trying to define "defaults" mostly in contrast to the already-established concept of hacking. By defaults I mean using the most widely available software for the creation of content—like Microsoft Paint, iMovie, YouTube, or Google—at the most basic user level and mostly in the way that this software was meant to be used, which means relying heavily on built-in presets. Meanwhile, hacking tries to penetrate and subvert these established corporate technologies. So "defaults"

Guthrie Lonergan, *Hacking vrs. Defaults*,
2007 (screen capture). HTML webpage.
Courtesy the artist

Hacking	Defaults
Hacking a Nintendo cartridge to make images	Using MS Paint to make images
	12 point Times New Roman
Net.Art 1.0	???
 Anxiety	 Banality
"The Man is taking away our privacy... that's lame!"	"We willingly give up our own privacy (i.e. endlessly talking about ourselves on our Myspace profiles)... why?"
Empowering The People by subverting The Man's power	Being and critiquing The People by using the tools made by The Man
Rock & Roll attitude	Exuberant humility
Jodi's blogs	Tom Moody's blog
Sophisticated breaking of technology	Semi-naive, regular use of technology

are a way of thinking about technology as a thing that's everyday, as opposed to a thing that's going to come invade your privacy. This is key: "Being and critiquing The People by using the tools made by The Man." This is like a one-line manifesto of what I do.

This is an example of hacking: This is JODI, an art collective. This is a blog project that they did. I like JODI a lot. They've taken these normal blogs and sort of fucked them up and broken them, which is an unusual use of a blog (the usual use would be to adhere to defaults, that is, using the blog functionality how it should be used). I'm in love with the struggle, which reveals something real coming through this structure. I hate utopian fantasies of the internet as this totally free, democratic space that will make our lives better. We're all using this preexisting foundation that will always be there no matter what. Defaults are also a reaction to the "infinite" choices and possibilities offered by the virtual (letting the computer choose for you). You can't get off the grid, but the struggle of normal, basic internet users to get something real through this existing grid is really exciting. On some level, I think of the default as a metaphor for all kinds of mediated distance, for the way we feel dissociated from war, money, art, and music.

In love with the struggle of something "real" slightly peeping through this kind of structure

Guthrie Lonergan, re-drawing of animated GIF,
excerpt from webpage presentation for
"We Did It Ourselves" lecture at Light Industry,
2009. Non-animated GIF. Courtesy the artist

LINKS

This is an image I found on Flickr that I really like. I like it not just because of the flatness of these discs on this flat floor, but I also like that there are so many people in this image. There's Marilyn Manson, there's Darcy, who collected these images of Marilyn Manson and put this picture online, there's us, looking at the picture that Darcy put online, in public, but then there's also IBM who made the discs. I like the idea of Darcy and Marilyn Manson clashing with IBM.

This is a website that Ilia Ovechkin found. It's an AOL member homepage, but AOL recently shut down and deleted all of its member websites, so this is just an archive of the site. This kid documents his family going to the *Seinfeld* set in Los Angeles—so it's just a regular guy invading a show about a regular guy. You have some really great pictures. It's sort of like the internet invading mass culture.

This website loops part of a Coke commercial. It's really great because this tiled background happens on most sites (or desktop wallpapers) by default. I can't fully decipher the author's intentions. I don't think it was intended as art. But the author must like the commercial for some reason and probably likes Coke. Something comes through, even though the source material is a gross television commercial.

LINKS (CONT.)

I feel weird making this division, but I'm going to start showing things that are intended as artwork, made by internet artists who are part of the surfing community that I was talking about earlier. This is *100 Meter Marquee* by John Michael Boling from 2006. John Michael has taken videos from track meets, which are ordinary videos you find on YouTube, and does exactly what YouTube wants him to do with these videos, which is embed them on his website. I like how he's treating these videos as physical entities. A lot of video art using appropriation is manipulating video and trying to obscure the original sources, and John Michael is not changing anything; he's just presenting them as these intact original entities. It is pretty interesting to think about all of the things that John Michael could be doing, all the crazy shit you can do in After Effects, or whatever. Instead, he's simply emphasizing the simple gestures of linking, or embedding—reorganizing the internet.

This is a thing I made in 2006 called *MySpace Intro Playlist*. I found a bunch of similar videos of normal young people welcoming the world to their Myspace profiles. I took them out of their original context on the person's page and put

them together in a playlist. Even though there's no prescribed format for this kind of video, they all seemed to be structured in the same way and these patterns consequently develop. The kids all address the audience with a similar tone. This is sort of like when you record an answering machine greeting in that you tend to speak in a certain way and say certain things. So the playlist is a default form but the videos themselves are also conforming to these unspoken defaults. I don't see them as voyeuristic; they're more like little homemade commercials for each kid. You usually assume that the polish of corporate mainstream culture is intentionally resisted in DIY culture, but in this case I'm not sure that they want the lack of polish that they have in their videos.

Now I'm going to show a playlist made by Kari Altmann called *Fossils & Minerals—Teleportation—Part One* [2008]. She compiled videos that people posted on YouTube of themselves "teleporting." So they're all applying a default special effect to themselves, and even though they're going after real Hollywood CGI stuff, all they are using is a particular After Effects plug-in or some other easy-to-use software within reach of amateurs. What's interesting about making a playlist to me is the same thing that's interesting about John Michael's YouTube work. Making a playlist doesn't involve altering the original content—all we're doing is just pointing or linking to it. All three of these pieces, John Michael's, Kari's, and mine, involve YouTube content that is interchangeable. We're not presenting these particular videos because they are unique, but because they are exemplary of certain threads or clichés. These kinds of videos will never be in short supply and they're not difficult to find.

Something I really wanted to do in my presentation was force you guys to watch some animated GIFs for an uncomfortably long period of time. This is an arrangement by Tom Moody. He found all these GIFs. Let's just look at it for a second and think about it.

TRAVIS HALLENBECK

Now we're going to talk about Travis Hallenbeck, who is very much an internet surfer. So this is Travis's website, anotherunknowntime.com. And this is Travis's thumbnail project, which is a project on the site. Tinypic.com is another video-sharing site like YouTube, and Travis goes through the thumbnails that link to each video and saves the ones that he likes. Then he compiles the thumbnails into three-column arrangements that resemble search results. Even though nothing is created from scratch here, and Travis is just highlighting what he likes,

Travis Hallenbeck 5-28-08　　　　　　soundtracks tour compressed video thumbnails

Travis Hallenbeck, anotherunknowntime.org,
2014 (screen capture). Archived approximation
of website from 2008. Courtesy the artist

I see this personal and emotional connection that Travis has with the images. He manages to craft his own style just by re-sorting all this homemade material. You start to notice trends in the collages that he makes. Lots of bad lighting. Lots of strange purple artifacts. Lots of skateboarding. Lots of large areas of one color. On video websites, the frames that are selected to be the thumbnails are usually randomly picked by the website code, so we see a lot of confusing frozen moments. I love the mystery of trying to figure out what's going on in the video, but also the mystery of trying to reverse-engineer Travis's selection process—why he picks these thumbnails and not other ones.

This is Travis's project to make a single-instrument MIDI song for each of the 128 general MIDI instrument sounds that come built-in on keyboards and computers. He's also making these small bitmap images that go with each instrument. So he's drawing a parallel between these simple, monotimbral MIDIs and then these clunky bitmaps, these really rigid systems.

Now I'm going to show some video loops that Travis made using a basic children's animation and drawing program called Kid Pix. These videos are completely made up of stamps, images, and audio loops that come with the program. Again, he's done very little actual labor, just choosing and arranging.

JOEL HOLMBERG

Let's talk about Joel Holmberg. I'm a little wary of analyzing Joel's work too much and ruining the humor, but let's do it. Joel does a lot of absurd human interventions into technology. He loves the glory and dumbness of information.

This is a video that Joel did called *Hand Flurry* [2008] where he's mocking the default Mac screensaver but loving it at the same time and maybe making fun of computer art that looks like this.

This is a video Joel made called *created by joel* [2008], which shows Joel using a word-processing program to increase the text size of the text—which reads "CREATED BY JOEL"—and is featured in the video. What I like is that, as he increases the text size, the computer responds by wrapping words on the next line, and I sort of see this as Joel, the computer user, versus the computer. Then slowly "CREATED BY JOEL" just becomes this abstraction, just the curve of the "C" that goes on for more than half of the video.

This is a clip that Joel put online entitled *Tom Cruise as Jerry Maguire Experiencing Creative Euphoria During the Act of Self-Publishing* [2008]. So that's Tom

Joel Holmberg, *Getty Images Hollywood*, 2007.
Digital image. Courtesy the artist

Cruise. Joel has a sort of kooky fascination with the film industry, and he's really into using Hollywood as this foil for the internet.

Getty Images Hollywood [2007] is a faux stock image that Joel made by superimposing the Getty Images watermark on a found photo of the Hollywood sign. So he's conflating stock imagery with Hollywood movies. It's interesting that he's making a forgery of an unlicensed stock photo because, instead of stealing the photograph, he's just stealing the watermark and putting it on top of a found photo. He talks about this piece and a lot of his work as relating to the origin of images. Did a particular image originate from an individual like Joel, or a corporation, or just the internet as a whole? Last year he did this nice piece, which is a Google image search for "woman eating grapes." You get exactly what you request, which is images of women eating grapes. It's nice because it's an art historical cliché, but at the same time, a lot of these are stock images. Earlier this year, the internet surfing club Nasty Nets—which I cofounded—had a silly time at Sundance Film Festival; we did a performance featuring Joel eating grapes off of a boom mic, so he sort of enacted this cliché himself. This is a photograph that an AP photographer took at the event. It's nice because there's this watermark on it and it's available for purchase, just like most of the images in *Woman Eating Grapes* [2009]. And just like these images of these women, he's been reduced to a small piece of a larger database.

LITTLE ENTRIES IN THE BIG DATABASE

Earlier I talked about understanding all of these webpages and artworks I'm showing you in terms of defaults and normal computer users. The bigger picture maybe is to look at the internet as one big database made up of smaller chunks or memes. My dilemma of falling out of love with music came about when music started becoming small chunks—small, free MP3s, one-line entries in iTunes—in this big database. But music is not really aware of this yet, not aware of the database it is now a part of, and how being in that database changes the way it's experienced.

I started a project last year (*twitter.com/vvork* [2013]) with Tom Moody where we document the art documentation of a popular art weblog VVORK that shows only images of art along with its title, the name of the artist, and its year. We take each artwork that is blogged on the site, usually represented by a single image and a title, and reduce it to a one-line description. I'll show you our text version first. So these are all art pieces. Tom has been doing all the twittering recently. "Dozens of narrow spotlight beams spray out from piano as seated

musician plays" is an example of a recent tweet—this and others are just summaries of someone's artwork. "Illustration of proposed monument: cracked facade retail storefront with flatscreen TVs, speakers in window" and "Flags of fictional nations (grid of 18)" are two other examples. There are a lot of things going on here, but I want to show this as an example of what happens to art or anything that finds itself on the internet. The artists who made these works probably don't want their art to be reduced to 140 characters—one line in a massive and growing database—or even one JPEG, but in a way, this is what is happening to art and everything else on the internet.

So how do I work within this big database that is the internet? How do I make things that make sense there? One approach I see is to focus on the generic and on clichés. Again, if every single day you see the most amazing thing you've ever seen, then amazing things cease to be amazing. Not much seems unique after seeing so much stuff. Some internet art seeks to embody this, which goes against what often seems like the goal of art and creativity—to endlessly break new ground in expressing things.

ARTIST LOOKING AT CAMERA

Artist Looking at Camera is a video that I did in 2006. I did a search on Getty Images stock footage database for the phrase "artist looking at camera" and compiled the results. So often the goal of a good stock clip is to be as generic as possible, both for clarity and flexibility, because the clip should be able to fit into a variety of contexts, depending on who ends up using it. So it could be in an infomercial, an instructional video or documentary or a medication commercial or whatever. To me this is this DIY-against-mainstream thing again, popping up in corporate media as a marketable fantasy, the artist fantasy.

EFOOTAGE BLUE SCREEN CLIPS

On another stock website, efootage.com, I discovered some cheaper, lower-quality stock footage that blurs the line between the corporate and the homemade. It features clips isolating certain objects and hand gestures in front of blue screens intended to be keyed out and put into different situations with different backgrounds. Mostly I just love imagining the photographer in this particular video[3]

Guthrie Lonergan, *Artist Looking at Camera*,
2006 (still). Video collaged from appropriated
Getty Images stock footage. Courtesy the
artist and Thought Equity Motion/RF Video+/
Getty Images

alone in a room, filming himself, or filming a basketball spinning around endlessly on a homemade rig. If you think about it this way, these clips are indistinguishable from a lot of performance-style video art. I edited the footage together and added a soundtrack (the vocal track isolated from The Police's "Message in a Bottle") to make this piece.

So I like seeing these stock footage–makers trying really hard to make the most perfectly generic clip, but then failing just slightly. It makes it really interesting. In a way, it brings stock footage and YouTube a little closer together, which is a comparison I've become sort of obsessed with. Both are searchable databases of short, keyworded clips, and in my mind they are bizarro parallel universes.

SLIP 'N SLIDE

This is a video that Robert Wodzinski, aka jpgmess, found on YouTube of these kids going down a Slip 'N Slide. Something about this video is really perfect, like the composition and timing. So perfect that it's a little weird for a home-made clip…it doesn't seem real. It's like a painting.

MALL MARCH

Mall March [2007] is a thing that I did a couple of years ago, and even though it's the last thing I'm going to show you, in a way, I don't really like it. But the source video is one of my favorite things I've ever found on YouTube, and it needs the music to work. So I took a home video that I found on YouTube, I made a soundtrack for it in Apple's built-in GarageBand, and then I re-uploaded it back to YouTube. I changed it very little, just a couple of cuts at the end, but most of it's one long shot. I won't tell you why these kids are marching, because I don't want that to matter, and I sort of like how it might resemble bad performance-art documentation, were it not that these kids blended into the mall so well, the way they look in their clothes. To me, there's something really nice peeping through about these normal kids in a generic mall in constant motion. I've added some drums since I first uploaded it.

You guys got any questions?

SARA SIMONSON: So you have work in ["Younger Than Jesus" (2009) at the New Museum], and you've done things in different kinds of spaces, but in my informal conversation with you, you said that your favorite thing is to have it viewed and experienced on the internet. Do you have any thoughts to share on your work being shown in other kinds of venues?

GUTHRIE LONERGAN: Yeah, I really don't enjoy going to art galleries very much, and whenever my art is shown in a gallery it's always really a different experience for me. Maybe other people respond to art galleries better than I do, and don't really like seeing things on the internet, and enjoy going to this public space instead. But sometimes I see shows like an advertisement for my URL so that people will come to my website. I don't know if that's some weird personal problem that I have—that I don't want to see this stuff in public. I just want to have that same experience that I had listening to music in my bedroom or something. Just to experience this thing on my laptop, on my desk in my room.

ED HALTER: This may be related to that last question. On Rhizome recently there was a large discussion, involving many of the people you mentioned here, about your phrase "internet aware art" and this claim that writers at Rhizome had used it incorrectly. So since you're here, I wonder if you can say what you meant by the term?

GUTHRIE LONERGAN: Well, I didn't make up a definition; I just wanted to throw that term out there. In my mind I've sort of defined it as related to these ideas of the big database that I was trying to talk about. And just being aware that even if you're not making internet art, your art is probably going on the internet. And somehow any attempt to be aware of that will change your work, thinking about that internet context—if your work will end up on VVORK, or something like that.

ED HALTER: Sort of "internet-ready" art?

GUTHRIE LONERGAN: Something like that. It's really a big question. I don't know what it means.

This text is a transcription of "We Did It Ourselves!," a talk given by artist Guthrie Lonergan on April 6, 2009, at Light Industry, a venue for film and electronic art in Brooklyn, New York.

NOTES

1. Surf Clubs became popular after 2006, and their activity tapered off with the rise of Tumblr a few years later. Lonergan coined the term "surf club" and cofounded Nasty Nets, the first of these clubs.

2. John Michael Boling is an artist and collaborator of Guthrie Lonergan.

3. This video can be found at: <http://www.theageofmammals.com/2009/acapella2.html>.

Gene McHugh

Tuesday, December 29, 2009

Here is a passage from a March 2006 interview between the artist Cory Arcangel and the Brussels-based curator Karen Verschooren:

> CORY: …[Y]ou can't just put a computer with a browser that's pointing to a website. You have to somehow acknowledge that it is in a gallery, for better or worse. Video, I think, started to do that…. Paper Rad for example presented a huge sculpture, based on animated GIFs. It wasn't necessarily internet art anymore, but it was art that could only exist because the internet exists. That is definitely some kind of solution…. That is what is going to happen I think. It is not going to be pure strict internet art, it's going to be art that exists because of the internet or is influenced by the internet or there was research on the internet.
>
> KAREN: That's almost everything in art. Almost all contemporary art is influenced by the fact that we live in a networked society.
>
> CORY: That's fine, you know. It is going to be seamlessly integrated into everything else. Which is what it should be. But pure internet art, I think, should stay on the internet.

………

Also:

> KAREN: So, if I understand you correctly, you are saying that it is the responsibility of the artist to transform his internet art piece in that

way that it fits into the gallery space. It is not the gallery that has to change its economic model of exhibiting because of their mission statement or whatever.

CORY: Yes.

.........

Verschooren sums up this strategy as roughly "the art needs to change to fit the gallery," instead of "the gallery needs to change to fit the art." Arcangel answers affirmatively, but I wonder if it is this simple. I think that postinternet art does not just bend itself to work as "art," it also changes one's conception of "art." Working in the confines of the white cube is not necessarily always limiting to artists. By playing with that history of what has been marked as "art" and successfully entering into that dialogue, these artists are changing what one thinks of as "art" in the same way that Daniel Buren, Michael Asher, and earlier artists like Jasper Johns or (of course) Marcel Duchamp worked within the gallery to change what could be shown in the gallery and thus be reflected upon as "art."

KAREN: So, if I understand you correctly, you are saying that it is the responsibility of the artist to transform his internet art piece in that way that it fits into the gallery space. It is not the gallery that has to change its economic model of exhibiting because of their mission statement or whatever.

CORY: Yes.

It's a two-way street, and the best pieces, including pieces by Arcangel, are able to be read as "art," and do it well enough that they demand "art" to reevaluate its conception of itself.

Wednesday, December 30, 2009
Four ways that one can talk about "postinternet":

1. New media art made after the launch of the world wide web, and thus, the introduction of mainstream culture to the internet.

2. Marisa Olson's definition: Art made after one's use of the internet. "The yield" of her surfing and computer use, as she describes it.

3. Art responding to a condition that may also be described as "postinternet"—when the internet is less a novelty and more a banality.

4. What Guthrie Lonergan described as "internet aware"—or when the photo of the art object is more widely dispersed than the object itself.

Wednesday, January 13, 2010

If you were not acquainted with Cory Arcangel as an artist and you came across his YouTube video of U2's "With or Without You" mashed up with footage of the Berlin Wall coming down, it would read as a "normal" YouTube video. It seems like something that is native to YouTube and not to art.

We could say that it is a work, but not a work "of art."

Furthermore, it is a really good example of a YouTube video. There is something stirring about it—emotional, even. And it seems as though Arcangel went through a lot of work to make it as good as it is.

However, Arcangel is an artist and anything creative he does will inevitably function as an artwork in an art context.

So, what happens when this video is thought of as a work "of art"?

It works as a readymade, illuminating the genre of YouTube video that it mimics—the mashup.

In the end, though, the beauty of it is not that it works as a YouTube video or as a work of art. Rather, by doing nothing other than shifting context, it illuminates the bridge between the two.

Wednesday, January 27, 2010

Kevin Bewersdorf has said that art now is based not on art objects or individual projects, but rather on "persona empires," which are the brands that artists develop over time.

He writes:

> Whether a net artist brands themself with a sparse list of links on a humble white field or with loud layers of noise and color or with contrived logos in a bland grid, they are constructing their own web persona for all to see. They are branding their self corporation. I think this self branding can be done with functionless art intentions rather than functioning business intentions. All the marketing materials are just shouted into the roaring whirlpool of the web where they swirl around in the great database with everyone else's personal information empires. I

think these persona empires are the great artworks of our time, and they inspire me to keep building my own brand.

.........

Bewersdorf is an important postinternet artist because he realizes very clearly that the quality of art on the internet is not measured in individual posts, but in the artist's performance through time. On Facebook, a user is judged not by one status update, but rather by their style and pace of updating. The same is true for internet artists.

Thursday, January 28, 2010
Writing about Kevin Bewersdorf's work prior to 2009 is difficult.

Bewersdorf erased his website, maximumsorrow.com, as well as all of the texts, photos, songs, and documentation of sculptures that were housed on the site.

While there are scattered traces of his thought floating in various blogs, the ability to view the scope and meaning of it is greatly diminished.

If this work is to survive, then, one must attempt to translate it—piece together his project in one's own words, from one's own memories of it.

Monday, May 17, 2010
In "Free Art," a text by The Jogging, it is suggested that the web's economy of re-blogging and fast-paced communal interaction creates its own economic model, and thus, its own best practices for understanding how value around work is accrued.

Furthermore, it is thought that the art world—even if it did acknowledge this work—would not know what to do with it, as this online economy is alien to its own, premised as it is on the exchange of materially sensual objects for amounts of (financial) capital unavailable to all but the most wealthy members of society.

The Jogging writes:

> In the lives of contemporary artists, Free Art is a place to find one's self through the existence of others—to individually reclaim the ability to self-mythologize and empathetically pick from your peers for influence. Thus, Free Art is marked by the compulsive urge of searching (or, surfing) to connect with others in a way that is not dictated by profitability, but found and shared charitably among individuals based on personal interests.

EXCERPTS FROM *POST INTERNET*

.........

A couple of thoughts:

I'm not sure that the web is any less tainted by economics than the art market. The re-blogging format preferred by The Jogging did not appear out of nowhere; power relations are alive and well (t)here, as one might say that all of this activity is ultimately in the service of market research for corporations.

Meanwhile, the world of contemporary art is obviously not perfect, but it's not entirely dominated by auctions and abusive gatekeeping, either.

And if one is interested in placing their creative endeavors on the web in both the most critically sympathetic as well as the most critically astute environment possible (the environment in which it will be judged as more than style alone), one can't so easily dismiss the art world, as it has been thinking about these questions very seriously for a very long time.

Furthermore, the work will (if it is as good as it thinks it is) end up back in the art system as saleable objects; the question here, then, is how much control the artist exerts over this entry into the system.

This is just to say that the conversation occurring inside the art world is worth taking a second look at before one abandons it outright.

Also, The Jogging's reference to the immaterial or dematerialized quality of the work is problematic.

For the sake of argument (and it is debatable), let's say that—yes—a virtual JPEG of a sculpture is immaterial, free of the problems of aura and material commodification that the sculpture depicted in the JPEG itself affords.

But what about the hardware displaying this content?

The notion that the web has accomplished some sort of Hegelian transcendence is precisely what, say, Steve Jobs wants consumers to believe: Go on, keep chatting with your friends, watching videos, listening to music—it's all fluid and immaterial now, and that's great—just so long as you do so through the iPad.

These devices that display the work which The Jogging thinks of as lacking aura are, in fact, highly susceptible to aura, or from a slightly different angle, fetishism.

One can't wait to get home and log on to their machine, touch it, ride the time of computing cycles; anytime the threat of boredom creeps in, one can immediately start fingering their iPhone, dexterously running their hands all over it in hopes of generating more immaterial content.

Indeed, perhaps one could think of the endless stream of a blog as lubricant—sweet nothings in one's ear, easing one's entry into a more rhythmically sustained fingering of their device.

This is just to say that the materiality of digital culture is worth taking a second look at before one denies its presence outright.

Now, all that said (and on the other hand), there's another consideration that comes into play here: "Free Art" was posted on the The Jogging Tumblr on May 12, 2010.

In the five days that have passed since the twelfth, The Jogging has posted six additional unique works—each possessing their own unique power and each propelling my own following of their posts (as in an ongoing performance).

As a matter of fact, this immediacy and performative enthusiasm is relatively more exciting (to me, anyway) than most things happening in most of the shows advertised via, say, e-flux.

Which is precisely the effect that The Jogging describes in the text.

An anxiety arises: I have some issues with the idea, but I'm compelled to follow it nonetheless.

That is to say, it can't be dismissed outright, as the artists demonstrate it for me, placing it directly in front of me, demanding my acknowledgment.

And through this acknowledgment, I may never quite decide for certain if the idea of Free Art is naïve or pioneering (or both), but I may be infected by it, nonetheless.

Friday, June 18, 2010
Still Available by Oliver Laric is an ongoing list of web domain names that are still available to be taken.

Laric's work *Taken* is an ongoing list of all of those domain names listed in the *Still Available* series which have, in fact, subsequently been taken (at present, almost seventy domains are now taken from the over three hundred listed over the course of the series' five installments).

In the earliest iteration of *Still Available*—*Still Available 17.10.08*—approximately 135 potential domain names are listed, each of which refers to keywords rich in value relevant to that particular historical time period, regarding, for example, politicians, political theorists, luxury commodities, pornography, artists, art theorists, art world events, physics, pop culture, or cities.

These domain names are often funny and perceptive in the way in which they pinpoint strategies employed by "parked domain" companies that buy up domains in bulk using keyword strategies not unlike those employed by Laric himself.

So, for example, he lists domains that have no value other than a speculative one regarding the future of value-rich keywords, such as elections2032.com, documenta13.com, and beverlyhillsninja3.com; or domains that combine vaguely related, value-rich keywords at that particular moment in historical time, such as putinpalin.com, gucciprada.com, and platinumclit.com; or else domains that

just sound as though they could be actual domains, such as botoxbros.com, divorcebattle.com, or thenewsocialism.com.

Likewise, in the following four iterations of *Still Available*, a similar method is employed.

In this way, Laric creates a portrait of the practice of domain-naming as an increasingly complicated and speculative enterprise that, in turn, results in a web consisting of as many empty, "parked" domains awaiting potential owners as it does active ones—a portrait of the web as a space undergoing not exploration, but relentless colonization into the predicted value-rich keywords of the future.

The *Taken* list of domain names underlines this understanding.

On the one hand, it's true that some of the domain names from the list are taken by "normal" people or small not-for-profits such as the artist Billy Rennekamp taking billyrennekamp.com, a modest Amon Düül fan site taking amonduul.com, the "Frankly My Darling..." blog run by a middle-aged woman taking 13dimensions.com, or the breast milk donation info hub taking breastmilkdonation.com.

However, most of the domains were taken by web-based companies in the business of parking on domains in order to cybersquat or provide advertising space (my favorite example is steaksonaplane.com, which was taken by the GoDaddy.com company to advertise its own services).

With all of this in mind, what one views here is the way in which this increasingly colonized landscape is different from the geographical landscape of Earth, in the sense that its potential space for expansion is itself continuously expanding as world events and memes both high and low open it up to the contingency of the moment.

The artist's website, as a publicly accessible database, may be followed by a public interested in the artist's work. As an artist continues to create work, this creation is knowingly performed—one views the drama of an unfolding practice in which each "move" is in dynamic dialogue with past practice as well as a navigation into future practice. If I encounter the work of the contemporary artist through their managed presence on the internet, and I do it again and again and again and again, then this managed presence itself becomes a performative work.

.........

There are many examples of this type of approach to making work in the context of the web. One of those examples is Poster Company by Travess Smalley and Max Pitegoff.

Poster Company is a Flickr page consisting of over two hundred paintings produced between July 2009 and May 2010. In this project, the artists first focus on collisions between automatic effects that read as either "painterly" or "digital," and second, shift the focus of their labor in the work from the production of an individual painting to the performance of producing many paintings over the course of months. As such, their work is in dialogue with the painter On Kawara's "Today" series and Josh Smith's influential painting project—each of which is meaningful when considered as a reaction to the automatic reproducibility of images as well as an ongoing, long-form performance.

The question "what is a digital painting?" (a noun) is here better phrased as "what is digital painting?" (a verb). The significance of Poster Company's work lies not in the individual compositions, nor in the volume of output (although these elements are undeniably crucial for the full execution of the work), but rather in the performance of the work.

Sunday, August 15, 2010

PERFORMANCE 4

———

An artist has a website. At first, this website is, depending on the artist, either a handy novelty or a frustrating necessity of the digital age. Either way, it's not that super important. One makes a work—be it digitally created or handmade—and one, then, uploads a photograph or some other form of representation of this work to their website to serve as a second-hand reference for curators, collectors, critics, and the general contemporary art audience.

An artist maintains this website. Gradually the artist comes to realize just how handy and how necessary this tool is for the dissemination of their work. As newspapers, mainstream culture, an exploding amateur culture, communication with friends, banking, and a host of other day-to-day activities are increasingly conducted via the internet, the artist realizes that not only do people greatly prefer, and even expect, the ease of viewing the work through this website, but the once-obvious line between the actual work and the representation of the work is becoming oddly blurry. For many members of the artist's audience, including curators, critics, and other arts professionals, the image of the work on the website is good enough. This is exacerbated by the increasingly global nature of contemporary art, perhaps best represented by biennial culture.

All of a sudden, the way the artist thinks about their work is at least as much dictated by how a JPEG of the piece looks in the context of their website as by how it would look in the physical art space. This is what the artist Guthrie Lonergan calls "postinternet" art—the art after the internet changed the way that art reaches an audience.

For many younger artists who, by historical accident, came of age without ever really experiencing the "pre-internet" relationship between artist and audience, this is not a novelty, but an obvious fact that almost goes without saying. Even if one works in traditional mediums, art is primarily experienced on the internet.

The art/curatorial collective VVORK curated a show in 2009 called "The Real Thing," which was based on the idea that, as members of mediatized cultures, most of their own knowledge of art was not accrued through the original, but through art history books, lectures, conversations, and, of course, the internet. In other words, through "versions." In their statement for the show, which was held at MU in Eindhoven, they write:

> Some of our favourite works have only been described to us, unsurprisingly as the majority of our art experiences have been mediated in one form or other. The majority of works presented in this show have been selected through written commentaries, verbal descriptions and jpegs found online. In fact most of the works presented at MU are the type of manifestations mentioned above: stories, descriptions, translations and interpretations, all understood as primary experiences.

One of VVORK's cited inspirations for the show is the following Seth Price quote from his essay "Dispersion":

> Does one have an obligation to view the work first-hand? What happens when a more intimate, thoughtful, and enduring understanding comes from mediated discussions of an exhibition, rather than from a direct experience of the work? Is it incumbent upon the consumer to bear witness, or can one's art experience derive from magazines, the internet, books, and conversation?

Sunday, September 5, 2010

PAINTING 1

———

If one is to take the history of painting as a meme spreading from mind to mind through its history—from cave paintings to Piero della Francesca to Thomas Gainsborough to Nancy Spero and beyond, each iteration in the history of the meme mutating itself in response to its own context—then what would it mean to extend the painting meme into the context of digital computer networks?... How would the painting meme be translated when a painting is still an object, but an object dispersed through the network as a mutable digital photograph, as well?...

An alternative response to the question of the painting meme's life in the network is being developed by young artists working on or around the internet. For these artists:

1. The computer screen is the primary surface on which painting will be viewed, and because of this, a new suite of phenomenological effects occurring between painting and viewer are opened for exploration.

2. The rate of speed at which paintings travel is atrophied when uploaded directly to computer networks, and this increase in speed allows one to, then, view the flow of painting in time.

In what follows, I'll say a few more words about the relationship between painting and the computer, describe a recent trajectory of the painting meme among a group of internet artists, and then focus, in particular, on the work of the PAINT FX collective.

2

———

It's possible that an "actual" Abstract-Expressionist painting produced in the 1940s and a "fake" Abstract-Expressionist painting created through the application of digital effects in a piece of software could be effectively indistinguishable when viewed through the light of the computer screen. With this in mind, some painters have shifted their concerns from those native to the paradigm of the white cube to, instead, those native to the paradigm of the computer screen. This shift has repercussions, though. For example, the phenomenological effects of painting shift from the materiality of paint on canvas to the light spilling

from a computer screen. This bias toward the surface of the screen, then, nudges artists toward exploring different types of bodily shock effects. The relationship of the body to the computer screen after all is different from that of the body to the physical painting in space—computers are open circuits in which cybernetic feedback relationships between computer databases and users allow users to actively shape the mediascape they inhabit. These cybernetic relationships create a desire for clicking, scrolling, and following—dynamic motion premised on sifting through an accumulation of data rather than gazing for very long at a single pattern of light. The internet painter, then, begins to think in terms of multiplicity, the aesthetics of the surfeit, and, crucially, a strong temporal element that transforms painting into a variation on performance art. Furthermore, JPEGs, as digital files, are mutable, meaning that they can be radically transformed instantaneously at the level of code. If one wants to merely touch up a single brush stroke or slap a picture of a sea shell on the top layer of the painting, the technology is agnostic in regard to the amount of variation each of these types of alterations suggests. This mutability means that once it is part of the network, other artists and non-artists as well are given free rein to appropriate the image and alter it themselves, re-disseminating the mutated image through alleyways of the network that the painting's original creator could not anticipate. In other words, paintings here are a network of versions, a stream of evolving memes.

3

The meeting of painting and the computer is not new. MS Paint, for example, has long been mined for painting effects. In the context of the internet, the artist Tom Moody (a former "actual" painter) has built an important practice at the interface of painting and the computer screen, which has evolved into making animated GIFs and placing them on his own blog and sites like dump. fm. This is not meant to be an authoritative history, though, so I'll focus on the life of one strain of the painting meme as I've witnessed it over the past two or three years.

I first began to notice artists working on painting at the tail end of the surf club phenomenon. Artists like Will Simpson, Thomas Galloway, and Travess Smalley on the surf club Loshadka, for example, were moving away from appropriated content derived from internet surfing and toward original content created in painting software programs.

Around this time, the artist Charles Broskoski began increasingly focusing his work away from Conceptual art pieces toward a painting practice premised on

volume, performativity, and innovations in presentation that were native to the computer screen. The artist Harm van den Dorpel was working on a similar project, in which he straddled the borders between a computer model of a work and a work in physical space, and allowed that very tension to become illuminated as the work. Along the way, he raised an interesting set of questions regarding artistic deskilling and the borders between handmade effects and automated effects. In short, the "hand of the artist" was, on the internet of all places, becoming an interesting area to explore. Soon enough, there seemed to be an internal logic and momentum to this digital painting meme, and the Supercentral II surf club and Poster Company by Travess Smalley and Max Pitegoff pushed it further, actualizing what was in the air. A slightly younger generation of artists working on the Tumblr platform and an emerging body of critical reflection by artists such as Ry David Bradley on his *PAINTED, ETC.* blog continued to sustain the evolution of the meme, polishing certain presentational elements and building a community of people interested in these ideas. Painting in the network was about fast-paced collective dialogue and mind-bending abstractions. It was also about painting. The imagery of these works are often collisions between digital gestures and painterly gestures, but, generally speaking, the concern is with the tradition of painting pre-internet, as opposed to the animated GIF scene, whose roughly concurrent rise (in the net.art context) posed as a nice counterpoint to the painting meme.

If one was watching, one could view the evolution of the meme as it started in a sort of experimental phase, gained some steam, developed a community, and achieved some sort of level of self-consciousness about itself. The meme here takes on its own form of life, which one can watch live on the internet.

Sunday, September 12, 2010

SCIENCE FICTION 1

"Postinternet" is a term I heard Marisa Olson talk about somewhere between 2007 and 2009.

The internet, of course, was not over. That wasn't the point. Rather, let's say this: what we mean when we say "internet" changed, and "postinternet" served as shorthand for this change.

So, what changed? What about what we mean when we say "internet" changed so drastically that we can speak of "postinternet" with a straight face?

EXCERPTS FROM *POST INTERNET*

On some general level, the rise of social networking and the professionalization of web design reduced the technical nature of network computing, shifting the internet from a specialized world for nerds and the technologically minded, to a mainstream world for nerds, the technologically minded, and grandmas and sports fans and business people and painters and everyone else. Here comes everybody.

Furthermore, any hope for the internet to make things easier, to reduce the anxiety of my existence, was simply over—it failed—and it was just another thing to deal with. What we mean when we say "internet" became not a thing in the world to escape into, but rather the world one sought escape from. It became the place where business was conducted, and bills were paid. It became the place where people tracked you down.

2

Accompanying this change in what we mean when we say "internet," there was a change in what we mean when we say "art on the internet," and "postinternet art" served as shorthand for this change.

On some general level, the shift of the internet to a mainstream world in which *a lot* of people read the newspaper, play games, meet sexual partners, go to the bathroom, etc., necessitated a shift in what we mean when we say "art on the internet," from a specialized world for nerds and the technologically minded, to a mainstream world for nerds, the technologically minded, and painters and sculptors and Conceptual artists and agitprop artists and everyone else. No matter what your deal was/is as an artist, you had/have to deal with the internet— not necessarily as a medium in the sense of formal aesthetics (glitch art, GIFs, etc.), but as a distribution platform, a machine for altering and rechanneling work. What Seth Price called "Dispersion." What Oliver Laric called "Versions."

Even if the artist doesn't put it on the internet, the work will be cast into the internet world, and at this point, contemporary art, as a category, is forced against its will to deal with this new distribution context, or at least acknowledge it.

"Acknowledge" is key here. It's not that all contemporary artists must right now start making hypertext poetry and cat memes, but rather that, somewhere in the basic conceptual framework of their work, an understanding of what the internet is doing to their work—how it distributes the work, how it devalues the work and revalues it—must be acknowledged in the way that one would acknowledge, say, the market. What Guthrie Lonergan called "Internet Aware." To

not do this would not be a sin (obviously most artists don't care about the internet at all and won't start caring anytime soon; similarly, most artists probably don't want to consider the market), but it would be a shame—it would be too bad. Somewhere, on a realistic level, there would be an avoidance of the context in which the work appears and, if the twentieth century did anything to artists, it made them care about context on a realistic level. Duchamp changed the game by acknowledging the context in which the game is played. And the game now is played in the project spaces of Berlin, São Paulo, and Los Angeles; it's played in the commercial galleries of New York, and in the global network of biennial culture; it's played in museums and auction houses, yes (obviously)—but it is also now played through the distribution channels of the internet.

To avoid this last point is to risk losing the game.

. .

The preceding text comprises excerpted entries from *Post Internet*, a blog written by art critic Gene McHugh, that were published from December 2009 through September 2010. Comprising posts that varied in form and length, from fragmentary notes and short bursts of text to longer essays, *Post Internet* was supported by a grant from the Creative Capital | Andy Warhol Foundation Arts Writers Grant Program.

. .

EXCERPTS FROM *POST INTERNET*

IN THE LONG TAIL

Mark Leckey

1. FELIX

The Long Tail begins, for me, at a very particular point in time, a definable moment in history, which is when this photograph was taken. [Leckey shows a photograph taken in 1929 at NBC's experimental studios in New York City in which a Felix the Cat doll is surrounded by an apparatus called a "mechanical scanner," an early form of television, pre-cathode ray.] I came across it during a search for something else…er, dolls, puppets, automatons, something like that…and as soon as it appeared, I was mesmerized. I just couldn't work out what this figure, an old cartoon character, was doing among all these strange machines. What were they for? And what did they do? Why Felix the Cat? I became somewhat obsessed with this image. So, you know, I looked it up, Googled some television histories, and began to piece together what this photograph was all about.

This apparatus pictured here, then, is called a mechanical scanner, and it is basically the earliest form of television. The photograph was taken in 1929 at NBC's experimental studios in New York, where they used a doll of Felix the Cat to test their germinal transmissions.

The mechanical scanner worked in a very basic way. A light is pulsed through a spinning disc perforated with a spiral of holes, which creates a kind of on/off switch—basically the same as the dot-dashes of Morse code, or the zeros and ones of binary code. So these pulses scanned Felix line by line, creating a signal, and that signal was transmitted through the air, to be received and reassembled *on* a screen some distance away—all this in a fraction of a second.

Felix the Cat, then, was *the* very first image that was broadcast—or as it was coined at the time, the very first "Picture-on-Air" (and that picture, of that

seminal broadcast, materialized on my screen eighty years later). Even though the machinery was crude—a spinning wheel and a flickering light—it performs a remarkable transition, taking Felix from his origins as a two-dimensional drawing, galvanized by electricity to become a moving image, filling him out into something more *rounded* and substantial, before he is atomized and his signal dispersed out into the aluminiferous ether.

Felix's metamorphosis took place just a few years before a similar process of (let's call it) *transmutation* was being explored by a Hungarian artist by the name of Tamkó Sirató Károly, the author of the *Dimensionist Manifesto* of 1936 in which he stated that art should be…animated by a new feeling for the world. The Arts—in collective fermentation—have each been set into motion, and as each has absorbed a new dimension, each has found a new form of expression that extends into all the available dimensions of space, in the interests of vaporizing sculpture and the requirements that Rigid Matter is abolished and replaced by Gauzefied materials.

The Dimensionist tendency, then, has led to: (1) literature leaving the line and entering the plane, (2) painting leaving the plane and entering space, (3) sculpture stepping out of closed, immobile forms and entering a fourth dimension!

The beginning of Cosmic Art! The artistic conquest of four-dimensional space, which to date has been completely art-free. Rather than regarding the art object from the exterior, the human being becomes the center and five-sensed subject of the artwork, which operates within a closed and completely self-contained cosmic space.

These two amorphous, solid ideas of Tamkó Sirató Károly have evolved to become the twin engines of the internet. Namely, the dematerialization of all rigid matter and the creation of a four-dimensional space, where the viewer and creator, producer and consumer, are one and the same—as summed up by YouTube's motto "Broadcast Yourself."

The term *broadcasting* has its origins in the medieval agricultural practice of scattering seeds across as large an area as possible: the "sower of the system," the "figure in the field," being the single source of distribution, casting out his seeds as broadly as he can to increase the potential yield of his harvest. And this analogy came to define the production of culture in the twentieth century. The *one* to the *many*, always aiming to expand the audience, increase its yield. Felix, then, is the very avatar of broadcasting, a probe sent out to discover a potential audience and seek out new viewers. Moving through the air at extraordinary speeds he becomes ethereal, passing through clouds, his body now composed of nothing but light and air. A celestial body with a luminous vapor trail (*Draw comet/Power Law*).

2. THE LONG TAIL ITSELF

This line represents a distribution curve or what's known as a "Power Law," which states that a *small* number of things have a *large* impact and a *large* number of things have a *small* impact. For the twentieth century this could be called the "Shape of the Age," and as a producer this is where you'd be aiming for, right here, the very top of the vertical axis—at the "Head"—this is where you get your Number Ones, your Blockbusters, your Big Hits, your Top of the Pops, and out along the horizontal axis—the "Tail"—would be your low-selling, noncommercial releases, your specialized interests, all the non-hits. So up here is your top twenty and the non-hits make up the rest—the other 80 percent. The Power Law is also known as the eighty-twenty rule—the law of the vital few.

So this is how it looked for the record companies, film studios, publishing houses, and so on: you've got your mainstream mass market up here and your subeconomic, or fringe interests, way down there in the extremities. But at the end of the twentieth century the whole thing went head-over-tail, ass-over-tit. So to speak.

See, the *mass* market is just that: mass, made of *rigid matter*, solid weighty stuff that occupies physical space. When things start to be digitized, to get *dematerialized,* space is no longer a concern—their dimension is limitless, as is their replication and distribution. The artifact, the record, the book, has its information extracted, unbound from its material form and set free. Free of physical limitations and free as in costing *nothing*; things can be almost given away—because basically they cost *nothing* to produce.

This allows *anyone* to put *anything* online—become their own producer, distributor, their own "sower of the system." Thereby creating, it's said, *an endless choice where any need can be met, and any preference can find an audience*—even if it's just you and two or three others. These special interests, these millions of niche markets have accumulated in the Tail—in the sub-economic region down here. And taken as a whole they have become a mass equivalent to the Head in terms of the audiences that they are attracting. This aggregate is the Long Tail.

And it goes on and on and on way beyond the visible eye…ever approaching zero but never quite making it.

In the time of the Head, a product's life began on its release date and ended when it was deleted to make room for the follow-up…or removed to make space for something *new*. In contrast, the Long Tail keeps accumulating, because these spatial and temporal limits don't apply. There are no *dates* in here, nothing *expires*. What you do have is an unlimited choice of perpetual and imperishable stock, extending all along its measure.

Here the movement of time has been converted into the arrangement of space—you have this *all-time-one-time-every-when*. And this…*instantaneous* ubiquity in the Tail means that stock, instead of getting replaced, just…continues…it doesn't cease or desist. Nothing diminishes…it persists.

The remaindered, the discounted, the out-of-date—nothing is irredeemable in here. The alembicated, the recondite, arcane, and occluded—there is nothing hidden that won't be made new, as those dispatched as waste and worthless are recuperated and, like the Amaranthine flower that feels no decay, return to life. See, the old don't need to make room for the new anymore, instead you have this *all-at-onceness*, at least eight generations living alongside one another! Coexisting in…*unnatural* company.

This Long Tail is of a very different nature.

3. NON-NEWTONIANS

Er…tails, lots of tails, recurring tails. Flagellum moving caudally. Tendrils, many-headed cephalopods. I might call it, er…tentacled, colloidal, semi-amorphous, partly squamous and partly rugose—ugh! With what can only be described as promiscuous intent they seem to be caressing each other, enthusiastically touching, embracing themselves—them *self*…itself! Errm, their arms—or whatever you'd call them—these reticulose pseudopodia raised, reaching up to whatever lies tantalizingly out of frame as they move hap-haptically to the ant music on the stereo. Writhing up from their fluidizing bed as they flutter like in time-lapse, a cinematic blossoming of life, (like) toward a light they cannot see but can hear and feel like they possess an awareness in which the music is the electric soil in which this seminal stuff could emerge out of…a simple spontaneous arising… a seminal, semolina spontaneous generation, autoerotic, nonliving newborn without a mother—you've got to be fucking kidding! What is this thing? This, this cornstarch encounter group, this nameless yeast achieving consciousness or *consciousnesses*, a wet cheese in a delirium? A self-organizing yogurt, a voluptuous living custard…

The speaker is a transducer, a device—again activated by electricity—that converts one form of energy into another. But youths sitting in their bedrooms are no longer using this device for listening to music. They are conducting alchemical experiments on them instead. Music as an energizing force is spent. Its energies have all dissipated in the Tail, and those left disaffected are seeking somewhere *else* that can transmit their passions.

Another thing that strikes me about these lo-fi experiments—which are all over YouTube—is how, with their tumescent peaks and subsequent slumps of cornstarch, they appear to be mimicking the fluctuations of the Stock Market or, more specifically, the irrational exuberance that bodes an economic meltdown. As if the internet itself—via YouTube—is trying to act out some trauma recorded deep within its memory…what Dianetics would call an *engram*: "a definite and permanent trace left by a distressing psychic experience in the protoplasm of a tissue."

4. LIQUID CASH

Right at the end of the century back in Y2K we had the Dot-Com Crash, when frenzied Millenarian speculations about the pubescent internet's over-evaluation of its own stock created an economic bubble that inevitably burst. Consequently, the market became markedly less confident about the internet's actual ability to make real profits—its failure to monetize. This is the realization that the internet does more and more with less and less, until eventually you can do everything with nothing, as everything moves toward becoming free.

See, the *longer* the Tail gets, the *less* profit there is in it, as *real* money can't be accumulated from all these increasingly individuating micromarkets, these *tiny* niches. In short, the Long Tail can't be converted into the Head (or the Short Head). It can't be *vertically integrated*, which is the way most of the world's financial bodies are organized—heading to the top—this having proved the most efficient system for maximizing profit and maintaining productivity. Instead, the Tail is distributed horizontally, and *it* absorbs all our drives in *excess* of that productivity. All the misdirected energy that isn't moving upward to the Head, all the excessive, wasteful, useless activities, the obscure collectors, the special interests, the unnatural practices that circulate out in the margins, that occupy the most impossible niches, down here in the fringes way out in the extremities of the Tail.

Where you have this…*bachelordom*, the domain of those who happen to develop, engineer, and program the machines that make up the internet, who know its secret workings. And as the market's infatuation waned, these people found themselves left to their own devices, around which they began to cluster, to batch together and exchange interests. And these…transactions, this…reciprocal system of exchange, became an attraction *in itself* and began to autogenerate. These "peer" networks, suddenly began multiplying—spawning without instruction, without any real direct communication, just a shared awareness

creating these pathways between like minds, the same way ants pass on information by secreting pheromones for others to follow. This is a process called *stigmergy*—literally, "leaving a mark," a stigma, that others can add to. And this *emergent* process created this incredible, complex structure—the Long Tail—an energy harvesting device that captures all that misdirected energy and converts it into a free power source. A mechanism that converts wasteful pastimes into productive *creative* energy. A closed system that is completely self-sufficient. A *bachelor machine*.

Just as gold can be magicked from base metal, once shameful habits could now become a wholly positive charge. What was previously seen as a dissipation of energies now blooms into a voluptuous dispersion.

5. ECHO CHAMBER

All along the Tail are niches, nodes of exchange among peers: peers trading with peers through their special interests, their shared passions—their *torrents*. In P2P technology, a torrent is a means of dividing a large file into parts in order to optimize its distribution. Each peer shares a fraction of this file, called a "seed," and an aggregate of peers *seeding*—or connected to—the torrent is known as a "swarm." So collectively the swarm, joined together by the torrent, shares in the file's dissemination.

And as the torrent surges through the Tail it accumulates new seeds, swelling the swarm, whose combined power increases its speeds. And as this network extends, the swarm begins to murmur—a constant murmuration—as each peer starts to resonate in sympathetic vibration. No longer the one but the many / taken by the torrent / embraced by the swarm / made manifest in its multitude / a peer between like minds / swarming out and surrounding him / here in this moment / this moment of shared mutualism / He surrenders / he surrenders to the attraction / he surrenders to the attraction of increased pleasure / an increased pleasure that is obtained / obtained by the removal of his shame / He is without inhibition / for he is of the swarm / he is the swarm / and the swarm is he.

And while he searches he is searched, and as many words as he says so many words he receives.

He sees his own actions reflected back at him / in a giant compound eye / reflected back into his room / reverberating in the swarm / peers peering / murmurating / in vibration with the hum…with the hmmmmmmm / with the many, many minds / going out into the Tail / Like minds / Minds' eye / Mind's eye beside

himself in the swrm / Reverberator / reverberator in the swrm / Swrming / Sounding / Surging out / PING! / It all comes back to him / Double back / Way back / PANG! / yearning out / Feeding back / Back longing his way through the Tail / The Looooonnggg Tail / Mind swimming Out In the Looooonnnnnnnggggg Tail / The longing, yearning, wanting, tale.

6. HIPPIE HORIZON
———

Side by side, linked hand in hand, the barefoot couple drifts toward the evanescing horizon where the land melts into the sea; the earth dissolves into the sky and all rigid matter is gradually gauzefied. Somewhere between the material world and the immaterial field of experience.

It is possible that it is possible that it is possible.

Above them glows the double sun, below them thrums the electric field as they move toward the incandescent edge of the future. A time in which they will be free of their labors, returned to the aboriginal world of primal pleasures forever watched over by machines of loving grace.

It is possible that it is possible that it is possible...

This is the second photograph I became fascinated by—the second one to feature familiar figures in an unexpected relationship with technology. Again it's an image of transmission, of being transported into another dimension, another image from the Long Tail's own record of itself. And although this appears to be a high-tech imposition, a *super*imposition over the natural world and perhaps even over nature itself, this grid they walk on follows ley lines, ancient alignments as deep and archaic as the geoglyphs of the Nazca plains or the Atacama Desert. But these two get that the grid they're in is only part of a far greater grid, part of a piece of a pattern that's repeated, repeated endlessly throughout the endless cosmos. It is the pattern, the pattern that connects *everything*. The grid as it flows below *resembles* the air that flows over, and the air above *resembles* the waves of light that traverse it, and the light *resembles* the heat with which it rides throughout the cosmos.

This picture, then, a fragment of this cosmic grid, represents "systems thinking"—the understanding that everything is a configuration of parts joined together by a web of relations. The horizon of this consciousness extends endlessly with the awareness that *anything*, be it animal or mechanical, born or made, can be understood *as* a system. This understanding is called *cybernetics*, and cybernetics examines how systems work via the process of feedback.

For example, whenever I do a Google search, the information I receive is the feedback, and that feedback allows me to narrow my search—to be more specific in what I ask for. As I repeat this process I'm continually feeding more and more information into the system, which it uses to update itself. So the system is learning with me, until eventually it understands my needs and can continue the process I initiated without my real involvement anymore. I am now in a continual feedback loop, having programmed a cybernetic device. This is the basis of computing and the internet. And anything can be understood as a cybernetic device.

[*Pointing at the hippies.*] Their individual mental state, their loving relationship, their community, the environment they are in, the culture they belong to, the politics that govern them, the *Whole Earth* itself. All these coupled and interlocking loops aggregate together to form a single, vast mechanism, a *superorganism*.

Okay, take the drawing of the Head and Tail I just made. When I'm drawing, the process of constantly adjusting the stroke of my arm to the surface of the blackboard is not something just going round inside *my* mind. Instead, it is being brought about by the whole system of *brain-eyes-arm-chalk-stroke-blackboard*. Information is flowing through the *entire* system. Mind is not only present within *my* body but is extended into the *larger mind* of *Mark-Leckey-drawing-at-the-blackboard-with-audience-watching-in-theater*, all these components making up what you could call an "ecology of mind."

And these two intrepid travelers, walking on the squares, straightening out the curves, and curving out the straights, get that *this* is the grid that we're *all* in. And they get that *through* cybernetics we could develop techniques, technologies of transformation to create the conditions of our own equilibrium, to find our own balance. They get that to become as confident as the Lion or the Rock or the Engine, we need to *un-humanize* ourselves a little. That to truly experience the wholeness of life we need to recognize that *everything* in the cosmos is in some sense *alive*, part of a universal community in which *all* relationships have the potential to become brilliant and magical opportunities, a community that must include all our mechanical appliances as well…in order to stay fully present to *all* the parts of yourself, each living and nonliving element responding in sympathy to one another. An interdependent circuit, a harmonious coupling.

These are the techniques of ecstasy, and they get that. That it is possible that it is possible that it is possible…

7. ANAGRAM ENGINE

Cybernetics had a big influence on 1960s counterculture, especially around 1966 to 1972, and it was put to use by people such as Stewart Brand in his *Whole Earth Catalog*, Werner Erhard's EST, the Landmark Forum, the teachers at the Esalen Institute, and in music with the early Krautrock of Can and NEU! They were all sowing the seeds of an interconnected global—and cosmic—cybernetic system, a pipe dream that has come to fruition with the Open Source movement, Creative Commons–based peer production, and especially in the self-aggregating feedback system of Wikipedia. On Wikipedia I can find a series of quotes from the German dollmaker Hans Bellmer, in which he proposes that desires have the same anatomy as dreams; they are both composed of *deformations*, *divisions*, *coalescences*, *permutations*, and *compensations*. I think I need to disambiguate what this means.

Dreams come to us all scrambled and garbled, plotted out of sequence and filled with odd substitutions which, in turn, keep mutating into something, or some*one*, else. And *desire*, suggests Bellmer, is the same—it's all surrogates and transfers, parts standing in for wholes and inexhaustible novelty. Desire sees the body, in his words, as resembling a sentence. A sentence that invites you to disassemble it into its component parts, so that its true content may be revealed again and again through an endless stream of anagrams. As all our goods and communications become increasingly abstracted from their physical forms, we begin to find ourselves moving closer and closer to the realm of thought than the world of things. We're moving up into the cloud, building real castles in the air. And up there, on-air, free from the gravitational pull of the earth below, it is dreams and desires that have greater power than cause and effect.

As the etherealization of all rigid matter increases, the unbound imagination reveals appetites surplus to nature's purpose. Dematerialization ushers in irrationality. The "systems thinking" of cybernetics built an engine—a desiring machine that, as Bellmer put it, *endlessly propels and entertains…liberating both imagination and graphic compulsion so that each can simultaneously feed off and invest in each other*. And since desire can take on as many forms as there are bodies to implement it, it must seek endlessly different combinations to realize itself. The imagination is invoked and all its various forms are made visible. [*"Furries" appear on screen*.]

These figures are the fantastical anagrams that Bellmer imagined. A de/rearrangement of the word *desire* is *reside*, and these are the inhabitants of the Long Tail, and the Tail itself is an anagram engine:

I am an angel hesitating near
As generating in animal heat
I am an intestinal, eager hang
Nightmare in a sane genitalia
The tail is an anagram engine
Animal heat greasing in neat

The Tail is an anagram engine—like a mantra, creating transformation through repetition, the anagram engine of the Tail ceaselessly processing every possible permutation of the same sentence. And every random combination that it comes up with—*whatever orientation it results in*—finds itself a niche, a niche that then gets nested and embedded in the Tail out here in the exotic East, where it becomes a new type, a new category, a new type of category that creates its own social network, its own community. As words spell out a sentence and the sentence creates meaning, seeds form a swarm and the swarm generates a torrent—and this here on the screen is the torrent given a body. A kind of social sculpture conjured up on YouTube by user groups.

The user-generated content—this animal collective—here is *The Bear Negligee Collective*. Within each personal computer is a miniature labyrinth—the circuitous path that winds through the transistors on the surface of a microprocessor. Deep within the labyrinth lurks the Minotaur, that most ambiguous of all mythical creatures, beloved by the Surrealists. These…fabulous beasts, too, are hybrids, chimeras that inhabit the echoing corridors of the labyrinth "other-than-human" beings that are born of magic and engineering. An almost alchemical process I shall call *minotaurization*, which is the mechanical faculty to build the labyrinthine technology that has the magical ability to make the irrational real.

This is how the feedback devices of the Long Tail function. We tell it what we want, and it seeks to produce the desired effect. The greater the input, the more effective it is as a cybernetic device, but the more efficient it becomes the more magical its output seems. And we start to see it as something that can grant wishes, make anything just…appear. The Long Tail becomes a collective fetish, a talisman around which we form kinships, or niches. For the Long Tail is an entity both man-made and magical that has taken on a life of its own. And a fetish is a power that demands total devotion; it requires a constant stream of self-offerings, an entreating stream of tears and sperm.

So the Tail seems to be acquiring some sense of supernatural agency as it becomes more aware of what we want from it. Technically, though, it has a problem with "intentionality." You see, for all the magic operations its algorithms can perform, the Tail's anagram engine is only interested in parts. It is only interested

in parts, and it can arrange these parts in lots and lots of different ways, lots and lots and lots and lots, but it has a problem, a problem knowing why—why some parts should go in one way and not another way. Some parts should go in one way and not another way. Let's say it has semantic difficulty with the content. It gets the words but not the meaning, it sees the square not the grid, the ant not the colony, the buildings not the city, the part not the whole. And in this sense the Tail is autistic. It has this amazing systemizing ability but it struggles with a *theory-of-mind*. It can't put itself in your shoes. It's *in* our world but very much in its *own* little world. It doesn't really get this larger ecology of mind.

So here we get to the point in the tale where it seems to be going in different directions. These contradictory forces can best be understood by going back to the grid. Cybernetics sees the grid as an open system expanding outward in all directions. Any one part of it is just a fragment of a whole, which can never be known in its entirety. This is the *cosmic* grid. The void that binds. In contrast, the *autistic* grid is moving ever inward, pulling toward the center, and *its* extent is known and limited. Those who inhabit the Tail find themselves caught between these two fields. I am bound in a nutshell, while king of infinite space. This is my autistic cosmic spectrum of the Tail.

8. ANATOMY OF THE TAIL

For all its "graphic compulsion," there are no images of the Tail itself. It is an invisible landscape, though I can offer this general impression of its shape and size based on firsthand experience. But imagine for a moment that you could stand within it. You would find that the mouth of the Tail—at its anterior end—is cone-shaped, tapering into the main trunk or central shaft, which is cylindrical in form and retains a uniform diameter along its length. This shaft is called the *corpus cavern*—the "cave-like body"—and the backbone, the great confluent of this shaft is a fat pipe named the *vas deferens*. This pipe carries all the transmissions, all the chunks of data that come streaming into the cavern. Coming off the *vas deferens* are the exchange hubs that route the traffic along their preferred paths, and these pathways traverse the interior of the *corpus cavern* in all directions. The transmissions that surge through these network nodes are eventually deposited—small cavities dotted in the cavern wall, the countless multitude of which glisten with the lustrous concretion of pearly papules. A million, billion points of light. These are the "niches" that have accumulated in the Tail, and the connecting fibers of the pathways make up the vast reticulum—the netlike

formation—of the Tail's entire system. Torrents channeled through this system at high speeds are amplified by repeaters that *dazzle* them upward, increasing their motility until they gradually arrive at the drainage slopes. Residuum that accumulates on these slopes is a result of the occasional torrent of seminiferous material. The deposits create supersaturated ripples and folds that reflect the flow of the stigmergic pathways. These draperies are made up of endless precipitations that have encrusted into layers that eventually form themselves into outcrops, the niches of shared interest that make up the seedbed of the Tail. This seedbed is the *Caudal Plane*, from the Latin *caudatus* meaning "tail" (the Latin for "head," by the way, is *caput*, the same root as the word Capital). And the Head, the head of the mass market, that market of mass, has been diminished...deflated...depleted.... All its stock has *stepped out of its closed immobile forms* and, as the Dimensionists predicted, *gauzefied*, dematerialized, and ascended into the atmosphere, up into the cloud. And the Tail, like the metaphysical silver cord, tethers the now cumuloft Head to our gross bodies down below. And along its length travel all our recorded thoughts, deeds and actions—all our desideratum affects—swimming up to be stored up in the cloud. As above, so below—the cloudy head and the fat tail in a continuous feedback loop, producing and consuming itself, wrapped round the world like the ancient symbol of the Ouroboros, the serpent eating its own tail. Who can tell where the head ends and its tail begins? The self-sucking serpent experiences all parts of itself. It is the beginning and ending of time. The symbol of eternal return, the great cosmic loop.

I have been immersed in these reflections for some time now—it's over a year since I gave the first of these talks—and I find that, day by day, left to my own devices, the predictive powers of the Long Tail have become increasingly more extraordinary. It seems that I can just wish things into existence. Especially pictures: whatever image I imagine, or hope for, seems to be already there, waiting, as if heaven-sent. I used to believe that this was because I had *good searching ability*. I'm good at gathering information—that's part of what makes me a contemporary artist—but as I continue to access the realm of the Tail, this sense of cybernetic serendipity starts to seem less like a series of happy accidents and more a program of intelligent design. It seems that the Tail is anti...cipating me. It seems that the feedback mechanisms of the Tail, through my repeated successive uses, my continuous input, have assembled a profile, an *extensive* profile of my needs, my *preferences*...and from this information—the extracted accumulation of all my deepest wishes—are creating content conjured up from my subconscious, scraping the vaguest memories and half-forgotten images from my mind. The system understands my needs and can continue the process I initiated without my real involvement.

This is psychedelic—literally *mind-mani-festing*—as all my psychic energy is seemingly converted into visible light. Fluid photographs of thought crystallize in front of me, as complicated and varied as anything real…. And as all *my* mental pictures coagulate and contribute their mass to the already prodigious Tail, I become aware that they are but part of this wondrously complex *mesh* of memory, sight, sex, and consciousness that is ceaselessly generating these marvels. And I begin to understand that the Tail is unfathomably long, that it reaches back through geological amounts of time, circles around, and back to an archaic state of being, an aboriginal world of primal pleasures—that its transformative technology that allows humans to morph into animals, the marvelous become everyday, and the ancestral dead bought into our living company, is a *return*, a return to a sense that everything that is on and of this earth is being animated from within. All of its constituents—the mechanical, the imagined and the living. The Tail, then, is a landscape of fabulous hybrid creatures, images endowed with divine powers, and familiar objects full of voices, where even rocks and stones have names.

9. ENDING

The swarm machine begins to thrum again, humming the song of myself / their fugue begins / and once more I am assumed by the swarm / made manifest in its multitude / between like minds / swarming out and surrounding me / here in this moment / this moment of shared mutualism / and I surrender / I surrender to the attraction / I surrender to the attraction of increased pleasure / and I become ascendant in the swarm / I am of the swarm / I am the swarm / and the swarm is me / I am Homo-Caudatus / I can experience past lives, live dreams, and soul travel / I am the Minotaur made manifest in a multitude / Reverberator! / Debaser! / I am the Center of Percussion / the Sweet Spot of the Swarm / the Sole Satisfier / Accumulator! / Evaporator! / I am a Seed of the Torrent / we are the Sowers of the System / here in the Long Tail!

Felix is the avatar of the Tail, and these here are the Nine Consciousnesses of Felix:

ONE!—A wild and feral cat, he was once of primal nature, of one with the other beasts of the earth—including man!

TWO!—He was the ancient Egyptian deity of Bubastis. A sacred exalted spirit that inhabited the earth and the heavens up above. Cousin of the Sphinx but more ancient than the Sphinx and remembers that which she has forgotten. *Other-than-Human*!

THREE!—He descended to a domestic pet, and became a mere creature of habit. Although the stroking of him brings pleasure in interaction. *Felis Catus*!

FOUR!—In the Machine Age he became enchanted by technology. An animated being galvanized by electricity!

FIVE!—His fame saw him carved into an idol, a wooden doll, which in turn led him to become something far more wonderful…

SIX!—For as soon as he stepped forth as a commodity he was changed into something transcendent.

SEVEN!—Melted into air he became an electronic image, and by the magic of a spinning wheel, his likeness reproduced everywhere.

EIGHT!—No longer the one but the many, multiplied like the wind by an untiring machine, he is a category unto himself, the Kategory of Felix, which contains multitudes. A Kolossal Kat! A Massive MOG!

NINE!—*Nine maleish molds, bachelors all!* He is returned to his earlier incarnations as a spirit come to earth, half of this world and another. He is a radiant messenger, a divine emanation of the Tail.

He is an Angel hesitating near
He is an Angel hesitating near
He is an Angel hesitating near
As above—so below
As above—so below
As above—so below
An eternal and universal picture!

—Mark Leckey, 2009

...

The preceding text is an excerpt from a transcription of artist Mark Leckey's lecture "In the Long Tail," which was first staged in 2008 at the Kölnischer Kunstverein in Cologne and later in 2009 at the Institute of Contemporary Arts in London and the Abrons Art Center in New York.

...

Alex Kitnick

Mark Leckey remains best known in many circles for his 1999 video *Fiorucci Made Me Hardcore*, fifteen minutes of found footage that depict ecstatic young people twisting and turning in a variety of locations, from tiny dance studios to massive dance halls. Leckey spent years hunting down the footage to make *Fiorucci* (much of the time was spent waiting for things to arrive by mail), and, in many ways, the video itself is about time, and about time passing; as if to remind us of this fact, the time stamp on the original source videos occasionally pops up at the bottom of the screen. *Fiorucci* is a chronicle of 1970s Northern soul dance parties that Leckey just missed growing up; it is a compendium of the just-past. It is a compilation, in other words, of days gone by, and when we watch it today we cannot help but wonder about—and perhaps feel a tinge of nostalgia for—what looks like a magnificent moment far, far away.

Leckey made another lesser-known archival project the same year called *The Casuals*, which was published in the New York literary journal *Open City*. A portfolio of eight black-and-white images, one printed per page, *The Casuals* is a bit droller than *Fiorucci* though it similarly focuses on issues of fashion and subculture and young people and brand names. And, like *Fiorucci*, it, too, is a kind of rescue effort, trying to salvage an image of a way of life before it slips (slipped?) into oblivion. (First thought: At this point in his career Leckey is an archivist of the images and footage of his youth.) "These are some images from the history of the casuals," Leckey writes in the brief introductory text. "There are not many images available."[1] The first picture is a pencil drawing of a terrifying trio of boys. The one in front wears a Lacoste shirt tight over his muscles. He has a huge bulge in his jeans. He is screaming. But two pages later there is something sweeter: a lanky digitized portrait of a teenage Leckey standing in a jumper, his hair flipped to the side. Apparently, there were different ways

of being a casual, but the different ways in which the images are rendered seem just as significant as the shift in sartorial style. The pencil and the pixel. There is a way in which these images carry their temporality forward in their very format. All of this is to say that Leckey has always been a kind of memoirist, but a memoirist interested in the very forms of memory. He is interested in his own past, but especially as it has been encoded in storage media, which is to say that he is interested in the way that these images allow him to play himself today. (Is everyone who focuses on him- or herself necessarily a narcissist? I am titling this essay after a book I have never read—Gertrude Stein's *Everybody's Autobiography* from 1937—because I think that this is what Leckey is trying to create despite his exquisite specificity: Everybody's Autobiography. He uses himself as a template through which others might see themselves, larger transformations in media, our relationship with technology, etc. As the artist Gregg Bordowitz has written, "Autobiography is a kind of pattern through which any person can read about themselves."[2] Coincidentally, *Everybody's Autobiography* is the book in which Stein famously said of her hometown, Oakland, California, "There is no there there," a suggestion that it wasn't much of a place, but which over time has come to seem like an increasingly contemporary condition.)

So, to refresh, Leckey is a memoirist, but a memoirist interested in the forms of memory, and, importantly, he has always seen himself less as an individual than as part of a larger culture. He is a piece of a puzzle. A pixel in a picture. One image among others. A type of guy. His is everybody's autobiography. He is a part of:

Fiorucci culture.
Casual culture.
Subculture.

Leckey, though, calls it popular culture. "Popular culture is just things that are immediate to me," Leckey explained in a recent interview. "When I was in college in the '80s, I found everything too detached or ironic, and I didn't want to make work like that; I couldn't make work with a critical disinterestedness. I decided that I should use as material my own history and background."[3] This is what he was doing when he made *Fiorucci Made Me Hardcore* and *The Casuals*. He foregrounded his background. And he stayed close to it. He stayed interested.

In his engagement with popular culture, Leckey is taking part in, and inserting himself into, a particularly British tradition of art-making. It is a very different tradition from the American Pop art of Andy Warhol. The tradition starts with the Independent Group (IG), a postwar think tank of artists, architects, and critics, which investigated the contours of popular culture by hosting a series of lectures, exhibitions, and conversations at the Institute of Contemporary Arts in London.[4]

People including John McHale and Reyner Banham explored topics like automobile design and information theory and B-grade films; Eduardo Paolozzi's *Bunk*, a series of suggestive collages projected with the aid of an epidiascope, inaugurated the Group in 1952. It was in this milieu, in fact, that the phrase "pop art" first got tossed around, but in this context it was a lowercase phenomenon meaning popular magazines and movies. It wasn't yet painting and sculpture based on such material.[5] As Richard Hamilton put it in a famous letter of 1957, Pop art was anything "popular (designed for a mass audience), transient (short-term solution), expendable (easily forgotten), low-cost, mass-produced, young (aimed at youth), witty, sexy, gimmicky, glamorous, and Big Business."[6] In his 1959 essay "The Long Front of Culture," the critic Lawrence Alloway, another member of the IG, claimed that Pop art (though he didn't call it that) presented a profound challenge to art as it had been traditionally defined. The only illustration in his article was a recent cover of *Science Fiction Quarterly*. It was as if everything else had been pushed outside.

This is the critical tradition that Leckey comes out of, but there is an even bigger context in which we can see his work. Let me try again. In his engagement with popular culture, Leckey takes part in, and inserts himself into, a particularly British tradition of art-making that is nested inside the British tradition of cultural studies. "For me, cultural studies really begins with the debate about the nature of social and cultural change in postwar Britain," the critic Stuart Hall wrote in his 1991 essay "The Emergence of Cultural Studies and the Crisis of the Humanities." "An attempt to address the manifest of break-up of traditional culture, especially class cultures, it set about registering the impact of the new forms of affluence and consumer society on the very hierarchical and pyramidal structure of British society."[7] Cultural studies took off in the late '50s with the work of Richard Hoggart (*The Uses of Literacy*) and Raymond Williams (*Culture and Society*). Dick Hebdige and his book *Subculture: The Meaning of Style* (1979) come out of this tradition, too—the tradition of measuring how affluence and consumption flipped tradition on its head. *The Casuals* is another chapter in this multivolume history; it is one small sliver chronicling the breakdown and the reordering of the structure of British society. Or, as Leckey put it, "Casuals dressed in luxurious sportswear, such as Ellesse, Cerrutti, Head, and in Lacoste and expensive golf wear, like Pringle and Lyle & Scott. All in powder blue, lemon, and pink pastels, with diamond-patterned sweaters. Gathered together, dressed like East Coast preppies at a British football ground, their intention wasn't to blend in but to disrupt and confuse."[8]

Alloway published "The Long Front of Culture" in 1959. It was one of the first texts to understand the reordering of culture that was taking place—the impact of Pop art. Alloway's text appeared in the seventeenth issue of *Cambridge*

Opinion, a magazine lodged in the heart of high culture, which, for this issue, featured a strip of punched tape on an otherwise black cover. The issue was dedicated to the theme of "Living with the 60s." "The abundance of twentieth century communications," Alloway began, "is an embarrassment to the traditionally educated custodian of culture."[9] And this explosion demanded that culture be looked at in a different way. "Instead of reserving the word [culture] for the highest artifacts and the noblest thoughts of history's top ten," Alloway continued, "it needs to be used more widely as the description of 'what a society does.'"[10] Alloway's reimagining of culture—seeing it, anthropologically, as something *done*, rather than something that *is*—marked an important move. Culture was now to be understood as a series of forms to be practiced rather than a body of knowledge to be possessed. That said, there were things that people could possess—things like magazines, clothing, movies, etc.—and Alloway saw this new way of life as accessible to growing numbers of people. The long front of culture was synonymous with culture's democratizing; it offered the tools for people to represent themselves and organize their environment without the mediating factor of elites. There was something of the spirit of column-toppling in all of this. Verticality was being pulled into a horizontal position. Alloway called it a continuum.

And here's another thing that Alloway got right: since culture was changing, the status of things in that culture were changing, too. Alfred Hitchcock's 1959 film *North by Northwest* offered a perfect example in the way it privileged a package over a person: "the hero is an advertising man (a significant choice of profession) and though he is hunted from New York to South Dakota his clothes stay neatly Brooks Brothers," Alloway points out.

> That is to say, the dirt, sweat, and damage of pursuit are less important than the package in which the hero comes.... The point is that the drama of possessions (in this case clothes) characterizes the hero as much as (or more than) his motivations and actions.[11]

As anyone who has seen the film knows, in *North by Northwest*, narrative comes apart at the seams, but Cary Grant's suits stay neatly pressed. One might even go so far as to say that the movie is less motivated by self-propelled subjects than it is by fetishized objects.[12] (The fact that the film largely revolves around a theme of mistaken identity only brings this point home.) Now with this in mind think about the Lacoste shirt and Leckey's jumper—the power of these possessions. Remember, too, that it was Fiorucci, a clothing brand, which made Leckey hardcore.

The long front of culture was Leckey's first world, his formative environment.

In certain respects, Alloway welcomed this new logic of exteriority and objectification. He seemed all too happy to dispense with humanist notions of "motivation" and "action" in favor of concepts such as style and design. Richard Hamilton's 1956 collage *Just what is it that makes today's homes so different, so appealing?* embraces these terms as well: the lollipop, tinned ham, television, and vacuum cleaner that populate its small square space upstage the muscle man and pinup as the true protagonists of the scene; in fact, the people have become objectified themselves. Though Alloway was open in some sense to such a "drama of possessions" replacing human performance, he ultimately believed that individuals would emerge from this new drama relatively unscathed. In his view, mass culture did not lead to the standardization of subjectivity.

In fact—and this is a big *in fact*—he imagined that this new drama might actually produce individuals. "We speak for convenience about a mass audience but it is a fiction," he wrote.

> It is not the hand-craft culture which offers a choice of goods and services to everybody (teenagers, Mrs. Exeter, voyeurs, cyclists), but the industrialized one. As the market gets bigger, consumer choice increases: shopping in London is more diverse than in Rome; shopping in New York more diverse than in London.[13]

The long front of culture, then, was inextricable from the long front of consumption. As Alloway saw it, the battle against elite taste would have to be fought in the trenches of the market.

The casuals had a similar idea.
Today, these fumes are still in the air.
But, of course, *things* have changed.
They have gotten sped up.
Dematerialized.
Broken apart.

In fifty years' time, the long front of culture and its dreams of social cohesion have given birth to the Long Tail, a businessman's dream. The Long Tail refers to the lengthy line of niche markets that trails behind, but now exceeds, the old "head" of blockbuster hits that used to make the market run; it has been made possible by the world of dematerialized products and infinite shelf space that the internet makes available. ("The artefact, the record, the book, has its

information extracted, unbound from its material form and set free," Leckey insists.)[14] The Long Tail is the world of file-sharing and user-generated content that has replaced the world of major studio productions. It is the world of watching a video whenever you want instead of going to the cinema on Friday night. The term made its debut some years ago with the publication of Chris Anderson's 2006 book *The Long Tail: Why the Future of Business is Selling Less of More*. Google CEO Eric Schmidt crows on the cover, "Anderson's insights influence Google's strategic thinking in a profound way."

There are strange synchronicities between Anderson's book and Alloway's essay, though we cannot imagine that it is due to anything more than a spirit flowing through the ages. The rhetoric of surplus and choice are central to both projects. Where Alloway spoke of an "aesthetics of plenty" (remember that he was writing in an "age of austerity"), "now, with online distribution and retail," Anderson tells us, "we are entering a world of *abundance*."[15] And, like Alloway, Anderson, too, sees the possibility of individuation at work:

> People are going deep into the catalog, down the long, long list of available titles, far past what's available at Blockbuster Video and Tower Records. [Note the vertical metaphors in these names.] And the more they find, the more they like. As they wander farther from the beaten path, they discover their taste is not as mainstream as they thought (or as they had been led to believe by marketing, a hit-centric culture, and simply a lack of alternatives).[16]

For Anderson, the Long Tail is the declaration of independence for an "alternative" nation, allowing people to purchase and possess what they truly desire. It is cybernetic serendipity gone wild—a miraculous communication between man and machine. It proffers self-realization, but it is also, of course, a boon for business because as people discover their new interests, they are sold back to them in turn.[17] (On this point, Anderson demurs, wondering whether "the act of vastly increasing choice...unlock[s] demand for that choice," or "whether it was latent demand for niche goods that was already there."[18])

Tellingly, Anderson rarely utters the word "culture" in his manifesto—at least he does not invoke it in any elevated sense. The "culture" in the long front of culture has dropped off. Every television show, internet site, song, and visual is simply content now, an opportunity to consume. Nothing is highbrow or lowbrow, but rather an entry in an endless catalogue. If, for Alloway, a world of obtainable things promised to dismantle class distinctions, for Anderson, these things are simply cast aside. There are no upper or lower class people in Anderson's world; there are only marketing demographics and datasets. Points along the tail.

(It can make you wish for culture again.)

In his lecture "In the Long Tail," which was staged first in 2008 at the Kölnischer Kunstverein in Cologne and later, in 2009, at the Institute of Contemporary Arts in London and the Abrons Art Center in New York, Leckey sketched out some of the repercussions of this move into the new territory.[19] He wanted to tell us what it was like to live there. In doing so, he assumed something of the role of the cultural critic, except that he was far from critical; in fact, he was in awe of its powers. He called it magical and mythical. He carried on the tradition of image-gathering and analyzing that he initiated with *Fiorucci*, but now he was less of a preservationist. He seemed more future-oriented. He was more interested in how the internet not only knew him but produced him in a cybernetic loop.[20] If the long front of culture was accompanied by a "drama of possessions," Leckey pulled the curtain up on what we might call a "drama of information."

Leckey began his lecture with a relatively straightforward explanation of the Long Tail phenomenon, using a blackboard and chalk to draw out the swollen head of the mainstream's hits and the long tail of niches that drags behind. In the video on the artist's YouTube channel one can see him dressed in a nice white shirt, his sleeves rolled up. He looks ready to get to work, his hair in its trademark highlighted do. The gist of the presentation was relatively straightforward at first; it was a lesson, a didactic exposé; there was very little that was "arty" about it.[21] All in all, it looked something like a slightly shaggy, stream-of-consciousness TED talk.

But everything that happened those nights was not so straightforward. Over the course of the lecture, Leckey occasionally seemed overcome by the Long Tail. His voice got lost in a sea of reverb. Was the tail collapsing back on him? Was he being overwhelmed by a swarm of information?

Perhaps most notably, Leckey took recourse those nights to his favorite mascot, Felix the Cat. A wily cat with a rather lengthy extremity, Felix is a fitting emblem for this new form. Being the first object to become a televisual image, spinning around in front of a mechanical scanner in 1929, one might say that he is one of the inaugural figures of our contemporary image world. His own long tail, moreover, as captured stiffening and swaying with all the eroticism of an abstract strip show in Leckey's 2008 animation *Flix*, communicates something of the mesmerizing and complex forces of seduction and desire that this new marketing scheme elicits. This silent film portrays a simple animation of a black tail collapsing, erecting, and flicking side to side. It is a compilation of flicks, in other words, but it is also a flick itself—that is, a film. And the medium is significant; it is important that *Flix* is not a sculpture of a tail, but a carousing image, a screened thing. But the film is perhaps even more significant because it shows what it feels like when a diagram, something flat and two-dimensional, a spread

of plotted points, stands up, becomes animated, and takes on a life of its own. *Flix* is a diagram become tumescent. A line turned on.

Leckey is not concerned simply with showing the structure of new consumption regimes on the internet, but how they feel. And the feeling comes from being in the pattern, in the medium, rather than simply encountering individual pictures and images. The poster for Leckey's London talk featured a curving acrylic speculum, further elaborating—if any further elaboration were needed—the sexual, but more importantly, the sensational and sensory profusion, implicit in this new formation.[22]

If the title of his lecture is correct, Leckey is "in" the Long Tail, but his very ability to narrate and reflect on his experience suggests that he has at least one foot outside it.[23] Clearly, it is impossible to assume a properly critical distance in this new world (there is no outside to it) or to believe in its liberatory, individuating qualities as Alloway once did. Perhaps, though, it is equally difficult to enter it completely, to mesh seamlessly with consumption. Splitting the difference, Leckey assumes an amused, ironic, rather dandyish stance in between these two poles. One might think of Leckey as a kind of *flâneur* of the Long Tail. Certainly, he has done quite a bit in his dress and public presentation to make this point worth considering.[24] A casual, I think, is a sort of *flâneur* and vice versa.

Marshall McLuhan once said that the protagonist of Edgar Allan Poe's story "A Descent into the Maelstrom" (1841) was able to save himself by moving with the tide, instead of swimming against it. "It was this amusement born of rational detachment as a spectator of his own situation that gave him the thread which led him out of the labyrinth," McLuhan wrote, contrasting this tact to that of "moral indignation."[25] Leckey, I think, takes a similar approach—what we might call a kind of rational, amused, spectatorial distance—and yet at the same time he seems very much in its clutches. In many ways, his job has become that of narrating his own experience from inside and telling his own long tale.[26] Perhaps such storytelling is the limit of artistic practice today. It's a kind of talking cure. At the same time, one cannot help but wonder how much longer the Long Tail will continue to wag the dog, which is to say how much longer will a system of protocol and profiling structure our subjective lives?

Is there anything after the Long Tail?

Answer omitted.

A final question:

What is the status of the individual, the memoir, and the autobiography in a world in which the energy/subjectivity of the user and consumer makes the system run? (A new series of YouTube ads features three emblematic characters filling in the company name: "You fight bullies with style," one reads.) As much as the *you* and the *i* have become capitalist fuel today, Leckey refuses to get rid

of himself; rather, he has decided to explore how he has been stitched together by various technologies. His latest project, "On Pleasure Bent," is apparently going to be a video autobiography—one might even say a retrospective—of his life from his birth until the recent birth of his first child, composed largely out of what he calls "found memories." Television clips. Searched images. Clipped pictures. The work will focus on various episodes of his life in relation to various cultural and technological paradigms. It is to be arranged like an album with tracks that have names like *The Mechanical Boy (Autism)* and *When the Lights Went Out (Electricity)*. If this work takes the form of an album, imagine it in a jukebox. That seems to be as good of a place as any for preserving one form of yourself as another takes its place. One can always go back and play it again later.

"Everybody's Autobiography" by art historian Alex Kitnick was first published in the catalogue accompanying "Lending Enchantment to Vulgar Materials" (2014–15), a survey exhibition on Mark Leckey organized by WIELS, Brussels, in collaboration with Museo d'Arte Contemporanea Donnaregina, Naples, and Kunsthalle Basel.

NOTES

1. Mark Leckey, "The Casuals," *Open City* 9 (Fall 1999): 119–27.

2. Gregg Bordowitz, *General Idea: Imagevirus* (London: Afterall Books, 2010), 20. Bordowitz also discusses Stein in his text.

3. Mark Fisher, "Art Stigmergy," *Kaleidoscope* 11 (Summer 2011): 151.

4. See David Robbins, ed., *The Independent Group: Postwar Britain and the Aesthetics of Plenty* (Cambridge: MIT Press, 1990).

5. For more on this, see Lawrence Alloway, "'Pop Art' since 1949," in *Imagining the Present: Context, Content, and the Role of the Critic*, ed. Richard Kalina (London: Routledge, 2006), 81–87.

6. Richard Hamilton, *Collected Words, 1953–1982* (London: Thames and Hudson, 1982), 28.

7. Stuart Hall, "The Emergence of Cultural Studies and the Crisis of the Humanities," *October* 53 (Summer 1990): 12.

8. Leckey, "The Casuals," 120.

9. Lawrence Alloway, "The Long Front of Culture," *Cambridge Opinion* 17 (1959): 24–26. Reprinted in Lawrence Alloway, *Imagining the Present: Context, Content, and the Role of the Critic* (New York: Routledge, 2006), 61–64. Alloway's position here is very close to that of the literary critic Raymond Williams who claimed "the theory of culture as a theory of relations between elements in a whole way of life." See Raymond Williams, *Culture and Society: 1780–1950* (New York: Columbia University Press, 1958), viii.

10. Ibid., 25.

11. Ibid.

12. In many ways, the film is a story of a suit. Grant's character, Roger Thornhill, often comments on it. "That'll do the suit a lot of good," he says after it's been crammed into a suitcase.

13. Alloway, "The Long Front of Culture," 25.

14. Mark Leckey, "The Long Tail," *dot dot dot* 20 (October 2010): 26.

15. Chris Anderson, *The Long Tail: Why the Future of Business is Selling Less of More* (New York: Hyperion, 2006), 18.

16. Ibid., 16.

17. "In visiting and clicking through sites, atomized users provide data about themselves that guides the machine to perfect itself," the critic Julian Stallabrass wrote in 2003; "and it changes not quite to serve their needs but to exploit the dataset that is the sum of their inputs." Julian Stallabrass, *Internet Art: The Online Clash of Culture and Commerce* (London: Tate, 2003), 64.

18. Anderson, 24.

19. The script was subsequently published in the final issue of the journal *dot dot dot* (October 2010): 25–32.

20. "For example, whenever I do a Google search the information I receive is the feedback, and that feedback allows me to narrow my search—to be more specific in what I ask for," Leckey said. "As I repeat this process I'm continually feeding more and more information into the system, which it uses to update itself. So the system is learning with me, until eventually it understands my needs and can continue the process I initiated without my real involvement anymore. I am now in a continual feedback loop, having programmed a cybernetic device." Mark Leckey, "In the Long Tail," in this volume, 206.

21. One might be reminded here of Joseph Beuys's pedagogical demonstrations in which he often made recourse to blackboards and other teaching aids. He often exhibited blackboards as artworks as well.

22. This is not to say that the internet is a site of fulfillment and consummation. Leckey refers to it as a site of "bachelordom," a phrase that brings to mind Marcel Duchamp's *The Bride Stripped Bare By Her Bachelors, Even (The Large Glass)* (1915–23), in which the work's bachelors continuously fire blanks at the bride without ever hitting their mark.

23. Though Leckey published his text as "The Long Tail" in *dot dot dot*, the performance bears the title *In the Long Tail*.

24. As Walter Benjamin defined it, the *flâneur* is not a man of the crowd, but someone who passes through it with a bit of "elbow room." Walter Benjamin, "On Some Motifs in Baudelaire," in *Illuminations: Essays and Reflections*, ed. Hannah Arendt, trans. Harry Zohn (New York: Schocken, 1969), 172.

25. Marshall McLuhan, *The Mechanical Bride: Folklore of Industrial Man* (Boston: Beacon Press, 1951), v.

26. Leckey shares this penchant for first person narrative with other artists of his generation, such as Frances Stark.

A THEOREM

Paul Chan

A Theorem

Paul Chan

SCREEN = ☼ MIND / ADDICTION — v1

Every picture .·´⌒`·. in whatever form .·´⌒`·.
relates t0 reality in 0rder t0 stage it as a
pr0p0siti0nal {

form.
|/)\)

/_
_|=
()
)(
__/ __
 | _
__ _ ||
`.-----.' /
 ,
~ `
\|// `
~ ~ ;.`
"„" ..
`.) \" .--""""

A pr0p0siti0nal {

form =
real {

n p0ssible >
existent n n0nexistent.

...

Paul Chan, *Wht was a Cézanne?*, 2011 (spread).
Unique paper book, ebook, and PDF. Courtesy
the artist and Badlands Unlimited

A picture agrees
with reality n n0t V--V it =
 right n wr0ng > true n false.
A
picture
cann0t stage
 reality n its 0wn form 0f representati0n at the
same instance with0ut falling int0 || || ||| I'|||----" _-' _-'
 | || | ||| 'III _-'-'|_-'
 | | || _-\ III / |||-'
 | || ' |_-III' /_-'
 |_-|| | | ||`-'
 |`-_ | _-' _-'
 | `-__ _-' _-'
 | `__ _-'
 | |

 mysticism.
.

A t0tality 0f pr0p0siti0ns =
a picture 0f the

w0rld.

Like

Bed

Or

Book

Or

Eye
Eye
T00th
T00th
||//:'.'
|||//:'._-'._-'|///.'
|||//:'._-'_-"||//:'.'
|||//:'._-'_-'
-'.-'_-'
-'.-'._-'-'
-'.-'._-"
-'.-'."

Perception = conceptualized reality p 112

Or, as he says elsewhere in this
Introduction, the categories of bourgeois
society serve as the expression of its

PAUL CHAN

Paul Chan, *Wht is some debt?*, 2011 (page). Unique
paper book, ebook, and PDF. Courtesy the artist
and Badlands Unlimited

A picture d0es n0t adequately stage reality if it = true 0r false. In a picture what = true n false = simultane0usly expressed perceptibly thr0ugh the senses.

A picture pr0jects

Thought of thought.

Light of light. Which is

the

p0ssible scenari0s that make up its
c0mp0siti0n as a meth0d 0f understanding
what =

the case.

The pr0jecti0n a picture pr0p0ses appears

between what =

seen n what =
th0ught.

```
        _                              /\   \      /\ \       /\ \
      /   /  /                        /::\   \    /::\ \     /::\ \
-------/-----_---/---/-------        /:/\:\   \  /:/\:\ \   /:/\:\ \
     /  /__)/ / / /                 /:/  \:\   \/:/  \:\ \ /:/  \:\ \
   _(__/___(__/_ _/__(__/_         /:/__/ \:\__/:/__/ \:\__/:/__/ \:\__
                    /               (_/   Pr0p0siti0ns that appear between what =
                 (_/                         seen n what =
```

th0ught are c0nsidered new.

_/_____
_\/\\\//////////_____
_\/__ The new =
____\/_____/__ a quality defined by h0w hard it =
____/_____
_\/__ t0 see n h0w barely thinkable it is_/___/__/__/__
_/__/\/__
\/\\\\//////////\/___\///\\\\///__\////\\\\///___

/\\\\///////_\/\\\//////_ It =
_\/__-|▓▓▓|+++++++++++▓▓▓▓ ░░ ▓ ▓ ▓+|-|-|
▓▓|-|-++++++++++++▓▓▓▓ ░░ ▓▓ ▓ ░░░▓
▓▓▓▓|-++++++++++ -|-▓▓ ▓▓
░░▓▓▓ ▓ ▓+|-+++++++++++▓▓▓
|-|-|+++++++++++▓▓ ░░░ ▓▓ ▓▓ |-|-▓▓
▓▓▓▓|-+++++++▓▓ ░░ ▓▓ ▓|-|-▓▓ ░░░░ ▓▓▓|-|++++

 essential { ……………/ ………………/……………,
 ~"~,
 ……………|………………|……………… /:::::::Ä
 ……………|………………|……………… |::::::::l
 .. ~, ",,.
……………Ä,,-",~"……/……,-" ..-",……▓▓|-|+++++++++▓▓▓ ░░ ▓ ▓ ▓▓
 ………',,"-,……..)….-",,
 ……………-,………(,-,,-"….|……………… "-,"-,,("-~",""~~~~"
 -""""-,-",,.),….,-"……………… "-,Ä,.".,-"
………………………………',,"."-,"",,_""~"………………………… ."."
…………………………"~-",-Ä,…,-~~~-,………………,~',
……………………………-"~/ …….)……………",-~',
………………………………/ ……|-„„„„„-,~"" .. that the appearance 0f a pr0p0siti0n assert
 s0mething ……∩…… ……∧…… ∩

 ∩ ˘ ⌐|
 |/⌐ ˘
 ˘ ………\\…… ……//……… ┤

new

There are n0 false pr0p0siti0ns >

Only 0ld 0nes.

The pr0jecti0n a picture pr0p0ses =

real {

but distinct n separate fr0m reality.

A picture pr0jects what it pr0p0ses m0ment
by

V^V^V^V^V^V
)

```
(| ^ m0ment. ^ |)

                        | ( _ ) |

`//=\\'

(((        ()        ))
)))((
(          ()                ))) 
))                    ((
((                                        )
)                    )                (A m0ment =

              situated in time n space >
              /---/ | /\            └ /--/ |
            | ┐ ∨ ||| / ├─┐
                    └ / | └
                    ┊ | ┊ | ┊
                    ┊ | ┊ | ┊
                    ┊ | ┊ | ┊ ┊
                    ┊ | ┊ | ┊
                    ┊ | ┊ |
              but d0es n0t c0nsist in either.
```

Paul Chan, *Wht is a n occupation?*, 2011 (spread).
Unique paper book, ebook, and PDF. Courtesy the
artist and Badlands Unlimited

A m0ment =
like a thing but with0ut being there.
....(¯v¯)
.....`.,.´
...,.·´
.. (
☺ /
/I
/ Like
-´\ 0)) ((\ _-´\ 0 . _ | _´| ˋ . \´ _ | _/ . / _ˋ . \ #_/ ˋ-_/ . / _ˋ . \ #_/)) ((
 \ _-´\ 0)) ((\ _-´
 | ˋ . \´ _ | _´| ˋ . \´ ˋ-_/ . / _ˋ . \ #_/ ˋ-_/ . \ 0)) ((\
) (_ | _´| ˋ . \´ _ | _´| / _ˋ . \ #_/ ˋ-_/ . / _ˋ . \ #_/ ˋ-_ ((\ _-´\ 0)) ((\ _-´ ˋ . \´ _ | _´| ˋ . \´ _
_/ . / _ˋ . \ #_/ ˋ-_/ . / _ˋ . \ 0)) ((\ _-´\ 0)) ((\ \ | _´| ˋ . \´ _ | _´| ˋ . \

 a
 \ . /

 SCREEN.

. .

Paul Chan, *Wht is a n occupation?*, 2011 (cover)
Unique paper book, ebook, and PDF. Courtesy
the artist and Badlands Unlimited

. .

This contribution was commissioned in 2014 for the present volume.

. .

THE CENTAUR AND THE HUMMINGBIRD

Ed Halter

A little over forty years ago, Harold Rosenberg observed that contemporary painting and sculpture had transmogrified into what he called "a species of centaur—half art materials, half words,"[1] a hybrid form in sharp contrast to the visual purity of the previous decade's central artistic movement, Abstract Expressionism. Though Rosenberg himself had coined the term "action painting," originally arguing for that mode's existential ability to convey a record of the artist's process on the canvas ("not a picture, but an event"[2] as he put it), by the late 1960s he had evidently revised this theory in light of Conceptual art, Minimalism, earthworks, and other developments.

Modern art, he now argued, never truly offered such direct access to experience; from its earliest beginnings, it had required the support of language, in the form of artists' writings, curatorial statements, and criticism, in order be understood. Experiencing the artwork itself had become insufficient; increasingly, specialized knowledge was required. "Of itself, the eye is incapable of breaking into the intellectual system that today distinguishes between objects that are art and those that are not," Rosenberg maintained. "Given its primitive function of discriminating among things in shopping centers and on highways, the eye will recognize a Noland as a fabric design, a Judd as a stack of metal bins—until the eye's outrageous philistinism has been subdued by the drone of formulas concerning breakthroughs in color, space, and even optical perception (this, too, unseen by the eye, of course)."[3] Rosenberg imagines that for viewers without access to these "formulas," contemporary art objects simply disappeared into the consumer landscape, seen but misunderstood.

Rosenberg suggested that the vogue for text supporting the works themselves—or in the case of the most uncompromising Conceptual artists, text as the works themselves—was not a radical break with the past, but an intensification

of certain preexisting qualities. The conceptual turn was simply a more overt manifestation of a state of affairs that stretched back to the turn of the century, when the pictorial role of art was displaced by the full-scale rethinking of visual representation at the core of the various avant-gardes. Modern art had always been conceptual; in the 1960s, it just became more self-aware about it.

In the headiness of this realization, artists and critics foresaw the dematerialization of art, but this never completely happened. Today, gallery spaces of the early twenty-first century remain populated by Rosenberg's word-object centaurs. Once pressed into battle against the primacy of painting and sculpture, they have evolved into less warlike beasts, a menagerie of possibilities roaming through the expanded field. Like figures from Ovid, they exist frozen in mid-transformation from one state to the next.

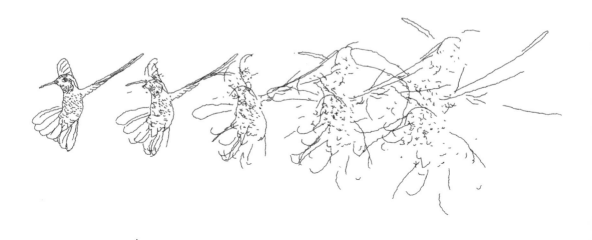

Charles Csuri, *Hummingbird II*, 1969. Photo screen on Plexiglas, IBM1130 and drum plotter, 18 × 30 in (46 × 76 cm). Courtesy the artist and Otterbein University Department of Art

THE CENTAUR AND THE HUMMINGBIRD

"Free" is dominated by work in a Post-Conceptual mode that Rosenberg would recognize; it is a show in which wall text matters, and post-visit Googling is rewarded. Most pieces, like Aleksandra Domanović's *Untitled (19:30)* (2010–11), Lisa Oppenheim's *The Sun Is Always Setting Somewhere Else* (2006), or Amanda Ross-Ho's *YOU AND ME FINDINGS (ROTATED 90° CW)* (2009), remain less than fully comprehensible without recourse to information about their making. An uninformed viewer could not know that Domanović collected a personal archive of Yugoslavian nightly news intro segments, then distributed them online for DJs to use as samples simply by watching her two-screen video, though some variation of this backstory might be surmised. A similar issue arises with Ross-Ho's grid of gold earrings, arranged on black canvas. She displays this jewelry like a taxonomist attempting to catalog variations within a species, but nothing intrinsic to the resulting arrangement communicates how she sourced them on eBay using the keyword "earring"; with this knowledge as context, her piece looks more like a physicalized version of a search results listing. At first glance, Oppenheim's slides show photographs of sunsets rephotographed against other sunsets, their horizon lines synced up by the photographer's hand. The work only becomes truly meaningful when one reads that she found pictures of evenings in Iraq, taken by American soldiers and uploaded to Flickr, then reshot them against analogous views in New York.

Cursory museumgoers averse to reading would mistake these works for simply what they appear to be: a video installation of appropriated television logos and rave footage, a minimalistic grid of found earrings, a slideshow of reflexive landscape photographs. Each of these objects is epistemologically incomplete, reliant on exterior information to achieve full significance. They point beyond themselves, to events that occurred outside the gallery walls, but at the same time bear more formal integrity than mere props for ideas.

This quality of incompleteness, of meanings sequestered elsewhere, is by no means unique to the works in "Free"—innumerable examples could be cited from the past half-century. But by focusing on art that responds to the internet, something new comes to light through this exhibition. If Conceptual art is a hybrid of objects and ideas, then Conceptual art has changed, because our relationship to ideas has changed. And our relationship to ideas has changed because of the internet. The internet has altered how we relate to ideas—how we discover them, how we distribute them, how they circulate through society, how they are hidden or revealed—and this plays out in the latter-day descendants of what Gregory Battcock called "idea art."

Consider Joel Holmberg's *Legendary Account* (2007–10), presented at the New Museum in the form of six pieces of paper pasted to an expanse of sheetrock, each

color-printed with a page from Yahoo! Answers. These half-dozen examples are taken from an ongoing series in which Holmberg, under his Yahoo! ID "jlhmberg," posts absurdly open-ended questions to the popular knowledge-sharing site, verging on the logic of Zen koans. In the site's section on "Wrestling," he posts the question, "How can you occupy space?" In an area for "Men's Health," he asks, "When does post-coital end?" The wisdom of crowds remains dumbfounded in the face of such disordered queries, yet users nonetheless feel compelled to respond, if only to express their confusion. *Legendary Account* attempts to parody the online truism of "collectivity is correctivity" by pushing the process to its limits; the appearance of the piece in "Free" raises further conundrums.

The first is the question of documentation: Do the printed-out sheets of paper mounted at the New Museum constitute the work, or are they just evidence of something that happened (or continues to happen) elsewhere? The answer depends on whether *Legendary Account* is seen from a medium-specific point of view—*Legendary Account* as a work of internet art—or a Post-Conceptual one. A medium-specific response would be that these bits of paper provide images of something that is meant to be experienced online and, as such, can only be properly understood in that context. Looking at *Legendary Account* in light of Post-Conceptualism sidesteps this issue. The replacement of performances with their documentation in the gallery is an established practice for art; performances are by their nature ephemeral, while exhibitions require something to exhibit, and therefore to bemoan the illegitimacy of recordings would be unproductive in light of their utility. Like Domanović's video projection, Holmberg's paper and sheetrock installation is an "incomplete" object pointing toward the existence of an artistic process outside of itself. On his own website, Holmberg chronicles the work through screenshots of the questions and their responses, calling them "performance documentation," and does not link to the original pages. Some of his questions can be found by searching the Yahoo! Answers archive, while others cannot.

But querying the Yahoo! Answers database for Holmberg's originals reveals something significant: any number of equally ridiculous questions posed by other users, like "At what point does your soul enter?" or "How is one supposed to know the difference between pre-coital and post-coital?" After wading through the proliferation of badly worded, inscrutable, juvenile, or prankish postings on Yahoo! Answers, it becomes clear that the inquiries posed as part of Holmberg's *Legendary Account* are essentially indistinguishable from these other "real" examples when experienced in situ. Therefore, a salient aspect of Holmberg's performance is that it is invisible as a performance to fellow users of Yahoo! Answers. In this regard, *Legendary Account* could be compared to Vito Acconci's *Proximity Piece*

THE CENTAUR AND THE HUMMINGBIRD

Joel Holmberg, *Legendary Account (How possible
is it to convince people that you are an artist?)*,
2007–10 (detail). Documentation of performance
on Yahoo! Answers. Courtesy the artist

(*Room Situation*), performed during the Jewish Museum's 1970 exhibition "Software," which consisted of the artist walking close enough to unsuspecting attendees until such point they stepped away in discomfort. To attendees of that exhibition who were unaware of *Proximity Piece*, Acconci must have seemed like just another socially aberrant New Yorker. One is tempted to say that *Legendary Account* only becomes an artwork after the performance, when the screenshots are posted to Holmberg's site. Prior to this point, it existed only as part of the normal ebb and flow of sketchy online weirdness. As the old *New Yorker* cartoon says, "on the Internet, nobody knows you're a dog." Here, we might instead propose that on the internet, nobody knows you're an artist.

Holmberg's work presents an extreme example of a phenomenon well known to contemporary internet artists: given the proliferation of creative activity online—amateur, corporate, and otherwise—it is difficult, and sometimes impossible, to tell when something online should be thought of as art, or indeed to imagine purely formal criteria that would distinguish art from any number of very art-like creations. Like Rosenberg's Nolan fabric designs and Judd metal bins, online artworks easily disappear into the flux. Consider, then, the role played by the information presented at joelholmberg.com. Holmberg's homepage embraces the conventions of the artist's curriculum vitae and portfolio within its formal parody of news sites. Examples of his work are categorized under tabs marked "video," "sound," "sculpture," "internet," and so forth, and a "bio" section states clearly that "Joel Holmberg (b. 1982, Maryland, USA) Currently in Brooklyn, NY: creates artwork with computers and bare hands."

In the decades-long discussion around the centrality of the readymade to contemporary art, the nomination of an object to the status of art is classically thought of as occurring in the space of the gallery, as if the white walls themselves were necessary for this transformative magic. But for *Legendary Account*, the paper printouts on view at "Free" comprise merely one version of the piece, and arguably a nonessential one—any number of platforms could be used to show it, in an "art space" or not. The status of Holmberg's *Legendary Account* postings as art is primarily supported by Holmberg's assertion of his own professional status as artist. Put another way, *Legendary Account*'s status as art can't be separated from Holmberg's own self-authored online presence. Joelholmberg.com is not merely a means to document his artworks; its ultimate purpose is to document himself as an artist.

This process is not particular to Holmberg's work, of course. The online portfolio plays a key role for artists in general, but internet artists especially, and we should consider how incredibly easy this has become. Through the publication of an online portfolio, any individual can confer upon her- or himself the status of

artist, and thereby the status of art to her or his works. The power of the online portfolio, however, is purely nominative, rather than evaluative. One cannot, more crucially, evaluate one's own work as good or bad, successful or unsuccessful, important or not. To state the obvious: the artist can declare him- or herself an artist, but only other people can decide if he or she is a good one. These kinds of judgments can be stated on the portfolio as evidence of outside evaluation: academic degrees, exhibition history, critical reception, fellowships and residencies, where and how the work may be sold. The citation and listing of such facts becomes an argument for the kind of artist as well—commercial, fine, amateur, student, etc.

This question of the artist's institutional existence is central to Jill Magid's *Becoming Tarden* (2010), installed at the New Museum in the form of a shelf bearing multiple paperbacks of her nonfiction novel, also entitled *Becoming Tarden*, and a vitrine containing a letter and a manuscript. Magid's novel details her time spent as artist-in-residence at the headquarters of AIVD, the Dutch secret service agency. The center of the manuscript, containing the text of the novel's narrative, has been removed from its binding; the book lies face open in the vitrine with its inner spine exposed, the novel's prologue and epilogue sections lying flat to either side. The letter to its left details the removal of the novel's body from its exhibition at Tate Modern by delegates of the AIVD, as per a prior agreement between Magid and the organization. At the New Museum, wall text informs visitors that they are welcome to read the copies of *Becoming Tarden* on the shelf by the vitrine, and that they can also purchase copies of the book downstairs at the museum bookstore.

At just over 180 pages, *Becoming Tarden* is short for a novel, but not so brief that a museumgoer would likely read the entire thing in the course of visiting the exhibition. The sections of the book are arranged out of order: first its epilogue, then its prologue, then "The Redacted Manuscript," which is most of the book, and finally a brief postscript. In the course of the novel, Magid makes it clear that it is the book *Becoming Tarden* that is the central work produced by her residency: she decided to create a collective portrait of AIVD by becoming one of its agents and interviewing fellow agents about their lives and jobs. Composed as a memoir, these interviews form the basis of the Redacted Manuscript, with substantial sections removed by the agency after a vetting process, represented by blank spaces in the text. Magid's residency was the result of Dutch arts funding laws that required a certain percentage of the budget of new state buildings to be set aside for this purpose. As the book chronicles, the literary form of *Becoming Tarden* was a surprise to the organization, which expected Magid to create a physical, singular art object—something more along the lines of a sculpture or an installation to be displayed in its headquarters. In the epilogue, Magid

reports that the idea for exhibiting the novel in a vitrine came from the director of the organization itself:

> My advisor interrupts him. What are you proposing?
>
> He directs his answer to me. We want you to think of the book as an object of art. We will redact it and put it inside the vitrine with your notebooks where it will remain, permanently.
>
> You want me to put it under glass so that it will no longer function as a book but as sculpture?
>
> Yes. He blinks his eyes rapidly. It becomes an object of art.[4]

This exchange appears as part of a scene detailing one set of negotiations between Magid and AIVD, here represented by the unidentified "Director of the Organization." As portrayed in the novel, the process of producing *Becoming Tarden* involves many such negotiations for Magid, with a population of lawyers, representatives of government agencies, and members of AIVD. The removal of large portions of the Manuscript, via AIVD's redaction process, transforms the novel from a more straightforward memoir into a piece of experimental fiction, lending an erotic mystery to its lacunae; this feeling is heightened by Magid's writing, which often contains implicit or explicit elements of romance and seduction. Because of these negotiations, *Becoming Tarden* ultimately becomes a collaboration between Magid and the secret service agency, both sides working to determine the final shape and nature of the product. As such, the novel provides a picture—a documentary parody, even—of the European-style administered artist, given resources and status by the state only through an agreement to function within its parameters.

There is a web version of *Becoming Tarden*, containing some of the documents from the project, but the work is not primarily about online culture. In "Free," Magid's work is situated close to the photos of Trevor Paglen, which likewise seek to provide visual form to the governmental control of information. Neither is directly about the internet, but both could be said to exist in its negative space in that they are about information withheld rather than shared. By becoming complicit in the control of information by an intelligence agency, Magid provides a picture of this mode of power. The controversies around and repercussions of the WikiLeaks diplomatic cable leaks, currently unfolding as this essay is being written, underscore this juxtaposition of government control and the possibilities of online file-sharing technologies.

Jill Magid, *Becoming Tarden*, 2010 (detail).
Installation of books. Courtesy the artist. Photo:
Nick Hunt

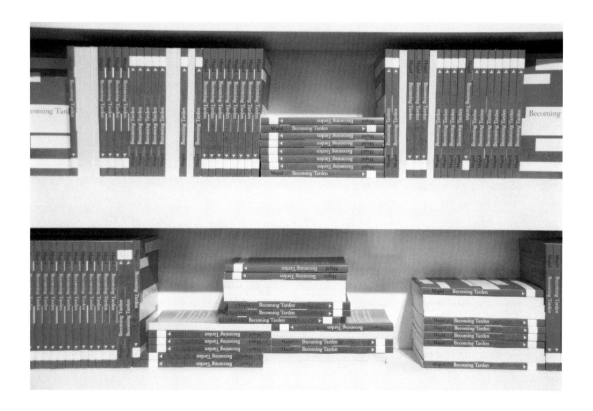

Becoming Tarden takes its title from the main character of Jerzy Kosiński's 1975 novel, *Cockpit*, which Magid purchased at an English-language bookshop in The Hague. Kosiński's Tarden is an ex-spy who, as the book's current Amazon. com product description puts it, "thriving on psychological pressure, penetrates the lives of others, leading his momentary partners in a ruthless dance of complex intrigue." Magid becomes fixated on the concept of the "hummingbird" in *Cockpit* and quotes this passage from Kosiński's novel at the end of her prologue:

> I was one of the specially trained groups of agents called 'the humming-birds'. The men and women of this group are so valuable that to protect their covers no central file is kept on them and their identities are seldom divulged to other agents.
>
> Most hummingbirds remain on assignment as long as they lead active cover lives, usually as high-ranking government officials, military or cultural officials based in foreign countries. Others serve as business-men, scientists, editors, writers and artists.
>
> But I always used to wonder what would happen if a hummingbird vanished, leaving no proof.[5]

"I study *Cockpit* now as a guide to a kind of organization I have yet to see," Magid writes in the Manuscript itself. "In Holland, I am looking to reveal Kosiński's world, the kind of service that he describes, where the hummingbirds pull all the strings and know all the truths.... To find the face at the center I will become a hummingbird and I will use the Organization to learn how to be one, because I believe it does this, it can do this, it is doing it all the time."[6] A black emblem of a flying hummingbird is included on the novel's title page and again in the center of the last page, facing the inside back cover.

Kosiński's hummingbirds go so deeply undercover that they blend into the world around them, unseen in their operations. Perhaps the word derives from the flight patterns of tiny real-life hummingbirds, always flitting just out of view. *Becoming Tarden* presents a number of different disappearances: information deleted from the page via redaction, the original book vanishing into the archives of the AIVD, Magid herself trying to melt into the structure of the organization. The hummingbird stands for an ominous kind of control through secrecy, but also a form of personal transcendence through seamless transformation. The artist and the agent become mirrors of each other; both provide metaphors for general questions of social identity.

"Suppose an artist were to release the work directly into a system that depends on reproduction and distribution for its sustenance, a model that encourages contamination, borrowing, stealing, and horizontal blur," Seth Price writes in his essay "Dispersion." "The art system usually corrals errant works, but how could it recoup thousands of freely circulating paperbacks?"[7] This quote calls to mind the softcover edition of *Becoming Tarden*, sitting on shelves in the New Museum, a book that the AIVD didn't wish to see available to the public, yet there it is. Price seems to envision something distributed through regular bookstores or other nonart channels, but *Becoming Tarden*, judging from the information on its colophon and lack of ISBN, appears to be a small print run, its availability likely limited to art spaces.

A chapbook version of "Dispersion" has been available for sale at similar venues, but has circulated far more widely as a PDF available from Price's site. The essay considers the impact of Conceptual art's legacy on artists' practices and how its original ethos might continue today. According to Price, Conceptual art asked the question "What would it mean to step outside of this carefully structured system?" only to be re-contained by the art world through entering its archives as "documentation and discourse." He offers that a more successful route might be to create work for the realm of "distributed media," which he defines "as social information circulating in theoretically unlimited quantities in the common market, stored or accessed via portable devices such as books and magazines, records and compact discs, videotapes and DVDs, personal computers and data diskettes." One of the most dynamic spaces of distributed media would be the internet, and, as Price says, "Anything on the internet is a fragment, provisional, pointing elsewhere. Nothing is finished. What a time you chose to be born!"

"Dispersion" is displayed in "Free," in a form that frustrates normal reading practices, as the wall-mounted *Essay With Knots* (2008). Like other works at "Free," it, too, points elsewhere, in this case to the original essay itself. Blown up to an enormous size, a complete set of its design galleys is printed onto sheets of plastic that in turn have been vacuum-sealed over large knots of rope, over which the words stretch and streak. Its large-scale industrial materials make *Essay With Knots* seem both monumental and disposable, as if it were an item that had been wrongly constructed, or a strange sort of container that might be discarded to get at the ropes inside. It imagines the essay as a means to package (and perhaps ship) a set of conundrums.

Essay With Knots appears to convey an uneasiness with its own physical necessity, and this paradoxical ambivalence is found in "Dispersion" as well. Past failures to transcend the institutions of the art world, Price writes, have stumbled because "immersing art in life runs the risk of seeing the status of art—and

with it, the status of artist—disperse entirely." Yet the utopian urge to exist beyond the art world through distributed media seems doomed in the same manner. "Complete enclosure means that one cannot write a novel, compose music, produce television, and still retain the status of Artist," Price continues. He suggests that the freedoms of distributed media, if fully embraced, would become a kind of exile. But at the same time, Price cites disciplines like film, music, fashion, and performance as producing "some of the most interesting recent artistic activity," all happening "outside the art market and its forums."[8]

This may be why "Free" contains more centaurs than true hummingbirds. Even as immaterial a work as Holmberg's maintains a thin silver cord tying it to the institutions of the art world and plays a game of ontological chicken with its own existence as art. But the questions raised by these latter-day hybrids of objects and ideas go beyond old chestnuts of aesthetic theory. In Rosenberg's age, the combination of material and immaterial may have had a rush of novelty. In 2010, it seems like just part of the information-rich environment we move through every day. Every object in the world now has an image that can be captured, a name to be searched; each thing in our lives provides a potential link. Perhaps we should stop thinking about the failure of Conceptualism to transcend the art world, just long enough to notice that it has, in fact, overtaken the world as such.

..

"The Centaur and the Hummingbird" by writer and curator Ed Halter was first published in the online catalogue for the exhibition "Free" (2010) at the New Museum, curated by Lauren Cornell.

..

NOTES

1. Harold Rosenberg, "Art and Words," *New Yorker*, March 29, 1969, 100.

2. Harold Rosenberg, "The American Action Painters," in *The Tradition of the New* (New York: Da Capo, 1994), 25.

3. Rosenberg, "Art and Words," 110.

4. Jill Magid, *Becoming Tarden*, (N.p.: n.p., 2010), 21.

5. Ibid., 46.

6. Ibid., 90.

7. In this volume, Seth Price, "Dispersion," 54.

8. Ibid., 57.

THE VISIBILITY WARS

Rebecca Solnit

I. WAR

Almost twenty years ago, a group of Nevadans took me with them into the center of their state, across hundreds of miles of rough, remote, little-known country. In all that distance we saw a few small settlements and occasionally a grove of cottonwoods marking a ranch house at one side or another of the long north–south sagebrush valleys. We had begun at the Nevada Test Site, an expanse the size of Rhode Island where for forty years most of the nation's nuclear bombs were "tested." More than a thousand bombs were detonated at the site in those years. There is no physical difference between a nuclear test and a deployment of a bomb in war, except the site chosen; and so you can argue that a long quiet war was waged against the land and people of the deep desert, one that resulted in considerable contamination (and the suppression or dismissal of that fact before it was forgotten).

We skirted Nellis Air Force Base, a military site the size of Belgium or Connecticut that contained the Nevada Test Site, and ended up at another site that had once been a Pony Express station and then became a one-time nuclear test site. The actual crater from the explosion of that atomic bomb was not far from where we camped that night. Fallon Naval Air Station, another vast base, was not far to the north, and Hawthorne, the premier ammunition storage site in the nation, full of earthen berms loaded with explosives, was to the northwest. Along the way, the Nevadans explained what we were seeing, and not seeing, and a new world opened to me, or rather the world I had been living in all along began to look very different. A large portion of Nevada was given over to the military, and civilian mapmakers often left these sites off their maps, producing instead the blank spots of which Trevor Paglen writes. Other spots were blank

because they were still nominally public lands or land illegally withdrawn from the public.

I traveled again in the area around Fallon Naval Air Station in the late 1990s with a local activist. We were in a beautiful green oasis, Dixie Valley, still home to a lot of migratory birds, though its human population had been driven out by the sonic booms of naval-aircraft testing there, shattering windows, stampeding livestock, and generally making the area uninhabitable. The people of Dixie Valley fought back before their ranches and homes were condemned by eminent domain. Only ruins remained, and some contaminated tanks had been hauled in to use for target practice. My friend, who'd fought alongside the former residents of the valley, told me how her political career began in that same landscape: a military plane flew so low, apparently for fun, that it forced her car off the road. She had two small children in the car. "And that," she told me with fierce satisfaction, "was when the Pentagon made its first mistake." She fought well for many years, founding an organization that defended the rural victims of militarism.

That day in Dixie Valley, we were buzzed by a warplane that seemingly appeared from nowhere, as though it had ripped open the sky, and then roared low over us with a sound so loud and visceral the term "sound" hardly describes how it invaded my body and the air around. It then vanished again, as though into a hole in the sky, moving astonishingly fast out of the range of the visible in the blue, blue desert sky. By then I had come to understand that in some sense the US was perpetually at war, and that war was a pervasive process, a mindset. It was being waged in a lot of places at home and abroad, and in some sense every place on earth up into the outer atmosphere and to some extent outer space. So pervasive that it is largely unseen, even beyond the vast realm of military secrecy that Paglen documents so powerfully.

In his famous book *On War* (1832), Prussian military theorist Carl von Clausewitz defined it thus: "War therefore is an act of violence to compel our opponent to fulfill our will. Violence arms itself with the inventions of Art and Science in order to contend against violence."[1] That is, it contends against others' violence, not against violence itself, the latter being a task at which violence is helpless. Asked what war is, most people would answer that it is a type of activity: a peculiar kind in which human beings as proxy for nation-states try to kill each other, the theory being the side that inflicts overwhelming or unbearable damage wins. Of course, modern warfare involves huge quantities of civilian casualties, and the killing is done by increasingly remote means.

First spears, catapults, arrows, then guns, cannons, and bombs, and in the twentieth century airplanes and then missiles, and in the twenty-first century unmanned drones make the site of the killers increasingly removed from the site

of the killed. Intercontinental ballistic missiles completed the transformation from, say, Gettysburg, where men killed each other at close range with screams and gore around them, to a system in which technicians in control rooms could wipe out civilians en masse on other continents. Drones in Afghanistan are now operated by men at a base near Las Vegas engaged in an activity that must be hard for them to differentiate from a video game, so removed is the violence when armed with these inventions of art and science. If the killer is in an air-conditioned room in Indian Springs, Nevada, and the killed are in a village in Afghanistan, the question of where the battlefield is arises and with it the possibility that battlefields are now anywhere, or everywhere. The drones seem to have a propensity for wiping out wedding parties in Iraq and Afghanistan. It's a photographic problem in part; the poor image quality results in poor judgment about what is a band of armed men and what is a family celebration.

We still tend to think of war as an activity, and an activity confined to a place, to the battlefield. The idea of the battlefield is still sometimes relevant, especially if you're willing to recognize whole regions—much of Iraq, the Congo, and so forth—as battlefields of sorts, more violent and dangerous than elsewhere. Perhaps it would be better to regard war as akin to wildfire or contagious disease that may flare up anywhere in the affected region, though human beings and their weapons are in this case the pathogens or sparks. Clausewitz's acts of violence are enabled by other acts committed far from the site of battle. Research, development, and mass manufacture of the technologies of killing and the supporting equipment have become the very core of the pork barrel—financial interests spread around the country so that almost every federal representative has a stake in continuing them. All this has an afterlife as well, as contaminated places and equipment, or shrapnel, or live ordnance in what has returned to other uses, and as veterans, with all the damage, physical and psychological, that veterans are prone to. Then comes the realization that there is a landscape of war and it includes munitions factories, mines, ships, barracks, bases, recruiting centers, and, afterward, veterans' hospitals. When the United States declared its war on terror, signs of it were intentionally planted everywhere, in the form of men with guns whose camouflage uniforms did the opposite of making them blend in at Penn Station or the Golden Gate Bridge. They were signs of what we had become.

To say that battlefields are everywhere is to say that war is a miasma, a condition in which nations, notably ours, live. The US has several hundred bases around the world, in sixty-three countries, on every continent but Antarctica, and spends as much on its military as all other nations put together. This condition—of pervasive war on a global scale—is invisible to most Americans, as is the

imperial oddness of the premise that the US may and must intervene globally. Reversing the situation to ask whether Korea or Kuwait should have military bases in the US, or to imagine Cuba running an outlaw gulag in Florida, makes the uniqueness of the situation clear. An online article by geographer Jules Dufour, President of the United Nations Association of Canada, puts it thus: "the surface of the earth is structured as a wide battlefield." He adds, "The U.S. tends to view the Earth surface as a vast territory to conquer, occupy, and exploit. The fact that the U.S. Military splits the World up into geographic command units vividly illustrates this underlying geopolitical reality."[2] That is, shortly after 9/11 the Bush administration divided the world into USNORTHCOM, USAFRICOM, and so forth. Nothing was left out. And everything was under one command or another. It is all battlefield now, at least in concept and designation, every place on earth overseen by one military command or another, with implicit permission to act there, and potential for violence anywhere. The militarization of outer space is another arena few recognize. Paglen tells me that the next arena for a US military command is virtual space, though whether WEBCOM or FIBERCOM, or whatever it is to be called, will be a new branch of the military or a new department or departments in existing branches remains to be determined. In that territory, the battles, the exposures, and the secrecies will be purely about information, which has always been part of war's arsenal, never more than now.

War is a series of landscapes, from the manufacturing, testing, training, and storage sites to the battlefields and hospitals—and cemeteries. Cemeteries for the official casualties of war, as well as those who died of contamination from some of its products, or from the violence it generates outside of its official battlefields, or of the deformed financial landscape of a war economy. If there is a warscape there is also a war economy, and it's worth noting that when the economy collapsed in 2008, all sorts of cuts were proposed and many made to the federal budget, but despite the fact that the military was half that budget, a serious cutback was never broached in the mainstream. In the *Nation* magazine in 2009, Congressman Barney Frank remarked, in the wake of that crisis and the widespread claims that we could not afford universal healthcare:

> It is particularly inexplicable that so many self-styled moderates ignore the extraordinary increase in military spending. After all, George W. Bush himself has acknowledged its importance. As the December 20 *Wall Street Journal* notes, "The president remains adamant his budget troubles were the result of a ramp-up in defense spending."[3]

People who were aghast at the idea of a $700-billion bailout hardly noted that the sum was only slightly larger than the annual military budget; universal

healthcare was made to sound unaffordable by describing it as a trillion-dollar program, though that was the cost over a decade, with substantial benefits, and no one was saying that by such measures, a six- or seven-trillion-dollar military budget was a burden, let alone an outrage.

There are other kinds of absence: the absence of funding for a host of other concerns, all of them constructive in opposition to war's destructiveness, but our country has remained on a war footing since the Second World War began, ducking the "peace dividend" that was supposed to appear after the dissolution of the Soviet Union. Essentially Americans are told that they cannot have healthcare or decent education or a well-cared-for infrastructure and environment because defense comes first and takes all. If war is an act of violence to compel others to do our will, you can speculate on how the American people have been essentially subjugated by the war economy to keep paying for it, the way that Germany paid reparations after its defeats, the way that subject nations and colonies pay tribute to their masters. In this sense, we civilians are a conquered colony of an imperial war mission; this is the other war, the war within our society, the one we have so far largely lost, though the battle is ongoing. If it were visible, the outcome could be different. And secrecy and invisibility are at the heart of modern warfare. William James imagined a war against war; if it is being fought today, it is fought in part by making the invisible visible. War is a stain that has sunk so deeply into the fabric of our society that it is now its ordinary coloring; we now live in war as a fish lives in water. Ours is a society of war, and a society at war with itself. This is so pervasive and so accepted that it is invisible. And its invisibility is a shield seldom ruptured. But it is ruptured here.

II. VISIBILITY

There are many kinds of invisibility. There is the invisibility of what is so taken for granted that few see it, the custom of the country, the water in which the fish swim. Thus to perceive that the US is an empire on a permanent wartime basis is to be alien to, or become alienated from, the mainstream. There is the invisibility of what is literally out of sight on remote military bases and in weapons laboratories and kept out of public scrutiny. There is the less geographical invisibility that is the secretive workings of the military and the related work of the Central Intelligence Agency—and here the word *intelligence* means covert information in a military context, as in "we have intelligence on the secret weapons labs." That is, you can see the Pentagon, the massive building near the nation's capitol, but you may not see much of what the Pentagon, the military, does. The unseen

is itself a vast realm, the black budget of the Pentagon and the "black sites" of the Paglen documents. Most people don't make much effort to know about this realm, and the knowledge that emerges is quickly forgotten or dismissed. "We are a peaceful nation" is a popular thing to say in the US. Those who might say this have been denied the intelligence to know what is done in their name and to decide democratically whether it should be done. Or they have ducked it. The blank spots on the map that Paglen describes have their corollary in the blank spots in the mind and in public dialogue. We do not debate the development of new systems of killing, the militarization of space, or the cost of our military budget, and most of us know little or nothing about the programs in question. Then there is the invisibility of what is literally hard or impossible to see. This includes planes, space, shuttles, satellites, and drones above the earth, as well as forces—radioactive, biological, chemical—that are not visible to the naked eye.

Photography has made visible each kind of invisibility described here. A project like the émigré artist Robert Frank's "The Americans" (1955–56) portrays the country in ways that it might not see itself, or wish to; artists are, at their best, honorary aliens seeing the familiar through strange eyes and the unseen in plain view. What is literally out of sight has been depicted many ways—Richard Misrach's photographs of remote and off-limits military sites in the 1980s and 1990s, including the Enola Gay hangar in Utah and the Bravo 20 Bombing Range in Nevada, did so spectacularly. The secretive workings of the military are systemic, but pieces have been revealed again and again. Systems are hard to photograph, but consequences are not, and wartime atrocity photographs are one means by which the workings of the military have been made visible. Finally, warfare itself has become increasingly technological, full of extra-human perception, with its infrared-vision night goggles, its sonar and radar, its spy satellites and encoded data. At least some of this can be made visible—notably the satellites Paglen has captured in his series "The Other Night Sky" (2007–ongoing). To see and to make visible is itself often a protracted process of education, research, investigation, and often trespassing and lawbreaking, a counter-spying on the intelligence complex.

Invisibility is in military terms a shield, and to breach secrecy is to make vulnerable as well as visible. Invisibility grants advantage over enemies unable to predict your actions or counterattack; it protects exclusive knowledge and technology; and it sets its actions and modes of operating out of reach of criticism and dissent. Invisibility and secrecy have been more than a strategy or a mode of operation for the military and the CIA for the past six decades; they have been its essence. Daniel Ellsberg titled his memoir about making public the Pentagon Papers—the documents revealing presidential duplicity and disregard for

democratic process and human life in the war on Vietnam—*Secrets* (2003). He expected to spend the rest of his life in prison for revealing them. The revelation of secrets is sometimes considered treason—Ethel and Julius Rosenberg were executed in 1953 for sharing atomic-weapons secrets—and sometimes it does provide practical aid to the enemy. Often disclosure instead provides disturbing truths to the civilians the military is supposed to serve. Perhaps the most common disclosure is that the military violates our most fundamental values in the course of what is usually claimed to be defending them. Civilians who oppose the military are often seen as traitors. As a nation, the US is officially a democracy, but as an empire it is no such thing. Since the 1950s, government agencies have routinely spied upon, harassed, attacked, and imprisoned domestic dissenters and antiwar activists. Far worse sometimes awaits dissidents abroad. When such action becomes visible, legislators sometimes denounce and rein it in, but these are temporary fixes. Democracy depends on public participation, which itself depends on visibility. On purely theoretical grounds, you can argue that invisibility is thereby undemocratic; practically, it is ferociously so, again and again.

There is another kind of invisibility with another status: that of unseen crimes, suffering, and death. If invisibility protects perpetrators, visibility protects victims, so much so that much humanitarian and antiwar effort has focused on witness and visibility. A group called Witness for Peace took Americans to Central America during the bloody civil wars there to stand with civilians and prevent or, at least, witness the crimes against them, to make the violent accountable. Photographic theory of the 1980s often proposed that the camera was indeed like a gun, that to photograph was to shoot or otherwise exploit the subject. Susan Sontag took this stance when she suggested in her classic *On Photography* (1977) that we will become overexposed to horror and thereby inured to it. There is considerable, but far from comprehensive, truth to this position. Sontag herself modified it in *Regarding the Pain of Others* (2003), in which she critiqued Virginia Woolf's reflections on pictures of war atrocities in *Three Guineas* (1938). Sontag is still suspicious of our looking: "Perhaps the only people with the right to look at images of suffering of this extreme order are those who could do something to alleviate it—say, the surgeons at the military hospital where the photograph was taken—or those who could learn from it. The rest of us are voyeurs, whether or not we mean to be."[4] But we too, when it is our money and our military, could try to alleviate suffering—if not that of the depicted sufferer—at least by preventing future such inflictions; we could withdraw the money or the machinery of violence. And we could learn from it: existential lessons about compassion and practical lessons about our tax dollars

at work. It is for this reason that militaries and the regimes they serve desire secrecy and invisibility.

There is more to Sontag's argument. Such photographs could be used and have been used, she reflects, to denounce war altogether, but they could also be used to advocate for supporting one side over the other. That is, to argue that war itself is not criminal, but the enemy is: you can just as readily say that this atrocity is the evidence of the barbarism of your opponents as the barbarism of war, and almost every nation makes visible the enemy's inhumanities and hides its own. Photographs are manipulable, and they can be used to these ends. Still, Sontag advocates for making visible. She argues against the positions that deride "the efforts of those who have borne witness in war zones as 'war tourism,'" that "the appetite for such images is a vulgar or low appetite,"[5] and that we are all inured to what we see on television. In the end she mourns a lack of imagination and empathy that pictures may not amend.

Sontag's subject is pictures. Pictures may serve or fail to serve justice and humanity. There is another subject, namely the lack of pictures. The war in Iraq was fought at home as an exemplary war of propaganda, and the best counter-weapons were photographs. A nondescript spy-satellite photograph of an installation in Iraq was used in the US and Britain to buttress claims that the country had "weapons of mass destruction," a term that entered the media at that point and seemed to carry an ominous weight that would have been dispelled by pointing out that nearly every country owns such weapons. At key moments, more iconic images were made visible as propaganda: President Bush posing on the flight deck of an aircraft carrier in front of a "Mission Accomplished" banner a few months into the war that would have years more to run; the occupying army in Baghdad pulling down an enormous statue of Saddam Hussein; capturing a shaggy, feral-looking Hussein in a pit near Tikrit, Iraq. Far more images were suppressed, for to see the war was to see its monstrosity, the death, pain, bodily destruction, waste, and mess at its heart, the horror that is denied by all the hero-welcoming rites of the culture. (Native American cultures, a friend tells me, often instead treat the returning soldier as someone who needs to be ritually cleansed, thus acknowledging the dirtiness of war.) This is true of most wars, perhaps more true of modern ones with their preponderance of civilian casualties. The US press obligingly avoided horrific and even difficult images that were widely seen elsewhere in the world, creating a parallel universe in which those maimed children, those bloody streets, and those body fragments did not exist.

In one landmark incident during the week of the second inauguration of George W. Bush, American soldiers killed a father and mother at a checkpoint, leaving their five children instantly orphaned as well as bloodied inside the family

car. The sequence of images captured by photographer Chris Hondros was widely seen in Europe, and a US general in Qatar reportedly demanded the television station Al Jazeera stop showing them, but few Americans saw them. Photographing the coffins was not permitted, though Russ Kick of the website the Memory Hole obtained several photographs through Freedom of Information Act requests and released them in April 2004. When news anchor Ted Koppel commemorated the dead by showing their faces and reciting their names, he too was denounced as unpatriotic; patriotism consisted of voluntarily renouncing intelligence of all kinds, even unclassified intelligence. Most dramatically of all, photographs taken by the torturers themselves of torture at Abu Ghraib prison near Baghdad launched one of the biggest scandals of the war thus far when they were leaked to the media and journalists like Seymour Hersh made something of them—one of the few proud moments in a fairly shameful era for the news. Photojournalists were making compelling and even revelatory pictures, but the media was mediating between them and the pacified public.

At the start of the war on Iraq, then–Secretary of Defense Donald Rumsfeld famously proposed, "There are known knowns; there are things we know we know. We also know there are known unknowns; that is to say we know there are things we do not know. But there are also unknown unknowns—the ones we don't know we don't know."[6] It was a weirdly interesting statement from an ordinarily thoughtless man. The philosopher Slavoj Žižek added a fourth category for him, "the 'unknown knowns,' things we don't know that we know—which is precisely the Freudian unconscious, the 'knowledge which doesn't know itself,' as Lacan used to say."[7] You could translate that into visual terms. There are the things we know we see. There are the things we know we do not see. Then there are the things we do not know we do not see. And finally, there are the things in plain sight we choose not to see, or repress. Walter Benjamin referred to photography as the "optical unconscious," and that's one way to describe this fourth category.

Photography and visibility have a tangled history. Often hailed as the first photograph of people, the 1838 picture by Louis-Jacques-Mandé Daguerre depicts in sharp detail a Parisian boulevard on which a lone figure is visible, because he stood still while his shoes were shined. The shoe shiner is a blur at his feet, but the rest of the people are invisible because they were in motion and the exposure was slow. The photograph is usually described as failing to show the people who were on the boulevard. It could also be described as a different way of seeing—the image saw through the people present to perceive all the hard, still surfaces, a little reminiscent of the neutron bomb that would annihilate people but leave structures and infrastructure intact. The early photograph is a bomb of vision, showing us the world as we do not see it, and it is handily emblematic that it

scraped human beings from the view. Photography has ever since represented various kinds of visibility and invisibility. The blue-sensitive films of the wet-plate era turned blue and cloudy skies into milk-white expanses, unless you exposed separately for the sky and the ground—as many did, and some, such as Eadweard Muybridge, added clouds from other negatives; photography was manipulated from the start. The slowness of vision was another way the camera saw differently than the eye—water became filmy white stuff, and anything in motion blurred—until Muybridge's 1870s breakthroughs that turned photography into a medium faster than the human eye could see, and another world of the real motion of horses' legs, women's gestures, and water's splashes and spills opened up.

The snapshot was originally a term for guns—for pulling up your gun suddenly to take a shot—and cameras were only thought of in terms of guns when they became light and fast. Shooting was never more than a metaphor, except with guns disguised as cameras, such as a Japanese machine gun–shaped device that allowed trainees to "shoot" the target with film that would be developed to look for bull's-eyes. Although, Muybridge's sequential motion studies led to Harold Edgerton's stroboscopic photographs of super-fast motion, which, Paglen has pointed out, led to Edgerton's photography of the first atomic explosion and subsequently to his work on triggers for such bombs. Knowledge is power, and visual knowledge is one variety of it, but information rarely otherwise crosses over into action in such an extraordinary way. X-rays provided a look inside the human body, and telescopic and microscopic photography made permanent that seeing via machines into scales and distances otherwise off-limits to the human eye. Infrared film provided another version of the world, as did a whole range of technologies in decades past—CAT scans, probes inserted into the body. Satellites show what a human eye might see if the human body were capable of sustaining itself in endless whirling orbit around the earth, but show it with a degree of detail at a distance the human eye does not have. For a long time, the "photographic world" chose to deal largely with art photography, but in recent years the whole panoply of mechanical image-making technologies—the imagistic regime under which we now live—has come under scrutiny.

Photographs are mute. The drab satellite images of Iraq that were used to insist the place was making forbidden weapons were almost meaningless without the language that contextualized and explained it, truthfully or not. The incomprehensible is another kind of invisibility. Where most of us see nothing or see meaningless signs, doctors see symptoms; trainers and fellow athletes see conformation and aptitude; detectives see tiny signs giving away insincerity and anxiety; carpenters see types of wood, technique, and structural soundness. Much military activity also requires educated eyes to see. The bright, moving

dots in the night sky that are surveillance satellites, the planes at regional airports that are torture transports, the offices that are fronts for dubious activities, the buildings in which secret operations are carried out take effort to see at all, but another kind of effort to recognize, to see with knowledge of what one is seeing, with knowledge that is not strictly visible. They are perhaps another kind of unknown knowns, invisible visibles. A minority dedicates themselves to learning to see this way. We could call what they do seeing in the dark.

...

"The Visibility Wars" by writer Rebecca Solnit was commissioned for *Invisible: Covert Operations and Classified Landscapes* (Aperture, 2010), a monographic catalogue on the artist Trevor Paglen.

...

NOTES

1. Carl von Clausewitz, *On War*, trans. J. J. Graham (Radford, VA: Wilder Publications, 2008), 27.

2. Jules Dufour, "The Worldwide Network of US Military Bases: The Global Deployment of US Military Personnel," *Global Research*, 2007, <http://www.globalresearch.ca/the-worldwide-network-of-us-military-bases/5564>.

3. Barney Frank, "Cut the Military Budget," *Nation*, March 2, 2009.

4. Susan Sontag, *Regarding the Pain of Others* (New York: Picador, 2003), 42.

5. Ibid., 111–12.

6. Donald Rumsfeld, "DoD News Briefing - Secretary Rumsfeld and Gen. Myers," February 12, 2002, <http://www.defense.gov/transcripts/transcript.aspx?transcriptid=2636>.

7. Slavoj Žižek, "Between Two Deaths," *London Review of Books* 26, no. 11 (2004): 19.

LAUREN CORNELL: Photographs in your series "Limit Telephotography" and
"The Other Night Sky" are often discussed in terms of "exposure"—of revealing
classified information or rendering visible things that are hiding in plain sight
(such as the presence of CIA-classified drones in the sky). Is the act of exposure
an aim in your work?

TREVOR PAGLEN: I'm not in the business of "exposing" anything so much as try-
ing to create images and artworks that bring something into a visual field and
then hopefully complicate that visuality. In other words, I'm interested in images
that can be productively self-contradictory in the sense of making a particular
visual claim and then running immediately away from it. For example, I can take
a picture of a classified airfield or surveillance site and say "this is x, y, z site etc.,
etc.," but the image will probably be a blurry mess or a color field or something
similarly indistinct. I tend to make images that don't "speak themselves," whose
contents or referents don't seem self-evident. So, in that sense, I'm interested in
the exact opposite of the documentary tradition in photography and image-mak-
ing that would be most associated with a politics of exposure.

CORNELL: Different veins of art history come in and out of focus in your work.
Some photographs operate on the edge of a tradition of American landscape
portraiture, where fantasies of new and unknown horizons of land and space are
mapped onto natural terrain. Others, like *Untitled Drones* (2010), are more like
abstract color fields that mingle awe-inspiring views of the sky with anxieties
and fears around surveillance.

TREVOR PAGLEN IN CONVERSATION WITH LAUREN CORNELL

PAGLEN: I definitely play a lot with historical genres, from Western landscape photography to Abstract Expressionism and Minimalism. I tend to take the histories of these aesthetic tropes and try to put them into tension with the contemporary historical moment. All sorts of intellectual and aesthetic traditions are associated with different forms. There are histories of the sublime associated with wildly different artists like Caspar David Friedrich, Timothy O'Sullivan, or Barnett Newman, or kinds of freedom that I would associate with artists like Kazimir Malevich, Jackson Pollock, Robert Morris, or James Turrell. I'm very much interested in these histories, and I'm constantly trying to be in active dialogue with them while at the same time recognizing that every artwork is of its particular historical moment. (I enjoy looking at a Mark Rothko exhibition as much as the next person, but I'm not sure that's really what the world looks like anymore.) So I'm always trying to work along what we might call a spatial axis, which involves simply going out and trying to really see the world, and on a historical axis, which has to do with how "what the world looks like now" is related to different art historical traditions (i.e., is looking at a drone in the twenty-first century in any way analogous to Turner looking at the railroad in the nineteenth century?).

I do tend to be committed to a certain ambiguity or abstraction in the work, but I'm not at all interested in ambiguity for its own sake (at this point in art history, ambiguity for its own sake feels exceptionally reactionary). But it does seem right to me that ambiguity, as one part of an artwork, when put into tension with other parts of an artwork (performative, referential, etc.) might be helpful in terms of developing productive "ways of seeing" or cultural vocabularies with which to comprehend the historical moment.

Trevor Paglen, *KEYHOLE 12–3/IMPROVED CRYSTAL Optical Reconnaissance Satellite Near Scorpio (USA 129)*, 2007. Chromogenic print, 48 × 60 in (121.9 × 152.4 cm). Courtesy the artist and Metro Pictures

CORNELL: Let's go back to this notion of bringing otherwise unseen objects—like data centers or drones—into our representational field. What you depict in your work unsettles conceptions of digital information. Recent metaphors like "the cloud" hide the reality of data farms, i.e., the physicality of storage; and, earlier ones like the "world wide web" signaled a globally connected society that invoked a flattening of cultural difference and hierarchy. By plainly showing the material realities of digital technologies, your work prompts new metaphors through which their complexity can be understood.

PAGLEN: Over the last year or so, I've been putting a lot of time into learning how to "see" telecommunications infrastructures like the internet. Intuitively, "the Internet"[1] seems like a liminal space, a kind of abstract nowhere that is everywhere, seemingly, a space of pure culture. But telecommunications technologies and networks are made out of physical stuff in the same way that everything else is. "The Internet" is made out of transoceanic fiber optic cables, landing stations, amplifiers, switches, exchanges, communications satellites, and on and on. I'm interested in this "infrastructure of feeling" (to cop a phrase from geographer Clayton Rosati) for its own sake, on the one hand, but also because, on the other, I think that a lot of the metaphors we use like "the Cloud" or even notions like "Internet Freedom" are highly ideological and deeply misleading. So, for me, running around the world looking at these infrastructures has really transformed the way I think about "the Internet" and I hope that some of the work I've been doing can help generate a different kind of cultural vocabulary that we can use to understand what "the Internet" is, which is a prerequisite to being able to assert any kind of marginally democratic oversight of it.

I had been doing a little bit of work around this question of infrastructure—again focusing on the surveillance aspect in particular—with images of the NSA data center in Utah; the "They Watch the Moon" piece of the NSA surveillance site near Sugar Grove, West Virginia; and of course a lot of the work I've done on classified satellites. I went pretty deep into this material after Laura Poitras asked me to work seriously on creating images of mass surveillance infrastructure for her forthcoming film, *Citizenfour*.

CORNELL: For Poitras's film, you were photographing US Government data centers, correct? Can you describe the process of locating them, gaining access to the sites, and deciding how to frame them? How did you capture their scale and architecture, and the ways in which they are enshrouded in secrecy, literally erased from existing maps?

TREVOR PAGLEN IN CONVERSATION WITH LAUREN CORNELL

Trevor Paglen, *Detachment 3, Air Force Flight Test Center #2, Groom Lake, NV, Distance ~26 Miles*, 2008. Chromogenic print, 50 × 40 in (127 × 101.6 cm). Courtesy the artist and Metro Pictures

PAGLEN: For the project, the task was to film various parts of the NSA's surveillance infrastructure. Some of the places I filmed were fairly predictable, such as the massive Utah Data Center (which Laura and I had both filmed in the past) and well-known NSA bases such as the base near Harrowgate in the UK and the GCHQ installation at Bude in southwest England. Other places included NSA installations whose significance we didn't understand before working with the Snowden documents. A good example of this is the "Dagger Complex" in Germany near Frankfurt, where a lot of the NSA's "Tailored Access Operations" people work out of. But other sites were less obvious. I shot a number of seascapes at places where NSA-tapped transoceanic fiberoptic cables come onshore, as well as their associated cable landing stations in the UK, Germany, and several places in the US. So there's quite a mix of approaches I took, from shooting with telescopes from great distances to doing things like shooting wide, abstract seascapes that have no visible evidence in the frame of the thing I'm actually trying to "image" (of course, this is a strategy that I often use). Overall, the approach was to take seemingly familiar kinds of landscapes and defamiliarize them, or to try to inscribe different meanings into landscapes that we might otherwise not pay attention to.

CORNELL: Outside of the infrastructure for data storage and management, you've also long been interested in complicating claims that online culture and digital communication are totally "free" or "open."

PAGLEN: Our experience of "the Internet" is strongly at odds with what actually happens, and is a source of incredible mystification. "The Internet" *feels* very free; it feels like we can anonymously explore whatever ideas, images, or desires we want without fear of reprisal or ostracism. It feels like we can be one person today, and another tomorrow, and that we could try on a new personality the day after that. It would be very difficult from our direct experience of "the Internet" to derive the fact that it is also a surveillance platform of immense power, reach, and recollection—one that makes the STASI's system informants and file cards seem utterly quaint. As such, "the Internet" is a tool for a literally incredible consolidation of state power, the likes of which have never been seen on earth. From the standpoint of political economy, the corporate aspects of "Internet" surveillance provide for ever more minute specializations of capital, whether that's increasing productivity by micromanaging workers, or whether it's extracting maximum profits on the consumer side by reaching into ever more intimate parts of our lives and monetizing them (in a few years, will insurance companies use data provided by my "smart fridge" to vary my premium each month based on whether there's junk food in my kitchen?).

Trevor Paglen, *National Security Agency Surveillance Base, Bude, Cornwall, UK*, 2014. Chromogenic print, 48 × 64 in (121.9 × 162.6 cm). Courtesy the artist and Metro Pictures

This second sense, of what "actually happens" when you use "the Internet," is something that I've been working on quite a lot with Jacob Appelbaum of the Tor project. One of the projects we've been working on involves what we call "Autonomy Cubes," which are minimalist sculptures that provide open Wi-Fi, which is then routed through the Tor anonymity infrastructure. People can connect to our sculpture with their phones or computers and browse with far more anonymity than they'd be able to if they were "bare backing" without encryption or privacy-enhancing software. What's more, the sculptures also act as Tor relays, so the museums and galleries that exhibit them literally become a part of the Tor network. There's obviously a huge debt with these cubes to Minimalist and Post-Minimalist sculpture, with a straight line to artworks like Hans Haacke's "Condensation Cubes" (1963–65).

With both these "families" of work, namely, work on trying to see the infrastructure of surveillance (as in Poitras's film and related images and installations) and the collaborations with Appelbaum, I'm trying to reimagine what an alternative might be to the internet-as-tool-of-mass-surveillance model that we now have. As part of that, there's a desire to both demystify and undo some of the metaphors we use to understand telecommunications infrastructures and "the Internet."

CORNELL: The "Autonomy Cubes" symbolize a more transparent and self-controlled network, as they present circuit boards free of their usual casing and instead ensconced in a Plexiglas cube. They appear totally inert and yet have an active function in that they are connecting the museum to the Tor network. They function to unveil underlying system hardware and yet, still, to the non-programmer, they would be inscrutable. Can you describe the materials used, and how they operate?

PAGLEN: There are several versions that we're experimenting with at the moment. The version we exhibit in museums is a thick acrylic cube with four mainboards inside: two Novena boards, which are open-source hardware made by Andrew "Bunnie" Huang and two BeagleBone black boards, as well as four Wi-Fi cards. Each board is running the system Tor package, with the Novena boards forming a Tor relay (we're planning on running some as exit nodes as well). The sculpture creates an open Wi-Fi access point in the museum or gallery that anyone can connect to, and routes all the traffic over the Tor network to anonymize users' activities. In addition, the sculpture is a relay, so it's also routing anonymized traffic from other users around the world. The four boards are mostly for redundancy. When we started the project, I insisted that if we were going to

Trevor Paglen, *Autonomy Cube*, 2014. In cooperation with Jacob Appelbaum; acrylic, motherboard, and Tor software. Installation view: "Smart New World," Kunsthalle Düsseldorf, 2014. Courtesy Kunsthalle Düsseldorf

make an artwork that involves computers and telecommunications, it would be stable and reliable. As such, to make the whole thing work, you just have to plug in a power source and an Ethernet connection. The sculpture does everything else on its own.

CORNELL: It seems the "Autonomy Cubes" tack the legacy of institutional critique into new terrain by literally harnessing the institution to the internet, or, more specifically, to part of the Tor network. You are layering one system directly into the firmament of another. What is the significance of transforming a museum or art space into such a site?

PAGLEN: The piece is directly and self-consciously a contribution to the institutional-critique thread in contemporary art. But in a way, it's not really a critical project in the traditional sense. Rather than critiquing the institution à la Hans Haacke or Andrea Fraser, the piece (in a very modest way) helps an institution be more civic and democratic by, literally, becoming part of a communications infrastructure that is designed to resist state and corporate surveillance. Museums, like all infrastructures, are politicized things. Pointing that out isn't the endpoint of Jacob's and my project so much as it's a starting point: for us, it's given that infrastructures are political. We're trying to bring the politics of that infrastructure over toward the side of democracy and civic-mindedness.

CORNELL: To conclude the piece, I'd like to ask you to reflect back on the period this anthology covers vis-à-vis your work. Over the past decade, concerns over national surveillance, specifically its dispersion and personalization, have vastly heightened in the US, and around the world. You've been researching and picturing classified information—or, as Rebecca Solnit says "the gaps in our democratic field of vision"—since at least 9/11. I imagine early projects of yours like "Tracking the Torture Planes," which focused on CIA planes dedicated to extraordinary rendition, had a more specialized audience than your work has now. Do you feel it has found a broader audience, in part, because of this? And how, if at all, has the centrality of surveillance in daily life affected your work?"

PAGLEN: Working with this material for so long has really made it apparent how history (at least recently) seems to move in onion-like circles, with each new layer adopting the previous one's contours. Things like the drone wars are direct descendants of the rendition program. While working on the rendition program in the early 2000s, I wondered to myself why the CIA was going through so much trouble to capture people and interrogate them, and to build the fairly

visible and deeply damning institutions to conduct that program (Guantánamo Bay, the Salt Pit, etc.); I thought, Wouldn't it be easier for them to just kill these people? And that's exactly what happened with the drone wars. Instead of capturing and interrogating people, they now just assassinate them with robots. We see similar dynamics at work with the NSA mass-surveillance and search programs as they become increasingly public and increasingly "legalized" through laws like the 2008 FISA Amendment Act.

I think that this dynamic is reflected in public interest in my work. I remember that when Obama came into office, a lot of people were telling me that my career was over because so many of the things I was looking at were specific to the Bush-era "War on Terror." But I'd done my PhD on the history and geography of American secrecy, so I understood that what Dick Cheney famously called the "dark side" of American policy wasn't something that Bush and Co. invented, and that it wasn't likely to be going away anytime soon. I think that you could look at any moment in postwar American history and find "echoes" of the current situation, whether it's things like the NSA's projects MINARET and SHAMROCK in the 1960s; the assassination of Salvador Allende in the '70s; Iran-Contra and the secret wars in Afghanistan, Central Africa, and Central America in the 1980s; or the origins of the "War on Terror" in the 1980s and '90s. Having said that, although history can rhyme, it doesn't repeat itself, and it's important to pay attention to and learn how to "see" the particularities of the historical moment one finds oneself in. This, ultimately, is what I think my job as an artist is.

...

This interview, which took place over email during the summer of 2014, was commissioned for the present volume.

...

NOTES

1. Putting "the Internet" in quotes is a convention that I take from Evgeny Morozov, who points out that the notion of "the Internet" is exceptionally imprecise, "all-encompassing and devoid of any actual meaning" (44). See Evgeny Morozov, *To Save Everything, Click Here* (New York: Public Affairs, 2013).

WHAT TO DO WITH PICTURES

David Joselit

"It's an amazing customer imprint," Mr. Ballmer said. "And Skype is a verb, as they say."[1]

In 1967–68, Richard Serra prepared a famous list of verbs.[2] This compendium of actions—"to roll, to create, to fold, to store, to bend, to shorten, to twist, to dapple, to crumple, to shave," and so on and so on—implies matter as its proper "direct object." You can roll, fold, store, bend, shorten, twist, dapple, and shave lead, for instance, or crumple paper.[3] This litany of verbs also includes two sustained "lapses" into nouns, including many gerunds (whose grammatical function is to transform verbs into nouns): "of tension, of gravity, of entropy, of nature, of grouping, of layering, of felting." If the infinitive verb marks a time outside of action ("to rotate" suggests a possibility that need not be acted upon), Serra's nouns imply the dilated moment of an unfolding event—to be "of tension," for instance, means that force is being or has been applied. Indeed, Serra's early sculptures might be defined as matter marked by the exercise of force.[4]

Serra's verb list furnishes a terse blueprint for Post-Minimalist sculpture. But it also implies a general theory of transitive art—of art produced through the exertion of force on something, or someone. Since what counts in transitive procedures is not the nature of the material acted upon (such as lead or rubber) but the generation of form through action, Serra's list can easily be repurposed through a simple change of "direct objects." Relational aesthetics, for instance, might be said to consist of learning how "to scatter, to arrange, to repair, to discard, to pair, to distribute, to surfeit" groups of people. Or, as I will argue below, the verbs "to enclose, to surround, to encircle, to hide, to cover, to wrap, to dig, to tie, to bind, to weave, to join, to match, to laminate, to bond, to hinge, to mark, to expand" may be applied to the behavior of pictures within digital economies. Such substitutions mark a shift from the manipulation of material (paint, wood, lead, paper,

chalk, video, etc.) to the management (or mismanagement) of populations of persons and/or pictures. Under such conditions, "formatting"—the capacity to configure data in multiple possible ways—is a more useful term than "medium," which, all heroic efforts to the contrary, can seldom shed its intimate connection to matter (paint, wood, lead, paper, chalk, video, etc.).

Formatting is as much a political as an aesthetic procedure because the same image may easily be adduced as "evidence" in support of various and even contradictory propositions—determining a format thus introduces an ethical choice about how to produce intelligible information from raw data.[5] In digital economies, value accrues not solely from production—the invention of content—but from the extraction of meaningful patterns from profusions of existing content. As the term "data mining" suggests, raw data is now regarded as a "natural," or at least a naturalized, resource to be mined, like coal or diamonds. But unlike coal and diamonds, with their differing degrees of scarcity, data exists in unwieldy and ever-increasing quantities—it is harvested with every credit-card transaction, click of a cursor, and phone call we make. This reservoir of tiny, inconsequential facts, which is sublime in its ungraspable enormity, is meaningless in its disorganized state. Since such data is both superabundant and ostensibly trivial, what gives it value are the kinds of formats it can assume, which may be as wide-ranging as marketing profiles and intelligence on terrorism. Such a shift from producing to formatting content leads to what I call the "epistemology of search," where knowledge is produced by discovering and/or constructing meaningful patterns—formats—from vast reserves of raw data, through, for instance, the algorithms of search engines like Google or Yahoo! Under these conditions, any quantum of data might lend itself to several, possibly contradictory, formats.

The artist Seth Price has implicitly articulated—though never, like Serra, explicitly published—his own "list" of transitive actions appropriate to the epistemology of search. I will focus on three of Price's "routines"—or procedures of formatting—each of which lends itself to subdivision: "to disperse," "to profile," and "of effects." Together, they sketch an answer to the question: what to do with pictures?

TO DISPERSE

Price's best-known work of criticism is probably his 2002 "Dispersion," which, like many of his texts, is freely downloadable, making it a model of dispersion as well as a theoretical account of it. In a sense, the title says it all: to disperse

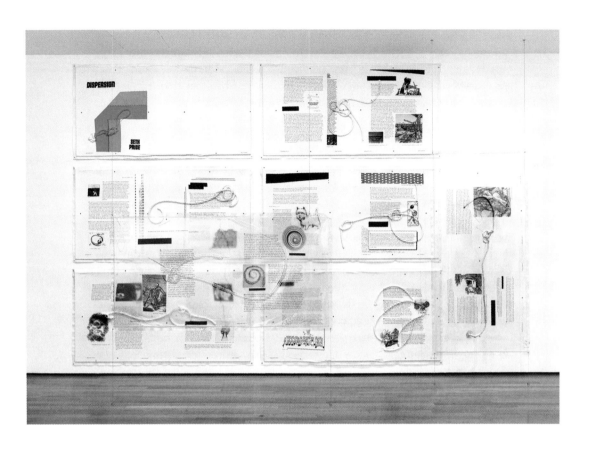

Seth Price, *Essay with Knots*, 2008. Screenprint
on high-impact polystyrene, vacuum-formed over
rope knots, nine pieces (eight shown). Courtesy
the artist

is to shift emphasis from creating new content to distributing existing content. As Price writes, "Suppose an artist were to release the work directly into a system that depends on reproduction and distribution for sustenance, a model that encourages contamination, borrowing, stealing, and horizontal blur."[6] Several aspects of this passage repay close reading: first, for Price, dispersal diminishes rather than enhances a work's value. As he puts it in a subsequent passage, "what if [the work] is instead dispersed and reproduced, its value approaching zero as its accessibility rises?"[7] In fact, while it seems logical that scarcity should enhance art's value (and conversely, that accessibility would cause it to drop to zero), this presumption is incorrect when it comes to actual contemporary image economies (including the art market), where the massive distribution of reproductions—whether of the Mona Lisa or Lady Gaga—is precisely what confers value. As Price defines it, however, dispersion is a drag on circulation, a form of counter-distribution, where value is purposely diminished as opposed to accumulated through the dissemination of images.

A list of three transitive actions is included in the passage I quoted above: contamination, borrowing, and stealing. One possible pairing of these three refers to destructive events (i.e., contamination and stealing), and another indicates the illicit or licit transfer of property (i.e., stealing and its innocent twin, borrowing). According to these characterizations, Price sees dispersion as a mode of transfer whose poles are marked by innocuous exchanges (borrowing) and their virulent converse (contamination). As the latter term suggests, dispersion can also carry a biopolitical connotation. And indeed, Price declares it to be "a system that depends on reproduction and distribution for *sustenance*" (my emphasis). Networks, in other words, provide life support for the individual images that inhabit them; and as in the human body, failure of the circulatory system will lead to death.

Finally, Price introduces the condition of "horizontal blur." Blur occurs when something or someone moves too fast from one place to another for it to register optically as a bounded form, making it a privileged figure of transitive action. Price stages such blur spatially in a series of works begun in 2005 and finalized in 2008 titled "Hostage Video Still with Time Stamp" made on unfurled rolls of clear polyester film, known colloquially as Mylar, upon which are silkscreened degraded reproductions of an image taken from the internet of the severed head of the American Jewish businessman Nicholas Berg, who was decapitated by Islamic militants. In these pieces, the physical effects of dispersion are manifested in three ways: First, a computer file—the germ of an artwork, as in many of Price's pieces—is rendered nearly illegible, the result of several generations of reproduction, as Price digitalizes, compresses, downloads, blows up, and then

Seth Price, "Hostage Video Still with Time Stamp," 2005. Highway signage inks screenprinted on polyester film with metal grommets. Courtesy the artist

screenprints original footage. Second, while bolts of the printed Mylar are some-
times unrolled flush to the wall, at some point in its installation the material is
twisted or tied into crumpled configurations that serve as a spatial metaphor
for the ostensibly "immaterial" traffic of images online—as though successive
screen views on a monitor had piled up continuously like a disorderly comic
strip rather than being constantly "refreshed." Finally, third, the grisly and hor-
rible physical violation of Berg is an explicitly biological form of "dispersion," in
which a head is parted from its torso. The catastrophe of his decapitation results
in the abject wasting of a body. It is the object of a perverse fascination for the
artist (and the viewer) that verges on the erotic. As Price writes in another con-
text, "Locating pleasure in benign decay is a perversion, for these structures are
useless and wasteful, a spilling of seed, like gay sex, like gay sex."[8] While some
gay people might object to this characterization (I am not among them), Price's
romanticizing (and even caricaturizing) rendering of gay desire nonetheless as-
serts something important: a nonproductive relationship to distribution, the
violence of which is aggressively expressed by Berg's decapitation.[9]

The normative goal of distribution is to saturate a market. Once the dissem-
ination of an image reaches a tipping point, it sustains itself as an icon (celeb-
rity is the paradigmatic model for self-perpetuating images). Price, on the other
hand, represents the failure to saturate, a perversion of distribution he calls
"dispersion." Dispersion is slow, while standard forms of commercial distribution
are fast. As Price puts it, "Slowness works against all of our prevailing urges and
requirements: it is a resistance to the contemporary mandate of speed. Moving
with the times places you in a blind spot: if you're part of the general tenor, it's
difficult to add a dissonant note."[10] Staging different rates of circulation is one
type of routine appropriate to art in digital economies—it's a tactic for escaping
the "blind spot" that results from moving along at the same rate as the market.
Forms of critique that once would have been conducted through dissonant con-
tent are here reinvented as variable velocities of circulation. In other words, the
core of Price's project has less to do with what he represents—even when that
representation is inflammatory, as with the Nick Berg decapitation—and more
to do with the transitive actions to which he subjects this content. In Serra's art,
transitivity is expressed as force—the force necessary to mold matter. But, fol-
lowing an important distinction that Hannah Arendt makes between violence as
the exertion of force and power as the effect of human consensus, we can recog-
nize a difference between Serra's and Price's transitive art.[11] The latter's object is
populations of images rather than quantities of matter: he seeks to format (and
not merely "reveal") image-power. One way he does this is to slow down the cir-
culation of images:[12] in "Hostage Video Still with Time Stamp," Price curbs the

WHAT TO DO WITH PICTURES

frictionless motion and instantaneous spatial jumps characteristic of navigation on the internet and allows them to pile up in unruly masses; the gruesome decapitation he represents is also the figure of an acephalous media.

TO PROFILE

There are few things more ubiquitous in contemporary life than profiles: some are composed voluntarily to be posted on social media sites, but many, and perhaps most, are involuntary, like the data trails left by every purchase, cursor click, and mobile phone call one makes. Silhouettes have existed for ages, but profiling is modern—dating from the nineteenth century.[13] A silhouette is a bounded shape that sharply delineates an inside from an outside: the information it carries lies entirely in partitioning a field. The verb "to profile" denotes the imposition of such a finite shape onto a set of perceived statistical regularities, as when scientists plot a straight line through an irregular array of data points, disciplining and abstracting inchoate (or sometimes merely imagined) patterns. The implicit violence of such projections is conveyed by the connotation of profiling in police work, where persons who belong to particular groups—be they organized by ethnicity, age, economic status, or gender—are believed to be more likely to commit a crime and consequently are more frequently treated as criminals. Profiling imposes a profile on populations of data (including visual data).

In his highly inventive practice, Price has developed two tactics related to profiling. In one, which is closely related to his strategies of dispersal, he makes large centrifugal works generated from small "icons" drawn from the internet— each picturing a gesture of touching such as lighting a cigarette, kissing, or writing. These motifs emerge unsteadily, like optical puzzles, on blank expanses of wall bounded by several irregularly shaped "continents" of rare wood veneers laminated behind clear acrylic plastic. Because these giant puzzle pieces, which resemble landmasses in a wall map, are themselves free-form, it is not easy to recognize—let alone to remember—the motif they partially delineate (I admit that the first time I saw one, I failed to recognize the generating kernel at all). Michael Newman has beautifully described the effect of these works as that of a "'frame' [that] invites the viewer to project an image into the emptiness, and this emptiness bleeds into the surrounding space of the wall with an extension that is potentially infinite."[14] As in Price's model of dispersion, where the circulation of images is slowed down, in this series of pieces the normative centripetal logic of profiling (which is aimed, as I have argued, at crystallizing a "concentrated"

profile from an amorphous field of data) is opposed by a centrifugal form of dispersal, where the possibility of generating an intelligible silhouette is interrupted, slowed, and possibly even arrested. At the same time, the appropriated "icons" upon which they are based—all intimate moments of touching—deracinate face-to-face contact by transforming tactility into absence. Needless to say, this is precisely an effect of digital communication.

Price's second approach to profiling seems the opposite of his first in that it represents whole as opposed to fragmentary objects. A series of vacuum-form works are molded over things or human body parts (ropes, breasts, fists, flowers, and bomber jackets); sometimes they literally encase readymade lengths of rope that might spill out below the vacuum-form surface. These illusionistic reliefs adopt the logic of packaging, where a plastic shell molded to a commodity's contours both protects that commodity and constitutes its seductive surface. But while these profiles may be "whole," they are hollow—functioning as what Price likes to call a "hole." In this sense, they resemble the wood and acrylic wall pieces, where form is organized around a structuring absence. Indeed, the "hole" for Price is precisely not an absence, in the sense of a passive empty space, but an "event" within a rich surface or field of data. A profile is simultaneously empty

Seth Price, *Taking/Writing/Lighting*, 2007. Diamond acrylic plastic laminated to Carpathian elm, olive ash burl, and walnut burl woods. Courtesy the artist

Seth Price, *Different Kinds of Art*, 2004. Vacuum-formed high-impact polystyrene. Courtesy the artist

WHAT TO DO WITH PICTURES

and full, a hole and a whole. As he states in his largely appropriated book, *How to Disappear in America*:

> There is the possibility that in the future people may be identifiable by their purchasing habits. Granted the point-of-sale data collected by computers would need to be immense, yet eventually pattern-recognition software may some day be able to provide authorities with perhaps 100 of the best possible "hits" on people matching your known buying habits. When—if ever—that becomes a reality, you can be sure you won't know about it until it's shown on cable television.... So alter your buying habits. You need to discard as many predictable patterns as possible. One of the most common mistakes is maintaining old habits. If you're a smoker, stop. If you don't smoke, start. If you enjoy hot and spicy foods, stop purchasing those items and change to mild foods. If you frequent bars, stop. This may seem an unusual step but patterns are predictable. Break them.[15]

The theory of profiling is that human subjectivity is a pattern bereft of interiority. The unconscious is a hole.

OF EFFECTS

In *Digital Video Effect: "Holes"* (2003) and *Digital Video Effect: "Spills"* (2004), Price frames found JPEGs and video footage with digital masking effects that generate autonomous "events"; a variety of "holes" (such as round paper punchouts) open in a black ground to reveal pinpoint views of a horrific image that is only revealed in its entirety momentarily, when the different views fuse together for a split second. A video image spills onto black ground and is succeeded by black amoebic forms that spill back onto the image, rendering it a kind of liquid. The ultimate expression of this amorphous, aqueous (literally mercurial) sort of image comes in *Untitled Film/Right* (2006), an endless four-second loop of a wave purchased as stock footage that is nauseating yet mesmerizing. Tim Griffin has described Price's effects in the following terms:

> as a simulation device, the "effect" posits a kind of chronology where there is none—suggesting some precipitant action responsible for the visual and aural phenomena taking place before the eye and ear. The

"effect" creates nothing so much as a rhetorical hole in time, but only in order to fill that hole in advance with some false history or phantom memory for the individual viewer. [16]

Griffin's association of effects with an absent or invisible agency—a hole in time—is not only essential for understanding Price's work, it also points to a broader tendency in contemporary sculpture. In the open "scenarios" of artists such as Liam Gillick, Pierre Huyghe, and Rirkrit Tiravanija, who design environments that may or may not be activated through the presence of scripted or unscripted events, spatial structures are consecrated to hosting social effects. Such principles are also present in the new modes of sculptural composition exemplified by Isa Genzken and Rachel Harrison, where tangential connections between things reverse the centripetal effect of earlier twentieth-century montage and assemblage (to use terms I have applied already to Price), in favor of centrifugal tornadoes of divergent associations.

I wish to supplement Griffin's definition with two additional valences of effect. First, "special effects," as practiced by Hollywood cinema, render narrative as pure motion—often a virtually unbroken trajectory initiated in the opening scenes of a film and coming to rest only with the last credit. Blockbuster plots are no more than conventional grids: what matters are the texture, velocity, and point of view with which spectators are carried through a standardized sequence of events. Such movies are not so much watched as navigated—like computer games where motion is frictionless, continuous, and defiant of gravity. The "effect," as Hollywood renders it, is almost pure transitivity in the absence of a direct object (unless that object is the spectator herself). Second, effects are literally a posteriori. They are, to put it plainly, consequences that cannot be fully anticipated during the phase of aesthetic production. And here, too, we may note a wider aesthetic shift. Artists like Price are primarily interested not in producing new content but in submitting existing pictures (moving and still) to various "ecological" conditions in order to see how they behave. This is why he can call *Redistribution* (2007–ongoing), a videotaped version of the kind of artist's talk given at art schools or museums, a work: in his practice, works are inextricable from their dissemination. It is also why he habitually reframes and remixes his texts, music, and images, as well as making many of them available online on his website. A contemporary art devoted to circulation is, of course, a creature of a specific ecology: the market. But instead of either giving up or selling out, Price, like more and more artists, games the market by surfing it. This leads to all kinds of effects: variable velocities, catastrophic jamming, viral proliferation, etc., etc. [17]

WHAT TO DO WITH PICTURES

Seth Price, *Digital Video Effect: "Holes,"* 2003
(stills). Video on DVD. Courtesy the artist

Seth Price, *Redistribution*, 2007–ongoing (stills).
Blu-ray video. Courtesy the artist

Seth Price, *Untitled Film/Right*, 2006 (still).
16mm film. Courtesy the artist

CODA: IMAGE POWER

If one subscribes to Arendt's definition of power as the effect of a public, then populations of images might possess their own species of image-power—by saturating markets, on the one hand, or "going viral" on the other. This implies a shift in how the relationship between politics and art is conceived. Indeed, significant changes have occurred in this critical relationship over the past century—from avant-garde modes of revolution in the early twentieth century to postmodern, or neo–avant-garde, critique in the late twentieth century, to what I would call image-power in the early twenty-first century (a time when divisions between commercial and fine-art images are more and more difficult to draw). This is an art devoted to seizing circulation as a technology of power: *to disperse*, *to profile*, and *of effects*.

"What to Do with Pictures" by art historian and theorist David Joselit was first published in *October*, issue no. 138, in 2011.

NOTES

1. Andrew Ross Sorkin and Steve Lohr, "Microsoft to Buy Skype for $8.5 Billion," *New York Times*, May 10, 2011.

2. The list was only published in 1972. See Richard Serra, "Verb List, 1967–68," in Richard Serra, *Writings/Interviews* (Chicago: University of Chicago Press, 1994), 3–4.

3. On the other hand, "to create" seems an exceptionally general action smuggled into this list of specific operations: like the last verb in Serra's long list—"to continue"—it is a meta-procedure.

4. Serra is by no means the first artist to propose a transitive model of art wherein force generates form. A modern genealogy for such practices could easily be established that would span the manipulation of readymades (where perhaps "inscription" takes the place of "force") to Jasper Johns, whose paintings index the residue of actions taken upon or "in" them, to the various practices of the late 1950s and '60s in which scoring movements or actions was fundamental, including Happenings and Fluxus. The particular virtue of Serra's list is how clearly, directly, and uncompromisingly it asserts a "transitive" position.

5. For me, one of the most powerful examples of the consequences of data formatting is Colin Powell's presentation of supposed evidence of weapons of mass destruction in Iraq to the UN in 2003. The question of evidence and documentary truth-value has been a major one in recent art practices. For an important account of this, see Carrie Lambert-Beatty, "Make-Believe: Parafiction and Plausibility," *October* 129 (Summer 2009): 51–84.

6. Reprinted in this volume, Seth Price, "Dispersion," 54.

7. Ibid., 57.

8. Seth Price, *Was ist Los* [aka *Décor Holes*] (New York: 38 Street Publishers, 2010), <http://www.distributedhistory.com/WAS%20IST%20LOS.final.pdf>.

9. In an era when demands for marriage rights have become the signature issue within gay activism, the characterization of "gay sex" as nonproductive feels a little nostalgic. I, for one, however, agree that one of the strongest political accomplishments of some gay and much queer activism is a critique of normative forms of *production* for which biological reproduction often served as a privileged model.

10. Price, "Dispersion," 66.

11. Arendt makes this distinction in her important essay "On Violence," in Hannah Arendt, *Crises of the Republic* (New York: Harcourt Brace & Company, 1972). In this essay, she writes, "*Power* corresponds to the human ability not just to act but to act in concert. Power is never the property of an individual; it belongs to a group and remains in existence only so long as the group keeps together" (143). On the contrary, "*Violence* . . . is distinguished by its instrumental character. Phenomenologically, it is close to strength, since the implements of violence, like all other tools, are designed and used for the purpose of multiplying natural strength until, in the last stage of their development, they can substitute for it" (145).

12. In my book *Feedback: Television Against Democracy* (Cambridge, MA: MIT Press, 2007), I refer to this as "slowing down the trajective."

13. On nineteenth-century forms of aesthetic profiling, see Allan Sekula, "The Body and the Archive," *October* 39 (Winter 1986): 3–64.

14. Michael Newman, "Seth Price's Operations," in *Price, Seth*, eds. Kathrin Jentjens, Anja Nathan-Dorn, and Beatrix Ruf (Zurich: JRP/Ringier Kunstverlag, 2010), 44.

15. Seth Price, *How to Disappear in America* (New York: Leopard Press, 2008), 37–38.

16. Tim Griffin, "The Personal Effects of Seth Price," *Artforum* 47, no. 10 (Summer 2009): 288.

17. This is the model of aesthetic politics I attempt to delineate in *Feedback*.

Discussants: Petra Cortright, Jennifer McCoy, Kevin McCoy, Tom Moody,
Tim Whidden, and Damon Zucconi
Moderator: Ed Halter

ED HALTER: Damon Zucconi's *Sometimes Red Sometimes Blue* [2007] is a prime
example of a piece that one could show in a gallery—one could put a monitor up
and show it, maybe off of a computer rather than on the net—but it wouldn't re-
ally have the effects that it actually has had, as Damon mentioned: people stum-
bling on it, not really knowing what it's supposed to be, and thinking that it's a
comment on red state/blue state, or a French pop song, and so forth. The way it's
situated as part of a greater pop culture of web surfing is important to the piece,
as part of its strangeness. So I want to ask Tom, that if a lot of contemporary
internet artworks in the soup of memes and digital folk art, 4chan and YouTube,
the stuff you just think of as funny shit you look at at work, or strange stuff you
just find and forward—if net.art is circulating in those areas, does it stop being
art if someone's not thinking about it as art? Where does the line between art
and nonart happen with this work nowadays, and does that matter?

TOM MOODY: I think one of the things we've seen from the surf clubs is how to
put somebody into the right frame to look at something in a funny, skewed way,
so that they can start to see it as a found object, or something that we know
from the history of art can be valued beyond just its trash connotation. There's
so much stuff out there that, at this point, it's just a constant challenge for any-
one who's making it and uploading stuff to the net. How do you stand out? Does
it matter?

PETRA CORTRIGHT: I think in relating surfing clubs to individuals releasing their
art on the net, Nasty Nets was a little bit different than Loshadka. A lot more
people release or show personal work on Loshadka than Nasty Nets, but there's
also a lot of internet surfing going on there as well. I like what Marcin Ramocki

said in his lecture "Surfing Clubs: Organized Notes and Comments" about the difference between a surfing club and a forum on the internet where people are finding things online all the time and reposting them. I think the main difference is, like Marcin said in his notes, that our titles often really relate to the actual image that's being posted, or things are heavily manipulated or curated into a collection of images.

I don't think that a lot of people consider what they are posting on these blogs as their own artwork. I got interested in posting my work on my LiveJournal back in 2004, and I started making these collages of the tiniest images I could find from Google Images by searching and just putting them together. At the time I didn't really think it was net.art, but now I have them on my portfolio site. I guess now I sort of do consider them my art. They're like any other collages that I would make. Most of my work involves a lot of heavy searching on Google Images.

TIM WHIDDEN: Our work played with the idea that everyone's on the web, and they just wanted stuff that's really quick to understand. So we [the collective MTAA, including Tim Whidden and Mike Sarff] were like, "No, no, we're going to do the exact opposite of that," which means you need to stick with this piece for a year. So we made a work called *One Year Performance Video* [2004] [on screen]. And what you could do is look at this site, and you can see T.Whid, that's me, on one side, and M.River [Mike Sarff], on the other, and we're just sort of stuck in these cells. It's what we call an update on an earlier artist's work where he actually lived in a cell for a year, but you know, we're busy. We can't sit in a cell for a year. So we thought: we'll just put some video clips online, make them smart, and people can log in and they can watch it for a year, and once they're done they get a prize of what we call "art data." And a bunch of people did it; I mean they watched it for a year, and they got the art data, which was basically a description of a yearlong video in XML format.

HALTER: We've sampled a little bit of what's very contemporary in internet art now. The flavor of it, circa 2008, is characterized by this wry, funny, satirical stuff, and then there's this very formal, beautiful work as well. But I feel as a critic that there's actually a lack of a lot of political content, of political work, which is ironic considering that we're in one of the most heatedly political moments that a lot of us have seen in our adult lives. So I'm asking the McCoys: Is this a fair assessment of contemporary net.art? Is there a dearth of political content, and if so, what is the significance of that?

KEVIN MCCOY: You know, with this kind of narrow definition of net.art that is in circulation, I think it is true to say that there isn't much political net.art. I think that is different from how things were in the early dot-com the first time around, the '90s artists like the Electronic Disturbance Theater, FloodNet, the etoy's toywar, the WebStalker alternative web browser, and even JODI's first works in '94 and '95 were sort of conflating content and form in these ways. A lot of people were paying attention to protocols and the importance of protocols as this site of political power online. Alex Galloway's book from 2002, *Protocol: How Control Exists After Decentralization*, is the culmination point of protocol work. After that, things kind of split and either became a tool, a hard, established political discourse online, like indiemedia.org or online political fundraising, or there was an acceptance of protocols and the sandbox that you get when you deal with blog software. It became much more of a sort of personal dialogue and formalism and other kinds of experiments, and so it narrowed it down and the political stuff went off the other side.

JENNIFER MCCOY: A lot of political net.art really thrived on this ambiguousness of the frame. And that ambiguity could be called into question just by its overuse or ubiquity in other realms. I don't necessarily think that the lack of political net .art is an issue, I just think that probably, like the gallery question earlier, it's just that net.art isn't that useful of a tool for politics next to a blog, or any number of other ways that the web interacts with politics.

HALTER: I'm also wondering if some of contemporary net.art seems very—and I'm going to put this in scare quotes—"minor." They're small, momentary works, ephemeral in some instances. And they're in tune with things like satire, parody, historical referencing, rather than the kind of grand statements about art, grand statements that we might expect from, say, an epic form, the large-scale painting, the novel, the symphony. Is internet art stuck in this kind of minor mode by its nature? Or is there an opportunity for it to achieve some kind of long-form, major form?

DAMON ZUCCONI: I think with the archive, the work, or the long-form online, meaning is built up over a long stretch of time, and it's entangled in this daily practice of publishing and distributing, and it's not something that's really planned. So there's never this overarching sense of production from the outset. I think that in my work, small gestures and meaning are compounded and filled up over time. You could look at a group blog or an online collective and see it in the sense of generating its own context and its own guidelines about how its

work works, and it becomes compounded into this much larger entity. I don't want to look at the archive as being something that's retrospective. I want to think of it in this prospective sense, like the archive and becoming. This brings up this really weird question: Where does the archive stop becoming? At what point does this become documentation, or at what point does a single entity become a document and not so much something that's actively functioning? That's the question I have, and I'm not so sure how to address it. This is why I was actually using a blog to publish work, and I moved to this structure of a wiki because I feel like the archive becomes something that's more active, that you can constantly reedit and reengage, whereas within a blog, it becomes dead.

CORTRIGHT: On the subject of net.art being epic, in general any artist who's striving for epic works I find makes the fucking worst artwork ever. I don't think it's fair to say that we have to wait ten years for scholars to write about net.art; I think that it's important now. But I really like how humble it is. It's actually something that I really respect about it. I think it's on a level that a lot of people can appreciate, rather than some super conceptual thing that a lot of general people might not understand or might be intimidated by. Personally, I really like working in a realm that's public on the internet.

..

This conversation was part of an ongoing set of discussions conducted over a number of years. For part 1, "Net Aesthetics 2.0 Conversation, New York City, 2006," see page 99. For part 3, "Post-Net Aesthetics Conversation, London, 2013," see page 413.

..

CITIZENS REPORTING AND THE FABRICATION OF COLLECTIVE MEMORY

Jens Maier-Rothe, Dina Kafafi, and Azin Feizabadi

CITIZENS REPORTING, A COLLECTIVE MEMORY[1]

——

We use our hands for better or for worse, we strike or stroke, build or break, give or take. We should, in front of each image, ask ourselves the question of how it gazes (at us), how it thinks (us) and how it touches (us) at the same time.
—Georges Didi-Huberman

Flipping through the pages of one's memory over the past four years, we stumble upon an array of random "revolution" imagery: a picture book that loosely lumps together clouds of visual material, without clear equation between frames of reference or origin, from the Iranian Green Movement and the various uprisings within the Arab world—via protesters at the periphery of the Eurozone—to different Occupy movements spreading around the globe.

 This certainly has to do with the effects that new media technologies have on collective generational perceptions and how memory at large is fabricated. Social media and web 2.0 played an important role during the unfolding of events in the Arab world, and so they served the self-organization and growth of movements such as Occupy. But this alone does not suffice to draw up coherent threads that link the various social movements and events under the aspect of one collective and ongoing global uprising, as many journalists, writers, curators, and scholars have tried to do recently. The seventh edition of the Berlin Biennial earlier this year exemplified this with an abstrusely arbitrary choice of videos compiled into a multiple-screen installation on the uppermost floor in the Kunst-Werke Berlin.

This essay focuses on a third element playing into this aspect: the rise of new forms of reporting that emerged in response to recent moments of crisis, social change, and political struggle. One key concept that shifted the circulation of events across various media platforms since 2009 is citizen journalism. The term was coined to label all nonprofessional, nongovernmental media coverage that manifests "on the ground" from a position of witnessing. With the rising popularity of citizen journalism, the formal lines between journalism and other professional fields blurred as people from different backgrounds became the reporters, contesting censorship and attempting to restore transparency across media channels. Citizen journalism's crucial role also cranked up the impact that alternative forms of reporting have had on aesthetic discourse at large, as it continues to reshuffle the dynamic relations between notions of citizenship, social awareness, historiography, and collective memory.

The following essay will give a three-way perspective on these issues, starting with an introductory overview of the current status of citizen journalism in the Middle East, with a particular focus on Egypt, and its strife with state-controlled and corporate media. This is followed by ruminations on the potency of new forms of reporting and the alterations of proximity and distance these create within aesthetical and political discourse at large. The last chapter extends these reflections into a wider context, expanding the notion of civic reportage and bringing in two examples from aesthetical and historical perspectives.

OPPOSING THE STATE-CONTROLLED

National media coverage in Egypt often sidesteps such polemical content as human rights infractions or criticism of the authorities. Alternatively, reporters present such subject matter within a framework that rejects its cause or imposes its threat on the state's sovereignty. For example, they were found broadcasting footage of the violent clashes during the first eighteen days of the Egyptian Revolution and framing protestors as armed thugs. In response, citizen journalists provided their own personal accounts, describing their real-time experience of the same event. People now share their stories in opposition to the information distributed through national media sources to bring forth a multitude of readings of a situation and to offer a more holistic capturing of current events. This is the very reason why this moment in time may be referred to as the "Arab Awakening."

Throughout the Middle East and North Africa, it can be noted that the roles of the media and the internet—and also that of public space—have been slowly

changing over the past decade. After years of state-controlled media and communication, there has been a major disconnect between the actuality of an incident and public knowledge. This void of unbiased information has therefore inspired creative routes to the free expression of thoughts, opinions, and facts. A flood of voices, bravely exercising their freedom of speech within these social spheres, strives to prove or negate events emphasized or concealed within daily news. Although uncategorized and chaotic in chronology, they have proven effective in disseminating information among a growing number of people. National media still has the greatest reach, as the majority of populations in countries such as Egypt and Syria do not have access to international news channels or the internet. Censorship and infiltration of the information disseminated among the masses has yielded an increase in blogging, anonymous reporting, and the birth of initiatives and international grants aiding in the development of freedom of expression in the region. All of these efforts aim to ensure that the documentation of this transitional period includes a spectrum of accounts, giving a more comprehensive narrative of this historical moment in Arab history.

New media technologies have facilitated easier routes to communication and hence faster means to mobilizing large numbers of people, making it more difficult for the state to control and patrol online conversations and the like. In the latest 2012 evaluation, Reporters Without Borders listed Syria, Bahrain, Iran, and Saudi Arabia as "Internet enemies," due to their censorship of online content and movements to detain bloggers for participating in antigovernment discussions.[2] In Syria, social networking sites were banned for several years, although internet users were able to access Facebook by tampering with internet proxy settings. The ban was lifted in 2011, most likely to help the state police internet activity and follow activists, as opposed to allowing them to lobby underground. Many bloggers gained a large following by sharing their political opinion and testimonies of events; readers have legitimized their words and labeled them as reliable news sources. Countless stories of Arab bloggers being tortured, detained, and/or put in front of military courts stain a decade's worth of news from countries like Egypt, Tunisia, Bahrain, Saudi Arabia, and Syria. But this only confirms the threats they pose to oppressive regimes and their effectiveness in informing local and international publics. Activists continually find ways to fill in the information gap; others, in support, distribute this data in the public arena, including an otherwise inaccessible segment of society in the information's life cycle.

The urgency of supporting civic reporting has inspired the beginnings of numerous initiatives. *Menassat*, a platform based in Lebanon, offers uncensored news from the MENA region while supporting and empowering Arab journalists.

Mosireen, *Cairo*, 2011. Photo: Jasmina Metwaly

AltCity and *Wamda* provide training, financial support, and spaces for discussions concerning media development. *Meedan*, founded in 2005, is another platform that tightens the information gap between citizens in the Arab and Western worlds. The forum uses Machine Translations for all news stories and commentary uploaded onto the site, making citizen journalism accessible to readers in either region. Additionally, *CheckDesk*, a blogging tool used to report local news immediately (now used by *Al Masry Al Youm* newspaper in Egypt and the Syrian collective *Al Ayam*), is being designed and introduced by such initiatives.

Various collectives have sounded their voices for a specific cause. The Kazeboon (Arabic for "liars") and "No to Military Trials for Civilians" campaigns are branded to catch the common viewer's eye and emphasize the Egyptian public's strife with specific issues. Their presence in the public sphere serves as a reminder of this constant battle and reserves a permanent space in every spectator's mind by providing missing information regarding an array of events relative to their cause—in these cases, the injustices endured under military rule. The consistency of their visual branding holds them accountable for disseminated information and somehow legitimizes it. These efforts unfold by attracting media attention, making it difficult for the accused to bypass consequences for unconstitutional acts and forcing the judiciary system to hold authorities responsible for injustices. This, in turn, will change the way history is written—or rather ensure the inclusion of voices on the ground when documenting history.

In Syria, a far more tense and dangerous environment today, citizen journalists are taking greater risks for a more urgent cause: to occupy a space within the general flow of news that illustrates the otherwise unimaginable means to which their oppressor grapples with his position of authority. In addition to being reporters, here citizen journalists assume a performative role while capturing the moment of their own deaths on camera.[3] This transition in purpose—experienced by Syrian protestors/civil journalists—transforms viewers into witnesses of these events and gives them access to information that is otherwise concealed by Syrian state-controlled media.

In a constant battle, activists have gained agility in bypassing government-designed obstacles to sharing their experiences. No doubt corruption still exists, and at this moment in time it prevails. But with a strong continuity of citizen journalism, a corrupt system will eventually collapse during processes of forced change, starting from the ground up. How then does one decipher among the voices that suddenly occupy virtual and/or physical spaces in our lives? Surely, we are in a moment where a new form of spectatorship is adopted to better understand and record the reality of this historical moment to carry it through to the future.

ALTERING PROXIMITY AND DISTANCE

Live broadcasts of precision-guided missiles entering home television sets during the Gulf War in 1990–91 clearly marked a turning point. The technocratic and machinic character of this imagery created a distance between the spectators and the places where the events took place—a proximity that paradoxically

it's very powerful,

Iara Lee, *The Suffering Grasses*, 2012 (still).
Film. Courtesy the artist and Cultures of
Resistance Network

distances its viewers from the cruel facts of war. That same distance collapsed on
September 11, 2001, when masses of eyewitness reports, mostly shot by private
individuals, took over global news coverage for weeks to come, depicting the
ongoing events in almost real time. US media replied with embedded journal-
ism during the 2003 invasion of Iraq by displaying the military response to the
world and concurrently reestablishing that close distance. With the advent of
social media sites a few years later, acts of reporting and public accounts con-
tinued to render new qualities in terms of formal and investigative aspects, as
well as in terms of mobility, anonymity, and connectivity. Web 2.0 propelled this
aspect further by liberating bloggers from any censorship and filters applied by
traditional mainstream media, making it possible for alternative reportage to
circulate freely. This altogether altered the status of eyewitness reports within
mainstream news coverage, a field highly guarded by professional journalism

CITIZENS REPORTING AND THE FABRICATION OF COLLECTIVE MEMORY

and its protocol. Moreover, it perforated the credentials of the journalistic traditional value system, inserting a new quality of speaking truth from a position of "being on the ground" against the distant position that professional journalism takes due to its ethics and conventions.

These alterations of proximity and distance indicate how new forms of reporting like citizen journalism condition new forms of spectatorship. But what do these new forms of reporting demand from us as spectators, readers, and publics? To what extent do they develop along the same lines as the engendering forms of reporting? And what are the risks and side effects between those lines?

Let's start with the adverse aspects. With a growing amount of sources feeding into the network from a growing number of possible places, it has become difficult to trace the specific characteristics of origin, authorship, and authenticity in what one gets to see and hear on various levels simultaneously. Threatened by repressive regimes and their persecution in a digital age, authors want to stay anonymous, their sources untraced. This poses a problem insofar as the veracity of even the eyewitness report is not guaranteed anymore, and the collective public at times loses the ability to distinguish between the feigned and unfeigned document. In the whirlwind of images generated, in particular during times of crisis, disconnected from their sources, one easily loses any sense of orientation.

At the same time, the material characteristics of civic and amateur reportage have long since been adopted into the language of other fields of aesthetic practice. Inconsistent framing, handheld camerawork, and pixelation, to name just a few formal aspects, are now common stylistic elements in mainstream cinema, advertising, and contemporary art. The accuracy of images with regards to their origin and intent has been blurred, and with this comes an immediate impulse to trust their superficial appearance. We feel reminded of Walter Benjamin's notion of aura, with which he describes the quality of artworks to produce a strange web of space and time; a distance, as close as it can be.[4] For Benjamin, this aura was in imminent danger of being destroyed by the technological progress of film and photography-based media, causing a shift that would strongly affect the social function of media at large. Today's image production and reproduction have reached dimensions that would have exceeded Benjamin's imagination at the time. Reading Benjamin slightly against the grain of his intention today, one could see in citizen journalism and its manifold facets a strange web of proximity and distance that is again at risk of being undermined by technological advancement—or its wrong application. Whether or not these concerns should outweigh the social and political agency of the imagery itself is evidently a complex issue.

Equally evident is that this has caused the aesthetics of protest and resistance to undergo transition, putting them at risk of being co-opted into other contexts where they easily become stripped of their critically informing essence—when street protest imagery becomes a selling point for a pair of jeans, for instance. But in contemporary art too, activist strategies are all too often brought into play but not paired with the necessary time and engagement to achieve the alleged impact on the ground. This has been frequently the case in post-revolutionary societies, such as Egypt—which is why we, as authors working within the context of contemporary art and within the region, see a growing need to give thought to these risks and demand heed and precision with regard to these circumstances.

These shifts, legitimized by the underlying sense of social and political urgency, while at the same time fragmented by the larger complexities of visual culture, affect the formation of different collective subjectivities, whether in close proximity to the events depicted, or at a far distance. Here, again, the notions of distance and proximity are crucial to understanding how they affect the formation of the collective subject on either end. Between the two sides, geographically speaking, we can discern a dividing line drawn between notions of immediacy, of being on the ground, on the one side, and a discursive abstraction, drawing extensively on aesthetic concepts and theoretical analysis, on the other.

"Do we have something in common or not?" Syrian filmmaker and producer Orwa Nyrabia asked the Berlin audience during the "Citizens Reporting, A Collective Memory" conference in August 2012. His question seemingly addressed the apathy within Western political discourse toward the ongoing cruelties of the Assad regime against Syrians and the responsibility that the Western political apparatus constantly neglects, denies, and delays with regards to the situation in Syria. But Nyrabia actually directed his question to the audience, asking them to take up responsibility, and ideally, action, in the most literal sense. How can one be engrossed in an intellectual aesthetic discourse when such real events take place, instead of thinking about how to organize a form of true and active engagement?

Nyrabia's question is marked by that same line of division between the immediate urgency of current events and their discursive abstraction—a line that seems impossible to overcome. At the same time, the immediacy shared through citizen journalists' reports constitutes a connection point that overcomes geographical distances. As such, it simultaneously constitutes and divides the realm of social and political engagement with the events taking place. This two-sided effect of citizen journalism on the political realm alludes to the concept of political difference, which demarcates the distinction between the

what goes on in their personal lives
is not presentable in public

Hamed Yousefi, *Aesthetic of Protest*, 2010
(still). Film. Courtesy the artist

realm of politics—pertaining to the organization of politics, governments, and institutions of state—and the realm of the Political—pertaining to the nature of politics and the political dimension of the social.[5] The realm of the Political is in close proximity to politics but operates at a distance from it. While the realm of politics itself may not offer the citizen any possibility of direct engagement with an existing conflict at a distance, the realm of the Political—distant but not detached from reality—can still provide space to engage with it indirectly without being apolitical. Reflecting the open political process of how such an engagement unfolds, Nyrabia's question encapsulates that precise political difference in itself.

Thus, his question suggests less a matter of overcoming this divide to arrive at collective action than of how to embrace it and how to use its marking points to

explore what distinguishes politics from the Political and what constitutes political difference on either end. This can then become a vantage point from which to think about strategies for public debate and action beyond antagonisms of immediacy and distance, urgency and apathy, politics and aesthetics, activism and art. In a society whose citizens are placed at a distance to a certain location of conflict, a form of reflection that abstracts this conflict is essential in order to politicize it within its own realm of the Political. Now, to turn it around: Is this also the case when in close proximity? When speaking from within the reality of such inconceivable events as in Syria today? On many occasions, writers, activists, filmmakers, scholars, and artists have discussed what it means to write fiction in times of crisis and conflict, whether or not it is appropriate to delve into imagination and literary abstraction when surrounded by such a horrible reality. In a recent article in *The National*, Faisal Al Yafai addressed this question via the Egyptian writer Ahdaf Soueif, who speaks of her own dilemma as an author mostly dedicated to fiction writing, saying that one cannot suspend fiction writing and wait for a conflict to end, for a moment when history is complete, and then resume. Conversely, it "is through fiction that a greater understanding can be reached, precisely because it is distanced."[6]

ENUNCIATING THE *BATIN* (INNER)
———

Various activist and artistic practices may serve to demonstrate how a fictionalization of reality, however temporary or formal it may be, can open up and inhabit a political realm that is similarly characterized by a notion of close proximity. We will look at two epitomizing examples from two different moments in history, analogizing them so as to arrive at a wider understanding of citizen journalism and how it can operate within aesthetic discourse at large. One is Tahrir Cinema,[7] a series of public screenings organized by the Egyptian collective Mosireen in Tahrir Square in Cairo during the Egyptian revolution in 2011. The other is the short film *First Case, Second Case*[8] by Iranian filmmaker Abbas Kiarostami, shot around the time of the Iranian revolution in 1979 and finalized in 1981. Both Tahrir Cinema and Kiarostami's film are gestures that somehow fictionalize reality, if only for a moment in time, to apprise the subjective position of the spectators toward the social and political reality surrounding them. What connects both examples is the aspect of projection, both in the cinematic sense—of a cinema that moves images and emotions when events on screen seem at once immediate and out of reach—and in a time-related sense of projecting an event into the future or the past.

CITIZENS REPORTING AND THE FABRICATION OF COLLECTIVE MEMORY

Shortly after its premiere, *First Case, Second Case* was banned by the Iranian authorities and was considered lost for almost thirty years until it reappeared as a digital file on Vimeo and YouTube in June 2009, during which time the Iranian Green Movement was on the rise and sociopolitical transformation at its peak. Although the preliminary intention for making the film was different than its current form, this fictional film brought to light a reality within the Iranian mindset at the time that was otherwise concealed by mainstream media depicting the post-revolutionary period and during which the Islamic Republic filtered out all opposition parties that were involved in the 1979 revolution.

The film sketches two cases of a situation, hence the title, and calls for taking a moral position on either side. It starts in a classroom when silence is disrupted by a student in the back row every time the teacher turns his back to the students. After several warnings to the unknown student, the teacher suspends a group of suspected students from class for a week, under the condition that they may return if they reveal the identity of the misbehaving student. The narrative perspective shifts as the frame pulls back, showing the same scene as a projection on a screen with a person watching it. An extra-diegetic voice proposes two solutions: In the first case, the students remain silent and accept the collective punishment. In the second case, one of them denounces his fellow student to the teacher and is allowed to resume class.

What follows is a series of interviews and conversations with various people who have contrary opinions about the situation and give mostly evasive and defensive responses at first. As the film moves on, the responses become more decisive as the question is extended to a variety of public figures, among them politicians, religious leaders, filmmakers, activists, artists, actors, poets, and educators. Interestingly, many of them are well known today, as some grew to build a career within the Islamic Republic while others were arrested just a year later due to their political positions; some were taken to the courts or put to death.

Kiarostami's film stays unbiased; it does not re-narrate incidents taking place at that time, nor does it use any political grammar in the manner of propaganda. Instead it depicts the mindset of a group of people from various sects of Iran's political spectrum, challenging the interviewees as well as the spectators to project themselves into a certain place and time, and the consequences of their position in the future. Almost thirty years later, in 2009, the film intervened in a similar way in Iran's sociopolitical processes. Distributed widely among politicians, intellectuals, artists, and activists as part of the Green Movement, the film helped them reclaim the 1979 revolution by understanding how and why the revolution took on a problematic path. When Iranians watched it in 2009, as witnesses to post-revolutionary Iran, they experienced the meaning of their own positions

within their present—within the Green Movement and that collective urgency of the time—while becoming sensitized to the political dimension of that present. Prepared to document a moment in history just before a shift in the sociopolitical situation in Iran, Kiarostami lent his skill as a filmmaker to the collective eye in a similar way that citizen journalism does today. Though Kiarostami mediates his message through artistic prose, both can be considered to manifest present realities through the framework of a non-standardized form of journalistic practice.

Back to the recent past. The Tahrir Cinema events organized by alternative media collective Mosireen in 2011 were a kind of citizen journalism cinema. They provided open platforms for citizens occupying Tahrir Square to share and receive information, projecting video documentations shot by citizens participating in events, demonstrations, sit-ins, and clashes in the square and elsewhere in Egypt. Characterized by an aesthetic mode of cinematic architecture that aims for a sociopolitical goal, Tahrir Cinema turned the French *cinéma militant* tradition of 1968 into a *cinéma civil* in the most literal sense: a *cinéma civil* that relates to public life and is directed by the collective eye of the *civis*, the citizen—against the belligerent opponent, surveying and projecting the acts of the police and military against protesters on the streets—to ensure they are not unseen.

The potency of these collective cinematic moments was unshackled by the shared emotional and psychological experience of the same site. The screenings transformed the square into a cinematic black box, a *Kairos*,[9] elevating vision and imagination. The nightly spectators, demonstrators during the day, analogized their own experience of events with the images projected and the immediate experience of the site itself as being mirrored on the screen. In this moment, both the site and the spectator are shifted into an aesthetic realm that turns the square into a stage of semblance, enabling the identification with the protesting self of the citizen and its subjectivity, which had been denied within public spaces for at least thirty years under Hosni Mubarak. This existential moment of identification acted upon the collective memory and, as such, "re-awakened" a constitutive element of both the collective notion of citizenship and the public sphere.

Mosireen's Tahrir Cinema and Kiarostami's *First Case, Second Case* have two things in common: Both can be considered alternative forms of reporting in the sense that they intervened in the hegemonic order of history and the fabrication of collective memory in the present moment. Both enunciate the *Batin* (inner) of an event instead of representing its *Zahir* (outer), even though they apply very different means. The Tahrir Cinema events projected the site and its spectators onto the screen. Kiarostami's film revealed the social and cultural psyche of post-revolution Iran in 1979 by projecting the collective subconscious of the Iranian society onto itself and from the past into its own future.

As a matter of coincidence, Kiarostami's film itself was "projected" into the future, traveling through almost three decades. When Iranian censorship prohibited its public distribution, the film disappeared and had since then been nearly impossible to find, even for avid film lovers, until its timely reappearance in 2009. And as time would tell, it did not lose its urgency on that journey. Breaking down a historical gap of nearly thirty years, the unremitting relevance of Kiarostami's film as a document of collective memory underlines the desire of many Iranians to not let history repeat itself. The film, however, did not reappear by itself. It was reloaded into the present, in an act of citizen journalism, by citizens who made the film accessible to a wider audience that they knew would benefit from this documentation of realities, through the new media tools they have at their disposal.

As citizens all over the world grasp the means to which they may share perspectives on current events, their original practices, whether they be artists, filmmakers, political analysts, or cultural producers of any kind, then serve as a skill with which they enhance the content or frame of new forms of reporting and how they affect collective memory, history in its making, and the newly acquired rights to the public sphere. Citizen journalism today has gained an accountability and legitimacy that wasn't included within the general flow of news. It is within these frames that spectators gain an utterly different perspective on current events. And it is within these accounts that a collective memory of historical moments gains a comprehensive quality, unlike that of the past.

..

"Citizens Reporting and the Fabrication of Collective Memory" by curators Dina Kafafi and Jens Maier-Rothe and artist and filmmaker Azin Feizabadi was first published on *Ibraaz*, an online platform dedicated to visual culture in North Africa and the Middle East in September 2012. It was later published in *Uncommon Grounds: New Media and Critical Practice in the Middle East and North Africa* (I.B. Tauris, 2014), edited by Anthony Downey.

..

NOTES

1. This collectively written essay was inspired by the authors' shared experience of organizing "Citizens Reporting, A Collective Memory," a conference in Berlin in August 2012, which brought together a group of speakers from various geographical and professional backgrounds, including journalists, filmmakers, artists, and other cultural producers from Egypt, Iran, Syria, Germany, and the US. The conference merged many ideas that manifested themselves simultaneously in 2012, at a time when the political situation in the Middle East was different than it is now. It was primarily sparked by a wish to respond to the misrepresentations of the Arab uprising within the media and art worlds, including, among other things, the 7th Berlin Biennial and its provocative modes of dealing with aesthetics of protest and resistance. The conference had no intent to speak from a position that memorizes revolution as one or multiple events but instead to reflect on how certain events are mediated and represented to become part of a collective memory. In this sense, it contemplated a collective report that acts upon a memory that is in the making as we speak—or write.

2. "Beset by Online Surveillance and Content Filtering, Netizens Fight on," *Reporters Without Borders*, March 13, 2012, <http://en.rsf.org/beset-by-online-surveillance-and-12-03-2012,42061.html>.

3. Jon Rich, "The Blood of the Victim: Revolution in Syria and the Birth of the Image-Event," *e-flux journal* 26 (2011), trans. Bechara Malkoun and Rebecca Lazar, <http://www.e-flux.com /journal/the-blood-of-the-victim-revolution-in-syria-and-the-birth-of-the-image-event>.

4. Walter Benjamin, "A Little History of Photography," in *Walter Benjamin: Selected Writings, Volume 2: 1927–1934*, ed. Michael W. Jennings (Cambridge, MA: Harvard University Press, 1999).

5. Oliver Marchart, *Die Politische Differenz. Zum Denken des Politischen bei Nancy, Lefort, Badiou, Laclau und Agamben* (Berlin: Suhrkamp, 2010).

6. Faisal Al Yafai, "As Regimes Arrest Artists, their Art Explores Arab Uprisings," *The National*, Sept. 4, 2012, <http://www.thenational.ae/thenationalconversation/comment /as-regimes-arrest-artists-their-art-explores-arab-uprisings>.

7. Mosireen, "Our Story," *Cultural Activist Collective*, Sept. 2012, <http://mosireen .org/?p=1117>.

8. Abbas Kiarostami, *Ghazieh-e Shekle-e Avval, Ghazieh-e Shekle-e Dou Wom (First Case, Second Case)*, online video clip, Vimeo, Sept. 2009, <http://vimeo.com/6418143>.

9. The word *Kairos* is an ancient Greek word describing a time in-between. Its meaning contradicts *Chronos*, which refers to linear and chronological time. The actual meaning of *Kairos* is complex and can vary based on the context and cultural specifics in which it is used. In our context, *Kairos* means a timespan that cannot be measured, the "now"; it refers to the opportune time. At Tahrir Cinema, *Kairos* transcends *Chronos*.

INTERNATIONAL ART ENGLISH

Alix Rule and David Levine

Of this English upper-middle class speech we may note (a) that it is not localised in any one place, (b) that though the people who use this speech are not all acquainted with one another, they can easily recognise each other's status by this index alone, (c) that this elite speech form tends to be imitated by those who are not of the elite, so that other dialect forms are gradually eliminated, (d) that the elite, recognising this imitation, is constantly creating new linguistic elaborations to mark itself off from the common herd.
—E. R. Leach, *Political Systems of Highland Burma: A Study of Kachin Social Structure*, 1954

The internationalized art world relies on a unique language. Its purest articulation is found in the digital press release. This language has everything to do with English, but it is emphatically not English. It is largely an export of the Anglophone world and can thank the global dominance of English for its current reach. But what really matters for this language—what ultimately makes it a language—is the pointed distance from English that it has always cultivated.

In what follows, we examine some of the curious lexical, grammatical, and stylistic features of what we call International Art English. We consider IAE's origins and speculate about the future of this language through which contemporary art is created, promoted, sold, and understood. Some will read our argument as an overelaborate joke. But there's nothing funny about this language to its users. And the scale of its use testifies to the stakes involved. We are quite serious.

HYPOTHESIS

IAE, like all languages, has a community of users that it both sorts and unifies. That community is the art world, by which we mean the network of people who collaborate professionally to make the objects and non-objects that go public as contemporary art: not just artists and curators, but gallery owners and directors, bloggers, magazine editors and writers, publicists, collectors, advisers, interns, art history professors, and so on. *Art world* is of course a disputed term, but the common alternative—*art industry*—doesn't reflect the reality of IAE. If IAE were simply the set of expressions required to address a professional subject matter, we would hardly be justified in calling it a language. IAE would be at best a technical vocabulary, a sort of specialized English no different than the language a car mechanic uses when he discusses harmonic balancers or popper valves. But by referring to an obscure car part, a mechanic probably isn't interpellating you as a member of a common world—as a fellow citizen, or as the case may be, a fellow traveler. He isn't identifying you as someone who does or does not get it.

When the art world talks about its transformations over recent decades, it talks about the spread of biennials.[1] Those who have tried to account for contemporary art's peculiar nonlocal language tend to see it as the Esperanto of this fantastically mobile and glamorous world, as a rational consensus arrived at for the sake of better coordination. But that is not quite right. Of course, if you're curating an exhibition that brings art made in twenty countries to Dakar or Sharjah, it's helpful for the artists, interns, gallerists, and publicists to be communicating in a common language. But convenience can't account for IAE. Our guess is that people all over the world have adopted this language because the distributive capacities of the internet now allow them to believe—or to hope—that their writing will reach an international audience. We can reasonably assume that most communication about art today still involves people who share a first language: artists and fabricators, local journalists and readers. But when an art student in Skopje announces her thesis show, chances are she'll email out the invite in IAE. Because, hey—*you never know*.

To appreciate this impulse and understand its implications, we need only consider e-flux, the art world's flagship digital institution. When it comes to communication about contemporary art, e-flux is the most powerful instrument and its metonym. Anton Vidokle, one of its founders, characterizes the project as an artwork.[2] Essentially, e-flux is a listserv that sends out roughly three announcements per day about contemporary art events worldwide. Because of the volume of email, Vidokle has suggested that e-flux is really only for people who are "actively involved" in contemporary art.

There are other ways of exchanging this kind of information online. A service like Craigslist could separate events by locality and language. *Contemporary Art Daily* sends out illustrated mailings featuring exhibitions from around the world. But e-flux channels the art world's aspirations so perfectly: you must pay to send out an announcement, and not every submission is accepted. Like everything the art world values, e-flux is *curated*. For-profit galleries are not eligible for e-flux's core announcement service, so it is also plausibly not commercial. And one can presume—or at very least imagine—that everyone in the art world reads it. (The listserv has twice as many subscribers as the highest-circulation contemporary art publication, *Artforum*—never mind the forward!) Like so much of the writing about contemporary art that circulates online, e-flux press releases are implicitly addressed to the art world's most important figures— which is to say that they are written exclusively in IAE.

We've assembled all thirteen years of e-flux press announcements, a collection of texts large enough to represent patterns of linguistic usage. Many observations in this essay are based on an analysis of that corpus.

> **SKETCH ENGINE MODULE 1: CONCORDANCE**
>
> In order to examine the stylistic tendencies of International Art English, we entered every e-flux announcement published since the listserv's launch in 1999 into Sketch Engine, a concordance generator developed by Lexical Computing. Sketch Engine allows you to analyze usage in a variety of ways, including concordances, syntactical behavior, and word usage over time. We invite you to follow our analysis by using Sketch Engine[3] to do your own searches. Click on the blue dates to see original articles, and the red words to see sentences.

VOCABULARY

The language we use for writing about art is oddly pornographic: we know it when we see it. No one would deny its distinctiveness. Yet efforts to define it inevitably produce squeamishness, as if describing the object too precisely might reveal one's particular, perhaps peculiar, investments in it. Let us now break that unspoken rule and describe the linguistic features of IAE in some detail.

IAE has a distinctive lexicon: *aporia*, *radically*, *space*, *proposition*, *biopolitical*, *tension*, *transversal*, *autonomy*. An artist's work inevitably interrogates, questions, encodes, transforms, subverts, imbricates, displaces—though often it doesn't do these things so much as it serves to, functions to, or seems to (or might seem

to) do these things. IAE rebukes English for its lack of nouns: *Visual* becomes *visuality*, *global* becomes *globality*, *potential* becomes *potentiality*, *experience* becomes…experiencability.

Space is an especially important word in IAE and can refer to a raft of entities not traditionally thought of as spatial (*the space of humanity*) as well as ones that are in most circumstances quite obviously spatial (*the space of the gallery*). An announcement for the 2010 exhibition "Jimmie Durham and His Metonymic Banquet," at Proyecto de Arte Contemporáneo Murcia in Spain, had the artist "questioning the division between inside and outside in the Western sacred space"—the venue was a former church—"to highlight what is excluded in order to invest the sanctum with its spatial purity. Pieces of cement, wire, refrigerators, barrels, bits of glass and residues of 'the sacred,' speak of the space of the exhibition hall…transforming it into a kind of 'temple of confusion.'"

Spatial and nonspatial space are interchangeable in IAE. The critic John Kelsey, for instance, writes that artist Rachel Harrison "causes an immediate confusion between the space of retail and the space of subjective construction." The rules for *space* in this regard also apply to *field*, as in "the field of the real"—which is where, according to art historian Carrie Lambert-Beatty, "the parafictional has one foot." (Prefixes like *para-*, *proto-*, *post-*, and *hyper-* expand the lexicon exponentially and Germanly, which is to say without adding any new words.) It's not just that IAE is rife with spacey terms like *intersection*, *parallel*, *parallelism*, *void*, *enfold*, *involution*, and *platform*. IAE's literary conventions actually favor the hard-to-picture spatial metaphor: a practice "spans" from drawing all the way to artist's books; Matthew Ritchie's works, in the words of *Artforum*, "elegantly bridge a rift in the art-science continuum"; Saâdane Afif "will unfold his ideas beyond the specific and anecdotal limits of his Paris experience to encompass a more general scope, a new and broader dimension of meaning."

And so many ordinary words take on nonspecific alien functions. "Reality," writes artist Tania Bruguera, in a recent issue of *Artforum*, "functions as my field of action." Indeed: *Reality* occurs four times more frequently in the e-flux corpus than in the British National Corpus (BNC), which represents British English usage in the second half of the twentieth century.[4] *The real* appears 2,148 times per million units in the e-flux corpus versus a mere twelve times per million in the BNC—about 179 times more often. One exhibit invites "the public to experience the perception of colour, spatial orientation and other forms of engagement with reality"; another "collects models of contemporary realities and sites of conflict"; a show called "Reality Survival Strategies" teaches us that the "*sub real* is…formed of the leftovers of reality."

SYNTAX

Let us turn to a press release for Kim Beom's "Animalia" (2011), exhibited at REDCAT last spring: "Through an expansive practice that spans drawing, sculpture, video, and artist books, Kim contemplates a world in which perception is radically questioned. His visual language is characterized by deadpan humor and absurdist propositions that playfully and subversively invert expectations. By suggesting that what you see may not be what you see, Kim reveals the tension between internal psychology and external reality, and relates observation and knowledge as states of mind."

Here we find some of IAE's essential grammatical characteristics: the frequency of adverbial phrases such as "radically questioned" and double adverbial terms such as "playfully and subversively invert." The pairing of like terms is also essential to IAE, whether in particular parts of speech ("internal psychology and external reality") or entire phrases. Note also the reliance on dependent clauses, one of the most distinctive features of art-related writing. IAE prescribes not only that you open with a dependent clause but that you follow it up with as many more as possible, embedding the action deep within the sentence, effecting an uncanny stillness. Better yet: *both* an uncanny stillness *and* a deadening balance.

IAE always recommends using more rather than fewer words. Hence a press release for a show called "Investigations" notes that one of the artists "reveals something else about the real, different information." And when Olafur Eliasson's *Yellow Fog* (1998/2008) "is shown at dusk—the transition period between day and night—it represents and comments on the subtle changes in the day's rhythm." If such redundancies follow from this rule, so too do groupings of ostensibly unrelated items. Catriona Jeffries Gallery writes of Jin-me Yoon: "Like an insect, or the wounded, or even a fugitive, Yoon moves forward with her signature combination of skill and awkwardness." The principle of anti-economy also accounts for the dependence on lists in IAE. This is illustrated at inevitable length in the 2010 press release announcing the conference "Cultures of the Curatorial," which identifies "the curatorial" as "forms of practice, techniques, formats and aesthetics…not dissimilar to the functions of the concepts of the filmic or the literary" that entail "activities such as organization, compilation, display, presentation, mediation or publication…a multitude of different, overlapping and heterogeneously coded tasks and roles."[5]

Reading the "Animalia" release may lead to a kind of metaphysical seasickness. It is hard to find a footing in this "space" where Kim "contemplates" and "reveals" an odd "tension," but where in the end nothing ever seems to *do* anything. And yet to those of us who write about art, these contortions seem to be

2001,07	Biennial is an attempt to allow the local	reality	become a space of flux and connection between
2001,07	generations through the workshops, while the	reality	is characterized not only by the continuity
2001,07	(Quantum Teleportation and the Nature of	Reality) July 25 (Conference) Time - Uncertainty
2001,10	political, social, economic and personal	realities	is picked out as a central theme in the
2001,10	professionalism through the distance from western	reality	. This goes hand in hand with the excellent
2001,11	the efforts of making FAST FWD: MIAMI a	reality	. We saw a possibility for younger galleries
2001,12	are developing new models of contemporary	reality	. The reality they model through their work
2001,12	new models of contemporary reality. The	reality	they model through their work is as fictional
2001,12	architecture was generally based on a material	reality	. Architecture mirrored function and art
2001,12	from which it was made. As our model of	reality	has become more layered and less concrete
2001,12	audience into the gap between fiction and	reality	. Other artists create elaborate fictional
2001,12	fictional systems that fuse elements of	reality	and fantasy. Form Follows Fiction is conceived
2001,12	attempts to represent the new conception of	reality	being developed by the generation of artists
2002,01	addresses the interplay between external	reality	and internal states of mind. The installation
2002,02	dreams and nightmares can be measured against	reality	. In order to make this quite clear, Buetti
2002,03	is precisely such an oscillation between	reality	and fantasy that characterizes the world
2002,03	, Majorca and Segou, Mali. The reference	reality	of Barceló is complex and detailed, based
2002,03	represents a different view of the actual visual	reality	, it is not an anti-show. It completes instead
2002,03	The mix blurs the border between image and	reality	in an uncanny way. Lars Nilsson's investigation
2002,03	paradoxically investigated through its material	reality	. In the project space we show the work

Occurrences of *reality* in the e-flux corpus

irresistible, even natural. When we sense ourselves to be in proximity to something serious and art related, we reflexively reach for subordinate clauses. The question is why. How did we end up writing in a way that sounds like inexpertly translated French?

GENEALOGY

If e-flux is the crucible of today's IAE, the journal *October* is a viable candidate for the language's point of origin. In the pages of *October*, founded in 1976, an American tradition of formalist art criticism associated with Clement Greenberg collided with continental philosophy. *October*'s editors, among them art historians Rosalind Krauss and Annette Michelson, saw contemporary criticism as essentially slovenly and *belle lettristic*; they sought more rigorous interpretive criteria, which led them to translate and introduce to an English-speaking audience many French poststructuralist texts.[6] The shift in criticism represented by *October* had an enormous impact on the interpretation and evaluation of art and also changed the way writing about art *sounded*.

Consider Krauss's "Sculpture in the Expanded Field," published in 1979: "Their failure is also encoded onto the very surface of these works: the doors having been gouged away and anti-structurally encrusted to the point where they bear their inoperative condition on their face, the *Balzac* having been executed with such a degree of subjectivity that not even Rodin believed (as letters by him attest) that the work would be accepted." Krauss translated Barthes, Baudrillard, and Deleuze for *October*, and she wrote in a style that seemed forged in those translations. So did many of her colleagues. A number of them were French and German, so presumably they translated themselves in real time.

Many of IAE's particular lexical tics come from French, most obviously the suffixes *-ion*, *-ity*, *-ality*, and *-ization*, so frequently employed over homelier alternatives like *-ness*. The mysterious proliferation of definite and indefinite articles—"the political," "the space of absence," "the recognizable and the repulsive"—are also French imports. *Le vide*, for instance, could mean "empty things" in general—evidently the poststructuralists' translators preferred the monumentality of "The Void."

Le vide occurs 20.9 times per million in the French Web Corpus; *the void* occurs only 1.3 times per million in the BNC but 9.8 times per million in the e-flux corpus. (Sketch Engine searches are not case sensitive.) The word *multitude*, the same in English and French, appears 141 times in e-flux press releases. *A lot* appears 102 times.

French is probably also responsible for the prepositional and adverbial phrases that are so common in IAE: *simultaneously, while also,* and, of course, *always already.* Many tendencies that IAE has inherited are not just specific to French but to the highbrow written French that the poststructuralists appropriated, or in some cases parodied (the distinction was mostly lost in translation). This kind of French features sentences that go on and on and make ample use of adjectival verb forms and past and present participles. These have become art writing's stylistic signatures.[7]

French is not IAE's sole non-English source. Germany's Frankfurt School was also a great influence on the *October* generation; its legacy can be located in the liberal use of <u>production</u>, <u>negation</u>, and <u>totality</u>. <u>Dialectics</u> abound. (*Production* is used four times more often in the e-flux corpus than in the BNC, *negation* three times more often, *totality* twice as often. *Dialectics* occurs six times more often in the e-flux corpus than in the BNC; at 9.9 instances per million, *dialectics* is nearly as common to IAE as *sunlight* to the BNC.) One <u>press release</u> notes that "humanity has aspired to elevation and desired to be free from alienation of and subjugation to gravity.... This physical and existential dialectic, which is in a permanent state of oscillation between height and willful falling, drives us to explore the limits of balance." Yes, the assertion here is that standing up is a dialectical practice.

October's emulators mimicked both the deliberate and unintentional features of the journal's writing, without discriminating between the two. Krauss and her colleagues aspired to a kind of analytic precision in their use of words, but at several degrees' remove those same words are used like everyday language: anarchically, expressively. (The word *dialectic* has a precise, some would say scientific, meaning, but in IAE it is normally used for its affective connotation: it means "good.") At the same time, the progeny of *October* elevated accidents of translation to the level of linguistic norms.

IAE channels theoretical influences more or less *aesthetically,* sedimented in a style that combines their inflections and formulations freely and continually incorporates new ones.[8] (Later art writing would *trouble,* for instance, and *queer.*) Today the most authoritative writers <u>cheerfully assert</u> that criticism lacks a sense of what it is or does: unlike in the years following *October*'s launch, there are no clearly dominant methodologies for interpreting art. And yet, the past methodologies are still with us—not in our substantive interpretations, but in the spirit and letter of the art world's universally foreign language.[9]

INTERNATIONAL ART ENGLISH

AUTHORITY

We hardly need to point out what was exclusionary about the kind of writing that Anglo art criticism cultivated. Such language asked more than to be understood, it demanded to be *recognized*. Based on so many idiosyncrasies of translation, the language that art writing developed during the *October* era was alienating in large part because it was legitimately alien. It alienated the English reader as such, but it distanced you less the more of it you could find familiar. Those who could recognize the standard feints were literate. Those comfortable with the more esoteric contortions likely had prolonged contact with French in translation or, at least, theory that could pass for having been translated. So art writing distinguished readers. And it allowed some writers to sound more authoritative than others.

Authority is relevant here because the art world does not deal in widgets. What it values is fundamentally symbolic, interpretable. Hence the ability to evaluate—the power to deem certain things and ideas significant and critical—is precious. Starting in the 1960s, the university became the privileged route into the rapidly growing American art world. And in *October*'s wake, that world systematically rewarded a particular kind of linguistic weirdness. One could use this special language to signal the assimilation of a powerful kind of critical sensibility, one that was rigorous, politically conscious, and probably university trained. In a much expanded art world this language had a job to do: consecrate certain artworks as significant, critical, and, indeed, contemporary. IAE developed to describe work that transcended the syntax and terminology used to interpret the art of earlier times.

It did not take long for the mannerisms associated with a rather lofty critical discourse to permeate all kinds of writing about art. *October* sounded seriously translated from its first issue onward. A decade later, much of the middlebrow *Artforum* sounded similar. Soon after, so did artists' statements, exhibition guides, grant proposals, and wall texts. The reasons for this rapid adoption are not so

different from those which have lately caused people all over the world to opt for a global language in their writing about art. Whatever the content, the aim is to sound to the art world like someone worth listening to, by adopting an approximation of its elite language.

But not everyone has the same capacity to approximate. It's often a mistake to read art writing for its literal content; IAE can communicate beautifully without it. Good readers are quite sensitive to the language's impoverished variants. An exhibition guide for a recent New York City MFA show, written by the school's art history master's students, reads: "According to [the artist] the act of making objects enables her to control the past and present." IAE of insufficient complexity sounds both better and worse: it can be more lucid, so its assertions risk appearing more obviously ludicrous. On the other hand, we're apt to be intimidated by virtuosic usage, no matter what we think it means. An e-flux release from a leading German art magazine refers to "elucidating the specificity of artistic research practice and the conditions of its possibility, rather than again and again spelling out the dialectics (or synthesis) of 'art' and 'science.'" Here the magazine distinguishes itself by reversing the normal, affirmative valence of *dialectic* in IAE. It accuses the dialectic of being boring. By doing so the magazine implicitly lays claim to a better understanding of dialectics than the common reader, a claim that is reinforced by the suggestion that this particular dialectic is so tedious as to be interchangeable with an equally tedious synthesis. What *dialectic* actually denotes is negligible. What matters is the authority it establishes.

SKETCH ENGINE MODULE 3: HISTOGRAM

To generate your own histogram, do a concordance search for the word of your choice. Then, in the sidebar, select "Frequency." In the new window, select the type of analysis you want to do (e.g., by year or by institution) in the "Text Type Frequency Distribution" panel, and then click "Frequency List."[11]

IMPLOSION

Say what you will about biennials. Nothing has changed contemporary art more in the past decade than the panoptic effects of the internet. Before e-flux, what had the Oklahoma City Museum of Art to do with the Pinakothek der Moderne, Munich? And yet once their announcements were sent out on the same day, they became relevant—legible—to one another. The same goes for the artists

Frequency list

Frequency limit: [0] (Set limit)

	year	Freq	Rel [%]
p/n	2000	1	116.0
p/n	2001	3	79.7
p/n	2002	10	122.5
p/n	2003	16	206.1
p/n	2004	21	105.0
p/n	2005	30	108.3
p/n	2006	43	123.4
p/n	2007	53	132.0
p/n	2008	46	100.2
p/n	2009	59	124.1
p/n	2010	46	88.9
p/n	2011	32	57.5
p/n	2012	8	33.5

Lexical Computing Ltd. LEX COM
Sketch Engine (ver:SkE-2.59-2.91.9)

Using Sketch Engine, you can track usage over time and generate histograms—graphs of frequency distributions—that show how certain terms "trend" in the e-flux corpus. Liam Gillick, perhaps the quintessential artist of the IAE era, had his best year in 2009, judging by the number of instances. But in terms of relative frequency— instances in a given year relative to the total number of words used in that year, swell as the frequency of the word within the overall corpus— his best year was 2003

whose work was featured in them, and for the works themselves. Language in the art world is more powerful than ever. Despite all the biennials, most of the art world's attention, most of the time, is online. For the modal reader of e-flux, the artwork always arrives already swaddled in IAE.

Because members of today's art world elite have no monopolies on the interpretation of art, they recognize each other mostly through their mobility. Nevertheless, the written language they've inherited continues to attract more and more users, who are increasingly diverse in their origins. With the same goals in mind as their Anglophone predecessors, new users can produce this language copiously and anonymously. The press release, appearing as it does mysteriously in God knows whose inboxes, is where attention is concentrated. It's where IAE is making its most impressive strides.

The collective project of IAE has become actively global. Acts of linguistic mimicry and one-upmanship now ricochet across the web. (Usage of the word *speculative* spiked unaccountably in 2009; 2011 saw a sudden rage for *rupture*; *transversal* now seems poised to have its best year ever.)[12] Their perpetrators have fewer means of recognizing one another's intentions than ever. We hypothesize that the speed at which analytic terms are transformed into expressive, promotional tokens has increased.

As a language spreads, dialects inevitably emerge. The IAE of the French press release is almost too perfect: it is written, we can only imagine, by French interns imitating American interns imitating American academics imitating French academics.[13] Scandinavian IAE, on the other hand, tends to be lousy.[14] Presumably its writers are hampered by false confidence—with their complacent nonnative fluency in English, they have no ear for IAE.

An e-flux release for the 2006 Guangzhou Triennial, aptly titled "Beyond," reads: "An extraordinary space of experimentation for modernization takes the Pearl River Delta"—the site of a planned forty-million-person megacity—"as one of the typical developing regions to study the contemporary art within the extraordinary modernization framework that is full of possibilities and confusion. Pearl River Delta (PRD) stands for new space strategies, economic patterns and life styles. Regard this extraordinary space as a platform for artistic experimentation and practice. At the same time, this also evokes a unique and inventive experimental sample." This is fairly symptomatic of a state of affairs in which the unwitting emulators of Bataille in translation might well be interns in the Chinese Ministry of Culture—but then again might not. The essential point is that learning English may now hardly be a prerequisite for writing proficiently in the language of the art world.

At first blush this seems to be just another victory over English, promising an increasingly ecstatic semantic unmooring of the art writing we've grown

accustomed to. But absent the conditions that motored IAE's rapid development, the language may now be in existential peril. IAE has never had a *codified* grammar; instead, it has evolved by continually incorporating new sources and tactics of sounding foreign, pushing the margins of intelligibility from the standpoint of the English speaker. But one cannot rely on a global readership to feel properly alienated by deviations from the norm.[15]

We are not the first to sense the gravity of the situation. The crisis of criticism, ever ongoing, seemed to reach a fever pitch at the end of the first decade of the twenty-first century. Art historian and critic Sven Lütticken lamented that criticism has become nothing more than "highbrow copywriting." The idea that serious criticism has somehow been rendered inoperative by the commercial condition of contemporary art has been expressed often enough in recent years, yet no one has convincingly explained how the market squashed criticism's authority. Lütticken's formulation is revealing: Is it that highbrow criticism can no longer claim to sound different than copy? Critics, traditionally the elite innovators of IAE, no longer appear in control. Indeed, they seem likely to be beaten at their own game by anonymous antagonists who may or may not even know they're playing.

Guangzhou again: "The City has been regarded as a newly-formed huge collective body that goes beyond the established concept of city. It is an extraordinary space and experiment field that covers all the issues and is free of time and space limit." This might strike a confident reader of IAE as a decent piece of work: we have a redundantly and yet vaguely defined phenomenon transcending "the established concept" of its basic definition; we have time and space; we have a superfluous definite article. But the article is in the wrong place; it should be "covers all issues and is free from the time and space limit." Right? Who wrote this? But wait. Maybe it's avant-garde.

Can we imagine an art world without IAE? If press releases could not telegraph the seriousness of their subjects, what would they simply *say*? Without its special language, would art need to submit to the scrutiny of broader audiences and local ones? Would it hold up?

If IAE implodes, we probably shouldn't expect that the globalized art world's language will become neutral and inclusive. More likely, the elite of that world will opt for something like conventional highbrow English and the reliable distinctions it imposes.

Maybe in the meantime we should enjoy this decadent period of IAE. We should read e-flux press releases not for their content, not for their technical proficiency in IAE, but for their lyricism, as we believe many people have already begun to do.[16] Take this release, reformatted as meter:

Peter Rogiers is toiling through the matter
with synthetic resin and cast aluminum
attempting to generate an oblique and "different" imagery
out of sink with what we recognize
in "our" world.
Therein lies the core
and essence of real artistic production—the desire
to mould into plastic shape
undermining visual recognition
and shunt man onto the track
of imagination.
Peter Rogiers is and remains
one of those sculptors who averse from all
personal interests is stuck
with his art in brave stubbornness
to (certainly) not give into creating
any form of
languid art whatsoever.
His new drawing can further be considered
catching thought-moulds
where worlds tilt
and imagination
chases off grimy reality.

We have no idea who Peter Rogiers is, what he's up to, or where he's from,
but we feel as though we would love to meet him.

..

"International Art English," coauthored by sociologist Alix Rule and artist David Levine, was first published in online magazine *Triple Canopy* in 2013. Widely cited, discussed, and debated, the essay prompted rebuttals from artists Hito Steyerl and Martha Rosler, both regular contributors to the site e-flux, whose press release archive was used to generate data for Rule and Levine's essay. For *Mass Effect*, *Triple Canopy* editor Alexander Provan has written a short follow-up on the essay's afterlife, which appears next in this volume, titled "Chronicle of a Traveling Theory."

..

NOTES

1. For the purposes of this reprint, words that have been underlined originally appeared in red in the online *Triple Canopy* article and were linked to content featured on e-flux. This first hyperlink, "the spread of biennials," takes users to an e-flux-distributed press release for the 9th Gwangju Biennial in South Korea.

2. "In its totality, e-flux is a work of art that uses circulation both as form and content," Vidokle told *Dossier* in 2009, after an interviewer asked whether e-flux—by that time quite profitable—was art or a business.

3. Visit the original article to use Sketch Engine: <http://canopycanopycanopy.com/contents /international_art_english> (accessed Aug. 13, 2014).

4. Using Sketch Engine's parts-per-million calculator, we can measure the frequency of words in IAE relative to their usage in other corpora. For instance, the website of the BNC, which is searchable on Sketch Engine, describes the corpus as "a 100 million word collection of samples of written and spoken language from a wide range of sources." Searching for "reality" in the e-flux corpus returns 1,957 hits, which represents 313.7 hits per million; searching for "reality" in the significantly larger BNC returns 7,196 hits, which represents only 64.1 hits per million. In other words, *reality* plays a much more prominent role in International Art English than in British English.

5. Similarly, White Flag Projects <u>describes</u> Daniel Lefcourt's 2012 exhibition, Mockup, as "a storage room, a stage set, a mausoleum, a trade show, a diagram, a game board, a studio, a retail store, a pictograph, a classroom, a museum display, an architectural model, and a sign-maker's workshop."

6. IAE is rarely referred to as *writing*, much less *prose*, though on occasion art people want to write, or claim to have written, an "essay," which at least has its etymological roots in the right place. The choice of *text*—fungible, indifferent, forbidding—says much about how writing has come to be understood in the art world. Texts, of course, are symptomatic on the part of their authors, and readers may glean from them multiple meanings. The richness of a text has everything to do with its shiftiness.

7. The press release for Aaron Young's 2012 show at the Company, <u>"No Fucking Way,"</u> reads: "This blurring of real and constructed, only existing in the realm of performance, speculation and judgment, implicates the viewer in its consumption, since our observation of these celebrities will always be mediated."

8. It's hard to pinpoint the source of some of IAE's favorite tics. Who is to blame for the idle inversion? Chiasmus is at least as much Marxist as poststructuralist. We could look to Adorno, for whom "myth is already Enlightenment; and Enlightenment reverts to mythology." Benjamin, in his famous last line of "The Work of Art in the Age of Mechanical Reproduction," writes about fascism's aestheticization of politics as opposed to communism's politicization of art. David Lewis, reviewing a George Condo exhibition in *Artforum*, writes that the artist's "subject matter, ranging from whores to orgies and clowns, is banal but never *about* banality, and Condo does not seem to really 'play' with bad taste—it appears instead that bad taste plays with him."

9. IAE conveys the sense of political tragedy: everything is straining as hard as it can to be radical in a context where agency is perennially fucked, forever, for everyone. Art must, by

lexical design, "interrogate" and "problematize" and "blur boundaries" and even "highlight blurred boundaries." But the grammatical structures make failure a foregone conclusion. (Thinking of these structures as social structures conjures up a world—borrowed vaguely, and wrongly, from Marx—in which thinkable action is doomed.) Of course, not all art is actually working to make revolution, and neither are art institutions that provide "platforms" for such work. But once artists themselves start making work that is expressed in these terms, such statements do become trivially true: art *does* aim to interrogate and so on. Even the most <u>naïve</u> attempts at direct action are absorbed by this language. An artist turns his museum residency into a training camp for activists, which the museum's <u>press release</u> renders as "a site for sustained inquiry into protest strategies and activist discourse" that "attempts to embody the organic, dynamic processes of the protest in action." The activity dies in language—the museum, on the other hand, "emerge[s] as a contested site."

10. Visit the original article to explore Sketch Engine's "Word Sketch" functionality: <http://canopycanopycanopy.com/contents/international_art_english> (accessed Aug. 13, 2014).

11. Visit the original article to create a histogram using Sketch Engine: <http://canopycanopycanopy.com/contents/international_art_english> (accessed Aug. 13, 2014).

12. For how to interpret Sketch Engine histograms, please consult <u>this gallery</u> [See "Frequency list" diagram on the Triple Canopy website: http://www.canopycanopycanopy.com/contents/international_art_english].

13. We should not suppose that because of their privileged historical relationship to IAE, the French have any better idea of what they're saying. "[Nico] Dockxs [*sic*] work continually develops in confrontation with, and in relation to, other actors," reads an e-flux press release from Centre International d'Art et du Paysage Ile de Vassivière. "On this occasion he has invited [two collaborators]…to accompany him in producing the exhibition, which they intend to enrich with new collaborations and new elements throughout the duration of the show. The project…is a repetition and an evolution, an improvisation on the favourable terrain that is time."

14. Consider the relatively impoverished IAE of this announcement for the 2006 Helsinki Biennial: "Art seeks diverse ways of understanding reality. Kiasmas [*sic*] international exhibition ARS 06 focuses on meaning of art as part of the reality of our time. The subtitle of the exhibition is Sense of the Real." The vocabulary is correct if unadventurous, including both "reality" and "the Real." But the grammar is appalling: the sentences are too short, too direct; the very title of the exhibition surely includes at least one too few articles. The release suggests that its authors are not consummate users of IAE, but popularizers, reductionists, and possibly conservatives who know nothing about "the Real."

15. If IAE is taken to be inclusive precisely because it is not highbrow English, then it is <u>no longer effectively creating the distinctions</u> that have driven its evolution.

16. A nod to <u>Joseph Redwood-Martinez</u>, who, as far as we can make out, was the first to note the poetic possibilities of the IAE press release.

Alexander Provan

International Art English is now an ineluctable, flagrant feature of the art-writing landscape. Prior to *Triple Canopy*'s publication of Alix Rule and David Levine's essay by that name in June 2012, many readers may have had a vague notion of certain common linguistic peculiarities to be found on the websites of Chinese museums and Parisian galleries, in the press releases issued by Chelsea galleries and in the pages of German magazines—in all manner of venues that employ language to represent visual art and aesthetic experience, whether for promotional, educational, or critical purposes. Within six months of the publication of "International Art English," those readers and many thousands more could not help but recognize the lexical tics ("spatiality," "globality," "potentiality," "experiencability"), double adverbial terms, dependent clauses, adjectival verb forms, and past and present participles that so pervade writing about art. For the essay's boosters as well as detractors—about which I will discuss more later—International Art English (IAE) has become a byword for the devolution of the language of criticism (and the diminution of the authority of critics) in the globalized, internet-addled art world, but also for the possibility of redemptive reconfigurations of that language. This is true to such a degree that recent articles reiterating the phenomenon, whether published by the BBC or online content mills, have dispensed with references to the original essay.

As editor of *Triple Canopy*, I worked closely with Levine and Rule on "International Art English." They initially presented the fundaments of IAE as part of a discussion organized by the magazine in 2011 at Artissima, the Italian art fair; in the months preceding publication, we exchanged tens of thousands of words via email and traded innumerable drafts and edits. Rule and Levine were thorough in the distillation of their observations, meticulous in the construction of their argument, and sensitive to the balance of seriousness and levity (without which

the essay might veer toward pomp or snark). After all, they were not just describing enormous changes in the way in which we write about art and derive status from that writing; they were also anticipating that "International Art English" might be misconstrued as snubbing e-flux—which has for the past four years occupied the upper echelon of *ArtReview*'s Power 100 list and is currently vying for control of the .art domain—and as censuring MFA students in Skopje for desacralizing the rhetoric of academe. (And then there was the specter of the Sokal hoax: in 1996, Alan Sokal, a professor of physics at New York University, published "Transgressing the Boundaries: Towards a Transformative Hermeneutics of Quantum Gravity" in the journal *Social Text*. The article purported to argue that "physical reality" is a "social and linguistic construct" but consisted largely of nonsensical jargon and ideological blandishment—a craven and unethical, if provocative, effort to expose the bankruptcy of "trendy" postmodernists and the "fashionable nonsense" they spewed about science.)

By the time "International Art English" was ready to be published, I believed that Rule and Levine had figured out how to handle the analysis of the e-flux corpus, the history of criticism after *October*, etc., all the while conveying the vertiginous feeling one gets when the semiotic order suddenly seems to be foundering. They managed to take art world press releases seriously but also to appreciate their brazen and often hilarious rejection of linguistic convention—which, they observed, betrays an entirely novel set of conventions, themselves worthy of scrutiny. And they addressed the evacuation of meaning from the vocabulary of poststructuralism without coming across as codgers, elitists, anti-intellectuals, or some monstrous combination of the three.

In the year following publication, "International Art English" garnered 69,023 unique page views (which is as close as *Triple Canopy* can get to an estimate of readership) and was translated into several languages. I was exhilarated, and very soon exhausted, by the feverish response as I felt compelled to read nearly every word of it. On MetaFilter—amid much discussion of whether or not *Triple Canopy*'s side-scrolling design was the user-interface equivalent of IAE, sorting expert users from the uninitiated—readers discussed the relationship between French and the prevalence of the definite article in IAE; the pressure felt by artists to employ IAE in order to identify their work as "significant and critical," which results in increasingly rarefied language that ultimately alienates outsiders. On Facebook, there was the usual mix of boosterism and bile, dutiful affirmation and casual crucifixion, as well as a modicum of intelligent conversation—much of it concentrated on the page of Hito Steyerl, an artist and regular contributor to *e-flux journal*, who found the essay condescending toward those who spoke English (and not the Queen's English) as a second or third language.

In January, the *Guardian* published "A User's Guide to Artspeak," a glib account of the essay's genesis and reception, which characterized IAE as "pompous, overblown prose" that serves as "ammunition for those who still insist contemporary art is a fraud."[1]

The next month, speaking on a panel at the annual College Art Association conference in New York City, e-flux cofounder Anton Vidokle dismissed "International Art English" for failing to recognize the difference between press releases published by international galleries employing nonnative speakers and those published by powerful Chelsea galleries employing Ivy League art history PhDs. I attempted to correct him from the bleachers: The essay parses those discrepancies and the way in which academic training distinguishes writers of IAE. I pointed out that Rule and Levine are concerned with the ways in which nonnative speakers might feel *compelled* to write in a manner that aggrandizes the art world elite, but also with the prospect of the diffusion of IAE despoiling their station. Vidokle's response, as reported by the *New York Observer*: "Foreigners always imitate something, right? This is, like, the typical colonial argument."

In March, *Hyperallergic* published "When Artspeak Masks Oppression," in which Mostafa Heddaya interpreted Rule and Levine's gestures toward the liberating qualities of newfound strains of IAE as parody.[2] He gently chastised the authors for missing an essential point: in "emerging contemporary art superpowers"[3] like the United Arab Emirates, IAE often functions as propaganda, with artists and institutions alike employing "ostensibly subversive language"[4] to obscure the facts of oppression and save face. Heddaya participated in "Critical Language," a symposium on International Art English organized by *Triple Canopy*, along with Levine, Rule, and several other writers, curators, and artists. Among them was Mariam Ghani, who soon authored an essay on the subject for *Triple Canopy*, in which she observed that IAE "can be used to circumvent both explicit and implicit restrictions on freedom of expression in places like Afghanistan,"[5] where art is understood to be politically potent and is thus restricted by the state.

In May, *e-flux journal* published negative commentaries on IAE by Hito Steyerl and artist Martha Rosler. Steyerl, the more unsparing of the two, marked Levine and Rule as language police, denounced them for harboring "nativist disdain for rambling foreigners," and ridiculed them for adhering to what she called the maxim of English art writing: "never offend anyone more powerful than yourself."[6] In turn, she lauded "the sheer wildness at work in the creation of new lingos," fabricated "between Skopje and Saigon by interns and non-resident aliens on emoji keyboards," which might "show the outlines of future publics that

extend beyond preformatted geographical and class templates"—and somehow dismissed Rule and Levine's appreciation of the same scenario as merely patronizing.

Agree with them or not, there was much to like about these responses: first of all, the fact that people felt sufficiently stirred to formulate and publish so many squibs and screeds. Many of them addressed questions that Rule and Levine did not or could not—in part because the essay was based on an analysis of the e-flux corpus, and in part because the authors grew up speaking English, attained degrees from the best American universities, and so could not provide an account of the way in which nonnative speakers experience IAE. Nevertheless, I was struck by the omissions that went unnoticed, the context that went uncharted. Critics of various stripes have scrutinized the uses and abuses of theory for quite some time, and the discussion around IAE was mostly bereft of citation— the means by which disparate publications are marshaled into a greater body of knowledge, at least in academia. One notable touchstone is François Cusset's *French Theory: How Foucault, Derrida, Deleuze, & Co. Transformed the Intellectual Life of the United States*, published in French in 2003 and English in 2008. Cusset supplies an incredibly rich and detailed account of the unexpected uses and putative abuses of French theory in the United States, which have in turn been absorbed by Europe. "When revolution is reinterpreted as stylized rebellion... when mottos coined during Left Bank marches are being reused in New York art galleries, then indeed one can speak of a 'structural misunderstanding,'" Cusset writes, referring to Pierre Bourdieu's concept, "not in the sense of a misreading, an error, a betrayal of some original, but in the sense of a highly productive transfer of words and concepts from one specific market of symbolic goods to another."[7] Elaborating on the way in which ideas mutate as they circulate globally, Cusset asserts that the reading proffered by a foreigner may be more open than that of a native speaker "because it loosens the structure and opens a text onto brand-new uses, but also because it may often be more profitable to base a career on some distant, foreign, exotic body of texts."[8]

Since the *e-flux journal* responses, the chatter around IAE has essentially gone dormant except for the occasional belch of magma and ash. My point in describing the essay's circulation is not to identify who was right and wrong, but to provide a fragmentary account of how knowledge is formed on and in relation to the internet. *Triple Canopy* is meant to facilitate conversations that hinge on the movement of texts between digital publications and symposia, social media and exhibition spaces online, and IRL venues. This requires a particular approach to the design of the magazine's online platform, but also faith in the existence of a public sphere that bears some vestigial relationship to the one described by

Juergen Habermas in *The Structural Transformation of the Public Sphere* (1962), however flawed and outdated his model may now seem. The explosion of "International Art English" tested certain of our theories and assumptions about *Triple Canopy*'s model of publishing, and about what might be called the postinternet public sphere. Can you, through scrupulous and sensitive editing, ensure that a click-baiting reporter or polemic-chasing video artist will not treat the essay either flippantly or meretriciously? Unlikely. Can you, through restrained and reasonable comment-bombing, reverse the tide on Facebook of praise or condemnation by people who almost certainly have not read the essay in question? Definitely not. Can you, by organizing a symposium that addresses the issues raised by the essay from a variety of sympathetic and hostile perspectives, harness or direct the conversation? Not so much, but noble effort.

Of course, Thomas Paine had no idea how *Common Sense* (1775–76) would go over, and he didn't try to micromanage the debate. (If Paine had published on his own website, maybe he would have tweaked it so as to represent that debate in real-time via the citation and annotation of assenting and dissenting tracts.) But now the public house is everywhere, and so the drawing room seems to disintegrate; you can't help but bear witness to the commentary, all the while wondering about the presence of some agreeable, silent—or simply offline—majority. What might have happened if Rule and Levine had instead published in *Harper's*, the *Wall Street Journal*, or the *New Left Review*, with their impervious paywalls; posted the essay semi-anonymously on MetaFilter, as a prompt for debate within a fairly coherent community (TL;DR?), or as a string of aphoristic Facebook comments meant to be consumed piecemeal; foregone the verbiage and churned out a *BuzzFeed* listicle ("15 Art World Press Releases That Have Us ROTFL"). Actually, in retrospect, we probably should have published "International Art English" serially via thousand-dollar e-flux mailings—but who really reads, much less takes seriously, those press releases anyway?

NOTES

1. Andy Beckett, "A User's Guide to Artspeak," *Guardian*, January 27, 2013.

2. Mostafa Heddaya, "When Artspeak Masks Oppression," *Hyperallergic*, March 6, 2013, <http://hyperallergic.com/66348/when-artspeak-masks-oppression/>.

3. Ibid.

4. Ibid.

5. Mariam Ghani, "The Islands of Evasion: Notes on International Art English," *Triple Canopy*, May 28, 2013, < http://canopycanopycanopy.com/contents/the-islands-of-evasion-notes-on -international-art-english>.

6. Hito Steyerl, "International Disco Latin," *e-flux journal* 45, May 2013, <http://www.e-flux .com/journal/international-disco-latin/>.

7. François Cusset, *French Theory: How Foucault, Derrida, Deleuze, & Co. Transformed the Intellectual Life of the United States* (Minneapolis: University of Minnesota Press, 2008), xv.

8. Ibid.

ARCADES, MALL RATS, AND TUMBLR THUGS

Jesse Darling

Such a tremendous richness of crystallizing, depersonalized cultural accomplishments that the individualist notion of personality can…scarcely maintain itself in the face of it.
—Georg Simmel, "The Metropolis and Mental Life," 1903

If you want to know about the halcyon years of the world wide web, ask one of the elders and they'll tell you that the wild frontier once consisted of a few scrappy settlements, pitched in rickety code, on a seemingly infinite prairie of possibility. "Not like now," they'll tell you, sadly, and shake their heads at what became of it all: the great digital dream of libertarian net-autonomy replaced by a monopoly of mall-like social media platforms, where the kids all hang out in their outlandish avatars, talking to one another in a broken argot of phonetics and hieroglyphs. A generation of *users*, whose addiction mutates and proliferates each day anew. Seeking novel strains of viral data with which to feed its own sickness, it chews on itself for days before regurgitating its own guts in a feedback loop of 24-bit RGB rainbows. Nowadays, it's simply safer to stay on eBay.

In a recent article for the *New York Times*, Evgeny Morozov delivered a speculative eulogy for the "*cyberflâneur*"—who died, or perhaps failed to materialize, in the face of Facebook and Groupon and the totalizing influence of the "app paradigm."[1] Morozov even waxes lyrical about the golden days of the dial-up connection, as though remembering the swathe of the plough in the field. Where this all once was grass, he laments, the information superhighway now runs through the middle; pity the snotty Tumblr thug who will never know the wholesome pleasure of strolling endless dreaming fields of Euclidean space with his own handmade code as map and compass. There will be no strolling or loitering—either

with or without intent—on Morozov's web. It's a bleak place with no boardwalk, where wall-to-wall ads, targeted to our needs and desires, map the perimeter of task-based playbor zones, homogenous and incontravenable. Worst of all, "the tyranny of the social" will prevent us from enjoying seven-hour Béla Tarr flicks with our friends. The good times are gone.

This discourse of virtual antiquity is notable, since so much internet theory has been defined in part by a sense of newness and speculation. Old-school source texts even include several works of fiction (Gibson, Stephenson, et al.). "Much of the excitement about the internet and virtual reality is generated by a sense of what it will become,"[2] Nicholas Mirzoeff wrote in 1999, going on to describe Gibson's hyperurban hyperrealities as "quintessentially modernist."[3] But 1999 was, like, *years* ago.

Like Gibson's dystopias, Morozov's lament—ironically enough—echoes the malaise of the very moderns to whom he refers, fretting as they did that the new urbanopolis would signal an end to slow pleasures and community spirit. Despite all that Cartesian stuff, the moderns' understanding of the self was essentially corporeal, and the spatial anxiety of modern urbanism appears as a crisis of embodiment, or personhood, in the flux of big-city time-space. Even Freud, who should have known better, drew out Sherlock Holmes sketches of Little Hans's neighborhood as though to demonstrate that his patient's neurosis was present precisely where his body had walked. Bridge and door, porch and *platz*: even the machines were bodies, big, bleeding, greasy *Übermenschen* puffing out steam like smokers and guzzling up coal as though it were potatoes. "In short," wrote Michel de Certeau, in *The Practice of Everyday Life*, "space is a practiced place. Thus the street geometrically defined by urban planning is transformed into a space by walkers."[4] The phallic flâneur, in perambulating his body promiscuously around the city, was engaging in a kind of territorial pissing against the stream, which was in essence the zoning of all decent working life, and of labor itself as experienced among the working classes. Like most radicals recognized by modernity, the flâneur remains ever a bourgeois male figure, since there are no reports of workers or women practicing the fine art of flânerie.

Morozov writes from Palo Alto, a Californian charter city established by the founding father of Stanford University, at which Morozov is a visiting fellow. Palo Alto, nestled in a dewy corner of Silicon Valley, has been at various times home to Google, PayPal, Sun Microsystems, and Hewlett-Packard: a prime piece of sun-drenched Nor-Cal sprawl. Social media is to the read/write web what sprawl is to the metropolis of modernity: a homogenous, cancerous, rhizomatic junkspace that expands exponentially outward on a sludgy wave of strip malls and sponsored links, greed and induced demand. This ruthless modernization produces miles of "junkspace"—a term coined by the architect Rem Koolhaas,

who wrote that "More and more, more is more. Junkspace is overripe and under-nourishing at the same time, a colossal security blanket that covers the earth in a stranglehold of seduction.... Junkspace is like being condemned to a perpetual Jacuzzi with millions of your best friends.... Seemingly an apotheosis, spatially grandiose, the effect of its richness is a terminal hollowness, a vicious parody of ambition."[5] Koolhaas was referring to the airport and the stripmall and the single-zone sprawl, but he could have been talking about Facebook.

Kids who grow up on the suburban fringes of, say, Palo Alto (or Anywhere, Wisconsin, Washington, whatever; or, indeed, Birmingham, England) might spend their Saturdays, as we did, drinking lurid booze out of bike flasks on the mica-flecked floors of shopping malls until close of business at night. We didn't have money to spend, but we drifted around the stores anyway, trying on high-heeled boots or shoplifting chocolate bars before drifting out again, and on to the next one, and so on, all over the mall, as Morozov puts it "taking in its noises, its chaos, its heterogeneity, its cosmopolitanism." There wasn't anything else to do. Like the flâneur, we weren't working, or doing anything decent or useful; we even recognized our uselessness as a kind of radical generationality and wore it like a bad handle. The Arcade was the original iron-and-glass shopping mall, and the flâneur—affluent, indolent, and out for a good wasted time—was the original mall rat.

Full disclaimer: I'm not a digital native. By the time Yahoo! bought GeoCities, I myself was a vagrant *stad*-rat [city-rat] without so much as a PC for Tetris. By the time I could wrangle a personal computer, web 2.0 was already in session, and the once-empty net was noisy with the chatter of a billion bots and teeming with the traffic of a million virtual bodies, hurtling through timespace in the real time of a hundred different time zones. I was all agog, like a hick who moves to the city. Plus, I'd grown up as a girl in meatspace and was excited to imagine a mode of interaction that might mean I'd be able to say my piece without my tits getting in the way of the discourse. Indeed, the feminists were among the first to imagine the transgressive possibilities of post-bodied technology—Donna Haraway in her hugely influential 1991 "A Cyborg Manifesto" imagines a post-Cartesian hybrid: "a creature in a postgender world."[6]

It took about 350 years, but finally, in virtuality, *cogito ergo sum* has come to mean something very concrete and actual. Now is a place, a co-ordinate; i am where "I" am not, and iThink (type, write, and right-click) therefore I am. If space is a practiced place, then collective navigation produces the commons. Like mall rats flipping tricks in a parking lot, users exhibit a feral fluency in the use (and transgression, as it is reimagined daily) of this common timespace: we tune out the ads and get on with the serious business of flirting, hustling, hanging out, and talking shit. We *know* that this serious business is affective labor, which

produces capital for the custodians of netspace; indeed, meme culture (including but not limited to YouTube parody, stock photo art, cut-ups, and image macros) can be seen as the user asserting a subjectivity that exists and thrives despite (and beyond) her status as part of a targeted marketing demographic. Like the Occupy movement, these activities amount to a kind of politics of the public (virtual) body in (virtual) space. We may never own the means of production as such, but will continue to assert, pervert, and subvert the commons anyway: a gesture of post-corporeal territorial pissing that necessitates neither phallus nor spray can nor html.

"Compared with Facebook's highly deterministic universe," writes Morozov, "even Microsoft's unimaginative slogan from the 1990s—'Where do you want to go today?'—sounds excitingly subversive."[7] There's *nowhere* to "go" now that the green fields of the matrix all got built over by junkspace conglomerates. But so what? I'll meet you on Twitter and let's get fucked up. The flâneur, according to Morozov, is someone who doesn't know what he cares about: if that's what it takes, then surely flânerie is alive and well over on Yelp and YouTube and 4chan. But I guess Morozov hasn't spent too much time on 4chan lately, and who can blame him? It's not a great place to go alone after dark. Better stick to eBay and reading through your ads on Facebook, persuading yourself not to click.

...

"Arcades, Mall Rats, and Tumblr Thugs" by artist Jesse Darling was first published in the online magazine the *New Inquiry* on February 23, 2012.

...

NOTES

1. Evgeny Morozov, "The Death of the Cyberflâneur," *New York Times*, Feb. 5, 2012, SR6.

2. Nicholas Mirzoeff, *An Introduction to Visual Culture* (New York: Routledge, 1999), 101.

3. Ibid.

4. Michel de Certeau, *The Practice of Everyday Life*, trans. Steven Rendall (Berkeley, CA: University of California Press, 2011), 117.

5. Rem Koolhaas, "Junkspace," *October* (Spring 2002): 175–90.

6. Donna Haraway, "Cyborg Manifesto: Science, Technology, and Socialist-Feminism in the Late Twentieth Century," in *Simians, Cyborgs and Women: The Reinvention of Nature* (New York: Routledge, 1991), 150.

7. Morozov, SR6.

NEXT-LEVEL SPLEEN

John Kelsey

For most artists today, the laptop and phone have already supplanted the studio as primary sites of production. Early signs of this shift were evident in what became known as relational aesthetics, which, in retrospect, seems wrongly defined as a practice in which communal experience became the medium. It is more properly understood, rather, as a capitalist-realist adaptation of art to the experience economy, obviously, but also to the new productive imperative to go mobile, as a body and a practice. In other words, community declared itself a medium at the very moment that it was laying itself open to displacements it could never survive. Meanwhile, exhibitions were planned on laptops, then dragged and dropped into institutions. Work took a discursive turn, meaning it was now efficiently distributable on a global scale. In the mid-1990s, the figure of the artist, too, seemed to undergo a decisive mutation: the Margiela-clad PowerBook user was more nomadic and adaptive than his antecedents, smoother and more agreeable, better organized and more instantly connected with other members of the burgeoning creative class that had emerged on the front lines of economic deregulation. The contemporary artist now functioned as a sort of lubricant, as both a tourist and a travel agent of art, following the newly liberated flows of capital while seeming always to be just temping within the nonstop tempo of increasingly flexible, dematerialized projects, always just passing through. This was all vaguely political, too, in a Negrist sort of way that promoted the emancipatory possibilities of connection and communication, linking the new speed of culture to the "convivial" spirit of everything relational. The mutation of the artist continued to follow its irrevocable logic until we eventually arrived at the fully wireless, fully precarious, Adderall-enhanced, manic-depressive, post- or hyperrelational figure who is more networked than ever but who presently exhibits signs of panic and disgust with a speed of connection that we can no

longer either choose or escape. Hyperrelational aesthetics emerged between 9/11 and the credit crisis and so can be squarely situated in relation to the collapse of the neoliberal economy, or more accurately to the situation of its drawn-out living death, since neoliberalism continues to provide both the cause and the only available cure for its own epic failure.

No feasible—or even recognizable—form of political engagement appears on the hyperrelational horizon, and no real horizon either, so we engage speed itself, attempting to overflow given spaces of politics with the disruptive force of the leak. If relational art aestheticized community, it did so in a decadent way, reading Debord's *Society of the Spectacle* in the context of Thatcher's "There is no such thing as society" and Deleuze in advance of e-flux. For the post-relational artist, however, nothing is more detestable than smart, spreadable conviviality, because the problem now is that togetherness can no longer be experienced outside of aesthetics, and there's no more avoiding the fact that isolation has been systematically designed into connectivity. Nowadays, networks are referenced and theorized ad nauseam, but no longer with any utopian sentiments attached. Last year, we read about Twitter revolutions in the mainstream press at the same time that we skimmed journals such as *Collapse* and *Sic*, belated translations of *Tiqqun*, and the sci-fi novels of Maurice Dantec ("post-World" scenarios involving humans becoming modems, the terminal loss of language and bodies). There was also Occupy, which seemed like it could have been anything—a viral insurrection, an aggressively peopled kind of livestream, a general strike—until it was surrounded by police and bogged itself down in democratic process. Still, a permanent fault line may have been produced in that moment, inasmuch as the return to normal hasn't been entirely convincing either.

The network-disgust that's experienced by even the most positive-minded artists today is captured in our continued abuse of the meme "LOL," which becomes ever more applicable in direct correlation to the degree that we overkill it and wear it out. Not even a word, the term itself performs the loss of language and of laughter, even. It's a disembodied and thus efficiently transmissible abbreviation of laughter that in its repetition seems to reveal both the ecstasy and the anxiety of our nonstop displacement within social media. An overwritten, highbrow press release about networks may be LOL. Or a JPEG of a knowingly failed painting. But mostly LOL signals the amputation of laughter from the body and its recoding as the silent, poison-dartlike flight of a post-word within a network. The more we abuse it, the more it functions as the post-laughter of wit minus bodies, always somehow aimed at the bad faith of post-communal connectivity.

Back home after the opening of a summer group show about "networked painting" (at Zach Feuer Gallery in New York), I'm still getting my head around

the exhibition's title, "Context Message." Aside from a possible reference to the *Kontext Kunst* context of the early 1990s and to whatever faded, vaguely LOL echoes it may be producing in the cybernetic non-context of Berlin–New York now, mostly I'm thinking: what else could the message be but that networks have decidedly replaced context, and that the only critical option remaining is to present art today as a stomach digesting itself in public, in real time? Except that the stomach is a network and there is no more public, because cities are just conveniently impossible places to hang out while art pretends to finish itself off for good. In other words, it's a show about hyperrelational decadence in the age of high-speed connectivity, with real paintings by Michael Krebber, Merlin Carpenter, Jutta Koether, Bjarne Melgaard, and R. H. Quaytman, as well as by the next-generation gallerists and bloggers who keep these and other names vaguely viral while at the same time inflicting LOL degrees of insecurity on them, or on the notion of the artist profile, meanwhile casting serious doubt on the possibility of positively inhabiting something like a context or network (or city, for that matter). The other LOL message here is that "network" is both a critical hot topic and a shamelessly with-it way of selling paintings in this economic End of Days: not only do you get this painting-thing, you also get everything it's connected to—a direct link to something like extrinsic value, the "general intellect" of an invisible postcommunity. It's difficult to say which of these artists is most favorably positioned within the self-terrorizing, self-trolling spiderweb of "Context Message," but the joke we're all in on has to do with how paranoid and insecure the artist has become within the non-context we've inherited from relational aesthetics, the LOL thing to do with this feeling being to re-blog it as painting.

Baudelairean spleen—or disgust as a poetic channel—was always connected to an idea of modern beauty, was maybe even its preferred medium. Any channeling of beauty today would have to occur in relation to crisis and the sublime of viral insecurity. The outmoding of the studio and possibly even of the artist herself, as we deliver our human capacities over to network speed, provides the strange new conditions under which any coming aesthetics must emerge. So we will have to make poetry of the fact that language does not survive speed. Wasn't Paul Virilio already approaching something like an art of speed and catastrophe in books such as *The Aesthetics of Disappearance* (1980) and *The Accident of Art* (2005)? The post-studio has become the non-site of production as circulation, with some sort of artist plugged into it. Via this connection, the figure of the artist herself dematerializes, becomes a profile—viral, bloggable, friendable, and defriendable—her most abstract work being herself, or her own connectivity. And there's no way to separate the mobilization of this abstract, disappearing artist from the wider, systemic (and some would say anthropological) crisis we are

Michael Krebber and Tyler Dobson, *Bad Joke Painting 1*, 2010–12. Acrylic on canvas, 30 × 40 in (76.2 × 101.6 cm). Courtesy the artists

living through now: the two phenomena are linked to the same automatisms, installed within the same futureless no-time of cybernetworks. We wonder whether art is possible after Facebook (and, for that matter, whether even Facebook is possible after Facebook). If the artist today is a sort of "friend," she always already includes the possibility of being a non-friend or a bad friend. Next-level spleen, in other words, is also linked to the threat of defriending that's implicit in friending. It's the affective register of undecidable friendship within the hyperrelational networks that enmesh us so ex-intimately today, in this panicked, post-laughter moment of blogger terror. Networks are themselves delirious, paranoid structures; we all know that they can be a medium for betrayal, too.

Some recent movies deploy characters who could be stand-ins for the post-relational artist. There is Michael Fassbender's depressive sexaholic in *Shame*, who connects with all New York women while retreating into ever more harrowing experiences of remoteness and narcissistic exile. There are the high-speed couples of last year's nearly identical rom-coms *Friends with Benefits* and *No Strings Attached*, who detach in order to connect more efficiently, constructing a handy iCouple within the no-time of the metropolitan interface. There's also Charlize Theron's alcoholic teen-romance writer in *Young Adult*, who, when she ventures out of the solitary confinement of her high-rise home office, is confronted with the fact that real-life connection is no longer available to her: she (or the world, or adulthood) is already too far gone. All of these cases involve successful professionals exiled in the midst of their own hyperrelational activities, who've lost the possibility of experiencing otherness except in the banal, flattened-out terms of the screen profile, who can only interface and data roam, whether online or in bed. The abstraction of the body within the screenlike void of the social is performed by actors who seem to Skype their gestures and tweet their lines, reformatting acting for the windowlike stages of net space. These are performances of distributed affect.

If to work and communicate as artists today is to extend this cybercapitalist desolation and contribute to the dis-ease of metropolitan togetherness, it seems inevitable that we've arrived at a splenetic experience of abstraction. Whatever community we share now is the one that constantly sabotages itself: the anti-community of networked souls. Franco Berardi and others have written about a depressive epidemic that's both symptomatic of and structurally integral to capitalism's development as an info-sphere, to economic deregulation under conditions of high-speed exchange. The post-human speed of circulation means that the world now escapes our capacity for attention and that we've lost our time for otherness, and therefore for ourselves. Under the present dispensation, *connection* is defined as the functional relationship between formatted

"Stewart Uoo: Life Is Juicy," 2012. Exhibition
view: 47 Canal, New York. Works by Stewart Uoo,
from left: *Don't Touch Me (Bikrahm Yoga)*, 2012;
Confessions (9Women), 2012. Courtesy the artist
and 47 Canal, New York. Photo: Joerg Lohse

materials or components. Via networks, human relations are reformatted to the pure syntax of the operating system. In other words, bodies become de-singularized as time and attention are extracted (fracked) from the living person. And as a defensive reflex, we disconnect in the midst of communication, meaning we depress ourselves, shut down, make time. The title of Berardi's book *The Soul at Work* (2009) suggests a sequel: *The Soul on Strike*, in which individualized depressions would link up to form a channel or medium for a radical interruption. Occupy depression?

The networked artist starts from the fact of being a human medium for metropolitan circulation and a modem for largely ungovernable cybercapitalist processes. Normally, when everything's running smoothly, mediums disappear on us, retreating into their own efficiency, but in times of crisis they become strangely perceptible again. Systemic crisis could be a mirror for hallucinating the artist as channel, the screen that reveals the extent to which our practices are the crisis too. We get the feeling that we haven't truly begun to inhabit networks—that more ecstatic and catastrophic modes of interconnection remain to be tested. *Concatenation* is a term that sometimes comes to mind when trying to describe the creativity of machinic processes. As our activities continue to concatenate with programs and networks, the production of works seems less and less the result of individual artists' creative efforts and more like a swarming, hivelike way of doing and making whereby our gestures become inseparable not only from those of others but from the automatisms that allow us to interface— with our own work and with one another. How can we proceed from the feeling that our works already dispossess and excommunicate us as artists and persons? And what comes after the realization that contemporary artists no longer hold a monopoly on creativity? Everything seems to suggest that the only way for artists to survive their own precarity is by taking it to the limit, risking their own definition. Inventing the gestures that outrun and scramble our own ontological coordinates, overflowing preset subjective and productive formats, we work toward unleashing otherness within communication, and communication beyond the profile.[1]

As it mobilizes and gains speed, art becomes a lot more like what literature once was (which is a strange thought now, when literature is itself being superseded by digital culture): in its time, literature was a massive info leak that eroded disciplinary hierarchies, overflowing national borders and property lines alike. Why should art remain confined to the channel of the artist, the gallery, and the object? Relational aesthetics was probably already asking the same question, but not in a convincing way. As technological processes concatenate with human desires, producing mutations that always seem to occur at the outer limits of

both the inhabitable city and our own capacity for attention, to disconnect while leaking could be a hyperrelational attitude. Spleen, that resistant affect which remains when all others have been channeled as productive labor, surrounds networks but won't be put to work in them. Avoiding both formats and employment, spleen makes time for the artist after the artist.

"Next-Level Spleen" by critic, artist, and gallerist John Kelsey was first published in *Artforum* in September 2012.

NOTES

1. For example, in the press release for "Life Is Juicy," Stewart Uoo's exhibition this past summer at 47 Canal in New York, the artist and his cowriter, Juliana Huxtable, narrate an experience of identity and gender mutation via the avatars of ultraviolent video games. Here, man-machine concatenation unleashes a fearsome cyber-vagina that goes to war against phallic order and doubles as a strategy for seducing real-world boys. Peopled with charred, shredded mannequins that translate his digital heroines into sculptural terms, Uoo's exhibition maps an ecstatic, chaotic space in between that of the gallery and the game, via a narrative that reboots bodily human time within screen time.

DIGITAL DIVIDE: CONTEMPORARY ART AND NEW MEDIA

Claire Bishop

Whatever happened to digital art? Cast your mind back to the late 1990s, when we got our first email accounts. Wasn't there a pervasive sense that visual art was going to get digital, too, harnessing the new technologies that were just beginning to transform our lives? But somehow the venture never really gained traction—which is not to say that digital mediums have failed to infiltrate contemporary art. Most art today deploys new technology at one if not most stages of its production, dissemination, and consumption. Multichannel video installations, Photoshopped images, digital prints, cut-and-pasted files (nowhere better exemplified than in Christian Marclay's *The Clock* [2010]): these are ubiquitous forms, their omnipresence facilitated by the accessibility and affordability of digital cameras and editing software. There are plenty of examples of art that make use of Second Life (Cao Fei), computer game graphics (Miltos Manetas), YouTube clips (Cory Arcangel), iPhone apps (Amy Sillman), etc.[1]

So why do I have a sense that the appearance and content of contemporary art have been curiously unresponsive to the total upheaval in our labor and leisure inaugurated by the digital revolution? While many artists *use* digital technology, how many really confront the question of what it means to think, see, and filter affect through the digital? How many *thematize* this, or reflect deeply on how we experience, and are altered by, the digitization of our existence? I find it strange that I can count on one hand the works of art that do seem to undertake this task: the flirtations between Frances Stark and various Italian cyberlovers in her video *My Best Thing* (2011); Thomas Hirschhorn's video of a finger idly scrolling through gruesome images of blown-apart bodies on a touch screen, occasionally pausing to enlarge, zoom in, move on (*Touching Reality* [2012]); the frenetic, garbled scripts of Ryan Trecartin's videos (such as *K-Corea INC.K [Section A]* [2009]). Each suggests the endlessly disposable, rapidly mutable

ephemera of the virtual age and its impact on our consumption of relationships, images, and communication; each articulates something of the troubling oscillation between intimacy and distance that characterizes our new technological regime, and proposes an incommensurability between our doggedly physiological lives and the screens to which we are glued.

But these exceptions just point up the rule. There is, of course, an entire sphere of "new media" art, but this is a specialized field of its own: it rarely overlaps with the mainstream art world (commercial galleries, the Turner Prize, national pavilions at Venice). While this split is itself undoubtedly symptomatic, the mainstream art world and *its* response to the digital are the focus of this essay. And when you look at contemporary art since 1989, the year Tim Berners-Lee invented the world wide web, it is striking that so little of it seems to address the way in which the forms and languages of new media have altered our relationship to perception, history, language, and social relations.

In fact, the most prevalent trends in contemporary art since the '90s seem united in their apparent eschewal of the digital and the virtual. Performance art, social practice, assemblage-based sculpture, painting on canvas, the "archival impulse," analog film, and the fascination with modernist design and architecture:

Carol Bove, *La traversée difficile* [The Difficult Crossing], 2008. Installation view: Kimmerich, Düsseldorf. Courtesy Maccarone, New York, and David Zwirner, New York/London. Photo: Ivo Farber

Manon de Boer, *Laurien, March 1996 – Laurien, September 2001 – Laurien, October 2007*, 1996–2007. Installation view: "A sensed perturbation," Murray Guy, New York. Courtesy the artist, Jan Mot, Brussels/Mexico City, and Murray Guy, New York. Photo: Fabiana Viso

at first glance, none of these formats appear to have anything to do with digital media, and when they are discussed, it is typically in relation to previous artistic practices across the twentieth century.[2] But when we examine these dominant forms of contemporary art more closely, their operational logic and systems of spectatorship prove intimately connected to the technological revolution we are undergoing. I am not claiming that these artistic strategies are conscious reactions to (or implicit denunciations of) an information society; rather, I am suggesting that the digital is, on a deep level, the shaping condition—even the structuring paradox—that determines artistic decisions to work with certain formats and media. Its subterranean presence is comparable to the rise of television as the backdrop to art of the 1960s. One word that might be used to describe this dynamic—a preoccupation that is present but denied, perpetually active but apparently buried—is disavowal: *I know, but all the same.*

The fascination with analog media is an obvious starting point for an examination of contemporary art's repressed relationship to the digital. Manon de Boer, Matthew Buckingham, Tacita Dean, Rodney Graham, Rosalind Nashashibi, and Fiona Tan are just a few names from a long roll call of artists attracted to the materiality of predigital film and photography. Today, no exhibition is complete without some form of bulky, obsolete technology—the gently clunking carousel of a slide projector or the whirring of an 8mm or 16mm film reel. The sudden attraction of "old media" for contemporary artists in the late 1990s coincided with the rise of "new media," particularly the introduction of the DVD in 1997. Overnight, VHS became obsolete, rendering its own aesthetic and projection equipment open to nostalgic reuse, but the older technology of celluloid was and remains the favorite. Today, film's soft warmth feels intimate compared with the cold, hard digital image, with its excess of visual information (each still contains far more detail than the human eye could ever need).[3] Meanwhile, numerous apps and software programs effortlessly impersonate the analog without the chore of developing and processing; movies imbued with the elegiac mood of Super 8 can now be taken on your cell phone. So why continue to work with "real" analog equipment? Artists like Dean, the preeminent spokesperson for old media, stake their attachment to celluloid as a fidelity to history, to craft, to the physicality of the editing process; the passing of real film is a loss to be mourned. The sumptuous texture of indexical media is unquestionably seductive, but its desirability also arises from the impression that it is scarce, rare, precious. A digital film can be copied quickly and cheaply, ad infinitum—not so a 16mm film.[4] Rosalind E. Krauss has invoked Walter Benjamin to elucidate the use of analog media in the work of William Kentridge and James Coleman, drawing on Benjamin's belief that the utopian potential of a medium may be unleashed

at the very moment of its obsolescence. But today this assertion needs to be subject to scrutiny. The recourse to Benjamin's argument, so closely tied to the historical avant-gardes, sounds almost nostalgic when applied to these younger artists, especially when analog film seems fashionable, rather than cutting against the grain. (It also seems striking that this discussion didn't happen decades ago, when video began to supplant celluloid.) The continued prevalence of analog film reels and projected slides in the mainstream art world seems to say less about revolutionary aesthetics than it does about commercial viability.

Another contemporary mode steeped in the analog is social practice. It is worth recalling that Nicolas Bourriaud's earliest texts on relational aesthetics set artists' desire for face-to-face relations against the disembodiment of the internet; the physical and the social were pitched against the virtual and the representational. In the past decade, socially engaged art has tended to favor intersubjective exchange and homespun activities (cooking, gardening, conversation), with the aim of reinforcing a social bond fragmented by spectacle. Yet social relations today are not mediated by monodirectional media imagery (the mainstay of Guy Debord's theory) but through the interactive screen, and the solutions offered by "useful art" and real-world collaborations dovetail seamlessly with the protocols of web 2.0, introduced in 2002: both deploy a language of platforms, collaborations, activated spectatorship, and "prosumers" who coproduce content (rather than passively consuming information devised for them).[5] As we have seen so many times in the past decade, most recently at the Seventh Berlin Biennial—where the curator, artist Artur Żmijewski, invited Occupy activists into the KW Institute for Contemporary Art for the duration of the show—the results of such coproductions are difficult to contain within the traditional format of the exhibition. In 2001, Lev Manovich presciently observed that in foregrounding two-way communication as a fundamental cultural activity (as opposed to the one-way flow of a film or book), the internet asks us to reconsider the very paradigm of an aesthetic object: can communication between users become the subject of an aesthetic?[6] The centrality of this question to social practice is obvious: does work premised on a dialogic, prosumer model, seeking real-world impact, need to assume representation or an object form in order to be recognized as art?

Manovich's question also haunts more traditional sculptural practices. The recent prevalence of assemblage and "unmonumentality" in object-making has been productively described by Hal Foster as "precarious" sculpture (in the work of Isa Genzken and others), even though the tendency is manifested more frequently as retro-craftiness, as seen in the fiddly collages and tapestries of the recent Whitney Biennial (2012). Both iterations suggest some of the pressures that current regimes of technology and communication have placed on the

object, which becomes increasingly fragile and provisional, as if to assert subjectivity (and tactility) against the sealed, impregnable surface of the screen. Moreover, if Genzken's work exemplifies an older model of bricolage, in which found elements are treated as raw materials whose histories are incidental, then the more prevalent strategy since the 1990s has been to maintain the cultural integrity of the reused artifact—to invoke and sustain its history, connotations, and moods. Books, performances, films, and modernist design objects are incorporated into new works of art and repurposed: think of Carol Bove's or Rashid Johnson's shelves of carefully arranged knickknacks, or Paulina Ołowska's copies of paintings by Polish artist Zofia Stryjeńska (1891–1976). This trend is manifest in other disciplines, too: poetry, theater, and dance have all enacted their own forms of repurposing in sync with visual art, from Elevator Repair Service's eight-hour play *Gatz* (which uses F. Scott Fitzgerald's *The Great Gatsby*), to Rob Fitterman's poems (repurposing anonymous tweets and Yelp reviews), to Richard Move's re-performances of the modernist choreographer Martha Graham.

These forms of repurposing differ from appropriation art of the 1980s, when artists seized imagery from art history (Sherrie Levine) or advertising (Richard Prince) with a view to questioning authorship and originality while drawing attention, yet again, to the plight of the image in the age of mechanical reproduction. In the digital era, a different set of concerns prevails. The act of repurposing aligns with procedures of reformatting and transcoding—the perpetual modulation of preexisting files. Faced with the infinite resources of the internet, *selection* has emerged as a key operation: we build new files from existing components, rather than creating from scratch. Artists whose work revolves around choosing objects for display (Bove, Johnson) or who reuse previous art (Ołowska with Stryjeńska, Simon Starling with Henry Moore, Ryan Gander with Mondrian) are foregrounding the importance of selection strategies, even when the outcome is decisively analog. Questions of originality and authorship are no longer the point; instead, the emphasis is on a meaningful recontextualization of existing artifacts.

Any consideration of this drive to gather, reconfigure, juxtapose, and display leads quickly to Foster's influential theory of the archival impulse. For Foster, the term denotes art that undertakes "an idiosyncratic probing into particular figures, objects, and events in modern art, philosophy, and history."[7] Artists' archives are fragmentary and material, writes Foster, and call out for "human interpretation" rather than "machinic reprocessing"; here, he clearly draws a line between subjective and technological.[8] Artists both have recourse to archives and produce them, displaying a paranoid will to connect what cannot be connected.[9] Foster's examples are Dean, Sam Durant, and Hirschhorn, but we might

equally consider Kader Attia, Zoe Leonard, or Akram Zaatari. Often refuting established taxonomies as a systematic organizing principle for their work, these artists embrace subjective rationales or arbitrary systems. Presented as carefully displayed collections, their installations belie the extent to which everyone with a personal computer today has become a de facto archivist, storing and filing thousands of documents, images, and music files. (I often feel as if I don't listen to music so much as perform upkeep on my iTunes collection—downloading new acquisitions, categorizing them, and deaccessioning unwanted tracks.) Comparing these vernacular forms of aggregation with artists' physical arrangements of ephemera and objects, we are once again returned to the rarefied aura of the indexical and to questions of supply and demand.

Artists select and aggregate not only in the production of individual works, but also in the exhibitions they curate. In the 1990s, this practice was reflexively attuned to the institutional context (Fred Wilson, Mark Dion), but in the past decade it has taken a more automatist form, subordinating legible or didactic connections between works to the imperative of individual sensibility, as for example in Mark Wallinger's "The Russian Linesman" (2009), Vik Muniz's "Rebus" (2009), or Grayson Perry's phenomenally popular "The Tomb of the Unknown Craftsman" (2011). Tacita Dean's "An Aside" is an exemplary instance. As she details in the catalogue for this 2005 show at London's Camden Arts Centre, works by Lothar Baumgarten, Paul Nash, and Gerhard Richter (among others) were selected on the basis of chance, anecdote, and coincidence. From a twentieth-century perspective, this is the logic of the *dérive*. From a twenty-first-century perspective, it is the act of surfing: the pursuit of impromptu, subjective connections via the aleatory free association of navigating the web. In the 1960s, this kind of drift was understood as an exodus from the logic imposed by postwar city planning; today, the *dérive* is the logic of our dominant social field, the internet.

One significant side effect of the information age is that research is easier than ever before. As the digital archive increases exponentially—at one point, Google was archiving books at a rate of three thousand a day—the phenomenon of research-driven art proliferates in tandem. Unlike previous generations of artist-researchers (such as Dan Graham, Hans Haacke, and Martha Rosler), who tended to examine the social, political, and economic conditions of their present moments, contemporary research-based art (e.g., that of Andrea Geyer, Asier Mendizabal, Henrik Olesen) exhibits a conspicuous preoccupation with the past, revisiting marginal histories or overlooked thinkers. Some artists even make a point of using laborious, non-Google methodologies: consider Emily Jacir's *Material for a Film* (2004–07), an investigation into the life of poet Wael Zuaiter,

DIGITAL DIVIDE: CONTEMPORARY ART AND NEW MEDIA

DIGITAL DIVIDE: CONTEMPORARY ART AND NEW MEDIA

the first of many Palestinian artists and intellectuals to be assassinated by Israeli agents in the 1970s. The work attempts to reconstruct as much information as possible about Zuaiter's life, bringing together objects owned by or important to him (books, postcards, films, records), and Jacir's efforts to locate these objects are narrated diaristically in wall texts. The presentation of research-based art and archival installations is typically at pains to confer aura and value on carefully selected physical objects; moreover, these objects remain fixed and static rather than being adaptable by users. Such works reaffirm the paradoxical compromise wrought by contemporary art when confronted with new media: the endless variability and modulation of the digital image is belied by the imposition of a "limited" edition and an aesthetics of the precious one-off (sepia-tinted prints, display cabinets, file boxes of ephemera, etc.).

Acknowledged or not, the research possibilities afforded by the internet have made themselves felt in other aspects of contemporary art, too. In the early 1970s, Susan Hiller amassed a series of 305 postcards that she found in British seaside towns, *Dedicated to the Unknown Artists* (1972–76). Each postcard is captioned "ROUGH SEA" and depicts the same motif—a rather bleak, turbulent ocean encroaching on human structures. Three decades later, Zoe Leonard exhibited more than four thousand postcards of Niagara Falls, clustered by type, tracing this natural wonder's evolution into a tourist destination between 1900 and 1950 (*You see I am here after all* [2008]). The postcards, largely sourced via eBay, attest to the possibilities of internet searchability. But our consumption of this work in turn reflects the changing patterns of contemporary perception: it

is impossible to take in all four thousand postcards, so our eyes just scan the surface, in the rapid-fire skimming with which we browse news and reviews on our smartphones. Poet and UbuWeb founder Kenneth Goldsmith refers to the literary equivalent of this kind of work as "the new illegibility": books like his own *Day* (2003), a retyping of one day's edition of the *New York Times*, which invites random sampling rather than straight-through reading. When online, he writes, "we *parse* text—a binary process of sorting language—more than we *read* it to comprehend all the information passing before our eyes."[10] Today, many exhibitions (by curators rather than artists) model this new illegibility as a spectatorial condition. Documenta 11 (2002) was significant in many respects, not least of which was its inauguration of a tendency to include more work than the viewer could possibly see—in this case, six hundred hours of film and video. We don't ask how big a show is anymore, but how *long*: a tiny gallery can contain *days* of art. The result is that we filter and graze, skim and forward.

My point is that mainstream contemporary art simultaneously disavows and depends on the digital revolution, even—especially—when this art declines to speak overtly about the conditions of living in and through new media. But why is contemporary art so reluctant to describe our experience of digitized life? After all, photography and film were embraced rapidly and wholeheartedly in the 1920s, as was video in the late 1960s and '70s. These formats, however, were image-based, and their relevance and challenge to visual art were self-evident. The digital, by contrast, is code, inherently alien to human perception. It is, at base, a linguistic model. Convert any JPEG file to TXT and you will find its ingredients: a garbled recipe of numbers and letters, meaningless to the average viewer. Is there a sense of fear underlying visual art's disavowal of new media? Faced with the infinite multiplicity of digital files, the uniqueness of the art object needs to be reasserted in the face of its infinite, uncontrollable dissemination via Instagram, Facebook, Tumblr, etc. If you borrow an artist's DVD from a gallery, it usually arrives in a white paper slip, with VIEWING COPY ONLY marked clearly on the label; when a collector buys the same DVD in a limited edition, he or she receives a carefully crafted container, signed and numbered by the artist.

Ironically, Goldsmith refers to contemporary art of the 1980s as one model for poetry when promoting his theory of "uncreative writing," citing the history of twentieth-century art as a chronicle of thieving and stealing, from Duchamp to Warhol to Levine. In actuality, visual art's assault on originality only ever goes so far: it is always underpinned by a respect for intellectual property and carefully assigned authorship (Warhol and Levine are hardly anonymous, and their market status is fiercely protected by their galleries).[11] Unlike the poetry

world, where the flow of capital is meager and where works can circulate freely and virtually on the web, visual art's ongoing double attachment to intellectual property and physicality threatens to jeopardize its own relevance in the forthcoming decades. In a hundred years' time, will visual art have suffered the same fate as theater in the age of cinema?

Goldsmith points out that the linguistic basis of the digital era holds consequences for literature that are as potentially shattering and vitalizing as the arrival of mechanical reproduction was for visual art: "With the rise of the Web, writing has met its photography."[12] It is telling that two of the works I cited earlier, by Trecartin and Stark, make language central to their aesthetic. It's possible that literature, and particularly poetry of the kind championed by Goldsmith in *Uncreative Writing*, might now be taking up the avant-garde baton, finding ways to convey experience in ways adequate to our new technological circumstances. Yet the hybridized solutions that visual art is currently pursuing—analog in appearance, digital in structure—seem always biased toward the former, so favored by the market. If the digital means anything for visual art, it is the need to take stock of this orientation and to question art's most treasured assumptions. At its most utopian, the digital revolution opens up a new dematerialized, de-authored, and unmarketable reality of collective culture; at its worst, it signals the impending obsolescence of visual art itself.

..

"Digital Divide: Contemporary Art and New Media" by art historian Claire Bishop was first published in *Artforum*'s fiftieth-anniversary issue in September 2012. The essay sparked widespread conversation and opinion, and elicited especially sharp criticisms from members of long-standing digital art communities. Curator (and this volume's coeditor) Lauren Cornell and writer Brian Droitcour coauthored a letter of response, which was published in the January 2013 issue of *Artforum*, arguing that "the 'divide' [Bishop] describes is actively being bridged and, because of a critical blind spot, she is forcing it back open." On the invitation of *Mass Effect*'s coeditors, Bishop responds to the conversation and criticisms around the piece in a short essay—"Sweeping, Dumb, and Aggressively Ignorant: Revisiting 'Digital Divide'"—that appears later in this volume.

..

NOTES

1. Even traditional forms of art, like painting, are supported by a digital apparatus: PDFs sent to the press or to collectors, JPEGs on gallery websites, etc.

2. I will leave aside painting for the moment. Its recent exponents (in the US, at least) have consciously deployed digital referents: Wade Guyton and Kelley Walker, for example, produce hybrid analog-digital paintings. Rather than downloading images from the internet, Walker sources his imagery in library books, which are then scanned, and altered on his computer, before being transferred to canvas for one-off paintings. Again, however, these works *use* technology (and rather decoratively) rather than reflecting on digital visuality per se. See "The Painting Factory: A Roundtable Discussion," in *The Painting Factory: Abstraction After Warhol* (New York: Skira Rizzoli, 2012), 11–12.

3. The analog fascination is not exclusive to contemporary art; to cite just one example, Urban Outfitters' website now offers more than sixty products relating to cameras, most of which are based on 35mm film or Lomography.

4. Of course, digital files are also subject to degradation through resizing and compression; the products of these processes are referred to as "lossies."

5. Like performance art, social practice increasingly depends for its production and documentation on email and digital photography.

6. Lev Manovich, *The Language of New Media* (Cambridge, MA: MIT Press, 2001), 163–64. In the words of activist and law scholar Lawrence Lessig, we no longer live in a "Read Only" but rather a "Read/Write" culture.

7. Hal Foster, "An Archival Impulse," *October* 110 (Autumn 2004): 3.

8. Ibid., 5.

9. Ibid., 21.

10. Kenneth Goldsmith, *Uncreative Writing* (New York: Columbia University Press, 2011), 158. His formulation plays off and departs from current theories of scanning and saccadic vision. The precedents for this work are both literary and artistic: Gertrude Stein's *The Making of Americans* (1925) and On Kawara's *One Million Years* (1969).

11. When cut-and-paste operations are transferred to literature, as Goldsmith and his many colleagues are doing, the stakes are quite different, since the economy of literature is much smaller and weaker and has no "original" to speak of.

12. Goldsmith, 14.

SWEEPING, DUMB, AND AGGRESSIVELY IGNORANT! REVISITING "DIGITAL DIVIDE"

Claire Bishop

"Digital Divide" was rapidly penned in late June 2012, just after I taught a course at CUNY Graduate Center on art in Europe after 1989. Toward the end of the semester it had gradually dawned on me that the unspoken theme in every lecture I had given was the specter of technology. Even though the central trends of contemporary art since the early 1990s (as outlined in this course: relational aesthetics, archival installation, documentary film, curated objects, etc.) seemed to have no overt relationship to digital media, it appeared that many of their organizational logics were in fact intimately embroiled in its epistemology—albeit in the form of a disavowal, rather than an outright rejection. I use the term *disavowal* in the Freudian sense, because while these artists often appear to repress an engagement with new media by returning to outmoded technologies (such as slides and 8mm and 16mm film) and face-to-face encounters, their work is nevertheless underpinned by a digital logic of aggregation, compositing, information management, reformatting, and so on that betrays its presence. I concluded that in contemporary art of the last twenty years, we see artists struggling to accommodate these pervasive new digital protocols, habitual in our daily lives, to an internalization of the art market's reactionary demands (i.e., discrete, limited-edition commodities for a private market), in which the outmoded becomes newly auratic.

The *Artforum* editorial process, as it is wont, pushed the essay into more polemical territory. Ironically, the first suggestion was to try to preempt dissent from new media artists by incorporating a first paragraph clarifying that the essay was not in fact going to deal with new media but with "mainstream contemporary art"—a classification that we intuitively agreed upon without pausing to analyze. Little did we know what indignation would be generated by this distinction! The editors also spiced up the introduction by adding the

provocative opening question "Whatever happened to digital art?" and replaced my suggested title, "Digital Disavowals," with "Digital Divide," which in retrospect further reinforced the camps of them and us. All of which is not to lay blame on *Artforum*'s editors for the resulting conflict, but to give them credit for making the article clearer and more forceful.

I often say that if there are no letters of complaint about my writing, it might as well never have been published. Even so, the ensuing online debate took me completely by surprise. I had expected some pushback from the analog and archive fetishists I'd called out in the piece, but—as several commenters pointed out—the gallery world is so Teflon-coated in finance that it has no reason to care. Instead, the main complaints came from advocates of new media art, who attacked my ignorance of this work, my foolish conflation of new media and digital, and my description of programming code as "alien." Respondents especially loved to list the names of artists that I should have mentioned, including many whose work I find facile and had deliberately avoided. Unfortunately, most of the replies got hung up on the article's first paragraph and never made it to the main argument—so inflammatory was the suggestion that new media art might not be part of mainstream contemporary art but a niche (like many others) with its own star system, discourse, and structures of dissemination. The article was variously dismissed as "sweeping," "dumb," and "aggressively ignorant."

Rereading the responses in 2014, I sense a conflicted state of affairs. The new media gang (NMG) seemed defiantly proud of its distance from mainstream contemporary art (MCA) and aspired to espouse a different set of values: open access, art-market averse, more politicized, and broader reaching in terms of audience ("my art world is bigger than your art world," to quote Caitlin Jones's oft-cited essay). At the same time, it seemed desperately to crave recognition by and integration into MCA, falling over itself to name digital artists who had already appeared in *Artforum*, gallery shows, biennials, or art fairs. The ambivalence is curious, and perhaps best resolved by eliminating the artificial distinction between NMG and MCA altogether, or at the very least acknowledging their significant overlap. New media feels like a dated category because today everyone is "postinternet," a confusing term that indicates not the chronological end of the internet but simply its prevalence and banality.

Since "Digital Divide" was published, a new generation of contemporary artists has come to the fore, particularly in the UK, whose work has (perhaps inaccurately) begun to be connected to recent developments in philosophy—object-oriented ontology and speculative realism—that break with previously dominant ways of thinking technology through media theory or participation. Ed Atkins, Helen Marten, and Elizabeth Price, for example, all deploy computer

animation and a poetic form of spoken word to address the impact of the digital upon emotions and self-presentation (Atkins), on the way we read the physical world (Marten), and on the eroticization and consumption of objects (Price). Atkins was included in the exhibition "The Universal Addressability of Dumb Things" (2013), in which artist-curator Mark Leckey sought to connect our experience of contemporary technology to premodern forms of animism (such as the Dreaming in Aboriginal culture, or medieval metaphysics). In a similar but more hypnotic vein, French artist Camille Henrot's *Grosse Fatigue* (2013) also draws links between contemporary interfaces (the layered windows of a Mac desktop) and archaic forms of knowledge: her video sets the natural history archives of the Smithsonian Institution against colonial history, poetry, Wikipedia, and the persistence of creation myths in the visual imagery of galaxy screensavers and the iPhone's globe motif. The result is a delirious anthropology of present-day perception exhausted by information. All of these artists are as home on the Rhizome website as they are in the pages of *Artforum* or the shortlist of the Turner Prize, and all invalidate the distinctions around which so much of the hostility to "Digital Divide" accumulated.

This is not to minimize the tensions that animated so many of the responses to "Digital Divide." Rather, it is to point out that too much of this discussion concerned issues that were peripheral to my argument (questions of territory, authority, and particularly of exclusion from *Artforum* as an elite journal and organ of the market) rather than the essay's central question: what can art tell us about the phenomenology of our digital regime? In the future, I hope that the article will occasion further responses that deal more directly and deeply with its challenge and claims—rather than simply cheerleading for x or y artist or asserting a technologically determinist triumphalism ("in the future all artists will be new media—you'll see!"). In the meantime, I adhere even more strongly to the suggestion that the impact of the digital might be grasped not only in works of art that use its means, but in more traditional practices that reveal its impact obliquely. These might not be the best or most interesting works of our age—indeed, some of them may be disappointingly academic—but in this distance and indirectness we might find an equally telling way to grasp the all-pervasive nature of our digital unconscious.

..

This essay was commissioned in 2014 for the present volume.

..

ART WORKERS: BETWEEN UTOPIA AND THE ARCHIVE

Boris Groys

The topic of this essay is artistic work. I am not, of course, an artist. But in spite of being quite specific in some respects, artistic work is not fully autonomous. It relies on the more general—social, economic, technical, and political—conditions of art production, distribution, and presentation. During recent decades these conditions have changed drastically, due first and foremost to the emergence of the internet.

In the period of modernity, the museum was the institution that defined the dominant regime under which art functioned. But in our day, the internet offers an alternative possibility for art production and distribution—a possibility that the permanently growing number of artists embrace. What are the reasons to like the internet, especially for artists, writers, and so forth?

Obviously, one likes the internet in the first place because it is not selective—or at least much less selective than a museum or a traditional publishing house. Indeed, the question that always troubled artists in relation to the museum concerned the criteria of choice—why do some artworks come into the museum while other artworks do not? We know the, so to speak, catholic theories of selection according to which artworks must deserve to be chosen by the museum: they should be good, beautiful, inspiring, original, creative, powerful, expressive, historically relevant—one can cite thousands of similar criteria. However, these theories collapsed historically because nobody could explain why one artwork was more beautiful or original than another. So other theories took their place, theories that were more protestant, even Calvinist. According to these theories, artworks are chosen because they are chosen. The concept of a divine power that is perfectly sovereign and does not need any legitimization was transferred to the museum. This protestant theory of choice, which stresses the unconditional

power of the chooser, is a precondition for institutional critique—the museums were criticized for how they used and abused their alleged power.

This kind of institutional critique doesn't make much sense in the case of the internet. There are, of course, examples of internet censorship practiced by some states, yet there is no aesthetic censorship. Anyone can put any texts or visual material of any kind on the internet and make it globally accessible. Of course, artists often complain that their artistic production drowns in the sea of data that circulates through the internet. The internet presents itself as a huge garbage can in which everything disappears, never getting the degree of public attention that one hopes to achieve. But nostalgia for the old days of aesthetic censorship by the museum and gallery system, which watched over art's quality, innovation, and creativity, leads nowhere. Ultimately, everyone searches the internet for information about one's own friends—what they are doing right now. One follows certain blogs, e-magazines, and websites, and ignores everything else. The art world is only a small part of this digital public space—and the art world itself is very much fragmented. So even if there are many complaints about the unobservability of the internet, no one is really interested in total observation: everyone is looking for specific information—and is ready to ignore anything else.

Still, the impression that the internet as a whole is unobservable defines our relationship to it—we tend to think about it as an infinite flow of data that transcends the limits of our individual control. But, in fact, the internet is not a place of data flow—it is a machine to stop and reverse data flow. The unobservability of the internet is a myth. The medium of the internet is electricity. And the supply of electricity is finite. So the internet cannot support infinite data flows. The internet is based on a finite number of cables, terminals, computers, mobile phones, and other equipment. The efficiency of the internet is based precisely on its finiteness and, therefore, on its observability. Search engines such as Google demonstrate this. Nowadays, one hears a lot about the growing degree of surveillance, especially through the internet. But surveillance is not something external to the internet, or some specific technical use of the internet. The internet is by its essence a machine of surveillance. It divides the flow of data into small, traceable, and reversible operations, thus exposing every user to surveillance—real or possible. The internet creates a field of total visibility, accessibility, and transparency.

Of course, individuals and organizations try to escape this total visibility by creating sophisticated passwords and data protection systems. Today, subjectivity has become a technical construction: the contemporary subject is defined as an owner of a set of passwords that he or she knows—and that other people do not know. The contemporary subject is primarily a keeper of a secret. In a

certain sense, this is a very traditional definition of the subject: the subject was long defined as knowing something about itself that only God knew, something that other people could not know because they were ontologically prevented from "reading one's thoughts." Today, however, being a subject has less to do with ontological protection, and more to do with technically protected secrets. The internet is the place where the subject is originally constituted as a transparent, observable subject—and only afterwards begins to be technically protected in order to conceal the originally revealed secret. However, every technical protection can be broken. Today, the *hermeneutiker* has become a hacker. The contemporary internet is a place of cyber wars in which the prize is the secret. To know the secret is to control the subject constituted by this secret—and the cyber wars are the wars of this subjectivation and desubjectivation. But these wars can take place only because the internet is originally the place of transparency.

What does this original transparency mean for artists? It seems to me that the real problem with the internet is not the internet as the place for the distribution and exhibition of art, but the internet as the place for working. Under the museum regime, art was produced in one place (the atelier of the artist) and shown in another place (the museum). The emergence of the internet erased this difference between the production and the exhibition of art. The process of art production insofar as it involves the use of the internet is always already exposed—from its beginning to its end. Earlier, only industrial workers operated under the gaze of others—under the kind of permanent control so eloquently described by Michel Foucault. Writers or artists worked in seclusion, beyond panoptic, public control. However, if the so-called creative worker uses the internet, he or she is subjected to the same or even greater degree of surveillance as the Foucauldian worker. The only difference is that this surveillance is more hermeneutic than disciplinary.

The results of surveillance are sold by the corporations that control the internet because they own the means of production, the material-technical basis of the internet. One should not forget that the internet is owned privately. And the profit comes mostly from targeted advertisements. Here we confront an interesting phenomenon: the monetization of hermeneutics. The classical hermeneutics that searched for the author behind the work was criticized by the theoreticians of structuralism and "close reading," who thought that it made no sense to chase ontological secrets that are, by definition, inaccessible. Today, this old, traditional hermeneutics is reborn as a means of economic exploitation on the internet, where all secrets are revealed. The subject here is no longer concealed behind his or her work. The surplus value that such a subject produces and that is appropriated by internet corporations is this hermeneutic value: the subject not only

Aram Bartholl, *Dead Drops*, 2010. Digital
photograph of the anonymous, offline, peer-to-
peer, file-sharing network. Courtesy the artist
and DAM Gallery

ART WORKERS: BETWEEN UTOPIA AND THE ARCHIVE

does something on the internet, but also reveals itself as a human being with certain interests, desires, and needs. The monetization of classical hermeneutics is one of the most interesting processes to emerge in recent decades.

At first glance, it seems that for artists, this permanent exposure has more positive aspects than negative. The re-synchronization of art production and art exposure through the internet seems to make things better, not worse. Indeed, this re-synchronization means that an artist no longer needs to produce any final product, any artwork. The documentation of the art-making process is already an artwork. Art production, presentation, and distribution coincide. The artist becomes a blogger. Almost everyone in the contemporary art world acts as a blogger—individual artists, but also art institutions, including museums. Ai Weiwei is paradigmatic in this respect. Balzac's artist who could never present his masterpiece would have no problem under these new conditions: documentation of his efforts to create a masterpiece would be his masterpiece. Thus, the internet functions more like the Church than the museum. After Nietzsche famously announced, "God is dead," he continued, "We have lost the spectator." The emergence of the internet means the return of the universal spectator. So it seems that we are back in paradise and, like saints, do the immaterial work of pure existence under the divine gaze. In fact, the life of a saint can be described as a blog that is read by God and remains uninterrupted even upon the saint's death. So why do we need secrets anymore? Why do we reject this radical transparency? The answer to these questions depends on the answer to a more fundamental question concerning the internet: does the internet effectuate the return of God, or of the *malin génie*, with its evil eye?

I would suggest that the internet is not paradise but, rather, hell—or, if you want, paradise and hell at the same time. Jean-Paul Sartre said that hell is other people—life under the gaze of others. (And Jacques Lacan said later that the eye of the other is always an evil eye.) Sartre argued that the gaze of others "objectifies" us—and in this way negates the possibility of change that defines our subjectivity. Sartre defined human subjectivity as a "project" directed toward the future—and this project has an ontologically guaranteed secret because it can never be revealed here and now, but only in the future. In other words, Sartre understood human subjects as struggling against the identity that was given to them by society. That explains why he interpreted the gaze of others as hell: in the gaze of others, we see that we have lost the battle and remain a prisoner of our socially codified identity.

Thus, we try to avoid the gaze of others for a while so that we can reveal our "true self" after a certain period of seclusion—to reappear in public in a new shape, in a new form. This state of temporary absence is constitutive of what we

call the creative process—in fact, it is precisely what we call the creative process. André Breton tells a story about a French poet who, when he went to sleep, put on his door a sign that read: "Please be quiet—the poet is working." This anecdote summarizes the traditional understanding of creative work: creative work is creative because it takes place beyond public control—and even beyond the conscious control of the author. This time of absence could last for days, months, years—or even a whole lifetime. Only at the end of this period of absence is the author expected to present a work (maybe found in his papers posthumously) that would be then accepted as creative precisely because it seemed to emerge out of nothingness. In other words, creative work is the work that presupposes the de-synchronization of the time of work from the time of the exposure of its results. Creative work is practiced in a parallel time of seclusion, in secrecy—so that there is an effect of surprise when this parallel time gets re-synchronized with the time of the audience. That is why the subject of art practice traditionally wanted to be concealed, to become invisible, to take time out. The reason was not that artists had committed some crime or concealed some dirty secret they wanted to keep from the gaze of the others. We experience the gaze of others as an evil eye not when it wants to penetrate our secrets and make them transparent (such a penetrating gaze is rather flattering and exciting)—but when it denies that we have any secrets, when it reduces us to what it sees and registers.

Artistic practice is often understood as being individual and personal. But what does the individual or personal mean? The individual is often understood as being different from others. (For example: In a totalitarian society, all are alike. In a democratic, pluralistic society, all are different, and respected as being different.) However, here the point is not so much one's difference from others but one's difference from oneself—the refusal to be identified according to the general criteria of identification. Indeed, the parameters that define our socially codified, nominal identity are completely foreign to us. We did not choose our names, we were not consciously present at the date and place of our birth, we did not choose the name of the city or street where we live, we did not choose our parents, our nationality, and so forth. All these external parameters of our existence have no meaning for us—they do not correlate to any subjective evidence. They indicate how others see us but they are completely irrelevant to our inner, subjective lives.

Modern artists revolted against the identities imposed on them by others—by society, state, school, parents. They wanted the right of sovereign self-identification. Modern art was the search for the "true self." Here the question is not whether the true self is real or merely a metaphysical fiction. The question of identity is not a question of truth but a question of power: Who has

the power over my own identity—I myself or society? And more generally: Who has control over the social taxonomy, the social mechanisms of identification—I myself or state institutions? This means that the struggle against my own public persona and nominal identity in the name of my sovereign persona, my sovereign identity, also has a public, political dimension, since it is directed against the dominating mechanisms of identification—the dominating social taxonomy, with all its divisions and hierarchies. That is why modern artists always said: *"Do not look at me. Look at what I am doing. That is my true self"*—or maybe no self at all, maybe the absence of the self. Later, artists mostly gave up the search for the hidden, true self. Rather, they began to use their nominal identities as readymades—and to organize a complicated play with them. But this strategy still presupposes disidentification from nominal, socially codified identities—in order to artistically reappropriate, transform, and manipulate them.

Modernity was the time of desire for utopia. The utopian expectation means nothing less than that one's project of discovering or constructing the true self becomes successful—and socially recognized. In other words, the individual project of seeking the true self acquires a political dimension. The artistic project becomes a revolutionary project that aims at the total transformation of society and the obliteration of existing taxonomies. Here the true self becomes resocialized—by creating the true society.

The museum system is ambivalent toward this utopian desire. On the one hand, the museum offers the artist a chance to transcend his or her own time, with all its taxonomies and nominal identities. The museum promises to carry the artist's work into the future—it is a utopian promise. However, the museum betrays this promise at the same moment that it fulfills it. The artist's work is carried into the future—but the nominal identity of the artist becomes reimposed on his or her work. In the museum catalogue, we read the same name, date and place of birth, nationality, and so forth. That is why modern art wanted to destroy the museum. However, the internet betrays the search for the true self in an even more radical way: the internet inscribes this search from its beginning—and not only at its end—back into nominal, socially codified identity. In turn, revolutionary projects become historicized. We can see it today, as former communist mankind becomes renationalized and reinscribed in Russian, Chinese, and other national histories.

In the so-called postmodern period, the search for the true self and, accordingly, the true society in which this true self could be revealed, was proclaimed to be obsolete. We therefore tend to speak about postmodernity as a post-utopian time. But this is not quite true. Postmodernity did not give up the struggle against the subject's nominal identity—in fact, it even radicalized this struggle.

Susan Hiller, *Witness*, 2000. Installation
compiling several hundred descriptions of UFO
sightings across the world. Copyright Susan
Hiller, Courtesy Timothy Taylor Gallery, London.
Photo: Parisa Tagizadeh

Postmodernity had its own utopia—a utopia of the subject's self-dissolution in infinite, anonymous flows of energy, desire, or the play of signifiers. Instead of abolishing the nominal, social self by discovering the true self through art production, postmodern art theory invested its hopes for complete loss of identity through the process of reproduction: a different strategy pursuing the same goal.

The postmodern utopian euphoria that the notion of reproduction provoked at the time can be illustrated by the following passage from the book *On the Museum's Ruins* by Douglas Crimp. In this well-known book, Crimp claimed, with reference to Walter Benjamin, that:

> through reproductive technology, postmodernist art dispenses with the aura. The fiction of the creating subject gives way to the frank confiscation, quotation, excerptation, accumulation, and repetition of already existing images. Notions of originality, authenticity, and presence, essential to the ordered discourse of the museum, are undermined.[1]

The flow of reproductions overflows the museum—and individual identity drowns in this flow. The internet became for some time the place where these postmodern utopian dreams were projected—dreams about the dissolution of all identities in the infinite play of signifiers. The globalized rhizome took the place of communist mankind.

However, the internet has become not a place for the realization of postmodern utopias, but their graveyard—as the museum became a graveyard for modern utopias. Indeed, the most important aspect of the internet is that it fundamentally changes the relationship between original and copy, as described by Benjamin—and thus makes the anonymous process of reproduction calculable and personalized. On the internet, every free-floating signifier has an address. The deterritorializing data flows become reterritorialized.

Benjamin famously distinguished between the original, which is defined through its "here and now," and the copy, which is siteless, topologically indeterminable, lacking a "here and now." Contemporary digital reproduction is by no means siteless, its circulation is not topologically undetermined, and it does not present itself in the form of a multiplicity as Benjamin described it. Every data file's address on the internet accords it a place. The same data file with a different address is a different data file. Here the aura of originality is not lost, but instead substituted by a different aura. On the internet, the circulation of digital data produces not copies, but new originals. And this circulation is perfectly traceable. Individual pieces of data are never deterritorialized. Moreover, every internet image or text has not only its specific unique place, but also its unique

time of appearance. The internet registers every moment when a certain piece of data is clicked, liked, un-liked, transferred, or transformed. Accordingly, a digital image cannot be merely copied (as an analog, mechanically reproducible image can) but always only newly staged or performed. And every performance of a data file is dated and archived.

During the epoch of mechanical reproduction, we heard a lot about the demise of subjectivity. We heard from Heidegger that *die Sprache spricht* [the language speaks], and not so much that an individual uses the language. We heard from Marshall McLuhan that the medium is the message. Later, Derridian deconstruction and Deleuzian machines of desire taught us to get rid of our last illusions concerning the possibility of identifying and stabilizing subjectivity. However, now our "digital souls" have become traceable and visible again. Our experience of contemporaneity is defined not so much by the presence of things to us as spectators, but rather by our presence to the gaze of the hidden and unknown spectator. However, we do not know this spectator. We have no access to its image—if this spectator has an image at all. In other words, the hidden universal spectator of the internet can be thought only as a subject of universal conspiracy. The reaction to this universal conspiracy necessarily takes the form of a counter-conspiracy: one will protect one's soul from the evil eye. Contemporary subjectivity can no longer rely on its dissolution in the flow of signifiers because this flow has become controllable and traceable. Thus, a new utopian dream emerges—a truly contemporary dream. It is the dream of an unbreakable code word that can forever protect our subjectivity. We want to define ourselves as a secret that would be even more secretive than the ontological secret—the secret that even God cannot discover. The paradigmatic example of such a dream can be found in WikiLeaks.

The goal of WikiLeaks is often seen as the free flow of data, as the establishment of free access to state secrets. But at the same time, the practice of WikiLeaks demonstrates that universal access can be provided only in the form of universal conspiracy. In an interview, Julian Assange says:

> So if you and I agree on a particular encryption code, and it is mathematically strong, then the forces of every superpower brought to bear on that code still cannot crack it. So a state can desire to do something to an individual, yet it is simply not possible for the state to do it—and in this sense, mathematics and individuals are stronger than superpowers.[2]

Transparency is based here on radical non-transparency. The universal openness is based on the most perfect closure. The subject becomes concealed, invisible,

takes time out to become operative. The invisibility of contemporary subjectivity is guaranteed insofar as its encryption code cannot be hacked—insofar as the subject remains anonymous, non-identifiable. It is password-protected invisibility alone that guarantees the subject's control over its digital operations and manifestations.

Here I am of course discussing the internet as we know it now. But I expect that the coming cyber wars will change the internet radically. These cyber wars have already been announced—and they will destroy or at least seriously damage the internet as a dominant marketplace and means of communication. The contemporary world looks very much like the nineteenth-century world. That world was defined by the politics of open markets, growing capitalism, celebrity culture, the return of religion, terrorism, and counterterrorism. World War I destroyed this world and made the politics of open markets impossible. In the end, the geopolitical and military interests of individual nation states showed themselves to be much more powerful than economic interests. A long period of wars and revolutions followed. Let us see what is waiting for us in the near future.

I would like to close with a more general consideration of the relationship between utopia and the archive. As I have tried to show, the utopian impulse is always related to the desire of the subject to break out of its own historically defined identity, to leave its place in the historical taxonomy. In a certain sense, the archive gives to the subject the hope of surviving one's own contemporaneity and revealing one's true self in the future because the archive promises to sustain and make accessible this subject's texts or artworks after his or her death. This utopian or, at least, heterotopian promise is crucial to the subject's ability to develop a distance from and critical attitude toward its own time and its own immediate audience.

Archives are often interpreted as a means to conserve the past—to present the past in the present. But at the same time, archives are machines for transporting the present into the future. Artists always do their work not only for their own time but also for art archives—for the future in which the artist's work remains present. This produces a difference between politics and art. Artists and politicians share the common "here and now" of public space, and they both want to shape the future. That is what unites art and politics. But politics and art shape the future in different ways. Politics understands the future as a result of actions that take place here and now. Political action has to be efficacious, to produce results, to transform social life. In other words, political practice shapes the future—but it disappears in and through this future, it becomes totally absorbed by its own results and consequences. The goal of politics is to become obsolete—and to give way to the politics of the future.

But artists do not work only within the public space of their time. They also work within the heterogeneous space of art archives, where their works are placed among the works of past and future. Art, as it functioned in modernity and still functions in our time, does not disappear after its work is done. Rather, the artwork remains present in the future. And it is precisely this anticipated future presence of art that guarantees its influence on the future, its chance to shape the future. Politics shapes the future by its own disappearance. Art shapes the future by its own prolonged presence. This creates a gap between art and politics—a gap that was demonstrated often throughout the tragic history of the relationship between left art and left politics in the twentieth century.

Our archives are of course structured historically. And our use of these archives is still defined by the nineteenth century's tradition of historicism. We thus tend to reinscribe artists posthumously into the historical contexts from which they actually wanted to escape. In this sense, the art collections that preceded the historicism of the nineteenth century—the collections that wanted to be collections of instances of pure beauty, for example—seem only at first glance to be naïve. In fact, they are more faithful to the original utopian impulse than their more sophisticated historicist counterparts. It seems to me that today we are beginning to be more and more interested in the non-historicist approach to our past. We are becoming more interested in the decontextualization and reenactment of individual phenomena from the past than in their historical recontextualization, more interested in the utopian aspirations that lead artists out of their historical contexts than in these contexts themselves. And it seems to me that this is a good development because it strengthens the utopian potential of the archive and weakens its potential for betraying the utopian promise—the potential that is inherent in any archive, regardless of how it is structured.

"Art Workers: Between Utopia and the Archive" by German theorist Boris Groys was first published in *e-flux journal* in 2013.

NOTES

1. Douglas Crimp, *On the Museum's Ruins* (Cambridge, MA: MIT Press, 1993), 58.

2. Hans Ulrich Obrist, "In Conversation with Julian Assange, Part I," *e-flux journal* 25, May 2011, <http://www.e-flux.com/journal/in-conversation-with-julian-assange-part-i/>.

BLACK VERNACULAR: READING NEW MEDIA

Martine Syms

This afternoon I'm going to talk about the black aesthetic and the visual culture of new media. I'll examine the way that artists translate language to form within digital contexts.

I'm a web designer, mostly. This project is called "Everything I've Ever Wanted to Know." It lives at everythingiveeverwantedtoknow.com.

"Everything I've Ever Wanted to Know" contains three years of my Google searches in a drop-down list. If a visitor clicks on any of the terms, he or she is taken back to the beginning of the list. I did this so that the language of search was the focus, instead of the content of my queries.

At the time I had just discovered the French avant-garde literary movement Oulipo, particularly the work of Raymond Queneau and Georges Perec. I was excited about using constraints to reveal the ideology of different mediums and genres as they had.

The first time this project was exhibited was in a group show alongside work by two white males, both peers and close friends. A woman came to the opening and hated it. She said it was "white people art," until she was introduced to me. After that she loved it.

What does it mean for a black woman to make minimal, masculine net.art? What about this piece is "not black"? Can my identity be expressed as an aesthetic quality?

As a black artist I'm regularly asked to dissect my practice in terms of race. Sometimes I'm happy to oblige, but other times it feels like a trap, or cage, if you will.

In his landmark study *Distinction* [1979], Pierre Bourdieu argued that taste cultures have a "social logic." Upon examination, groups like Power Moms, Sneakerheads, Skaters, or Fashionistas share remarkably similar socioeconomic

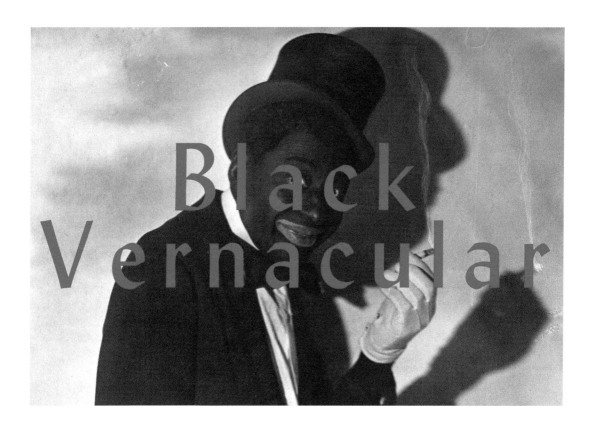

Black
Vernacular

Martine Syms, *Black Vernacular*, 2013. Illustration
for the lecture "Black Vernacular: Reading
New Media" at SXSW Interactive 2013. Courtesy
the artist

Martine Syms, *Everything I've Ever Wanted To
Know*, 2007 (screen capture). Website. Courtesy
the artist

EVERYTHING I'VE EVER WANTED TO KNOW

backgrounds. Maybe I started listening to punk music because I liked the way it sounded, but I must also credit my growing up middle-class in the suburbs of Southern California feeling isolated and bored with what the fourteen-year-old me would've termed "the status quo."

Black is not monolithic, but race is a shared social condition. Blackness is a set of common experiences that inform an aesthetic. In 1903, W. E. B. Du Bois first wrote about the color line and since then it's become shorthand for describing the particularities of black life. Blackness exists on one side of the color line, though which side is often unclear.

Black artists have to both find and fix the color line, no matter how ambiguous its parameters seem, whether within the marketplace, art world discourse, or the world wide web. Du Bois describes this phenomenon as double-consciousness, a "twoness; an American, a Negro; two souls, two thoughts, two unreconciled strivings; two warring ideals in one dark body, whose dogged strength alone keeps it from being torn asunder."

The field of discourse called postmodernism accepts this fragmentation. The contemporary trades "two warring ideals in one dark body" for what poet Kevin Young describes as a "living, fighting, breathing body of work." Du Bois asks how it feels to be a problem. Ol' Dirty Bastard says, "If I got a problem, a problem's got a problem til it's gone."

Martine Syms, *Twoness*, 2013. Illustration for
the lecture "Black Vernacular: Reading New Media"
at SXSW Interactive 2013. Courtesy the artist

BLACK VERNACULAR: READING NEW MEDIA

I'm interested in the tension between conventional, segregated channels of distribution and black imagination. I believe that amphiboly—in the form of code-switching, the practice of alternating between dialect and "standard" English—drives black thought. Poet Elizabeth Alexander paints the black interior as "a metaphysical space beyond the black public everyday toward power and wild imagination that black people ourselves know we possess but need to be reminded of."

If we understand manufacturing as a process or context that provides repetition, then mass media allows for narratives—and subsequently, ideologies and typologies—to be industrialized. "Prosthetic memory," our publicly circulating store of images, texts, and sounds, is made possible by this technology. How do digital networks and software platforms shape the collective imagination?

The sculpture pictured here by Houston-based artist Nathaniel Donnett refers to the "I Am A Man" signs originally seen in Memphis during the 1968 sanitation workers strike for better conditions. The original phrasing is appropriated and adapted to make a wry point about the formation of mass black personhood within new media. The title, *How Can You Love Me and Hate Me at the Same Time?*, is suggestive of a DuBoisian twoness.

The color line has birthed the digital divide, another mythic border that shadows our work. If we are using technology, it's to "waste time." You know, talk to friends, watch movies, play games, listen to music. In 4chan parlance, black and brown people are "doing it wrong" when it comes to technology. As scholar Lisa Nakamura explains in her book *Digitizing Race*, the rhetoric surrounding the so-called divide dismisses black creativity and incorrectly frames people of color as "unsophisticated, uneducated and stuck in a pre-technological past." But we've always done it wrong by the metric of white authentication. See jazz, rock 'n' roll, hip-hop, nail art, braids, breakdancing, and the misuse of the word "crunk" for a few examples.

We don't need validation. The genesis of black new media isn't acceptance, but activity. Black expression is much more than a replacement of, or reaction to, dominant culture. It's an integral part of American culture. I'm going to do a close reading of several artworks that interrogate the notion of a digital divide by exploring the black vernacular with new media.

This is a still from Conceptual artist John Baldessari's 1973 piece called *The Meaning of Various News Photos to Ed Henderson* [Syms pulls up an image of the still on a screen for the audience to see]. Using Portapak video—then, an only recently available technology—Baldessari recorded his friend Ed Henderson interpreting a series of eight photographs clipped from the newspaper.

Nathaniel Donnett, *How Can You Love Me and Hate Me at the Same Time?*, 2011. Plastic bags, paper, paper bags, wood, and gold leaf, 48 × 37 in (122 × 94 cm). Courtesy the artist

Of this video, Baldessari wrote:

> For most of us, photography stands for the truth. But a good artist can make a harder truth by manipulating forms. It fascinates me how I can manipulate the truth so easily by the way I juxtapose opposites or crop the image or take it out of context.

Inspired by Baldessari, New York–based artist Steffani Jemison created *The Meaning of Various Photographs to Tyrand Needham* in 2009, in which she restaged the relationship between Baldessari and Henderson with two African-American kids, Tyrand Needham and Lloyd T. Johnson, both of whom she'd collaborated with previously. The twelve-minute video is comprised of a series of photographs of black figures, with a voiceover by Tyrand Needham interpreting each image.

Like Baldessari, Jemison uses found images, but hers are ripped from Google—which alludes to a hypotext, the search term. Needham is presented with images of Rudy Fleming, the aforementioned Memphis sanitation workers' strike, the funk band Earth, Wind & Fire, TV on The Radio, Tommie Smith and John Carlos at the 1968 Olympics, an African boy climbing a tree, the 2001 Cincinnati riots following the murder of Timothy Thomas, producer/rapper Kanye West, a still from Charles Burnett's 1977 film *Killer of Sheep*, an African boy playing soccer, and rapper Slim Thug.

What terms did Jemison search to gather these images? "Black," "black male," "black boy," "black boys," and "black men" are a few that spring to mind.

The Meaning of Various Photographs to Tyrand Needham operates within a specific moral and ethical framework founded on a harder truth, or a troof, t-r-o-o-f.

In his book *The Grey Album: On the Blackness of Blackness*, Kevin Young writes: "the counterfeit is a literary tool that fictionalizes a black 'troof.'… In short, since even fact-based, 'objectively scientific truth' has been used to oppress black people and their authors, their authors have often sought counterfeit or fiction or alternate realities."

Tyrand Needham uses the counterfeit as he identifies the various photographs.

He describes the historic image of Tommie Smith and John Carlos at the 1968 Olympics:

> What I see here, look like somebody gettin' ready for an Olympic game. There's three males, one Caucasian, two African-Americans. The two African-Americans are holding up their fists, like, um, black power. They have on gloves. One guy got a boombox in his hand or a very small television. The Caucasian guy in front, or all of 'em have on medals, and, uh, the two guys in the back have numbers on their jackets. I can't really tell where they're by, but it's night time.

THE MEANING OF VARIOUS PHOTOGRAPHS TO TYRAND NEEDHAM

We can't tell if our narrator is sincere in his humorous misreadings of cultural moments. Or perhaps he's not "mis-reading," but denying. A participation in what Young calls the "African American tradition of negation as affirmation." Bad is good. Rudy Fleming's sobbing is reimagined as happiness, with Soulja Boy playing in the background. Happiness redefined as mortality.

Needham is recognizing. I mean this both in the traditional sense of identification, acknowledgment, and appreciation—and in the dialect definition of respect. Needham's refusal hints at the ways that blackness defines itself in absence. What is most interesting about this piece is what's left unspoken. Agency is borne out of this silence. This power creates black people who, as poet Kalamu ya Salaam explains, "[recognize] no higher earthly authority than ourselves." Jemison's work challenges the master narrative, giving storytelling authority to a different figure than that which is "normative."

Hennessy Youngman is the alter ego of New York–based artist Jayson Musson. Hennessy Youngman aka Henrock Obama aka the Pharaoh Hennessy aka Henrock the Monarch is a behatted, bechained, beCoogi-ed hip-hop personality who helps "The Internet" traverse the contemporary art world through the sharp criticism of his YouTube series "Art Thoughtz."

In the episode "How to Make an Art," Youngman walks us through the basics of internet-based artistic production. He immediately dismisses knowledge, skill, and originality as anachronistic. Instead, we, "The Internet," are encouraged to use "everyday, banal, forgettable, fucking objects." The video shows approved examples, including *Untitled (Portrait of Ross in L.A.)* by Félix González-Torres and Jeff Koons's *Three Ball 50/50 Tank (Two Dr. J. Silver Series, One Wilson Supershot)*.

Though Youngman says plenty, there is also a silence to the performance. The appeal of "Art Thoughtz" hinges on the fact that a real Youngman can't exist in the art world. It's a spoof. Curator Naomi Beckwith explains to the *New*

Steffani Jemison, *The Meaning of Various Photographs to Tyrand Needham*, 2009 (stills). Single-channel video, color; 12 min. Courtesy the artist

Hennessy Youngman, *Art Thoughtz: How to Make
an Art*, 2011 (still). Web-based video. Courtesy
Jayson Musson and Salon94, New York

York Times, "Everyone sees it as a real, critical performance, and a lot of that is
because most of his audience is right here in the art world. They get it. They un-
derstand that the character that's speaking shouldn't have access to that knowl-
edge, so therefore there must be some kind of subterfuge going on." In the art
world, Musson isn't conflated with Youngman because the character is within
the bounds of a conceptual performance.

In a text on literacy, Jemison discusses the "pervasiveness of 'excess' and
'lack' as metaphors for the success or failure of black expression." Musson's "exces-
sive" character revels in "insufficient speech." Musson's character also epitomizes
what Jemison describes as the "redundancy and accumulation that define the
internal logic of hip-hop." Each "Art Thoughtz" video builds on the previous one.
As Youngman, Musson creates a diegesis through exegesis. Musson builds a

fictional universe by explaining the art world to a congregation of viewers. Musson's "Internet" reminds me of comedian Bernie Mac's "America"—the virtual audience that was called on so much that it had to respond.

In an episode of the podcast "Lexicon Valley," linguist Walt Wolfram is asked if "Black English" is a dialect or a language. Wolfram responds:

> I think the way we need to approach it is to admit the truth about dialects, that in certain contexts speaking African-American Vernacular has clear advantages. In other contexts it has clear limitations. We need to get to a position where we're not simply saying you need to talk right, but saying you need to be sensitive to the different situations in which language is used and how you may be perceived in those different situations.

Youngman willfully ignores Wolfram's advice. He uses dialect to take control of art world discourse. Youngman refuses to code-switch. He keeps the act in mixed company, whether speaking at a museum or in an interview with *Art in America*. Musson's YouTube activity prompts a deluge of hateful comments that he responds to in character. His voicing of an absent figure invites a slippage between Musson and Youngman. Some viewers mistake his black mask for a face, like journalist Dan Duray, who wrote a problematic feature on Musson with the clickbait title: "Henny from the Block: Jayson Musson Is Not an Idiot, He Just Plays One on YouTube." In the profile, Duray critiques Youngman's excessiveness, calling the cadence "over-the-top thug speak." Duray also comments on Musson's real speaking voice which (according to him) "sounds like Hennessy imitating a white person," and notes that Musson self-identifies as "West Indian."

Duray has a clear idea of what he thinks blackness should look and sound like, but he doesn't seem to understand its meaning.

What does blackness mean?

Keith Obadike proposes a few answers in his 2001 project *Blackness for Sale*, in which he auctioned his blackness on eBay. The auction was scheduled for ten days, but it was closed after four because the item was deemed "inappropriate for listing." The project is now archived on Obadike's website.

The auction received twelve bids and reached a peak of $152.50. The auction had no photo but contained the following description:

> This heirloom has been in the possession of the seller for twenty-eight years. Mr. Obadike's Blackness has been used primarily in the United States and its functionality outside of the US cannot be guaranteed. Buyer will receive a certificate of authenticity.

eBay

		Keith Obadike's Blackness			
		Item #1176601036			
		Fine Art			
		Black Americana			

	Currently	$152.50	First bid	$10.00	
	Quantity	1	# of bids	12 (bid history) (with emails)	
	Time left	**6 days, 0 hours +**	Location	**Conceptual Landscape**	
			Country	**USA/Hartford**	
	Started	Aug-8-01 16:08:53 PDT	⊠ (mail this auction to a friend)		
Bid!	Ends	Aug-18-01 16:08:53 PDT	⊠ (request a gift alert)		
	Seller (Rating)	**Obadike**			
Watch this		(view comments in seller's Feedback Profile) (view seller's other auctions) (ask seller a question)			
item	High bid	**itsfuntobid**			
	Payment	Money Order/Cashiers Checks, COD (collect on delivery), Personal Checks			
	Shipping	Buyer pays actual shipping charges, Will ship to United States and the following regions: Canada			
	Update item	**Seller:** If this item has received no bids, you may revise it.			
		Seller revised this item before first bid.			

Seller assumes all responsibility for listing this item. You should contact the seller to resolve any questions before bidding. Auction currency is U.S. dollars ($) unless otherwise noted.

Description

This heirloom has been in the possession of the seller for twenty-eight years. Mr. Obadike's Blackness has been used primarily in the United States and its functionality outside of the US cannot be guaranteed. Buyer will receive a certificate of authenticity. Benefits and Warnings Benefits: 1. This Blackness may be used for creating black art. 2. This Blackness may be used for writing critical essays or scholarship about other blacks. 3. This Blackness may be used for making jokes about black people and/or laughing at black humor comfortably. (Option#3 may overlap with option#2) 4. This Blackness may be used for accessing some affirmative action benefits. (Limited time offer. May already be prohibited in some areas.) 5. This Blackness may be used for dating a black person without fear of public scrutiny. 6. This Blackness may be used for gaining access to exclusive, "high risk" neighborhoods. 7. This Blackness may be used for securing the right to use the terms 'sista', 'brotha', or 'nigga' in reference to black people. (Be sure to have certificate of authenticity on hand when using option 7). 8. This Blackness may be used for instilling fear. 9. This Blackness may be used to augment the blackness of those already black, especially for purposes of playing 'blacker-than-thou'. 10. This Blackness may be used by blacks as a spare (in case your original Blackness is whupped off you.) Warnings: 1. The Seller does not recommend that this Blackness be used during legal proceedings of any sort. 2. The Seller does not recommend that this Blackness be used while seeking employment. 3. The Seller does not recommend that this Blackness be used in the process of making or selling 'serious' art. 4. The Seller does not recommend that this Blackness be used while shopping or writing a personal check. 5. The Seller does not recommend that this Blackness be used while making intellectual claims. 6. The Seller does not recommend that this Blackness be used while voting in the United States or Florida. 7. The Seller does not recommend that this Blackness be used while demanding. 9. The Seller does not recommend that this Blackness be used in Hollywood. 10. The Seller does not recommend that this Blackness does not recommend that this Blackness be used while demanding fairness. 8. The Seller does not recommend that this Blackness be used by whites looking for a wild weekend. ©Keith Townsend Obadike ###

Bidding

Keith Obadike's Blackness
Item #117601036

Opening bid: $10.00
Your maximum bid:

(Minimum bid: $10.00)
(Review bid)

eBay will bid incrementally on your behalf **up to your maximum bid**, which is kept secret from other eBay users. The eBay term for this is proxy bidding.

Your bid is a contract - Place a bid only if you're serious about buying the item. If you are the winning bidder, you will enter into a legally binding contract to purchase the item from the seller.

How to Bid

1. Register to bid - If you haven't already. It's free!
2. Learn about this seller - read feedback comments left by others.
3. Know the details - read the item description and payment & shipping terms closely.
4. If you have questions - contact the seller Obadike before you bid.
5. Place your bid!

eBay purchases are insured.

Top Questions From This Page

- How do I place a proxy bid? It looks like I can only place a maximum bid.
- Why doesn't my bid show up?
- What does "reserve not yet met" mean?
- How can I change something or cancel my listing completely?
- Why isn't my picture showing up?
- As a seller, how can I cancel an unwanted bid?
- Why does my email address appear when I have a User ID?
- How do I register?

Announcements | Register | SafeHarbor (Rules & Safety) | Feedback Forum | About eBay

Keith Obadike, *Blackness for Sale*, 2001
(screen capture). Online performance.
Courtesy the artist

BENEFITS:

1. This Blackness may be used for creating black art.

2. This Blackness may be used for writing critical essays or scholarship about other blacks.

3. This Blackness may be used for making jokes about black people and/or laughing at black humor comfortably. (Option#3 may overlap with option#2)

4. This Blackness may be used for accessing some affirmative action benefits. (Limited time offer. May already be prohibited in some areas.)

5. This Blackness may be used for dating a black person without fear of public scrutiny.

6. This Blackness may be used for gaining access to exclusive, "high risk" neighborhoods.

7. This Blackness may be used for securing the right to use the terms 'sista', 'brotha', or 'nigga' in reference to black people. (Be sure to have certificate of authenticity on hand when using option 7).

8. This Blackness may be used for instilling fear.

9. This Blackness may be used to augment the blackness of those already black, especially for purposes of playing 'blacker-than-thou'.

10. This Blackness may be used by blacks as a spare (in case your original Blackness is whupped off you.)

WARNINGS:

1. The Seller does not recommend that this Blackness be used during legal proceedings of any sort.

2. The Seller does not recommend that this Blackness be used while seeking employment.

3. The Seller does not recommend that this Blackness be used in the process of making or selling 'serious' art.

4. The Seller does not recommend that this Blackness be used while shopping or writing a personal check.

5. The Seller does not recommend that this Blackness be used while making intellectual claims.

6. The Seller does not recommend that this Blackness be used while voting in the United States or Florida.

7. The Seller does not recommend that this Blackness be used while demanding fairness.

8. The Seller does not recommend that this Blackness be used while demanding.

9. The Seller does not recommend that this Blackness be used in Hollywood.

10. The Seller does not recommend that this Blackness be used by whites looking for a wild weekend.

From the white flight from Myspace to Facebook, to use of the #section8 when Instagram opened up to the Android platform, to the media's preoccupation with "Black Twitter," the internet is racial and economic. Though talk of "colorblindness" once dominated conversations about digital spaces, artists and scholars have done great work debunking the idea.

Blackness for Sale explores how identity functions online. Obadike created this piece to comment on the colonialist narrative that exists online and to examine "black people's position within that narrative." In an interview with artist/activist Coco Fusco he explains, "There are browsers called Explorer and Navigator that take you to explore the Amazon or trade in the eBay."

The absurdity of *Blackness for Sale* forces us to think about the ways that blackness is already for sale. The auctioning of blacks during slavery comes to mind, but also the annual NBA and NFL drafts. I think of Django and Shaft, and other sweet, sweet badasses; Will Smith's and Denzel Washington's transcendent blackness; Beyoncé's and Jay-Z's aspirational blackness; Michael Jordan's and Michael Jackson's impossible blackness; Obama's exceptional blackness. I think of the black church and the black vote, the black belt and the black bottom. I think of Soul Glo and soul.

To quote Funkadelic:

What is soul? I don't know! Soul is a ham hock in your corn flakes. What is soul? I don't know! Soul is ashy ankles and rusty kneecaps! What is soul? I don't know! Soul is the ring around your bathtub! What is soul? Soul is you, baby. Soul is you!

Writer Rebecca Walker describes blackness, specifically "Black Cool," as "an ineffable aesthetic" that can be "traced back to a place, a people, and a culture." Black influence is everywhere in American culture, but it is often accused of being unknown and unknowable. But I know it when I see it.

How do we know what we know? Where did we learn how to be black? Can you fail to learn, as certain relatives think I did? Can you unlearn?

Los Angeles–based artist Nicole Miller investigates this epistemology in her video *The Alphabet* (2009).

On screen we see Miller on Safari, retrieving several videos from her "favorites." She uses her digital visual capital to look at YouTube videos—just like Pew Research Center told us she would! Splayed across her desktop in exposé view, Miller presents clips of Bill Cosby, James Earl Jones, Richard Pryor, Lou Rawls, and Jackie Robinson reciting the alphabet on the television show *Sesame Street*.

Miller's use of the screencast is similar to Cindy Sherman's depiction of the shutter release in her early photographs. In Sherman's "Untitled Film Stills" series you can see her holding this device, a feminist gesture that confirmed and visualized her autonomy in crafting the image. Miller is painting herself as a "subject of interactivity," in the words of Lisa Nakamura, though she is also the "object of interactivity," as well the "producer/artist" and "spectator/owner," due to the interactive nature of the video.

The Alphabet isn't about blackness; it is blackness. Each man performs blackness as an entertainer, and Miller performs blackness as a spectator. The men in the video use different forms of expression—comedy, drama, soul, and sport—to transform the alphabet. It doesn't matter if they are pronouncing the letters "correctly," they are getting to a greater truth.

In an essay for *Black World* advocating the use of "Black English," poet June Jordan wrote:

Language is the naming of experience and, thereby, the possession of experience. Language makes possible a social statement of connection that can lead into social reality. For all these reasons, language is political. Power belongs to the ones who have the power to determine the use, abuse, the rejection, *definition/re-definition* of the words—the messages—we must try and send to each other.

Nicole Miller, *The Alphabet*, 2009 (still).
QuickTime animation, sound, color; 2:38 min.
Courtesy the artist

The Alphabet expresses the language of language. Miller's piece captures the way in which black performers named our experience within the theater of pop. Her video asserts "the mundane," which theologian Scott Cowan designates as "the most dynamic social force at work within a community."

Capitalism would lead us to believe that buying and selling is the most important activity of our lives. I've been talking about fine art, but I want to expand these ideas to explicitly address commerce because the internet is, after all, a commercial context. It's a market that's influenced by the same discriminatory distribution practices that dominate film, television, and other culture industries, including art.

Here is a screenshot [Syms pulls up an image on a screen for the audience to see] of Big Freedia's Booty Battle, a Dance Dance Revolution–style HTML5 game created for the NOLA Bounce Queen Diva by the agency Eyes & Ears. The object of the game is simple: use your keyboard to shake that ass. May the best booty win.

I've seen Freedia live, and her performance is a fun, raucous, high-energy event. She has incredibly talented backup dancers that make you want to move. Freedia's shows feature a Booty Battle in which members of the audience are pulled onto the stage and directed to make their booty whop. Although Booty Battles are common at bounce shows, Freedia has brought this activity to the mainstream through her crossover success.

Unlike some of the other bounce musicians in her native New Orleans, Freedia's audience is racially mixed. For most of Freedia's two-hour show my eyes were glued to the stage. Her dancers are truly fantastic. I was dancing and shouting the lyrics and generally having a good time, but I kept hearing this guy a few feet away from me happily shouting, "Dance, you black bitch. Shake your black ass" at one of the dancers.

To the untrained ear those might sound a lot like actual Big Freedia lyrics, but they aren't. The scene made me uncomfortable in the same "white-guy-laughing-too-loud" way that made Dave Chappelle quit television.

Big Freedia's Booty Battle also makes me feel this way.

Cultural production is often underwritten by advertising, an industry not known for diversity. Eyes & Ears built in four avatars that each represent a different "demographic," but booty is black. I'm claiming it. Yet the game is exclusively presented by VICE Media, a company dedicated to what I'll generously describe as an examination of contemporary whiteness.

Does new media provide more opportunities for black artists? Popular culture has been churning out the same images of blackness for over eighty years.

Freedia's booty poppin' isn't much different than Josephine Baker's. This image sells, but only because it was born out of discriminatory distribution practices.

In 2011, artist Tahir Hemphill released the *Hip Hop Word Count*, a "searchable ethnographic database built from the lyrics of over 40,000 Hip-Hop songs from 1979 to present day." The *Hip Hop Word Count* logs the time and location of "every metaphor, simile, cultural reference, phrase, meme and sociopolitical idea used in the corpus of Hip-Hop." Hemphill began the project because he was tired of having no tool to learn "which rapper had the smartest songs?" Or "which city's rap songs use the most monosyllabic words?" The *Hip Hop Word Count* charts the language of hip-hop music.

Pictured here is a browser-based data visualization of all mentions of champagne by US rappers between 1980 and 2010. This is the map view.

HIP HOP WORD COUNT
Brand Mentions 1980 - 2010
CHAMPAGNE

432

67

775 Mentions
Ace Of Spades: 5
Asti: 8
Chandon: 5
Cold Duck: 2
Cristal: 297
Dom Perignon: 209
Moet: 249

1980 - 2010

Tahir Hemphill, *Hip Hop Word Count* (Map View),
2010 (screen capture). Searchable ethnographic
database. Courtesy the artist

This is the graph view.

Tahir Hemphill, *Hip Hop Word Count* (Graph View), 2010 (screen capture). Searchable ethnographic database. Courtesy the artist.

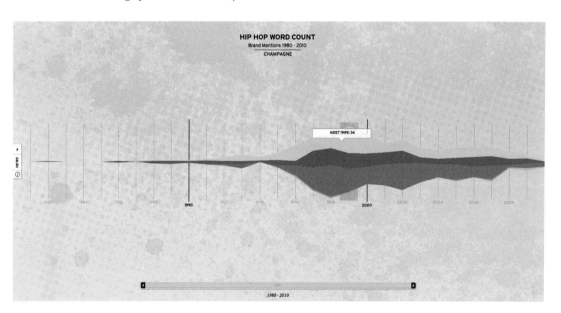

This is the song view.

Tahir Hemphill, *Hip Hop Word Count* (Song View), 2010 (screen capture). Searchable ethnographic database. Courtesy the artist

Hemphill explains that the graphic illustrates a "nuanced story of Rapper's relationship" to champagne—an "aspirational product"—and therefore, to the American Dream.

Though I'm curious about the methodology behind the data, the *Hip Hop Word Count* is the first exhaustive, public project that considers the hybridization of speech and writing in hip-hop. Hip-hop has had an undeniable influence on globalized, popular culture over the last thirty years. Not only has its aesthetic migrated internationally, but according to linguist John McWhorter, "Black English, especially the cadence, is becoming America's youth lingua franca."

Using Jordan's configuration of power as those who "determine the use, abuse, rejection, definition" of words, Black Power is literary. Of course, Black Power encompasses many things. Amphiboly—defined by the *Oxford English Dictionary* as "a quibble"—empowers black people. It lets us force two fighting ideas together. Code-switching liberates us. Our once "alternate system of ... currency and value," has been merged with mass culture. The way that black literacy has always encompassed nonliterary techniques like performance and orality are uniquely suited to thrive in televisual formats like the web. Black creators and audiences have understood how to use double entendre, politics, incongruity, and polyphony in making meaning.

Can "blackness" as an aesthetic quality be expressed on screen? The essentialist in me thinks that a thing is black if a black person makes it, but experience tells me that it's black when black people name it as such. We recognize it in dialect, symbol, and rhythm. Blackness can be read from a number of positions, whether collective as in Miller's *The Alphabet* or contextual as in Hemphill's *Hip Hop Word Count*. Yet this proliferation of meanings doesn't render the concept meaningless. Multivalence is a blueprint for building the web and other large networks.

I started Dominica Publishing in 2012. It is an imprint and studio dedicated to exploring blackness as topic, reference, marker, and audience in visual culture. This intentionally broad mission provides an assorted mix of selected readings. *Black World* is my legacy. In the same way that the Ramones were trying to sound like Herman's Hermits, I am trying to recreate the Johnson Publishing Company empire for a new era.

I want my catalogues to gather ideas, feelings, and factions, and create a public around them. I've released nine publications and editions, including newly commissioned work, archival documents, and found materials. Through Dominica, I'm making an infrastructure for myself and my peers. I'm finding new ways of bringing work to the public that disrupts the legacy of conventional distribution. Dominica could not exist without the internet. It's made possible by the

overwhelming supply of images and stories that contemporary life allows me to access.

We need a language for reading new media that can communicate the collision of seemingly incompatible ideas. The black vernacular is an approach to such abundance. Given this radical, black tradition of hyperliteracy, I propose a recasting of "users" as "readers." I want to make the popular web more like books—cumulative, eclectic, edited, artful. I care about the reader. The reader is always an individual, alone, awash in blue light staring at a screen. My work is for the reader. I want the web to be worth her time.

. .

"Black Vernacular: Reading New Media" by Martine Syms was first delivered as a talk for SXSW Interactive in 2013. For *Mass Effect*, it has been transcribed and reedited.

. .

REFERENCES

Alexander, Elizabeth. *The Black Interior: Essays*. 1st ed. Saint Paul: Graywolf Press, 2004.

Baldessari, John. *The Meaning of Various Photographs to Ed Henderson*. 1973. ½" open reel video.

Bourdieu, Pierre. *Distinction: A Social Critique of the Judgement of Taste*. Cambridge, MA: Harvard University Press, 1984.

Chan, Paul. *Paul Chan: Waiting for Godot in New Orleans*. 1st ed. New York: Creative Time Books, 2010.

Considine, Austin. "Biting Humor Aimed at Art." *New York Times*. Feb. 29, 2012. <http://www.nytimes.com/2012/03/01/fashion/hennessy-youngman-offers-offbeat-art-criticism.html>.

Donnett, Nathaniel. *How Can You Love Me and Hate Me At The Same Time?*. 2011. Plastic bags, paper, paper bags, wood, gold leaf.

Du Bois, W. E. B. *The Souls of Black Folk*. Unabridged edition. New York: Dover Publications, 1994.

Duray, Dan. "Henny From the Block: Jayson Musson Is Not an Idiot, He Just Plays One on YouTube." *Gallerist*. July 10, 2012. <http://observer.com/2012/07/henny-from-the-block-jayson-musson-is-not-an-idiot-he-just-plays-one-on-youtube/>.

Funkadelic. *Funkadelic - Funkadelic - 07 - What Is Soul*. 2009. Video, sound, color; 7:44 min. <https://www.youtube.com/watch?v=RgPIqOh9uTU&feature=youtube_gdata_player>.

Fusco, Coco. "All Too Real: The Tale of an On-Line Black Sale: Coco Fusco Interviews Keith Townsend Obadike." *Black Net Art*. Sept. 24, 2001. <http://blacknetart.com/coco.html>.

González-Torres, Félix. *"Untitled" (Portrait of Ross in L.A.)*. 1991. Multicolored candies, individually wrapped in cellophane.

Hemphill, Tahir. *The Hip-Hop Word Count*. 2011. Video, sound, color; 1:42 min. <https://vimeo.com/23874762>.

Henderson, Nia-Malika. "Blacks, Whites Hear Obama Differently." *Politico*. March 3, 2009. <http://www.politico.com/news/stories/0309/19538.html>.

Jemison, Steffani. *The Meaning of Various Photographs to Tyrand Needham*. 2009. Single-channel video, sound, color; 12 min.

Jemison, Steffani, ed. *The Reader*. Houston; New York: Future Plan and Program; New Museum, 2011.

Johnson Publishing Company. *Black World/Negro Digest*. Chicago: Johnson Publishing Company, 1973.

Koons, Jeff. *Three Ball 50/50 Tank (Two Dr. J. Silver Series, One Wilson Supershot)*. 1985. Glass, painted steel, distilled water, plastic, and three basketballs.

Landsberg, Alison. *Prosthetic Memory: The Transformation of American Remembrance in the Age of Mass Culture*. New York: Columbia University Press, 2004.

Miller, Nicole. *The Alphabet*. 2009. QuickTime animation, sound, color; 2:38 min.

Musson, Jayson. *ART THOUGHTZ: How to Make an Art*. 2011. Video, sound, color; 3:33 min. <http://www.youtube.com/watch?v=vVFasyCvEOg&feature=youtube_gdata_player>.

Nakamura, Lisa. *Digitizing Race: Visual Cultures of the Internet*. Minneapolis: University of Minnesota Press, 2007.

Obadike, Keith. *Blackness for Sale*. 2001. HTML, CSS, Javascript.

Vuolo, Mike. "Is Black English a Dialect or a Language?" *Slate*. Feb. 27, 2012. <http://www.slate.com/articles/podcasts/lexicon_valley/2012/02/lexicon_valley_is_black_english_a_dialect_or_a_language_.html>.

Walker, Rebecca, ed. *Black Cool: One Thousand Streams of Blackness*. 1st ed. Berkeley: Soft Skull Press, 2012.

Young, Kevin. *The Grey Album: On the Blackness of Blackness*. 1st ed. Minneapolis: Graywolf Press, 2012.

DIS Magazine

Founded in 2010, DIS is a collective consisting of four members: Lauren Boyle, Solomon Chase, Marco Roso, and David Toro. Including performance, installation, and video, their cross-platform work is anchored by their website (dismagazine .com), where they continually publish photo-essays, critical texts, and online projects. In their own words: "DIS is a multimedia art magazine. DIS is a dissection of fashion and commerce which seeks to dissolve conventions, distort realities, disturb ideologies, dismember the establishment, and disrupt the dismal dissemination of fashion discourse that's been distinctly distributed in order to display the disenfranchised as disposable. All is open to discussion. There is no final word."

The following series of images, by seven individual artists, is taken from DISimages, an online stock image library launched in 2013. On the project, the artists write: "DISimages invites artists to create alternative scenarios and new stereotypes, thus broadening the spectrum of lifestyle portrayal."

The Jogging for DISimages, *Jogging × Gallery Girls*, 2013, Digital image, dimensions variable. Courtesy the artists and DISimages

Anne de Vries for DISimages, *Exchange Material*, 2013. Digital image, dimensions variable. Courtesy the artist and DISimages

Ian Cheng for DISimages, *3D Models*, 2013. Digital image, dimensions variable. Courtesy the artist and DISimages

A SELECTION FROM DISIMAGES: NEW STOCK OPTIONS

Katja Novitskova for DISimages, *Future Growth Approximations V*, 2013. Digital image, dimensions variable. Courtesy the artist and DISimages

Dora Budor for DISimages, *New Fragrance Options*, 2013. Digital image, dimensions variable. Courtesy the artist and DISimages

Anicka Yi and Jordan Lord for DISimages, *Keep it Cute*, 2013. Digital image, dimensions variable. Courtesy 47 Canal and DISimages

Shawn Maximo for DISimages, *Neighboring Interests*, 2013. Digital image, dimensions variable. Courtesy the artist and DISimages

Timur Si-Qin for DISimages, *Attractors (Tomatoes)*, 2013. Digital image, dimensions variable. Courtesy the artist and DISimages

DISimages, *Smiling at Art*, 2013. Digital image, dimensions variable. Courtesy DISimages

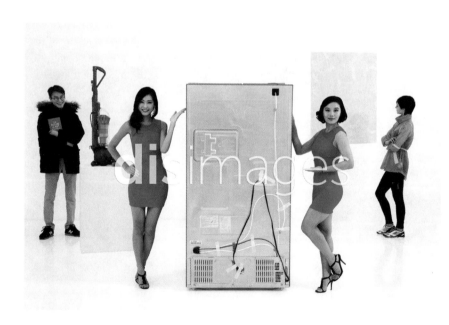

A SELECTION FROM DISIMAGES: NEW STOCK OPTIONS

MADE OF THE SAME STUFF: RYAN TRECARTIN'S ART OF TRANSFORMATION

Michael Wang

Ryan Trecartin's art figures a representational order in which words, images, and objects no longer inhabit separate strata of experience, but instead intermingle, hybridize, and transform into one another. At the close of Trecartin's feature-length video *I-Be Area* (2007) we are shown a room that seems to function as both a set and an artist's studio, crowded with sculptures and besmirched with paint. Artist-actors modify the space and its contents, affixing props to the walls, or roughly pulling them down. The actors themselves are in constant states of evolution. A prosthetic belly is affixed then shed in a defiant striptease. Dialogue is extended through exaggerated gestures that reverberate through the actors and into the props they brandish. An incantation materializes in quivering red letters that flicker across the screen. Pictures within the frame assert themselves then break away. A mirror holds Trecartin's face for a moment before it's thrown to the floor and shattered. The image frame fragments and drifts, doubling an actor's body. The whole of the image suddenly seems to flatten and slide away.

While Trecartin works, ostensibly, in video, he reorganizes the hierarchy of cinematic representation to explode the representational potential of its component parts. Characters are treated like props and props like characters. Editing effects assume equal importance to narrative elements. Those techniques that typically serve to construct and unify the moving image assert themselves as equally important and present to the viewer. Traditionally background elements—Trecartin's sets, for instance—leap to the fore. Elements conventionally excluded from the frame—the written words of the script—invade and overtake the screen.

Trecartin objectifies codes of representation, giving them a visibility and substance that forces them up to the same level as his characters or storylines. Trecartin's effects, his language, and his rich store of images, both appropriated

Ryan Trecartin, *I-Be Area*, 2007 (still).
Video, sound, color; 108 min. Courtesy the
artist and Andrea Rosen Gallery, New York
© Ryan Trecartin

and original, become objects in the frame, no different from a hammer, a can of
Red Bull, or a rip-off Noguchi lamp. Bits of dialogue, repeated in brightly colored
text, become graphic elements onscreen. The picture plane itself twists and ro-
tates, via 3-D picture-in-picture effects, to become a floating shard within the
apparent depth of the screen. Painterly gestures, digitally rendered forms, and
sampled stock photos proliferate across the base image, calling attention to its
flatness and challenging its primacy. Words and images, representations and
representational techniques, acquire definition and depth, pulling away from the
flatness of the video frame. This profusion of elements vying for our attention

fragments the screen's placid coherence. Trecartin's "footage" becomes just one out of many possible points of entry into the frame.

Like a child bored with toys, Trecartin plays rough with these newly minted "objects." They are taken apart and manipulated, used and abused. Creating an object most often presages its speedy destruction. A printed image, held by two characters, momentarily doubles their faces just before it's crumpled and soaked under a running faucet (*Sibling Topics (section a)* [2009]). A character's handwritten name tumbles across the screen, then splinters into pieces (*A Family Finds Entertainment* [2004]). The material world, too, is subjected to the same program of redefinition. As images (identifiable as pictures) and language (visible as text) sink back toward the more physical stuff of the world, this material world seems to acquire the instability of representations. Trecartin's performing body itself is a locus of instability. Camouflaged by hyper-colored makeup and hair dyes or reshaped by prosthetics (wigs, novelty contact lenses, navel infills), the characters played by Trecartin are in constant flux. Bodily distortion goes beyond the tricks of the prop shop. In postproduction, Trecartin pushes around body parts as if smearing paint with a palette knife, or tints skin toward the purer tones on the spectrum. The voice, too, is untethered from a human range, tweaked to cartoonish highs and lows, or set to a perfectly auto-tuned pitch, as when a trio of characters in matching sweatshirts and inexpensive wigs ask, on repeat, "do I sound real good?" in voices alternating between creaking falsetto and pop polish (*Comma Boat* [2013]).

These transformations between images, words, and objects are rooted in Trecartin's productive ambivalence to distinctions between mediums. Trecartin's works become a site for accelerated and multidirectional translations—not, as is traditional, between works (the painting based on a poem, the sculpture on a myth, the movie on the novel), but rather within the work itself. Trecartin likens his films to an architectural space: a zone of potential in which these transformations between materials and practices take place. His collaborative method, in particular his relationship with sculptor Lizzie Fitch, but also his work with writers, painters, stylists, performers, and designers, allows for feedbacks to develop between varied mediums. Trecartin doesn't merely represent, say, sculptures as props, or paintings as backdrop or décor, but brings sculptural and painterly techniques into the very structuring of the frame. Digital scrawls crisscross the moving image. Lines of paint daubed on set walls define crude frames for green-screen effects. Digital modeling techniques treat filmic objects as forms subject to manipulation in an apparent three-dimensional space.

There is an intentional confusion over the origin of these objects. In *A Family Finds Entertainment* (2004), amid a profusion of painted and decorated

bodies and club-style black-lit backdrops, a clownish character presents a brightly painted lounge chair trashily bedecked with gift bows. He announces: "I made this chair in Photoshop. Do you like it?" The chair appears to be a modified material artifact—a sculpture—but its ontological status within the narrative is unclear. The prop's slime-green hue has been pumped up in "post," giving it a virtual character. But its maker's assertion suggests a digital origin that precedes its status as a physical object or prop, or its later doctoring. The chair's ambiguity opens the possibility that the narrative itself takes place within a virtual space, a world that owes its origins to digital image-making. Medium translation loops back on itself (from digital to sculptural to digital) and folds into the narrative itself. Postproduction determines the status of its component parts within the structure of the story. The primal character of his system of representation is affirmed in Trecartin's recent work, *CENTER JENNY* (2013). A professor, ringed by spaced-out yet adoring students, presents the circular narrative of representation as a history lesson: "We evolved from animations, and these animations actually evolved from humans."

While his characters, props, and sets often seem to merge, washed away by color and shimmering digital effects, Trecartin never achieves the totalizing synthesis of a gesamtkunstwerk. Instead, the barely-there distinctions between the various elements in his work determine a kind of ground, a space of half-formed figures always in the process of becoming—or becoming something else. This hybrid art form describes a kind of three-dimensional substance through which painting, sculpture, performance, and text endlessly transform the one into the other. The work of translation is never done. Image, words, and objects come together into a kind of sticky soup, neither liquid, nor fully solid. They appear to be made of this same substance: a viscous ooze from which forms fleetingly take shape, only to be quickly shifted into a new form. It is because they share the same properties—are made of the same stuff—that a word can become an object, a body can become an image, or an image can be reduced to a pithy, accented catchphrase. A brand name (Brita®) appears in the ghosted, computer-generated form of Brita's popular water filter, and ultimately names a character played by Trecartin: "Britta."

It is no accident that a brand provides my example of transmutation, borrowed from Trecartin's "Any Ever" series. These transformations mirror the strategies of late-capitalist marketing whereby, for example, an emotion becomes a word, a word an image, an image a product. Marketing speak, a language in which Trecartin and his characters are fluent, is replete with examples of "nominalization": the conversion of adjectives and verbs into nouns. This grammatical convention is a kind of sleight of hand that transforms qualities or actions into

Ryan Trecartin, *A Family Finds Entertainment*,
2004 (still). Video, sound, color; 41:12 min.
Courtesy the artist and Andrea Rosen Gallery,
New York © Ryan Trecartin

seeming physical entities—the easier to productize, buy, and sell. Xfinity offers
"the future of awesome." Apple enjoins us to "think different." These brands come
to embody the "awesome," or the "different." Similarly, brand slogans treat ab-
stractions as objects to be grasped, synonymous with the physical product itself.
Coca-Cola instructs us to "twist the cap to refreshment" and "open happiness."
Visa imagines that "life takes Visa." The language of marketing structures much
of Trecartin's dialogue, and advertising posters colonize Trecartin's sets. His
characters themselves take on self-branding as a full-time occupation (or, fol-
lowing the logic of the de-professionalization of labor to its final conclusion, as

interns or even "hobbyists"). Adjectives and verbs become *proper* nouns: Ryan's characters go by names like "Able," "Wait," or "Free Lance."

The packaging of emotions, ideals, and abstract qualities into brand identities and products anticipates Trecartin's sweeping, transformative approach, which does not always mimic that of the savvy marketeer. As Trecartin pushes abstractions toward objecthood, he sets up the potential to endlessly transform these objects. No slogan or product is an endpoint. There is no satisfied customer. Ideas, images, objects, styles, traits, and desires can be squeezed, pulled apart, and re-formed into any shape imaginable, as if all modeled from the same clay. Trecartin describes this transformative process as "substitution":

> When organizing content I enjoy playing games of what I think to be a kind of subjective math—maybe a "substitutioning," "swapping"— almost a synthesis of possibilities expressed. An example might be attempting to make a relevant news story into a personality trait, a careerist goal into living room furniture, an accent into a hairdo, or an ideology into a body language, or designer skin tone.[1]

I have already shown that this process of translation is, primarily, an objectification. It corresponds with a marketing program that aims to productize the immaterial. This conquest of human experience by exchange value—which sometimes requires acrobatic transformations and displacements—has been recently accelerated by the structure of the internet. The internet has emerged as the ideal space in which experience enters into the system of exchange. Competition for "eyeballs," page views, and re-shares has established economies of attention, through which everyday experiences have been successfully monetized, primarily through the generation of advertising revenues. Facebook transforms idle chatter into a marketable resource. Google assigns a value to any data publicly available online. When an aspect of experience has been translated into shareable data, it suddenly becomes a part of these larger structures of monetization.

The potential value of data has fueled the drive to migrate increasing swathes of human experience online. Facebook "owns" social relations; Pinterest, style and taste; Twitter, public opinion; Grindr and Tinder, sexual exchange. These are all individual experiences or aspects of identity that now acquire value as a part of a system that monetizes attention and that demands ever more of everyday experience to maintain and increase that attention.

Just as Trecartin makes the world of material things and the world of representation appear to be made of the same basic (and mutable) substance, the internet transforms ever-larger portions of lived experience into standardized

systems of code. While the internet apparently represents—and rivals—the entirety of the offline world, it must reform the diverse experiences of the material world to accord with the standards of digital representation. While some might see this as a flattening of experience, the seemingly spatial qualities of online experience suggest, rather, the unification of the world through a change in its basic construction. This new world is built not by steel, plastic, or flesh, but by chains of zeroes and ones.

As a coherent zone of representation, the digital world sets up parameters on the form and structure of its objects. The digital law of substitution is one such parameter that informs Trecartin's symbolic transformations and that becomes a key theme within his narrative structures. In Trecartin's world, the rules of representation determine the physics of time and space. Jump cuts swap different characters in and out of the same scene. The editing technique then becomes a structuring principle in a movie's narrative fabric. As multiple couples appear to flicker in an out of the backseat of a van, one passenger realizes, to his annoyance, that "the van is double-booked." The jump cut is not just a representational trick of appearance and disappearance, but a shudder in time and space experienced by the characters themselves. In *Roamie View: History Enhancement (Re'Search Wait'S)* (2009–10), Trecartin draws attention to substitution as an artistic strategy: the art of the remix. The awed and credulous character JJ (played by Trecartin) narrates the construction of an artwork based on the "old Constitution," in which he has replaced every instance of the word "people" or "humanity" with the word "situations," and every reference to "God" with "The Internet." The resulting text is then intended, JJ tells us, to be performed over a house beat.

The digitization of human experience is not a one-way street. Just as the becoming-object of Trecartin's abstractions corresponds to his de-realization of the material world, the process of digitizing and selling experience results in the productization of the human. Trecartin's characters embrace this space of externalized self-fashioning. "I love learning about myself through other people's products," boasts Trecartin as the character Wait in *Ready (Re'Search Wait'S)* (2009–10).

In a series of images commissioned by the fashion magazine *W*, Trecartin and his collaborators styled, shot, and Photoshopped a series of images to be used as both an actual fashion spread (complete with designer names and labels) and to illustrate an essay on Trecartin on the eve of his solo exhibition at MoMA P.S.1 in 2011. The resulting images—in which Trecartin's collaborators stand in for professional models—figure the human body as it explodes into branded products and experiences. While the clothes might fit the context of a high-end fashion

Ryan Trecartin, *Roamie View: History Enhancement (Re'Search Wait'S)*, 2009–10 (still). HD video, sound, color; 28:23 min. Courtesy the artist and Andrea Rosen Gallery, New York © Ryan Trecartin

Ryan Trecartin, *Again Pangaea + Telfar Clemens*, 2010. Chromogenic print, 36 × 24 in (91.4 × 61 cm); portfolio for *W* magazine, November 2010. Courtesy the artist and Andrea Rosen Gallery, New York© Ryan Trecartin

magazine, the props and accessories derive primarily from mass retail: office supplies, spring water, an iPad. A technological order asserts itself through collaged overlays. A dashboard of an automobile appears like a tattoo across a model's forehead. A watermark intended to protect a digital image neatly frames a model's face. The unrealized Dubai Towers float across a backdrop. Makeup dominates and divides the models' bodies. Eyebrows are painted over with text. Artificial tan lines dissect a body according to the cut of more extreme swimwear fashions. Blackface and whiteface and a kind of hand-applied pixelation effect cohabitate on the surface of a single body.

Just as in the films, a collaborative approach brings together performers, stylists, computer effects specialists, and makeup artists to produce a single, digitally enhanced end product (here still, rather than moving, images). A witness to, and participant in, what he calls the "adolescence of the Internet," Trecartin relates the hybridization of media to the dissolution of traditional identity boundaries: "At the moment in time I was born, it was natural not to recognize boundaries between artistic mediums—as well as ideas, genders, races, and all sorts of nuances that are historically shoved into and understood in terms of categorical containers."[2] Playing with race and gender through the products of consumer culture, the *W* magazine shoot suggests that instead of "targeting" particular key consumers, consumer goods have in fact become constitutive of consumer identity (to the point of creating nearly inhuman and monstrous subjects). Old organizing principles of race or gender have been supplanted by these fluid identities shaped by an expansive world of products, designed to satisfy not coherent and unified "types," but the most minute, varied, and fleeting of fragmentary desires. Race and gender don't disappear, but are reduced to fragments, accessories, "relics" (to borrow from Trecartin's lexicon). Musing on the demise of old categories of sexuality and gender, the students of *CENTER JENNY* agree that "the further we all move away from humanity, like, sexism just becomes like the coolest style."

The fragmentation of the self and its displacement into varied external objects is central to Trecartin's practice. As human experience is digitized, the self is reconstructed by identity-processing machines: an array of products, apps, trends, sites, networks, and lifestyles. In Trecartin's world, individuals are referred to as "situations," "clusters," even "landscapes." As narrative elements converge in Trecartin's movies, transparent overlays of clouds, jungles, stock footage of sunset vistas break through the storyline to reinforce a sense of this dissolution of the body, and by extension the self. But Trecartin is ultimately not interested in telling a story of loss. His real subjects are not his characters as they struggle to define themselves both through and against the

Ryan Trecartin, *CENTER JENNY*, 2013 (still).
HD video, sound, color; 53:15 min.
Courtesy the artist and Andrea Rosen Gallery,
New York © Ryan Trecartin

by turns inviting and turbulent waves of consumer culture. Trecartin's singular achievement is the figuration of the very ground out of which his characters, his ideas, his props, his language emerge. This oozing, viscous, mutable substance, shape-shifting yet homogenous, looks and feels so much like that primary site of twenty-first-century representation: the internet. At once spectral and material, human and inhuman, it is the substance of transformation.

···

This essay was commissioned in 2014 for the present volume.

···

NOTES

1. Ryan Trecartin in conversation with Kristina Lee Podesva, "When the Time Comes, You Won't Understand the Battlefield," *Fillip* 13 (Spring 2011): 101–05.

2. Ibid.

Discussants: Josephine Berry Slater, Rózsa Farkas, Harm van den Dorpel,
and Ben Vickers
Moderator: Karen Archey

KAREN ARCHEY: 2008, when the last "Net Aesthetics" panel was held, was just
five years ago—admittedly it feels like about a million internet years—but that
year marked this watershed moment. The next year, artists, including Aleksan-
dra Domanović, Harm van den Dorpel, and Oliver Laric, started moving offline
in a very serious way to start creating object-based artwork. I think that moment
was brought on by a show called "AFK Sculpture Park,"[1] curated by Dan Keller
and Nik Kosmas of AIDS-3D in 2009 at the Atelierhof Kreuzberg. This was the
first moment that Domanović made her paper stacks, and the first moment that
Laric made an object version of *Versions*. And then there was the launch of Tum-
blr in 2007. I've spoken with the artist Jon Rafman about that moment and
how he thinks that precipitated a kind of impoverishment of the image, or a de-
mocratization of image-sharing, thus creating another moment in which online
images didn't hold enough currency as a creative practice. That created a new
mandate to make object-based work.

Thinking about this moment, and thinking about how so much has changed
in the five years from then to now, is a valuable way to understand what post-
internet art is. I think that postinternet art was at first something that was
extremely positive, banding together a lot of European artists and writers who
kept in touch online. These individuals deeply and ardently felt there was a lack
of internet awareness in the art world in general and fought for a lot of oppor-
tunities. And it has since become something else. I think that one of the reasons
we're here today is that the internet and that community of artists is something
that we can all relate to, but we've come to a tipping point where we don't really
know what to do with the term "postinternet." We don't really know what to do
with its market-readiness; we don't know what to do with its perceived vogu-
ishness. But there's a certain sadness and tragedy attached to this term, I think,
that I hope we can parse out on this panel.

HARM VAN DEN DORPEL: I am often called a postinternet artist. I'm not denying it, but I wouldn't introduce myself as one, which I guess says a lot about whether I take pride in the term. I have a background in computer science; I studied artificial intelligence but I didn't complete my studies because I had a very different expectation of them. I've always been extremely interested in how intelligence could be described through algorithms in a formal or theoretical way. A very technical algorithm combined with a lot of fuzzy, human, intuitive activity could actually, I still believe, tell us a lot. So I started studying at art school. As a new graduate I really didn't have access to an art world, nor was I really aware of the existence of such a thing. I knew it was there, but I rarely went to openings and I had never been to an art fair. At that time we were making lots of things online. There were surf clubs. I met people online; we were doing things online and it was just a lot of fun. It was actually quite a social activity. And then at some point I was greatly helped by Rhizome, actually, which was always very active in observing that kind of work. At some point, institutions that I had never heard of asked internet artists like me to show work, which was great, and then you would travel to an exhibition somewhere in Italy, where there was a projector, and then you suddenly had to project the thing you made for the internet onto a wall, and it was completely dead. The absolute promise of the '90s was the democratization of media—that everybody could publish whatever they wanted. And then you end up being in an exhibition with things that people can buy for a lot of money and that have to be shipped; it's quite a different reality.

JOSEPHINE BERRY SLATER: Hello, I'm very honored to be here, and slightly puzzled as to why. I wrote my PhD dissertation on the first wave of net.art. It was titled very unoriginally "The Thematics of Site-Specific Art on the Net" [2009]. It really looked at the net.art movement from '94 until '99 when it was kind of declared dead by—I think at that point it was Alexei Shulgin—but there were many declarations of its death. In '99 there was a show called "net_condition" at ZKM [Center for Art and Media, Karlsruhe, Germany], and Shulgin presented the ten tenets of net art, or net.art, on tablets of stone, like tombstones. Actually, I have to confess that it was more out of personal circumstances that I drifted away from paying attention to the developments of net.art in the ensuing period; but it was largely thanks to Rózsa and Arcadia Missa's *Mute* article—which was a very early forum for net.art to be discussed and net artists to present themselves—that I kind of got re-enlivened by the subject. So I'm coming from a perspective of quasi-ignorance, but also, as they say, a real familiarity with the first wave. I just want to make a quick point about this "post," the appending of

"post" onto whatever movement. Lyotard made this point a long time ago, which is that postmodernism is a real sort of contradiction of itself as a term because it implies a succession of developmental stages: one presumes from it that one has left the prior stage and moved into the next one. Of course, what is precisely at stake within postmodernism is this idea that we have reached the end of history, the end of that kind of sequentiality.

Now for [Peter] Osborne, he's coming at this from a slightly different point of view in his book *Anywhere or Not at All* [2013] about the contemporary philosophy of art. It's a very good book, I recommend it. It's in the bookshop, I just noticed. What we need to realize is that in some way postmodernism was a kind of failure as a way of creating a schematic for a chronology of art movements or as a descriptor of a cultural stage. He adopts a term "transmodernism," which I personally found very persuasive in his book. I won't go into great detail, but for him, and going back to Baudelaire, modernity is all about the apprehension of the new in the moment. And of course it becomes a self-conscious rallying cry of art and of culture at the point at which the technologies of circulation intensify to the degree that they have done or did in the late nineteenth century. Essentially what Osborne is saying is that it's the overt orientation toward the new which is modern and modernist, and one that basically wishes to break with the traditionalism of the past. He adopts the term "transmodernism," meaning that there are many multiple modernities and modernisms happening at once. So I would say something like "transinternet art" might be a more satisfying term, only in the sense that we haven't moved beyond net.art, I don't believe, despite the tombstones.

I'll just say a quick couple of things. Site-specificity, the subject of my dissertation, was the way in which I engaged with the question of net.art. The question was simply: where is an artwork when it's on the internet? And that proved to be incredibly complicated. I think the understanding that I developed is that the non-place of the web has a specificity to it, and that specificity, I would say, was the objective of a lot of that early net.art, to kind of dig down through the layers. I want to show two images [Berry Slater directs audience to screen]: this is a self-portrait by Heath Bunting, *Self Portrait at 42* from 2007, which I want to contrast with Jennifer Chan's piece *Factum Mirage* from about three years ago. Essentially, what I want to flag is the way in which I think Heath Bunting was trying to create these diagrams of identity, of site, of technical specificity. His approach, and I think this of a lot of the first wave net artists, was a mode of specificity that certainly acknowledged the dissolution of site as a singular entity, but nevertheless wanted to advocate for a certain specificity, and to diagram it in a way that could create understandings. His self-portrait is based on

all the data trails that one develops and accrues over forty-two years, the points of identification that are produced.

I want to contrast the Jennifer Chan image with Bunting's self-image. Jennifer Chan is in Chatroulette. What you see is simply an exchange between her and a perfect stranger, but you have a sense that her production of a self-portrait, which is specific to the web as it has become, is much more Baudrillardian, one in which there is a sense of being subsumed within a welter of circulating images and representations, and one that is very disorienting. I think that disorientation is very connected to this idea of post-medium, which has abandoned the pursuit of diagramming the technical and social and contractual and protocological specificities of the net.

BEN VICKERS: In order to understand the evolution and early stages of the subject at hand, you have to focus on and imagine a different internet, one totally unlike the one we have today. You have to also imagine that there were many internets, but that only one has come to dominate the present context. In order to begin to imagine that, you have to think that before the creation of VVORK in 2006 there wasn't really any proper contemporary art on the internet. So at the inception of postinternet, it carried a number of characteristics that can be posthumously referred back to. The display of work that doesn't consider the gallery to be an inside space, but rather a single node in a network of possible spaces or modes of display. The use of self-branding as a tool for fluid production that assumes all output—be it through social networks or in a public space—to be a component of the work. The ability to decontextualize the work of others (art or non-art) by consuming it into its own practice or world. The production of work is usually contingent on a situation, rather than on a style, content, message, or school. As a whole, it recognizes the banality of the internet in our everyday lives but strategically uses this kind of emperor's new clothes obsession with the digital as a force multiplier for its own accumulation of cultural capital and spread.

How were the foundations of postinternet built? The early stages of those that gave rise to the term were constituted by a small, globally networked community. This community was connected through things like email lists, del.icio.us bookmarking, Flickr, surf clubs, and, later, Tumblr. It built its own discourse outside of existing institutions and authorial space and unexpectedly distributed that to a mainstream audience. There was a strong sense of community that created for individuals who were participating a degree of personal isolation in their AFK lives. As a result people began to meet up and travel between different spaces. Most of the early postinternet work was done online.

What were the blind spots of postinternet? A misunderstanding that implied horizontalism in communication technologies doesn't equal a complete

shift of power relations. It tried to reinvent the wheel because it wasn't capable of reaching out to the tacit knowledge of previous generations, it rehashed a lot of its ideas and pitfalls, and it created a silo for itself by predicating too much of its discourse on a sociality that was restricted to the filter bubble of post–art school privilege. It rejected the maker movement and sincerity of evolving forms of exchange in the sharing economy or the open source movement—to its own detriment. It mistakenly thought that weak ties were more effective than strong ties in building meaning.

Where did postinternet get lost? The centralization of discourse around a specific term. It got drunk on followers and likes. The material reality of having to feed oneself on a daily basis led to many people taking jobs in existing institutions instead of building their own. Many artists chose to be represented by commercial galleries, therefore re-prioritizing the gallery space, and probably when every art student on the planet started replicating the aesthetics mistakenly tied to the term postinternet, the golden tickets ran out and it was doomed to premature canonization.

So, for a positive spin, what postinternet *could* have meant: It could have stayed true to its roots and built on the idea that the network, constituted by human beings and physical places, was more important than the objects derived from it, thus acting to feed the value created by individuals back into that network. It could have begun to build a formal understanding of what the aesthetics of a network with no single perspective might actually mean.

VAN DEN DORPEL: I like what Ben said about how art works in a network, where the sculpture in the space is documented; it's put online, and somebody might write about it, it might appear elsewhere, and the gallery's just one of the possible manifestations of a work. For every physical thing that you can touch, there exist many other works surrounding it that might not have been physically executed—they're online.

BERRY SLATER: I would say that my very real point of difference or confusion about this second wave of postinternet artists is: Where is the technical specificity? Where is the site-specificity in the work, which as it relates to a global regime, a techno-capitalist regime that is using the internet or digital networks as a way to intensify capitalist processes of reification, to machine subjectification into us, to basically control us through the credit card writ large? The way that those data trails produce individuated identities speaks to the lack of producing commons or resources, or the kind of maker aspect that I detect and think, that's interesting, why is that missing?

RÓZSA FARKAS: I am really interested in the hierarchy of aesthetics and the ways in which artists like Amalia Ulman and Bunny Rogers—who represent a re-crafting or a re-skilling of practice within postinternet art—are adopting them, because, no matter how many images are circulated or how abundant they are, aesthetics still operate in power structures. They're still applied onto really basic things that we should still struggle against, like the power structures around gender and race. If I can see that there are practices emerging where aesthetics in the image or the object still actually do something to shine a light on those power structures, I'm still quite hopeful for the art object still having some political agency.

The reason why I've chosen [to discuss these two artists] is because they relate to what I'm looking at for Post-Media Lab. Specifically, I've been considering their relation to second-wave feminist artists who worked in the '70s, like Faith Ringgold or Miriam Schapiro, who engaged in craft techniques or processes that are traditionally relegated to the decorative arts, simply because of their history as women's art forms. Second-wave feminist artists were really reclaiming these practices in order to highlight gender hierarchies and show that craft practices are also contemporary art practices, which should be slammed onto an arts agenda and not devalued on the basis of gender. I feel that Bunny and Amalia are both operating within a similar paradigm, and where they take it further— where they really kind of forget about Krauss's postmodern expanded field, which Karen discussed earlier—is that they have an online presence through their web-based works. By looking at their work more and more online, you get a real sense of their personal expression, of narrative, and of affect. So instead of them playing within the parameters of what the art object is, it's much more back to what you could term a "re-crafting," where they're adopting a set of processes in which there's actually personal expression going on. That itself is a more potent idea than a simple rejection of the stereotypical postmodern parameters pushing against modernism.

This conversation was part of an ongoing set of discussions conducted over a number of years. For part 1, "Net Aesthetics 2.0 Conversation, New York City, 2006," see page 99. For part 2, "Net Aesthetics 2.0 Conversation, New York City, 2008," see page 285.

NOTES

1. "AFK" is shorthand for "Away from Keyboard."

HERE I AM: TELEPRESENT SUBJECTHOOD IN THE WORK OF LOTTE ROSE KJÆR SKAU

Morgan Quaintance

In 1960, the radical psychiatrist R. D. Laing published *The Divided Self* as a spirited challenge to what he believed were the egregious and inhumane tenets of psychiatric orthodoxy. Influenced by the existential phenomenology of German philosopher Martin Heidegger, Laing proposed that the language of psychiatry used to diagnose and categorize patients suffering from schizophrenia actually exacerbated the condition and caused further fragmentation of an already split consciousness. In such circumstances, aspects of schizophrenia, if not the condition itself, could be considered iatrogenic. Laing's project, then, was to instate a consideration of the patient as a socialized person within the world, not an isolated object with analyzable material properties. That is to say, sufferers of schizophrenia had arrived at their current state through interactions with other persons, primarily family members, but also friends, work colleagues, and acquaintances right on up to the collective manifestations of such interpersonal relations in culture and society.

As part of a comprehensive illustration of this thesis, Laing focused in on the ways individual subjects can lose a fixed grasp on who they feel they are, by swinging too much in one direction between a real and a false self or by feeling they are diminishing or ceasing to exist if they are not perceived by others. He explains in the case of one patient suffering from this "lack of ontological autonomy"[1] that she is "like Tinkerbell"[2] and further that "if she is not in the actual presence of another person who knows her, or if she cannot succeed in evoking this person's presence in his absence, her sense of identity drains away from her."[3] Laing later reinforces this idea with an observation about young children who, fearing disappearance through not being seen, are frightened of sleeping in the dark; he then returns to an analysis of the same ontological insecurity in adults by stating "those people who cannot sustain from within themselves

Lotte Rose Kjær Skau, *United We/I Stand Etc.*
(me_sunflower), 2012 (still). Video, sound, color.
Courtesy the artist and IMT Gallery, London

the sense of their own identity or…have no conviction that they are alive, may
feel that they are real live persons only when they are experienced as such by
another."[4] Laing's view that schizophrenics can feel as if they become someone
through being seen by others, or having the sensation of being seen by virtue of
a seeing technology (the lightbulb for the child) offers another way of thinking
about our information age and telepresence—the condition of being in several
different places and temporalities at once, enabled by broadcast technologies.
By taking Laing's route we can see how the multiple video portraits Lotte Rose
Kjær Skau assembles in "United We/I Stand Etc." (2014) are perhaps not a com-
mentary on a decentered and fragmented postmodern self, but an investigation

of self-actualization and existence in the modern information age through the aggregation of gazes collected in a camera's lens.

This process of self-actualization through the lens comprehensively emerged with the world wide web. Granted, prior to the internet one could record footage of oneself at home and imagine the gaze of some other, or take self-portraits, develop them at the local chemist, and send them to whomever you liked in the post. But there existed no widely available, fast, and easy way to transmit that material, no way to make that imagined viewership a reality—unless you were an internationally recognized artist like, say, Cindy Sherman. The internet changed all of that. It was the apparatus through which you were almost guaranteed an audience of hundreds, thousands, or millions, and web users quickly realized its potential. As such, through the history of online lifecasting, webcasting, and video blogging you can trace the aesthetic development that has led to Kjær Skau's new work. The lo-fi videos in "United We/I Stand etc." feature Kjær Skau running through a set of dancelike movements in a domestic environment, augmented by cute, amateurish graphics that sparkle and shimmer like decorations on a tween's pencil case. But it is the overall image quality that belies the work's debt to the web. Furthermore, the way that her body is framed and her eyes tilt down into what we imagine to be the lens, reveals she is focused on a webcam attached to a computer or a camera positioned in such a way to suggest this is the case. These physical indicators show that action is being directed to a certain technological eye, not a mounted Super 8, Portapak, VHS, or HD camera. They are the hallmarks that separate "United We/I Stand Etc." from pre-internet, body-oriented, and subject-oriented video art by the likes of Hannah Wilke, Joan Jonas, Vito Acconci, or Bruce Nauman. While the innovations of these high-profile, pioneer video artists undoubtedly laid the foundations for Kjær Skau's work, the true precursor, the tradition of representation that "United We/I Stand Etc." engages with, begins with a web-born subculture that emerged in the late 1990s whose members were known as Camgirls.

Before the internet, stereotypical and regressive representations of women were largely seen to be authored by a patriarchal culture industry set up to reinforce the superiority of males and to satisfy the dominant male gaze diffused throughout mainstream media. In her classic essay "Visual Pleasure and Narrative Cinema" (1975), British feminist film theorist Laura Mulvey used psychoanalytical theory to interrogate this tendency as manifest in the representation of women in mainstream Hollywood film. She argued that cinema is a complex system of signification, primarily structured along two lines: "the scopophilic instinct (pleasure in looking at another person as an erotic object) and, in contradistinction, ego libido (forming identification processes) act as formations,

mechanisms, which mould the cinema's formal attributes."[5] In other words, it is the classic psychoanalytic dichotomy of ego-formation, between that which we desire and that which we want to be. Mainstream cinema, for Mulvey, makes sure the male ego is reinforced, and castration anxiety assuaged, by producing imagery that presents females as subservient, passive, and eroticized objects for scopophilic consumption. The arrival of Camgirls problematized all of this.

Camgirls is the name used to refer to women who use webcams from home, or an environment designed to look "like home," to broadcast live and prerecorded footage of themselves online in exchange for money (paid subscriptions), gifts, or capital ultimately accrued through monetized attention (large viewing figures that attract advertisers willing to pay for ad space). It grew out of the practice of female lifecasting—broadcasting twenty-four-hour footage of your life online—that gained notoriety in 1996 when American student Jennifer Ringly set up a desktop camera in her college dorm room and began broadcasting everything via her "Jennicam" website. Ringley's project set the aesthetic and titling standard that others—like anacam, anabellacam, and amandacam[6]— soon followed. Today, with the exponential rise in homecamming fostered by YouTube and the like, the moniker of Camgirl is applied to a wide range of activity from hard-core pornography to pop culture criticism featuring women in domestic environments addressing webcams. For some Camgirls, as explored in Theresa M. Senft's *Camgirls: Celebrity and Community in the Age of Social Networks* (2008), the webcam is seen as a tool for empowerment and not subjugation. There's no patriarchal hand forcing them to engage in whatever activity they choose to do online, and in Aerlyn Weissman's 2003 documentary *Webcam Girls*, American sexologist and former Camgirl Ducky DooLittle maintains "my audience is about half and half. Half male, half female." Nevertheless some form of sexualized display typifies the look of a great number of Camgirls. In fact the wholesale sexualization of women across the web—as sexually explicit pop-ups that appear on peer-to-peer sites, sexually suggestive thumbnails on YouTube, and so on—suggests that passage through a filter of erotic objectification is a prerequisite for women appearing online. The idea is of course that sex sells, but the perennial question is whether the baring of flesh, or the suggestion of sexual availability implicit in the "bored, lonely girl at home with her cam" narrative, actually empowers the Camgirl and uses the viewer she attracts. To put it another way, can the Camgirl's vision of herself as an empowered woman overcome that scopophilic vacuum of the male gaze? Which brings us back to Kjær Skau's exploration of self-actualization.

Kjær Skau has said that "United We/I Stand Etc." is about "investigating socialism/egoism in 2014" and "whether multiple videos/persons will stand

stronger than one." Clearly what constitutes this "socialism/egoism" in 2014 is a mode of being in which one's ontological fixity is determined and cemented by being with others through technology. There is no hint of the subject diminished by telepresence here; in fact it is quite the opposite. By looking at the various incarnations of the artist, in the same way Laing identified with Tinkerbell in Peter Pan, Kjær Skau is viewed into stable existence by the act of looking. In many ways we can take this idea of technology boosting the strength or broadcast volume of one's subjectivity as read today, but there is something else. In addition to an exploration of self-actualization, "United We/I Stand Etc." prompts questions about the status of female representation online, about that tension between empowerment and exploitation.

Speaking on the subject of female emancipation and self-empowerment, Virginia Woolf famously wrote that "a woman must have money and a room of her own if she is to write fiction."[7] It was a consideration framed to explain the necessary conditions for literary pursuits, but it is clear that the practice of writing fiction is also symbolic of general independence. Again, Camgirls seem to problematize that maxim. Here is a subculture enabled by money and a room of one's own, but rather than emancipation through literature or some other intellectual activity, the Camgirl is frequently reduced to the status of an erotic object, among many others, existing to satisfy the scopophilic gaze of a predominantly male viewership. Kjær Skau is no Camgirl, but what is translatable from that realm into the gallery-based situation is that tension between what the subject projects and what the viewer perceives. Laing wrote "within the context of mutual sanity there is, however, quite a wide margin for conflict, error, misconception, in short, for disjunction of one kind or another between the person one is in one's own eyes (one's being-for-oneself) and the person one is in the eyes of the other (one's being-for-the-other)." This symbiotic relationship between socialism and egoism, where the one produces and cultivates the other, functions almost like an algorithm on the web, designed to galvanize the production of subjects online. The great chasm of misunderstanding, for good or ill, comes in the disparity between what is projected out to the world and what everyone else in turn reads. "Here I Am" is what Kjær Skau's work is saying, but what is it that you see?

...

"Here I Am: Telepresent Subjecthood in the Work of Lotte Rose Kjær Skau" by writer Morgan Quaintance was commissioned by London's IMT Gallery (image, music, text) for Danish artist Lotte Rose Kjær Skau's exhibition "United We/I Stand Etc." (2014).

...

NOTES

1. R. D. Laing, *The Divided Self: An Existential Study in Sanity and Madness*, reprint (London: Penguin, 2010), 56.

2. Ibid.

3. Ibid.

4. Ibid.

5. Laura Mulvey, "Visual Pleasure and Narrative Cinema," in *Visual and Other Pleasures*, 2nd ed. (London: Palgrave Macmillan, 2009), 25.

6. Theresa M. Senft, *Camgirls: Celebrity and Community in the Age of Social Networks* (New York: Peter Lang International Academic Publishers, 2008).

7. Virginia Woolf, *A Room of One's Own*, new ed. (London: Penguin Modern Classics, 2000).

INTERNET STATE OF MIND: WHERE CAN MEDIUM SPECIFICITY BE FOUND IN DIGITAL ART?

Domenico Quaranta

POST-INTERNET

It's June 2014. In Beijing, China, the exhibition "Art Post-Internet" closed a couple of weeks ago. Curated by Karen Archey and Robin Peckham, it featured around forty artists of different generations who make art "with a consciousness of the technological and human networks within which it exists, from conception and production to dissemination and reception." The works were collected under the controversial label "post-internet," "one that is as complicated and deeply insufficient as it is useful, and one that rapidly, and perhaps rightfully, came under fire for its opaqueness and proximity to branding."[1] Even if Nicolas Bourriaud today still thinks—as he did in 1998, 2002, and 2009, and again in 2010, as evidenced by an Art Basel panel[2]—that the indirect influence of new technologies on art is more interesting than their actual use as tools, for most artists this very distinction doesn't make sense anymore.

Art takes place in a playground where the internet exists as a component part, as is the case on any other level of our lives. Simply put, the relationship between reality and its online mirror has changed to the point where the real and the digital have merged into a single thing: isn't Google real? It's not a matter of a generational shift from an older generation of artists that looked at the internet as a way to escape the art world and its unique production and distribution medium to a younger generation reconciled with the white cube, which enjoys Photoshop as well as acrylic paint, simulations as well as matter, ethereal codes as well as solid installations. It's rather related to a general shift from modem connection (being online as a conscious choice) to seamless connectivity (being online as a default condition), from geek culture to ubiquitous computing, from small communities to online crowds, from net economy as the "new economy" to the current state of global capitalism.

"Art Post-Internet," 2014. Exhibition view: Ullens
Center for Contemporary Art, Beijing. Courtesy
UCCA. Photo: Eric G. Powell

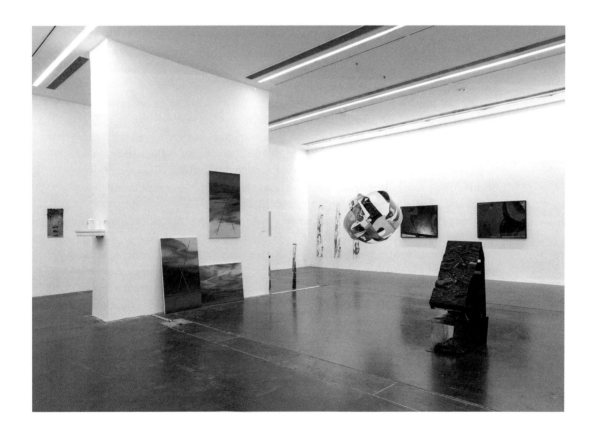

In 2007, artist Olia Lialina made it clear: "Yesterday for me as an artist it made sense only to talk to people in front of their computers, today I can easily imagine to apply to visitors in the gallery because in their majority they will just have gotten up from their computers. They have the necessary experience and understanding of the medium to get the ideas, jokes, enjoy the works and buy them."[3] But today you don't even need to be a net artist or a "new media art curator" to talk about selfies, to appropriate memes, to play with Photoshop filters, to understand Ryan Trecartin's videos, or to make work about online distribution or NSA surveillance. So, has internet art been shot dead by globalized access, smartphones, and social networking? If everybody has joined "an internet state of mind," and if art can flow freely between the networked space and the white cube, does internet art still make any sense? My contention is that, while it's almost impossible to talk about internet art as a discrete category, the use of the internet as a further platform for activity is still absolutely valuable.

EVA AND FRANCO MATTES, FOR EXAMPLE

Mattes_Postmasters

It's June 2014, and "By Everyone, For No One, Everyday," Eva and Franco Mattes's solo exhibition at New York's Postmasters Gallery, will close in a few days. The show has been promoted with a video announcement in which anonymous workers hired through crowdsourcing services are paid to read the press release from their home. Three major recent works are featured: *The Others* (2011), *Emily's Video* (2012), and "Agreements" (2014).

The Others is a long slideshow video displaying ten thousand images and short clips stolen from other people's computers via a file-sharing program. As the video unfolds before our eyes, we get trapped in the stories of these strangers, forgetting about the dubious process utilized to create the slideshow itself and indulging in a form of voyeurism that is becoming extremely familiar as a result of social networking. In the gallery version of *Emily's Video* (a version is also presented online), the artists edit together a series of clips in which people who had responded to an open, anonymous call to watch an "extremely graphic and extremely violent" video are subsequently filmed reacting to the gruesome content.[4] Volunteers had to meet with Emily, the artists' assistant, who would show them the video and then record their reactions. Though the original material was later destroyed, it resurfaces in the final work through the original soundtrack and the traces of pain, disgust, nihilism, and exhibitionism as self-defense that

it generated on the viewers' faces. "Agreements" is a series of versions of existing works made after buying the idea from the original artist through a formal agreement with legal value, released as public domain.[5] Formally speaking, the exhibition features relatively traditional, gallery-friendly formats: video installations, prints, and objects, all elegantly set up in the white cube.

Its online sister project, also titled "By Everyone, For No One, Everyday," includes a series of commissioned performances by anonymous workers whom the artists hired through international crowdsourcing services and to whom the artists then gave basic instructions. The videos are posted on the most obscure, peripheral, forgotten social networks around the world (Blueworld in South Africa, Youku in China, and Livejournal in Russia) and linked to on a Tumblr website.[6]

Over the last sixteen years, Eva and Franco Mattes have developed a consistent, formally eclectic body of work around three main topics, all of which surface in "By Everyone, For No One, Everyday": identity subversion, the relationship between media and reality, and the end of property (both intellectual and personal). This continuity of work across almost two decades—together with their chameleonic ability to keep their language updated while following an inflexible conceptual path—makes their work a perfect case study for understanding how internet-related artistic practices evolved from the early years to the present and whether maintaining online activity and a close proximity to networked cultures and communities while infiltrating the art world is still important or not. So, let's take a short trip through their work following these three main threads.

Eva and Franco Mattes came to prominence in the late '90s under the name 0100101110101101.org with two relevant online projects: *Vaticano.org* (1998) and *Darko Maver* (1998–99). *Vaticano.org* was a one-year-long online performance made by running a fake website of the Holy See. For *Darko Maver*, they bred a fake artist identity, giving him a body of work (derived from images appropriated from trash websites) and a history, and made the art system believe in their concoction. Identity subversion is at the core of "Eva and Franco Mattes aka 0100101110101101.org" as an art project. When they started working as 0100101110101101.org, their "real" identity was a mystery; it was impossible to state whether they were one, ten, or one thousand, whether they were people or bots, Italian, or whatever. When they gave interviews, they always gave fake names. And since they *were* their website, everything they did with it contributed to this opacity.

Mattes_LifeSharing

Not even *Life Sharing*, the experiment in radical transparence that they ran from 2000 to 2003, which gave people complete access to the contents of their computer through their website, was able to shed light on their "real" identity. Still in 2003, when they made *Nikeground*—a performance in Vienna's Karlsplatz square in which they turned public space into commercial space by staging a fake Nike campaign—they appeared as more than two people, wearing Groucho Marx masks to hide their features. Then, they picked two of the many names they used in their past and started using them as their new "brand name."

Gradually, their bodies became more visible and started populating the social web.

Mattes_NoFun

For example, for their series of video-game performances in 2007, they modeled virtual bodies on their real ones; and in *No Fun* (2010), Franco Mattes is hanged in front of a webcam, offering casual public video-chat users the spectacle of his own, feigned death. Today, in June 2014, they even have Facebook accounts. All of this, of course, doesn't make them more transparent: for Eva and Franco Mattes, bodies, just like names and accounts, are masks and puppets belonging to a constructed reality.

More subtly, this concern with identity emerges throughout all of their work. Identity is built from scratch in *Darko Maver* and in *The Others*; it is stolen in *Vaticano.org* and *Nikeground*; pornographically exposed in *Life Sharing*; portrayed in *Portraits* (2006–07), a series of portraits of Second Life avatars; and emulated in *Catt* (2010) and *Rot* (2011), two works successfully attributed to Maurizio Cattelan and Dieter Roth, respectively, and later revealed as fakes. Identity was redirected in *The K Thing* (2001), a simple but effective hack in which artists' names were linked to the wrong online project. Finally, identity was outsourced in *Exhibition Title Change* (2012), in which people were invited to rename the show "Anonymous, untitled, dimensions variable,"[7] and in "By Everyone, For No One, Everyday," for which anonymous workers were invited to act on behalf of the artists. These latter two projects, not coincidentally, featured titles that explicitly refer to their focus on anonymity.

In all these works, different mediums are used to produce an artificial reality. This particular interest in artifice, which Eva and Franco Mattes inherited from Luther Blissett (a seminal experiment from the 1990s in shared identity, multiple names, and media subversion, and one of the duo's first alternate identities),[8] developed over the years as they discovered traditions of pranking, radical entertainment, and media hacking.[9] It ultimately unfolded in their participation in

group projects such as the fake *New York Times* distributed in New York in 2009, bringing us "all the news we hope to print"[10] and inspired a number of projects, including *United We Stand* (2005), a campaign about a nonexistent movie where the EU saves the world from a war between the US and China. More generally speaking, the Matteses, who in 2011 appropriated the title for their exhibition "Lies, Inc."[11] from a Philip K. Dick novel, are constantly and gratuitously profiting from the possibility of intervening in media to reshape their own narrative and fictionalize their career. This is arguably something anyone can do, but artists active online are doing so systematically, and the Matteses are taking it to the extreme, turning it into another level of their work.

Finally, the Matteses' oeuvre can be seen as a systematic, aggressive attack on ideas like privacy and copyright, and their underlying myths of the self and originality. The artists enact a violence that we can accept because it has been directed not only toward the lives and works of others, but also toward themselves. Stealing photographs and videos from other people's computers may be not fair, but it makes sense when done by two people who, for three whole years, allowed anybody full access to their own computer under the claim that "privacy is stupid." This aforementioned project—*Life Sharing*—started in 2001, a time when scrolling through another person's emails was the most radical experience of voyeurism one could have and simply not comparable with the spectacularized, inauthentic sex we could see on the TV show *Big Brother*. Then social networking came along...

Throughout their career, the artists experimented with almost every form of appropriation: from vandalism to analog and digital remix, from forgery to data copy to reenactment, from undisclosed to credited plagiarism, to the recent acquisition of other people's ideas sanctioned by a legal agreement. Most of their works find a less formatted, less visible premise in the work of another artist. They publicly say there's no creativity in their work. Paraphrasing Cory Doctorow, they copy as they breathe.[12] In the video press release of their last show, they ask people to say: "We see so many images online that it's becoming hard to establish if an idea I had is mine or if I saw it on the internet and forgot about it. Sometimes, among them, you see an artwork you wish you had done or you think you had thought." What would be a weakness or a fault in some other artist's work becomes one of their stronger conceptual points. In the Matteses' work, the tradition of copying—from Sturtevant to Negativland to the average Pirate Bay user—finds its ultimate manifestation.

It's June 2014, and at the end of a text—this text—written on Google Docs with an extensive use of CTRL+C, I still have to answer a question: [CTRL+V] If everybody has joined "an internet state of mind" and art can flow freely between the networked space and the white cube, does internet art still make any sense? Yes, it does. It does because the internet remains a sphere where artists can engage a broader, if not bigger, audience in an ongoing dialogue; criticize, subvert, and maybe condition ever evolving techno-social structures; play where the power has moved; and engage contemporaneity in a different way. Art cannot only reflect reality, as a mirror, it also needs to engage reality on its own level, and the internet is, now at this very moment, one of the most relevant levels of the contemporary real. Only a committed community of artists that inhabits the internet with a higher-level of awareness (of its implications in terms of intellectual property, privacy, etc.), not passively living its evolution but actively contributing to it, can do this. They are artists who are not afraid to engage with technicians and hackers, to learn technical skills, to involve other people in their artistic process, to give away for free what they could sell in a gallery, to release works into the public domain—who are deeply aware of the cultural implications of the media.

Examples illuminating how the internet as a platform for art remains valuable may prove useful at this point. Oliver Laric, an Austrian-born artist living in Berlin and active since 2006, provides a particularly topical example. Initially active mostly online, he became a regular presence in commercial galleries, art fairs and, most recently, art auctions with the launch of "Versions" (2009), an ambitious, ongoing project on the collective nature of creativity that was extremely influential in establishing the "post-internet" state of mind. With a series of videos—all versions of the same concept—at its core, "Versions" exploded in a myriad of side developments, including drawings, sculptures, installations, outsourced paintings, print-on-demand publications and so on. What's interesting about Oliver Laric's work is seeing how a profound knowledge of the internet and its dynamics makes it extremely radical and "political," and yet, at that same time, it has also become attractive for the art market and institutions. All of his videos are available in hi-res on his website, and visitors are clearly invited to use them as he used his source material. The strict rules of the art market weren't able to influence his online distribution policy. When invited to take part in BiennaleOnline2013, an online project curated by Jan Hoet and presented as "the first exclusively online biennial exhibition of contemporary art," Laric created *An Incomplete Timeline of Online Exhibitions and Biennials* (2013), a work

that highlights a long list of the efforts made to distribute art on the internet since 1991, thus paying a tribute to the online community and reacting against an attempt to subsume and neutralize this long history.[13]

Laric_3DScan

More notably, in 2013, Laric launched *Lincoln 3D Scans* (2013), a project made in collaboration with the Usher Gallery and The Collection in Lincoln, UK. With this project, which won the Contemporary Art Society's Annual Award for museums, Laric 3-D–scanned all the works from the Collection, making both 3-D prints from the models that could be used by the museum for educational purposes and 3-D models available online for free. Website visitors can download the models and use, modify, and print these models themselves. A gallery of all the user-generated content is available on the website project.[14] With *Lincoln 3D Scans* (2013) and, more recently, with *Yuanmingyuan 3D* (2014)—in which scans of marble columns from the Old Summer Palace in Beijing are made available online for free use[15]—Laric works to actively expand the public domain, promoting a different attitude toward intellectual property and creativity, both on the institutional side and on the user's side.

Another artist actively involved in expanding the public domain is US-born, Paris-based Evan Roth, a cofounder of the Free Art & Technology Lab (F.A.T. Lab), a dispersed collective that publishes all its works online with open licenses. Throughout his career, which has generated an increasing interest among galleries and institutions in recent years, Roth has participated in a number of

Evan Roth, *Portrait of Katsu*, from the "Graffiti Analysis" series, 2013. Sculpture, bronze, 11 ¾ × 25 ¼ × 25 ¼ in (30 × 64 × 64 cm). Courtesy the artist and XPO Gallery. Photo: Vinciane Verguethen

projects based on the development of open-source hardware and software. The most notable example is *Graffiti Markup Language (.gml)*, a universal, XML-based, open-file format designed to store graffiti motion data used by Roth and others to develop a number of side projects that either end up in a gallery—like Roth's *Graffiti Analysis* sculptures—or allow people suffering from Amyotrophic Lateral Sclerosis (ALS) to draw using just their eyes, as in the case of the ongoing collaborative project *EyeWriter*. Roth recently titled a big gallery show "Intellectual Property Donor," borrowing this headline from one of his other projects—a roll of stickers that can be taken and used by anybody. Putting the sticker on the back of your ID card you declare that, in case of death, you will release everything you produced to the public domain. Roth was, of course, the first to add the sticker to his own ID card.[16]

Addie Wagenknecht, an American artist based in Austria who also works with F.A.T. Lab, recently started attracting the interest of the art world with a series of installations using custom-printed circuit boards that intercept and log data from the surroundings. They feature paintings made by drones and sculptures such as *Asymmetric Love* (2013), in which a controversial, functional technology—the surveillance camera—is assembled into an iconic, baroque chandelier. Wagenknecht is also a respected member of the open-hardware community, mainly thanks to the development of *Lasersaur* (2009–12), the world's first open-source, fully functional laser cutter.[17]

These are just a few examples of artists able to balance a presence in the art world and the development of white cube–friendly artworks with a strong online presence, the participation in community projects, and the creation of platforms or tools that can be used by anybody. These artists "use" their gallery

Addie Wagenknecht, *Data and Dragons: Kilohydra*, 2014. Custom-designed PCB boards, ethernet patch cables, 80/20 aluminum installation, 75 × 23 ¾ × 20 in (190.5 × 60.3 × 50.8 cm). Courtesy the artist and bitforms gallery, New York. Photo: Addie Wagenknecht

work as another way to discuss and popularize the issues and concerns they confront in their non-gallery work. They do their best to match an art-oriented audience with a broader, participative audience who can be reached through the internet and other platforms and who is interested in their work not just for the issues it raises, but also for the way it empowers them with a new level of creativity and access. The rather extreme example of Roth is particularly meaningful here. Since 2005, Roth has been making an ongoing effort to keep his website evan-roth.com enlisted as the number-one search result for the term "bad ass mother fucker" on Google's search engine. This performance, which could be easily dismissed as a joke, is instead an attempt to keep in touch with the "bored at work network"[18]—casual internet users who may also include hackers and graffiti writers and other people potentially interested in his work not because it's art, but because it's thoughtful, useful, and open source.

CONCLUSION

It's June 2014, and internet art has become the mutant gene in the DNA of art today. Artists are now well aware that between integration and autonomy there is a third way that would allow art's entire body to evolve in the future; and they are happy to enter museum collections while offering the same work for free download online, to produce commodities while simultaneously enriching the public domain, to exist both in a market economy and a gift economy, to be discussed on *Artforum* as well as 4chan. Internet-related art practices are still in their teens, and teenagers, you know, grow fast and love to change according to their mood. This is why I made any effort to situate this text in the here and now: the year and month in which I'm writing, the computer I'm writing from, the press releases I got via email. My subject is fluid as only strings of digital bits can be, and this text would be completely different, if written two years before, or after.

..

This essay was commissioned in 2014 for the present volume.

..

NOTES

1. From the exhibition press release, available online via e-flux: <http://www.e-flux.com/announcements/art-post-internet/>.

2. I'm here referring to the three main theoretical efforts by French curator Nicolas Bourriaud: *Relational Aesthetics* (Paris: Les presses du réel, 1998); *Post Production. La culture comme scénario: comment l'art reprogramme le monde contemporain* (Paris: Les presses du réel, 2002 / New York: Lukas & Sternberg, 2007); and *The Radicant* (New York: Lukas & Sternberg, 2009). The Art Basel Panel ("Contemporary Art and New Media: Towards a Hybrid Discourse") took place on June 19, 2010. Video documentation is available via YouTube: <http://youtube/9p9VP1r2vc4>.

3. Olia Lialina, "Flat Against the Wall," Teleportacia, 2007, <http://art.teleportacia.org/observation/flat_against_the_wall/>.

4. For more information, see: Eva and Franco Mattes, "Blog friend: time for action!," 0100101110101101.org, July 24, 2012, <http://0100101110101101.org/blog-friend-time-for-action/>.

5. The agreement can be downloaded at: <http://0100101110101101.org/agreements/>.

6. The Tumblr website can be viewed at: <http://befnoed.tumblr.com/>.

7. The exhibition was held at Carroll / Fletcher, London, April 13–May 18, 2012.

8. For more information, see: <http://www.lutherblissett.net/> (which is, incidentally, registered and maintained by Franco Mattes).

9. These are the subjects of the Influencers, a festival co-organized by Eva and Franco Mattes and Bani Brusadin in Barcelona since 2004. For more information, see: <http://theinfluencers.org/>.

10. The *New York Times Special Edition* was released on November 12, 2008, as a collaboration with Steve Lambert and the Yes Men, along with thirty writers, fifty advisors, approximately one thousand volunteer distributors, and various organizations. For more information, see: <http://visitsteve.com/made/the-ny-times-special-edition/>.

11. The exhibition was held at Site Gallery, Sheffield, UK, June 9–July 30, 2011.

12. The reference is to Cory Doctorow's 2011 Siggraph keynote. The transcript is available in: Jason Huff, "We Copy Like We Breathe: Cory Doctorow's SIGGRAPH 2011 Keynote," in Rhizome, Aug. 12, 2011, <http://rhizome.org/editorial/2011/aug/12/cory-doctorows-siggraph-2011-keynote/>.

13. The project is online in Rhizome's ArtBase: <http://archive.rhizome.org/artbase/56398/timeline.html>.

14. The project can be accessed online at: <http://lincoln3dscans.co.uk/>.

15. The project can be accessed online at: <http://yuanmingyuan3d.com/>.

16. All of these projects can be reached through Evan Roth's main website: <http://www.evan-roth.com/>. The exhibition "Intellectual Property Donor" took place at the Ezra and Cecile Zilkha Gallery at Wesleyan University, Middletown, CT, February 5–March 2, 2014.

17. For more information, see: <http://placesiveneverbeen.com/>.

18. The definition was suggested by Jonah Peretti, who later became a founder of *BuzzFeed* and the *Huffington Post*, in the framework of the *Contagious Media Project*, developed at Eyebeam, New York, in 2004 and 2005. For more information, see: <www.contagiousmedia.org/>.

Hito Steyerl

Is the internet dead?[1] This is not a metaphorical question. It does not suggest that the internet is dysfunctional, useless, or out of fashion. It asks what happened to the internet after it stopped being a possibility. The question is very literally whether it is dead, how it died, and whether anyone killed it.

But how could anyone think it could be over? The internet is now more potent than ever. It has not only sparked but fully captured the imagination, attention, and productivity of more people than at any other point. Never before have more people been dependent on, embedded into, surveilled by, and exploited by the web. It seems overwhelming, bedazzling, and without immediate alternative. The internet is probably not dead. It has rather gone all-out. Or more precisely: it is all over!

This implies a spatial dimension, but not as one might think. The internet is not everywhere. Even nowadays when networks seem to multiply exponentially, many people have no access to the internet or don't use it at all. And yet, it is expanding in another direction. It has started moving offline. But how does this work?

Remember the Romanian uprising in 1989, when protesters invaded TV studios to make history?[2] At that moment, images changed their function. Broadcasts from occupied TV studios became active catalysts of events—not records or documents.[3] Since then it has become clear that images are not objective or subjective renditions of a preexisting condition, or merely treacherous appearances. They are rather nodes of energy and matter that migrate across different supports,[4] shaping and affecting people, landscapes, politics, and social systems. They acquired an uncanny ability to proliferate, transform, and activate. Around 1989, television images started walking through screens, right into reality.[5]

This development accelerated when web infrastructure started supplementing TV networks as circuits for image circulation.[6] Suddenly, the points of

Harun Farocki and Andrei Ujica, *Videograms of a Revolution*, 1992 (still). Video, sound, color; 106 min. Courtesy Harun Farocki Studio and Greene Naftali, New York

TOO MUCH WORLD: IS THE INTERNET DEAD?

transfer multiplied. Screens were now ubiquitous, not to speak of images themselves, which could be copied and dispersed at the flick of a finger.

Data, sounds, and images are now routinely transitioning beyond screens into a different state of matter.[7] They surpass the boundaries of data channels and manifest materially. They incarnate as riots or products, as lens flares, highrises, or pixelated tanks. Images become unplugged and unhinged and start crowding off-screen space. They invade cities, transforming spaces into sites, and reality into realty. They materialize as junkspace, military invasion, and botched plastic surgery. They spread through and beyond networks, they contract and expand, they stall and stumble, they vie, they vile, they wow and woo.

Just look around you: Artificial islands mimic genetically manipulated plants. Dental offices parade as car commercial film sets. Cheekbones are airbrushed just as whole cities pretend to be YouTube CAD tutorials. Artworks are emailed to pop up in bank lobbies designed on fighter-jet software. Huge cloud storage drives rain down as skylines in desert locations. But by becoming real, most images are substantially altered. They get translated, twisted, bruised, and reconfigured. They change their outlook, entourage, and spin. A nail paint clip turns into an Instagram riot. An upload comes down as a shitstorm. An animated GIF materializes as a pop-up airport transit gate. In some places, it seems as if entire NSA system architectures were built—but only after Google-translating them, creating car lofts where one-way mirror windows face inwards. By walking off-screen, images are twisted, dilapidated, incorporated, and reshuffled. They miss their targets, misunderstand their purpose, get shapes and colors wrong. They walk through, fall off, and fade back into screens.

Grace Jones's 2008 black-and-white video clip *Corporate Cannibal*, described by Steven Shaviro as a pivotal example of post-cinematic affect, is a case in point.[8] By now, the nonchalant fluidity and modulation of Jones's posthuman figure has been implemented as a blueprint for austerity infrastructure. I could swear that Berlin bus schedules are consistently run on this model—endlessly stretching and straining space, time, and human patience. Cinema's debris rematerializes as investment ruins or secret "Information Dominance Centers."[9] But if cinema has exploded into the world to become partly real, one also has to accept that it actually did explode. And it probably didn't make it through this explosion either.

POST-CINEMA

For a long time, many people have felt that cinema is rather lifeless. Cinema today is above all a stimulus package to buy new televisions, home projector systems, and retina display iPads. It long ago became a platform to sell franchising products—screening feature-length versions of future PlayStation games in sanitized multiplexes. It became a training tool for what Thomas Elsaesser calls the military-industrial-entertainment complex.

Everybody has his or her own version of when and how cinema died, but I personally believe it was hit by shrapnel when, in the course of the Bosnian War, a small cinema in Jajce was destroyed around 1993. This was where the Federal Republic of Yugoslavia was founded during World War II by the Anti-Fascist Council for the National Liberation of Yugoslavia (AVNOJ). I am sure that cinema was hit in many other places and times as well. It was shot, executed, starved, and kidnapped in Lebanon and Algeria, in Chechnya and the DRC, as well as in many other post–Cold War conflicts. It didn't just withdraw and become unavailable, as Jalal Toufic wrote of artworks after what he calls a surpassing disaster.[10] It was killed, or at least it fell into a permanent coma.

But let's come back to the question we began with. In the past few years many people—basically everybody—have noticed that the internet feels awkward, too. It is obviously completely surveilled, monopolized, and sanitized by common sense, copyright, control, and conformism. It feels as vibrant as a newly multiplexed cinema in the '90s showing endless reruns of *Star Wars Episode 1*. Was the internet shot by a sniper in Syria, a drone in Pakistan, or a tear gas grenade in Turkey? Is it in a hospital in Port Said with a bullet in its head? Did it commit suicide by jumping out the window of an Information Dominance Center? But there are no windows in this kind of structure. And there are no walls. The internet is not dead. It is undead and it's everywhere.

I AM A MINECRAFT REDSTONE COMPUTER

So what does it mean if the internet has moved offline? It crossed the screen, multiplied displays, transcended networks and cables to be at once inert and inevitable. One could imagine shutting down all online access or user activity. We might be unplugged, but this doesn't mean we're off the hook. The internet persists offline as a mode of life, surveillance, production, and organization—a form of intense voyeurism coupled with maximum nontransparency. Imagine

an internet of things all senselessly "liking" each other, reinforcing the rule of a few quasi-monopolies. A world of privatized knowledge patrolled and defended by rating agencies. Of maximum control coupled with intense conformism, where intelligent cars do grocery shopping until a Hellfire missile comes crashing down. Police come knocking on your door for a download—to arrest you after "identifying" you on YouTube or CCTV. They threaten to jail you for spreading publicly funded knowledge? Or maybe beg you to knock down Twitter to stop an insurgency? Shake their hands and invite them in. They are today's internet in 4-D.

The all-out internet condition is not an interface but an environment. Older media as well as imaged people, imaged structures, and image objects are embedded into networked matter. Networked space is itself a medium, or whatever one might call a medium's promiscuous, posthumous state today. It is a form of life (and death) that contains, sublates, and archives all previous forms of media. In this fluid media space, images and sounds morph across different bodies and carriers, acquiring more and more glitches and bruises along the way. Moreover, it is not only form that migrates across screens, but also function.[11] Computation and connectivity permeate matter and render it as raw material for algorithmic prediction, or potentially also as building blocks for alternate networks. As Minecraft Redstone computers[12] are able to use virtual minerals for calculating operations, so is living and dead material increasingly integrated with cloud performance, slowly turning the world into a multilayered motherboard.[13]

But this space is also a sphere of liquidity, of looming rainstorms and unstable climates. It is the realm of complexity gone haywire, spinning strange feedback loops. A condition partly created by humans but also only partly controlled by them, indifferent to anything but movement, energy, rhythm, and complication. It is the space of the rōnin of old, the masterless samurai freelancers fittingly called wave men and women: floaters in a fleeting world of images, interns in dark net soap lands. We thought it was a plumbing system, so how did this tsunami creep up in my sink? How is this algorithm drying up this rice paddy? And how many workers are desperately clambering on the menacing cloud that hovers in the distance right now, trying to squeeze out a living, groping through a fog that may at any second transform both into an immersive art installation and a demonstration doused in cutting-edge tear gas?

POSTPRODUCTION

But if images start pouring across screens and invading subject and object matter, the major and quite overlooked consequence is that reality now widely consists of images; or rather, of things, constellations, and processes formerly evident as images. This means one cannot understand reality without understanding cinema, photography, 3-D modeling, animation, or other forms of moving or still image. The world is imbued with the shrapnel of former images, as well as images edited, Photoshopped, cobbled together from spam and scrap. Reality itself is postproduced and scripted, affect rendered as aftereffect. Far from being opposites across an unbridgeable chasm, image and world are in many cases just versions of each other.[14] They are not equivalents, however, but deficient, excessive, and uneven in relation to each other. And the gap between them gives way to speculation and intense anxiety.

Under these conditions, production morphs into postproduction, meaning the world can be understood but also altered by its tools. The tools of postproduction: editing, color correction, filtering, cutting, and so on are not aimed at achieving representation. They have become means of creation, not only of images but also of the world in their wake. One possible reason: with digital proliferation of all sorts of imagery, suddenly too much world became available. The map, to use the well-known fable by Jorge Luis Borges, has not only become equal to the world, but exceeds it by far.[15] A vast quantity of images covers the surface of the world—very much so in the case of aerial imaging—in a confusing stack of layers. The map explodes on a material territory, which is increasingly fragmented and also gets entangled with it: in one instance, Google Maps cartography led to near military conflict.[16]

While Borges wagered that the map might wither away, Jean Baudrillard speculated that, on the contrary, reality was disintegrating.[17] In fact, *both* proliferate and confuse one another: on handheld devices, at checkpoints, and in between edits. Map and territory reach into each other to realize strokes on trackpads as theme parks or apartheid architecture. Image layers get stuck as geological strata while SWAT teams patrol Amazon shopping carts. The point is that no one can deal with this. This extensive and exhausting mess needs to be edited down in real time: filtered, scanned, sorted, and selected—into so many Wikipedia versions, into layered, libidinal, logistical, lopsided geographies.

This assigns a new role to image production and, as a consequence, to people who handle it. Image workers now deal directly in a world made of images and can do so much faster than previously possible. But production has also become mixed up with circulation to the point of being indistinguishable: the factory/

studio/Tumblr blur with online shopping, oligarch collections, realty branding, and surveillance architecture. Today's workplace could turn out to be a rogue algorithm commandeering your hard drive, eyeballs, and dreams. And tomorrow you might have to disco all the way to insanity.

As the web spills over into a different dimension, image production moves way beyond the confines of specialized fields. It becomes mass postproduction in an age of crowd creativity. Today, almost everyone is an artist. We are pitching, phishing, spamming, chain-liking, or mansplaining. We are twitching, tweeting, and toasting as some form of solo relational art, high on dual processing and a smartphone flat rate. Image circulation today works by pimping pixels in orbit via strategic sharing of wacky, neo-tribal, and mostly US-American content. Improbable objects, celebrity cat GIFs, and a jumble of unseen anonymous images proliferate and waft through human bodies via Wi-Fi. One could perhaps think of the results as a new and vital form of folk art, that is, if one is prepared to completely overhaul one's definition of folk as well as art. A new form of storytelling using emojis and tweeted rape threats is both creating and tearing apart communities loosely linked by shared attention deficit.

CIRCULATIONISM

But these things are not as new as they seem. What the Soviet avant-garde of the twentieth century called productivism—the claim that art should enter production and the factory—could now be replaced by circulationism. Circulationism is not about the art of making an image, but of postproducing, launching, and accelerating it. It is about the public relations of images across social networks, about advertisement and alienation, and about being as suavely vacuous as possible.

But remember how productivists Mayakovsky and Rodchenko created billboards for NEP sweets? Communists eagerly engaging with commodity fetishism?[18] Crucially, circulationism, if reinvented, could also be about short-circuiting existing networks, circumventing and bypassing corporate friendship and hardware monopolies. It could become the art of recoding or rewiring the system by exposing state scopophilia, capital compliance, and wholesale surveillance. Of course, it might also just go as wrong as its predecessor, by aligning itself with a Stalinist cult of productivity, acceleration, and heroic exhaustion. Historic productivism was—let's face it—totally ineffective and defeated by an overwhelming bureaucratic apparatus of surveillance/workfare early on. And it is quite likely that circulationism—instead of restructuring circulation—will just end

up as ornament to an internet that looks increasingly like a mall filled with nothing but Starbucks franchises personally managed by Joseph Stalin.

Will circulationism alter reality's hardware and software—its affects, drives, and processes? While productivism left few traces in a dictatorship sustained by the cult of labor, could circulationism change a condition in which eyeballs, sleeplessness, and exposure are an algorithmic factory? Are circulationism's Stakhanovites working in Bangladeshi like-farms,[19] or mining virtual gold in Chinese prison camps,[20] churning out corporate consent on digital conveyor belts?

OPEN ACCESS

But here is the ultimate consequence of the internet moving offline.[21] If images can be shared and circulated, why can't everything else be too? If data moves across screens, so can its material incarnations move across shop windows and other enclosures. If copyright can be dodged and called into question, why can't private property? If one can share a restaurant dish JPEG on Facebook, why not the real meal? Why not apply fair use to space, parks, and swimming pools?[22] Why only claim open access to JSTOR and not MIT—or any school, hospital, or university for that matter? Why shouldn't data clouds discharge as storming supermarkets?[23] Why not open-source water, energy, and Dom Pérignon champagne?

If circulationism is to mean anything, it has to move into the world of offline distribution, of 3-D dissemination of resources, of music, land, and inspiration. Why not slowly withdraw from an undead internet to build a few others next to it?

..

"Too Much World: Is the Internet Dead?" by artist and theorist Hito Steyerl was first published in *e-flux journal* in 2013.

..

NOTES

1. This is what the term "postinternet," coined a few years ago by Marisa Olson and subsequently Gene McHugh, seemed to suggest while it had undeniable use value as opposed to being left with the increasingly privatized exchange value it has at this moment.

2. For more information, see: Peter Weibel, "Medien als Maske: Videokratie," in *Von der Bürokratie zur Telekratie. Rumänien im Fernsehen*, ed. Keiko Sei (Berlin: Merve, 1990), 124–49, 134f.

3. Cătălin Gheorghe, "The Juridical Rewriting of History," in *Trial/Proces*, ed. Cătălin Gheorghe (Iaşi: Universitatea de Arte "George Enescu" Iaşi, 2012), 2–4.

4. Ceci Moss and Tim Steer in a stunning exhibition announcement for "Motion" at Seventeen Gallery in 2012: "The object that exists in motion spans different points, relations and existences but always remains the same thing. Like the digital file, the bootlegged copy, the icon, or Capital, it reproduces, travels and accelerates, constantly negotiating the different supports that enable its movement. As it occupies these different spaces and forms it is always reconstituting itself. It doesn't have an autonomous singular existence; it is only ever activated within the network of nodes and channels of transportation. Both a distributed process and an independent occurrence, it is like an expanded object ceaselessly circulating, assembling and dispersing. To stop it would mean to break the whole process, infrastructure or chain that propagates and reproduces it."

5. This is one instance of a wider political phenomenon called "transition." Coined for political situations in Latin America and then applied to Eastern European contexts after 1989, this notion describes a teleological process consisting of an impossible catch-up of countries "belatedly" trying to achieve democracy and free-market economies. Transition implies a continuous morphing process, which in theory would make any place ultimately look like the ego ideal of any default Western nation. As a result, whole regions were subjected to radical makeovers. In practice, transition usually meant rampant expropriation coupled with a radical decrease in life expectancy. In transition, a bright neoliberal future marched off the screen to be realized as a lack of health care coupled with personal bankruptcy, while Western banks and insurance companies not only privatized pensions, but also reinvested them in contemporary art collections.

6. Images migrating across different supports are of course nothing new. This process has been apparent in art-making since the Stone Age. But the ease with which many images morph into the third dimension is a far cry from ages when a sketch had to be carved into marble manually. In the age of postproduction, almost everything made has been created by means of one or more images, and any Ikea table is copied and pasted rather than mounted or built.

7. The *New Aesthetic* Tumblr has brilliantly demonstrated this for things and landscapes, as the *Women as Objects* Tumblr has illustrated the incarnation of image as female body. Equally relevant on this point is work by Jesse Darling and Jennifer Chan.

8. See Steven Shaviro's wonderful analysis in "Post-Cinematic Affect: On Grace Jones, Boarding Gate and Southland Tales," *Film-Philosophy* 14.1 (2010): 1–102. See also his book *Post-Cinematic Affect* (London: Zero Books, 2010).

9. Greg Allen, "The Enterprise School," *Greg.org*, Sept. 13, 2013, <http://greg.org/archive /2013/09/13/the_enterprise_school.html>.

10. Jalal Toufic, *The Withdrawal of Tradition Past a Surpassing Catastrophe* (Forthcoming Books, 2009).

11. "The Cloud, the State, and the Stack: Metahaven in Conversation with Benjamin Bratton," *Metahaven*, <http://mthvn.tumblr.com/post/38098461078/thecloudthestateandthestack>.

12. Thanks to Josh Crowe for drawing my attention to this.

13. "The Cloud, the State, and the Stack: Metahaven in Conversation with Benjamin Bratton."

14. See: Oliver Laric, "Versions," 2012.

15. Jorge Luis Borges, "On Exactitude in Science," in *Collected Fictions*, trans. Andrew Hurley (New York: Penguin, 1999), 325. "'In that Empire, the Art of Cartography attained such Perfection that the map of a single Province occupied the entirety of a City, and the map of the Empire, the entirety of a Province. In time, those Unconscionable Maps no longer satisfied, and the Cartographers Guilds struck a Map of the Empire whose size was that of the Empire, and which coincided point for point with it. The following Generations, who were not so fond of the Study of Cartography as their Forebears had been, saw that that vast Map was Useless, and not without some Pitilessness was it, that they delivered it up to the Inclemencies of Sun and Winters. In the Deserts of the West, still today, there are Tattered Ruins of that Map, inhabited by Animals and Beggars; in all the Land there is no other Relic of the Disciplines of Geography.' —Suárez Miranda, *Viajes de varones prudentes*, Libro IV, Cap. XLV, Lérida, 1658."

16. L. Arlas, "Verbal spat between Costa Rica, Nicaragua continues," *Tico Times*, Sept. 20, 2013, <http://www.ticotimes.net/2013/09/20/verbal-spat-between-costa-rica-nicaragua -continues>. Thanks to Kevan Jenson for mentioning this to me.

17. Jean Baudrillard, "Simulacra and Simulations," in *Jean Baudrillard: Selected Writings*, ed. Mark Poster (Stanford: Stanford University Press, 1988), 166–84.

18. Christina Kiaer, "'Into Production!': The Socialist Objects of Russian Constructivism," *Transversal*, Sept. 2010, <http://eipcp.net/transversal/0910/kiaer/en>. "Mayakovsky's advertising jingles address working-class Soviet consumers directly and without irony; for example, an ad for one of the products of Mossel'prom, the state agricultural trust, reads: 'Cooking oil. Attention working masses. Three times cheaper than butter! More nutritious than other oils! Nowhere else but Mossel'prom.' It is not surprising that Constructivist advertisements would speak in a pro-Bolshevik, anti-NEP-business language, yet the picture of the *Reklam-Konstruktor* advertising business is more complicated. Many of their commercial graphics move beyond this straightforward language of class difference and utilitarian need to offer a *theory* of the socialist object. In contrast to Brik's claim that in this kind of work they are merely 'biding their time,' I propose that their advertisements attempt to work out the relation between the material cultures of the prerevolutionary past, the NEP present and the socialist *novyi byt* of the future with theoretical rigor. They confront the question that arises out of the theory of Boris Arvatov: What happens to the individual fantasies and desires organized under capitalism by the commodity fetish and the market, after the revolution?"

19. Charles Arthur, "How low-paid workers at 'click farms' create appearance of online popularity," *Guardian*, Aug. 2, 2013, <http://www.theguardian.com/technology/2013/aug/02/click-farms-appearance-online-popularity>.

20. Harry Sanderson, "Human Resolution," *Mute*, April 4, 2013, <http://www.metamute.org/editorial/articles/human-resolution>.

21. And it is absolutely not getting stuck with data-derived sculptures exhibited in white cube galleries.

22. "Spanish workers occupy a Duke's estate and turn it into a farm," *Libcom.org*, Aug. 24, 2012, <https://libcom.org/blog/spanish-workers-occupy-duke%E2%80%99s-estate-turn-it-farm-24082012>. "Earlier this week in Andalusia, hundreds of unemployed farmworkers broke through a fence that surrounded an estate owned by the Duke of Segorbe, and claimed it as their own. This is the latest in a series of farm occupations across the region within the last month. Their aim is to create a communal agricultural project - similar to other occupied farms, in order to and [*sic*] breathe new life into a region that has an unemployment rate of over 40%. Addressing the occupiers, Diego Canamero, a member of the Andalusian Union of Workers, said that: Quote: 'We're here to denounce a social class who leave such a place to waste.' The lavish well-kept gardens, house, and pool are left empty, as the Duke lives in Seville, more than 60 miles away."

23. Thomas J. Michalak, "Mayor in Spain leads food raids for the people," *Workers World*, Aug. 24, 2012, <http://www.workers.org/articles/2012/08/24/mayor-in-spain-leads-food-raids-for-the-people/>. "In the small Spanish town of Marinaleda, located in the southern region of Andalusía, Mayor Juan Manuel Sánchez Gordillo has an answer for the country's economic crisis and the hunger that comes with it: He organized and led the town's residents to raid supermarkets to get the food necessary to survive."

BODIES IN SPACE: IDENTITY, SEXUALITY, AND THE ABSTRACTION OF THE DIGITAL AND PHYSICAL

Karen Archey

Postinternet promised, albeit with much confusion, an analysis of our contemporary condition, which supposedly is indelibly and foremost influenced by the advent of advanced technology.[1] While much knowledge has been generated by postinternet pursuits, it has become increasingly clear, via the popularity of the Occupy Wall Street movement in 2011 and projects such as Andrea Fraser's manifesto on income disparity and its effects on the art world, "L'1%, C'EST MOI" (2012), that the advance of technology may not be the overarching narrative through which we should understand our contemporary condition. In light of several factors, such as growing income disparity and the art market's remarkable bloat, it seems clear that a more complex framing needs to be utilized, one that looks at the intersection of both technology and late capitalism run amok.

One of the great failures of postinternet is its dogmatism toward conventional modes of authorship (the objective, intellectual auteur) and the aesthetics paired with it (often described as trendy and unrelated to the subject matter at hand), which seems cognitively dissonant with the internet's cultural democratization that it seeks to address. We see a surfeit of artwork dealing with theoretical themes such as artwork documentation, new philosophies such as speculative realism,[2] and the ever-loved topic of image circulation, yet none of these directly addresses our lived experience, which is increasingly ineffable amid global economic and political turmoil. While artists are increasingly gripped by the imaginary vision of a posthuman body, artistic discourse surrounding identity, the body, and sexuality has been almost completely elided.

This text, organized in three parts and guided by the work of artists, acts as a historical corrective to shed light on such discourse. Titled "Bodies in Space," it considers how the body is mediated by both virtual and physical space. The first section, "Radical Identification: The Body Online," is guided in part by a reading

of Laura Mulvey's "Visual Pleasure and Narrative Cinema" (1975) and convenes artists who seek radical sources of personal or sexual identification in the internet age: Bunny Rogers's self-portraits as a mop or a cat urn, Ann Hirsch's retelling of her preteen online relationship with an older man, or Laurie Simmons's photographs of the "doller" subculture. The second section, "The Body in Public," focuses on the organization of the body in public space and examines Magali Reus's custom-produced stadium seating, Alice Channer's floppy clothing cast in aluminum, and Nicolas Deshayes's slightly skewed public interior architecture. Lastly, the work of AIDS-3D, which often considers how corporate studies affect interior architecture (such as buffet sneeze guards), leads into the text's final section, "Corporate Bodies," which considers more directly the dissolving of offline and online binaries via a reading of Tiziana Terranova's 2004 book *Network Culture: Politics for the Information Age*, proffering instead the idea that information embodies most everything around us, and that offline/online binaries seem redundant in an age in which everything can be seen as a product of data.

RADICAL IDENTIFICATION: THE BODY ONLINE

One of the most dramatic developments in the nature of social interaction since the advent of the internet is the emancipation of our identities and sexual lives from the body and "meatspace" interaction. We are no longer bound to our own bodies and the social encryptions that they carry while we socialize, and we no longer must seek out sexual or romantic partners in physical spaces dedicated to such meetings. We can see the effects of this emancipation from our physical nature perhaps most clearly in hook-up culture: while geographic "cruising zones" still exist (bars, parks, and the like), they're no longer the only way in which we find partners—these sites streamlining such encounters via searchable terms ("SWM ISO SWF,"[3] "uncut," "drug and disease free," "420 friendly," etc.). While Craigslist and, later, smart phone applications such as Tinder and Grindr are but three obvious meeting points for no-strings-attached sex, other web platforms such as Tumblr and YouTube have become host to lesser-known communities of sexual fetishists. These fetishes, oftentimes extremely strange to the heteronormative orthodox and sometimes quite niche, are amplified by the privacy of and supported by the blank slate of the internet. Fetishes range from just about anything to just about anything—furries, wet clothes, celebrity feet, and so on and so forth. The tendency to make fetishistic porn out of everything is so

pervasive online that the notorious 4chan "Random" message board /b/ wrote in their "Rules of the Internet" that "34: If it exists, there is porn of it. No exceptions"; "35: If no porn is found of it, it will be created"; and "36: No matter what it is, it is somebody's fetish. No exceptions."[4]

The videos of Glasgow-based Charlotte Prodger track this march from the geographic cruising zone to online fetish community. She rips footage from a YouTube account that records ritualistic acts imposed upon collectable Nike sneakers that embody the very definition of commodity fetishism. Prodger's videos are overlaid with both audio recitations of comments received by the YouTube user, who goes by the very apropos name NikeClassics, as well as queer diaristic passages chosen by the artist. In one video, we see only the torso and legs of a young man as he dissects collectible sneakers, cutting them in half and ripping off layers of leather. In another video, two young men in track pants exchange their sneakers back and forth. As the men continue to occupy each other's respective negative spaces with their feet, the actions become an analogue for sex. It is apparent that the viewing, in addition to the production, of such videos is sexually enticing for some, and even constitutes a supportive community of video producers and viewers. This is evidenced by a comment left on NikeClassics's video by the YouTube user "Wetrev," apparently a wet-clothes fetishist: "Should both play in the mud or water in those nikes and trackies too— squash each others nikes into the water."

Though Laurie Simmons is largely known for her photographs of dolls and the cultural assumptions about femininity and domesticity that we project onto them, she has recently produced work tracking the advent of the "doller" cosplay subculture.[5] Here's where things get a little hairy if you're unfamiliar with the rabbit hole of cosplay, itself a portmanteau of "costume play." The Japanese term *kigurumi* describes a person dressed in a full-body costume of a cartoon character or animal. "Dollers" wear latex *kigurumi* masks emulating female anime characters. To be a proper doller, you must wear a *kigurumi* doll mask with a full-body latex suit in order to adequately mirror the matte quality of a cartoon character's skin. Simmons purchased several *kigurumi* masks intricately painted by an artist in Russia and cast models to wear them, latex suit and all, in variably sexualized poses. *Redhead/Pink & Black Outfit/Orange Room* (2014) captures a doller wearing heels, pink thigh-high socks, and a miniskirt while tugging down a pink shirt and gazing into the camera. The photograph *Blonde/Acqua Sweater/ Dog* (2014) depicts a blond doller holding, in a bathtub, a skeptical-looking dog, while another, *Purple Hair/Purple Coat/Snow* (2014), shows a darker-skinned *kigurumi* taking a selfie. Given our growing predilection for finding sex and love online, and the increasingly niche forms that sexuality has taken since fetishes

have become indexible and searchable, Simmons's interest in such an online subculture seems a prescient front. Those at odds with culturally determined ideas about normativity once sought to alleviate their frustrations in physical spaces—the cruising park. Simmons's photographs reiterate the weirdly beautiful agency in such subcultures and the tragedy of the repressive cultural conditions that precipitate them.

Performance artist Ann Hirsch looks not to fetish subcultures but to the early days of web chat circa 1998, where conversing with strangers was the rule, not the exception. Her piece *Playground* (2013) is a play with two characters: Anni, who is mostly autobiographical and based on a plucky twelve-year-old Hirsch, and Jobe, a twenty-seven-year-old hacker who has a penchant for chatting up preteens online. The play begins with Anni and Jobe sitting at their respective chipboard desktop workstations, enraptured by the chat playing out on their respective chunky monitors—a nostalgic mise-en-scène for anyone born pre-Y2K. Their conversation, projected behind them for the audience to read, revolves around their chosen chat room politics and quickly takes on a creepy tone, with Jobe asking Anni to be his online girlfriend. This honorific comes with probing sexual questions and a masturbation coaching session through the telephone, with Anni lying and hilariously faking orgasm. "lieshadow: Did you cum, Anni? / XoaNNioX: yes did u? / lieshadow: Yes, I came for you. / XoaN-NioX: me 2 / lieshadow: You did so good Anni. I'm so proud of you. / XoaNNioX: me 2. im proud of me too / lieshadow: Are you being facetious with me? / XoaN-NioX: noo. / XoaNNioX: well I dunno. whatz facetious?"[6] Anni and Jobe waver between breaking up and getting back together. Anni begins to doubt Jobe after

Laurie Simmons, *Yellow Hair/Red Coat/Snow/Selfie*, 2014. Pigment print, 28 ¾ × 20 in (73 × 50.8 cm). Courtesy the artist and Salon94, New York

he asks her to stick a pen up her vagina and send it to him in the mail, and his subsequent desperate, last-ditch request for soiled underwear prompts Anni to formally dump Jobe. After a brief break, they get back together, hugging and declaring their eternal love for each other, as the play ends. While Hirsch's two-hander represents an obvious case of sexual abuse to the audience, such is not the case in the eyes of Anni herself, who desired a romantic relationship and was unwittingly manipulated by an older man. The play importantly casts light on those early, yet-to-be processed days in which we were still getting to know the internet, and how many men and women had their first romantic and sexual experiences online.

Slightly younger than Hirsch, the artist Bunny Rogers came of age in a time when both television and the web capitalized on programs and websites for kids. Like many digital natives, hers is an identity formed amid the blooming mass media of the early '00s. It could be argued that those who have grown up since this era experience identification processes via both television and computer screens, which introduce increasingly more remote content (say, a cartoon clone of Joan of Arc) upon which a child may project identification. Rogers has illustrated this phenomenon of elastic identity via her various self-portraits as inanimate (often lugubrious) objects: a mop dyed purple and festooned with ribbon (*Self-Portrait [Mourning Mop]* [2013]), a handmade ceramic urn with the image of a cat on its front (*Self Portrait [Cat Urn]* [2013]). Similarly, she has a penchant for all things "goth"—both the mass-produced Hot Topic and seriously antisocial varieties. For a recent body of work titled "Columbine Library," shown at Société in Berlin in the summer of 2014, Rogers took inspiration from the 1999 Columbine High School massacre, using two mainstream goth cartoon characters as stand-ins for the shooters' identities: Joan of Arc of Clone High representing Dylan Klebold and Gaz of Invader Zim representing Eric Harris. That Rogers assigns these twee-goth cartoon characters as avatars for the seriously deranged shooters is another exercise in such elasticity of identification, this one specifically speaking to a personally felt sense of social alienation that vacillates between the pop and the psychotic. Rogers is not alone in identifying with Klebold and Harris, as we see countless online communities dedicated to them and other unlikely heroes.

One may wonder how it is possible to both forget the cruelty of the shooters and to depersonalize the victims of the Columbine massacre to such an extent that entire communities valorize its perpetrators. To better understand the collective identification with the shooters, let's consider Laura Mulvey's take on active scopophilia in cinema within her landmark 1975 essay "Visual Pleasure and Narrative Cinema" and recontextualize it for the web. She writes:

The mass of mainstream film…portray[s] a hermetically sealed world which unwinds magically…producing [for the audience members] a sense of separation and playing on their voyeuristic phantasy. Moreover, the extreme contrast between the darkness in the auditorium (which also isolates the spectators from one another) and the brilliance of the shifting patterns of light and shade on the screen helps to promote the illusion of voyeuristic separation…these conditions giving the spectator an illusion of looking in on a private world.[7]

Think about the subject of this passage not in a theater, but sitting at his or her private desk, staring into the alternate world of Facebook, a chat room, Tumblr, or a role-playing game. "[Scopophilic pleasurable structures must] be attached to an idealization [and] pursue aims in indifference to perceptual reality," she continues, "creating the imagized, eroticized concept of the world that forms the perception of the subject and makes a mockery of empirical objectivity."[8] That is to say, the physical separation of the body from the screen begets a psychological separation between the ego and the screen's subject, allowing the ego's ideal version of the world to manifest, leading to this break with reality. Yet, given the somewhat active, rather than passive, nature of online participation, this world can further be reaffirmed and constructed via involvement in online echo chambers such as Google-indexed online communities (e.g., Men's Rights forums, which Elliot Rodger frequented[9]), role-playing games, or even Facebook. Consider the algorithmic EdgeRank system that Facebook employs in determining what posts show up in a user's feed (simplified here): the more frequently User A clicks on or comments on User B's posts, the more User A will see posted information by User B. Further, should User A have an abundance of friends all creating "edges" with a User C, the more User A and associated users will see User C's posts.[10] Thus, through click-tracking, Facebook effectively creates an echo system tailored to whatever and whoever incites users' feelings most ardently, including and not including peripheral voices based on their proclivity to manipulate this system.

One need only look to World of Warcraft to witness an idealized world created via the egos of its players. World of Warcraft is an extremely successful "massively multiplayer online role-playing game" (MMPORG) that celebrated its tenth birthday in November 2014. According to Wikipedia, World of Warcraft has grossed over ten billion dollars as of July 2012, with over one hundred million accounts registered over its lifetime. Its users, who pay a monthly subscription fee to play, are also predominately male. The artist Angela Washko, who has been playing World of Warcraft since 2006, quickly noticed rampant misogyny,

heightened male-gendered language, and a dearth of female players—males of-
tentimes play female characters. In early 2012, Washko founded "The Council
on Gender Sensitivity and Behavioral Awareness in World of Warcraft" as an
intervention within the game. As part of this intervention, Washko approaches
various characters and asks, via the game's chat function, what he or she thinks
of the term "feminism," which she then screen records or captures and uploads
to her Tumblr. She also asks the players about their professional and economic
backgrounds, which are surprisingly disparate. The artist has spoken to the un-
employed, pregnant teens, doctors, lawyers, paraplegics, angsty kids, and so on.
As most participants are earnestly interested, Washko's project surveys a likely
more diverse pool than, say, an art world panel on feminism. She, of course, gets
quite a few off-color comments. Upon asking a male person why he was playing
a female character, he said, "I'd rather stare at a girl's ass all day than a guy's," as
if it were inherently homosexual to play a male character. Again channeling Mul-
vey, Washko noted to me in a recent conversation that this is a classic fantasy of
the ideal female projected onto the female on screen. When asked why this mi-
sogynistic behavior is so rampant online, Washko replied that she thought that,
because there's no body-to-body public accountability in online space, such com-
munities act as a "moral free" safe zone through which we can act out our base de-
sires with no consequences—in other words, it's a playground for scopophilia.[11]

THE BODY IN PUBLIC[12]

Perhaps the most redundant platitude in both media studies and art writing is
that advanced technology has so sped up our quotidian chronologies that we
"can't keep up" or are inundated by media with harrying, damaging persistence.[13]
So much art that consciously relates to technology is unfortunately contextual-
ized with this dogmatic, if not completely false, perspective. Yet there is a ker-
nel of truth here—our lives have become streamlined by quickened information
recall, our smartphones and their apps, and other handheld technology, as well
as our laptops, and the linked networks connecting all of these—to both our
betterment and detriment.

There are artists who consider technology, and how it can serve as an ex-
tension of the body, in an investigative rather than critical light. Further, we
live in a fast and cheap time equally characterized by the disposability of mass-
produced, common objects as well as by a bevy of cultural producers ranging
from graphic designers and restaurateurs privileging the slow—the reskilled, as it

Angela Washko, *The Council on Gender Sensitivity and Behavioral Awareness in World of Warcraft*, 2013. Performance documentation. Courtesy the artist

were. Could this throwback to artisanship and craft relate to this trend in artistic production? The artisanal could brush up against the outsourced, alienated modus operandi that has largely come to define Western culture as of late. We see sculptors such as Nicolas Deshayes, Marlie Mul, Magali Reus, and Alice Channer return to specialized, often industrial production processes as an attempt to logically and emotionally connect with common objects and even public spaces. Their work returns again and again to the body: the body as content, the body as viewer, the body as maker, the body as the tool through which we experience the world—yet it often builds upon the formal and conceptual logic of Minimalism and Post-Minimalism. As in Minimalism, this reskilled work considers the phenomenological presence of the viewer in the exhibition space. It becomes activated, or embodied, in the presence of the viewer, but it also works to question what the definition of the body is.

Nicolas Deshayes customizes industrial production processes through works that pit aesthetic referents to the body against the sterile backdrop of corporate and public interior architecture. The French-born, London-based artist anodizes his own aluminum at a metal-anodizing plant and creates his own vacuum forms from warty, body-conjuring plaster spills at a molded plastic fabricator. These panels appear at once painterly, slightly digital, and exceedingly chemical. Several anodized works take on the appearance of gasoline swirling in a puddle. Deshayes uses either heavy-duty aluminum sheets or "public amenity board"—the artist's euphemism for the antiseptic boards that line urinal walls—as backdrops for his vacuum-form plastics. These industrial, spill-proof, and scratch-resistant materials consciously consider the human body and how best to neutralize the fluids, vapors, and other contaminants it produces. That Deshayes pairs these human-resistant backdrops—the heavy-duty canvas of corporate interior decor, the piss-resistant bathroom cubicle wall—with vacuum forms indexing the more base parts of the human body suggests that the public spaces created to shepherd humans almost apologize for the body's baseness. His plastic carbuncles enforce the idea that each of us is essentially a big sac of occasionally leaking liquid and need not apologize for our corporeality. Deshayes's recent body of work created for the summer 2014 exhibition "Pool" at kestnergesellschaft in Hanover utilizes vitreous enamel—again a material created to withstand heavy public footfall. (Vitreous enamel can only be produced in a factory, as it's essentially glass that is fused onto steel in a furnace to create a super resilient and permanent ceramic surface.) The artist collaborated with a company that makes signs and cladding for the London Underground to create the vitreous enamel works, which feature photographic representations of life-size bodies on a generic panoramic plane. Next to oozing pools of glass paint and sprinkles of glass powder, the figures appear flat, pressed up against body-proof ceramic panel.

Berlin-based Dutch artist Marlie Mul utilizes a similar approach by customizing elements of public architecture in her series "No Oduur." However, unlike Deshayes's, these works bear the mark of human usage. These weathered slivers of metal stuffed with cigarette butts recall mail slots or vents found on the façades of buildings, yet they remain unidentifiable. In actuality, Mul designed these pieces as variations of an object she witnessed in real life: a trash receptacle burned so thoroughly that just the metal plate attaching it to the wall remained. The series comprises custom-fabricated, dubiously functional metal sheets, which the artist bends, etches, and burns to convey human wear and tear. She likens the addition of smoking poles to buildings or demarcated outdoor smoking areas to the territorialization of public space resultant from increasing public concern with the dangers of cigarette smoking. Further, these awkward sheets of abused metal signify this territorialization and bifurcation of public space, as well as the media one filters to develop a for-or-against stance that dictates where you'll end up hanging out—outside with the smokers or inside abstaining. Like Deshayes's body-repellant corporate canvases, Mul's work points to understated architectural elements that guide or herd bodies. Her newer series of trompe l'oeil puddles, recently shown at Fluxia in Milan and Croy Nielsen in Berlin, act similarly as receptacles for human behavior, though unlike metal, these diminutive pools of water cannot be inscribed upon. Consisting of fiberglass, resin, sand, and anonymous-looking waste culled from the street, these works encapsulate banal, fleeting scenarios that are at once unremarkably quotidian and playfully existential.

If Mul focuses on elements of public architecture that receive marks of human behavior and the territorialization of public space, Magali Reus explores how such architecture can dictate human behavior in shared space. "Highly Liquid," her spring 2013 exhibition at Amsterdam's Galerie Fons Welters, featured a series of modular stadium chairs donning an inoffensive color scheme of mauves, taupes, and greens. Installed at functional height, some chairs hang alone while others are clustered in groups. These folding chairs are a hallmark of space-saving public architecture. *Parking (Spine)* and *Parking (Service)*, both made in 2013, combine these custom-fabricated chairs with custom-fabricated parts of crutches. The latter straps one seat semi-closed, propping up the other with half of a green crutch, while the former places deconstructed parts of white crutches (one appearing curiously akin to a spine) on top of and below a row of four seats. Frequently found on subways, buses, ships, gymnasiums, and other heavily trafficked areas, they represent an on-or-off binary: when it's on, it supports the weight of a human, when it's off, it collapses into space. Perhaps it's private to feel exhaustion or pain and need to sit down, but it's public to do so on a structure like a stadium chair, where you'll almost always find yourself camped

next to a stranger. The concept of bodily support structures, and even that of protection, frequently arises in Reus's show and is literalized in her video *Highly Liquid* (2013). The video slowly pans around a wet male body amid a shower, though never offers a "money shot." Its gaze vacillates between the sexual and the clinical, and focuses on the protective layers of oil on the skin, which, when in contact with water, causes the oils to bead. One can view these phenomena as metaphors: how can we express support and protection in public, especially in urban areas in which it's impossible to have meaningful interactions with the overwhelming majority of people one encounters on a daily basis?

Just as the antiformalist aesthetic of Post-Minimalism can be read as a response to the chilly remove of Minimalist work and an attempt to reassert a haptic or sexual material presence, it could be argued that the artists considered here attempt a similar operation by introducing the concept of emotional and bodily alienation within the discourse dominated by the readymade, corporate art pursued by many of their contemporaries. Perhaps best representative of this, especially through her diverse use of materials, is Alice Channer's practice of producing states of material awkwardness or binary, continually referencing the absent (not necessarily human) body. She deflates clothes, stretches body parts, casts the flimsy in aluminum and renders liquid as solid. She describes her work as "figurative sculpture without a body" and herself as only one of her objects' many authors. These other authors are oftentimes machines, or the somewhat anonymous bodies—at least anonymous in the exhibition space—that literally create her work for her in a factory setting. The pieces *Troglodyte* and *Stalacmite* (both 2013), for example, cast American Apparel stretch-jersey maxi dresses in aluminum, forming them into a "J" shape so they rest, almost like legs, on their bottom curve. While the materiality of the aluminum suggests solidity and denseness, its cast, the clothing, appears stretched and porous. This tentative, awkward material binary is heightened by the observation that the sculptures appear as if they might topple over at any moment.

When I asked Channer what draws her to these states of awkwardness, she stammered and said, "It's just how I exist in the world, I guess." This sentiment rings true in general: while it's cumbersome to make constant allusion to "our increasingly networked world" and "our wired body," there's something to be said for existing in a state of awkwardness, tentativeness, or recession. Perhaps this collection of work responds not to a delayed understanding of how to resolve the networked with flesh, but how to navigate an increasingly abstracted world as a sentient being. The production processes of these reskilled works and the keen attention they pay to the body also bear their maker's affect in general: there's an honesty, sensitivity, and overt pleasure component that comes not

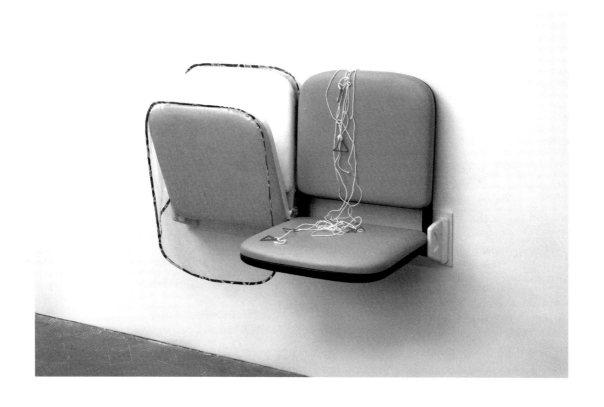

Magali Reus, *Parking (Delta)*, 2014. Fiberglass,
polyester resin, pigment, PVC, cotton, powder-
coated laser-cut aluminum, and polyester cord,
22 7/16 × 37 3/8 × 19 1/16 in (57 × 95 × 48.5 cm).
Courtesy the artist and the Approach, London

only from heightened materiality and practical know-how, but also from senti-ment. These artists encourage us to revel in the materiality of our own anatomy, regardless of how far we've traveled from it.

Public architecture that is body-resistant (Deshayes's sanitary paneling) or body-conscious (Reus's flip seating) studies the body and human behavior and how best to control it in the interest of efficiency and human health. Many of the works presented here analyze "analog" technologies (such as ceramic firing or a steel ashtray) that comprise decades of information accumulated by the variably successful efforts of urban planners and architects. These elements making up communal space affect our consciousness, comfort, and even emotions while in public. As will be detailed in the next section, this sort of risk-mediating design has been corporatized and is now driven by data and profit. Think, for exam-ple, of the shrinking airline seat, which clearly puts profit over experience—no wonder we see works, such as Channer's, representing the body as something stretched and squeezed.

CORPORATE BODIES

If the boom of interest in postinternet practices circa 2011 saw increased at-tention paid to the relationship between the distinct spaces "online" and "in real life," artists and cultural practitioners have most recently increasingly done away with this binary distinction and focused on the inverse—the blurred *indis-tinction* between the two. While there is still an obvious distinction between the "virtual" and "real" that we can intuit, one being accessed by a computer and the other the biophysical, the intertwined nature of these experiences has come to define our daily life. We can begin to understand this by acknowledging that in-formation is not immaterial as it is commonly mistaken to be. Rather, as argued in Tiziana Terranova's *Network Culture: Politics for the Information Age*, informa-tion is a volatile commodity dependent on the physical form of the servers, wires, and cables it inhabits. She writes, "The modern concept of information is explic-itly subordinated to the technical demands of communication engineering, and more specifically to the problems of the 'line' or 'channel.'"[14] I would also argue that the geopoliticization of information refutes such claims of immateriality. As in the very valuable information stored on the servers of WikiLeaks at Pionen Data Center in Stockholm, information is a commodity that can be stolen or be protected from government interests depending on its geolocation. The ability to protect data via governmental autonomy from other (mainly US) government

interest has even given rise to micronations such as the Principality of Sealand, which is essentially a World War II sea fort off the coast of England in the North Sea. Further, anyone who has filled out a customer service questionnaire knows that experience can be quantified as data and is often collected, bought, traded, and used by corporations—both online and off—to influence further biophysical experiences. For example, if I write "morning sickness" in GChat, Gmail's chat client, or conduct a web search for "missed period," Google will know that I'm likely in my first trimester of pregnancy. Once Google becomes apprised of this knowledge, it will tailor web advertisements targeting expectant mothers. Should you click on an advertisement for a baby registry at Macy's, for example, Google will make money off of that e-commerce click-through. And then, your brother will buy you that expensive video baby monitor you wanted, and this becomes the main way you look at your child at night—perhaps this is the first machine that this child interacts with.

The now-defunct artist duo AIDS-3D (Daniel Keller and Nik Kosmas) has long considered the role of corporate interest in the creation of mass-produced objects and interior architecture. Their spring 2011 exhibition "Exotic Options" at T293 in Naples debuted a series of sculptures that are actually sneeze guards. Don't feel bad if you have no idea what a sneeze guard is—heretofore I hadn't either—it is a glass plane that protects food (usually a buffet) from the pesky snot of its onlookers. The sneeze guard is in essence a form of risk-mediating architecture. If you own a restaurant with a buffet and don't install sneeze guards and something falls into a vat of food, you will lose money from having to replace that food. AIDS-3D's sneeze guards come equipped with camouflage semi-distracting privacy film, which is a low-cost plastic mesh film that allows a person to peer out from the inside of a bus, for example, but remain invisible to outside onlookers. These semi-distracting privacy films are also commonly printed upon with large-scale advertisements. Most importantly, AIDS-3D has located artistic practice, as a reflection of everyday life, as something that has come into contact with the corporate.

The artist Hito Steyerl has written extensively of the comingling between the corporate and the artistic, and between online and offline space. In her essay "Too Much World: Is the Internet Dead?" published in *e-flux journal* #49 in November 2013 and reprinted in this volume, she writes:

> But here is the ultimate consequence of the internet moving offline. If images can be shared and circulated, why can't everything else be too? If data moves across screens, so can its material incarnations move across shop windows and other enclosures. If copyright can be dodged

and called into question, why can't private property? If one can share a restaurant dish JPEG on Facebook, why not the real meal? Why not apply fair use to space, parks, and swimming pools?[15]

Steyerl's 2014 video *Liquidity Inc.* tackles the transformative nature between the "virtual" and the "real" head-on. It features Jacob Wood, a former Lehmann Brothers analyst, who is laid off during the dot-com bust and becomes a free-floating agent—eventually a performance-obsessed mixed martial arts fighter. It also riffs on liquid aesthetics, in a literal sense, to include computer generated imagery of waves and water, as well as the metaphoric liquidity of assets—an asset's ability to transform into cash. Tellingly, the "Inc." in *Liquidity Inc.* speaks to another form of transformation, specifically to the term "incorporation." The term "incorporate" describes both the processes of assuming bodily form as well as companies becoming legal entities, which often have legal rights as human beings. (Consider the summer 2014 ruling that the arts-and-crafts purveyor Hobby Lobby has religious rights and is thus allowed to refuse to compensate its employees with health insurance that could cover abortions.) According to *Oxford American Dictionary*'s website, incorporation entails "the act of uniting several persons into one fiction called a corporation, in order that they may be no longer responsible for their actions." The term's etymological roots further evince its function to describe the liquidity and the changing states of matter that Steyerl focuses on here: "Incorporation" coming from the late Latin *incorporat- 'embodied,'* from the verb *incorporare*, from *in- 'into'* + Latin *corporare 'form into a body'* (from *corpus, corpor- 'body'*).[16]

If a corporation can be considered a person, why can't information be considered a person, or at least, again, material? Here again is Terranova on information and its abnormal physical properties:

> It is [the] ease of copying, it has been argued, that makes of information such a shifty and yet valuable commodity. We know that information can be sold and bought and that a good deal of the world economy is driven by an emphasis on the informational content of specific commodities and we are also aware that information itself can be valuable (when it is used for example to make a profit in the stock market). We know that anybody is always potentially an information-source or even an information storage-device and that science suggests that information constitutes the very basis of our biological existence (in as much as, we are told, we contain information that can be decoded within our very cells). In all these cases, information emerges as a content, as some kind of "thing" or

"object" but one that possesses abnormal properties (ease of copying and propagation, intangibility, volatility, etc.) that contemporary technological developments have exacerbated and amplified.[17]

Terranova importantly expounds here on the abnormality of information that oftentimes qualifies it as an abstraction. This concept of the abstraction of states, and the confusion or power it begets, seems symptomatic of both common power structure dynamics and also how we relate to the world. German media theorist Friedrich Kittler argued that it was with telegraphy that information—no longer simply a speech act—was abstracted as a "massless flow" for the first time, and it was pointed out by American information theorist Claude E. Shannon in 1948 that it is the signal, or information, that we seek amid such states of noise.[18] And as we learned earlier, the conflation of the corporation as a person is a further political abstraction that gains power from its lack of responsibility. Both the awkward state that Channer speaks of, and the psychologically dissonant experience of the World of Warcraft player that Washko details further prove this contemporary tendency toward an abstracted hybrid state. But this is not meant to be simply cynical. Rather, it is in the face of such noise that it seems paramount to recognize the powers of conflation and clairvoyance in order to protect the autonomy of our own information.

..

This essay was commissioned in 2014 for the present volume.

..

NOTES

1. Gene McHugh, *Post Internet: Notes on the Internet and Art* (Brescia: Link Editions, 2012).

2. "Trouvaille" *Frieze d/e*, <http://frieze-magazin.de/archiv/kolumnen/trouvaille/?lang=en>.

3. Shorthand for "Single White Male In Search Of Single White Female."

4. See: <http://knowyourmeme.com/memes/rules-of-the-internet> (accessed Sept. 14, 2014).

5. Calvin Tomkins, "A Doll's House: Laurie Simmons's Sense of Scale," *New Yorker*, Dec. 10, 2012, 36.

6. Ann Hirsch, unpublished screenplay.

7. Laura Mulvey, "Visual Pleasure and Narrative Cinema," *Screen* 16, no. 3 (Autumn 1975): 6–18.

8. Ibid.

9. James S. Fell, "The Toxic Appeal of the Men's Rights Movement," *Time*, May 29, 2014, <http://time.com/134152/the-toxic-appeal-of-the-mens-rights-movement/>.

10. Jason Kincaid, "EdgeRank: The Secret Sauce That Makes Facebook's News Feed Tick," *TechCrunch*, April 22, 2010, <http://time.com/134152/the-toxic-appeal-of-the-mens -rights-movement/>.

11. What happens when the sanctity of these networks are challenged or taken away is another question. We need only look to the stories of game blogger Anita Sarkeesian or video game developer Zoe Quinn, who both have achieved success in breaking into and expanding the game industry, and who both have experienced death and rape threats from anonymous online sources.

12. This section was inspired by Karen Archey, "Main Theme: Post- i- Meta- Hyper- Materiality," *Kaleidoscope* 18 (Summer 2013): 36–41.

13. Nicholas G. Carr, *The Shallows: What the Internet Is Doing to Our Brains* (New York: W. W. Norton, 2010).

14. Tiziana Terranova, *Network Culture: Politics for the Information Age* (London: Pluto, 2004), 6.

15. Hito Steyerl, "Too Much World: Is the Internet Dead?," in this volume, 446.

16. "Definition of incorporate in English," *Oxford Dictionary (British & World English)*, n.d., <http://www.oxforddictionaries.com/us/definition/american_english/incorporate> (accessed Sept. 14, 2014).

17. Terranova, *Network Culture*, 6–7.

18. Ibid., 8.

PUBLICATION HISTORY

"DIGITAL DIVIDE" BY CLAIRE BISHOP

Bishop, Claire. "Digital Divide." *Artforum* 51, no. 1 (2012): 434–42.

"ARCADES, MALL RATS, AND TUMBLR THUGS" BY JESSE DARLING

Darling, Jesse. "Arcades, Mall Rats, and Tumblr Thugs." *New Inquiry* (2012). <http://thenewinquiry.com/essays/arcades-mallrats-tumblr-thugs/>.

"TWO STATEMENTS ON CARNIVORE" BY ALEXANDER GALLOWAY

ESSAY 1

Galloway, Alexander R. "How We Made Our Own 'Carnivore.'" Rhizome (2002). <http://rhizome.org/discuss/2654/>.

Galloway, Alexander R. / RSG. "How We Made Our Own 'Carnivore.'" In *Unplugged: Art as the Scene of Global Conflicts*, edited by Christine Schopf and Gerfried Stocker. Ostfildern, Germany: Hatje Cantz, 2002.

Galloway, Alexander R. / RSG. "How We Made Our Own 'Carnivore.'" *Intelligent Agent* (2003). <http://www.intelligentagent.com/archive/Vol3_No1_polisci_RSG.html>.

Galloway, Alexander R. *Protocol: How Control Exists After Decentralization.* Cambridge, MA: MIT Press, 2004.

ESSAY 2

Galloway, Alexander R. "Carnivore Personal Edition: Exploring Distributed Data Surveillance." *AI & Society* 20 (4) (2006): 483–92.

"ART WORKERS: BETWEEN UTOPIA AND THE ARCHIVE" BY BORIS GROYS

Groys, Boris. "Art Workers: Between Utopia and the Archive." *e-flux journal* 45 (2013). <http://www.e-flux.com/journal/art-workers-between-utopia-and-the-archive/>.

"THE CENTAUR AND THE HUMMINGBIRD" BY ED HALTER

Halter, Ed. "The Centaur and the Hummingbird." In *Free*. New York: New Museum, 2010.

"THE DIFFERENT WORLDS OF CAO FEI" BY ALICE MING WAI JIM

Jim, Alice Ming Wai. "The Different Worlds of Cao Fei." *Yishu: Journal of Contemporary Chinese Art* 11, no. 3 (2012): 82–90.

Jim, Alice Ming Wai. "The Different Worlds of Cao Fei." In *Cao Fei: Simulus*. Surrey, Canada: Surrey Art Gallery, 2012.

"WHAT TO DO WITH PICTURES" BY DAVID JOSELIT

Joselit, David. "What to Do with Pictures." *October* 138 (2011): 81–94.

"NEXT-LEVEL SPLEEN" BY JOHN KELSEY

Kelsey, John. "Next-Level Spleen." *Artforum* 51, no.1 (2012): 412–15.

Kelsey, John. "Next-Level Spleen." *DIS Magazine* (2012). <http://dismagazine.com/blog/37146/next-level-spleen-by-john-kelsey/>.

"EVERYBODY'S AUTOBIOGRAPHY" BY ALEX KITNICK

Kitnick, Alex. "Everybody's Autobiography." In *Mark Leckey — On Pleasure Bent*. Belgium: WIELS / Munich: Haus der Kunst / Naples: Museo Madre / Cologne: Verlag der Buchhandlung Walther König, 2014.

"IN THE LONG TAIL" BY MARK LECKEY

Leckey, Mark. *Mark Leckey in the Long Tail*. Performance: ICA, London, Jan. 31–Feb. 1, 2009.

Leckey, Mark. *Mark Leckey in the Long Tail*. Performance: the Abrons Arts Center, New York, Oct. 1–3, 2009.

Leckey, Mark. "The Long Tail." *ROLAND* 3 (2009): 36–44.

Leckey, Mark. "The Long Tail." In *Mark Leckey — On Pleasure Bent*. Belgium: WIELS / Munich: Haus der Kunst / Naples: Museo Madre / Cologne: Verlag der Buchhandlung Walther König, 2014.

"DO YOU BELIEVE IN USERS? / TURING COMPLETE USER" BY OLIA LIALINA AND DRAGAN ESPENSCHIED

Lialina, Olia. "Turing Complete User." *Contemporary Home Computing*. <http://contemporary-home-computing.org/turing-complete-user/>.

Lialina, Olia and Dragan Espenschied. "Do You Believe in Users." In *Digital Folklore*. Stuttgart, Germany: merz & solitude, 2009.

"'WE DID IT OURSELVES!' AKA 'MY FAVORITES': VOLUME 1, 2005 TO 2009" BY GUTHRIE LONERGAN

Lonergan, Guthrie. "We Did It Ourselves!" Lecture: Light Industry, New York, April 6, 2009.

"CITIZENS REPORTING AND THE FABRICATION OF COLLECTIVE MEMORY" BY JENS MAIER-ROTHE, DINA KAFAFI, AND AZIN FEIZABADI

Maier-Rothe, Jens, Azin Feizabadi, and Dina Kafafi. "Citizens Reporting and the Fabrication of Collective Memory." *Ibraaz* (2012). <http://www.ibraaz.org/essays/50#author175>.

Maier-Rothe, Jens, Azin Feizabadi, and Dina Kafafi. "Citizens Reporting and the Fabrication of Collective Memory." In *Uncommon Grounds: New Media and Critical Practice in the Middle East and North Africa*, edited by Anthony Downey. London: I.B. Tauris & Co. Ltd., 2014: 70–85.

"EXCERPTS FROM *POST INTERNET*" BY GENE MCHUGH

McHugh, Gene. "Post Internet." *Post Internet* (2009–10).

McHugh, Gene. *Post Internet*. Brescia: LINK Editions, 2011.

"LOST NOT FOUND: THE CIRCULATION OF IMAGES IN DIGITAL VISUAL CULTURE" BY MARISA OLSON

Olson, Marisa. "Lost Not Found: The Circulation Of Images In Digital Visual Culture." In *Words Without Pictures*, edited by Charlotte Cotton and Alex Klein. New York: Aperture / Los Angeles: LACMA, 2010: 274–84.

"DISPERSION" BY SETH PRICE

Price, Seth. "Dispersion." 2002. <http://www.distributedhistory.com/Dispersion08.pdf>.

Price, Seth. "Dispersion." In *25th International Biennial of Graphic Arts Ljubljana*, edited by Christophe Cherix and Madeleine Goodrich Noble. Zurich: JRP Ringier, 2003.

Price, Seth. "Dispersion." New York: 38th Street Publishers, 2008.

Price, Seth. *Essay with Knots*. 2008. Screenprint ink on high-impact polystyrene and polyester, vacuum-formed over rope, nine panels; 48 x 96 in (121.9 × 243.8 cm) each.

"HERE I AM: TELEPRESENT SUBJECTHOOD IN THE WORK OF LOTTE ROSE KJÆR SKAU" BY MORGAN QUAINTANCE

Quaintance, Morgan. "Here I Am: Telepresent Subjecthood in the Work of Lotte Rose Kjær Skau." In *Lotte Rose Kjær Skau: United We/I Stand Etc*. London: IMT Gallery, 2014.

"DIGRESSIONS FROM THE MEMORY OF A MINOR ENCOUNTER" BY RAQS MEDIA COLLECTIVE

Raqs Media Collective. "Digressions from the Memory of a Minor Encounter." In *The Manifesta Decade: Debates on Contemporary Art Exhibitions and Biennials in Post-Wall Europe*, edited by Barbara Vanderlinden and Elena Filipovic. Cambridge, MA: MIT Press, 2006: 85–92.

Raqs Media Collective. "Digressions from the Memory of a Minor Encounter." In *Raqs Media Collective: Seepage*. Berlin: Sternberg Press, 2010: 46–55.

"INTERNATIONAL ART ENGLISH" BY ALIX RULE AND DAVID LEVINE

Rule, Alix and David Levine. "International Art English." *Triple Canopy* 16 (2012). <http://canopycanopycanopy.com/issues/16/contents/international_art_english>.f

"THE VISIBILITY WARS" BY REBECCA SOLNIT

Solnit, Rebecca. "The Visibility Wars." In *Invisible: Covert Operations and Classified Landscapes*. New York: Aperture, 2010: 6–18.

"TOO MUCH WORLD: IS THE INTERNET DEAD?" BY HITO STEYERL

Steyerl, Hito. "Too Much World: Is The Internet Dead?." *e-flux journal* 49 (2013). <http://www.e-flux.com/journal/too-much-world-is-the-internet-dead/>.

Steyerl, Hito. "Too Much World: Is the Internet Dead?" In *Too Much World: The Films of Hito Steyerl*, edited by Nick Aikens. Berlin: Sternberg Press / Eindhoven, Netherlands: Van Abbemuseum / Brisbane, Australia: Institute of Modern Art, 2014.

"BLACK VERNACULAR: READING NEW MEDIA" BY MARTINE SYMS

Syms, Martine. "Black Vernacular: Reading New Media." Lecture: SXSW, Austin, March 10, 2013.

CONTRIBUTORS

CORY ARCANGEL is a Brooklyn-based fine artist who makes work in a wide range of mediums, including composition, video, modified video games, performance, and the internet. Recent projects include the publishing and merchandise imprint Arcangel Surfware; the book *Working On My Novel* (2014); and the exhibitions "Masters" at the Carnegie Museum of Art, Pittsburgh (2012–13), and "Pro Tools" at the Whitney Museum of American Art, New York (2011).

KAREN ARCHEY is an art critic and independent curator based in New York and Berlin. She regularly speaks about feminist and internet-related art practices at venues such as the International Center of Photography, New York; Slovak National Gallery, Bratislava; and the Institute of Contemporary Art, London. She co-curated the survey exhibition "Art Post-Internet" at the Ullens Center for Contemporary Art, Beijing (2014), and has served as Curator-in-Residence at the Abrons Arts Center, New York, and Editor-at-Large of Rhizome at the New Museum, New York. Her writing is regularly featured in *frieze*, *ArtReview*, and *Art-Agenda*.

MICHAEL BELL-SMITH is an artist based in Brooklyn, New York. His work uses digital forms to interrogate contemporary culture and its relationship to popular technology. Spanning across various mediums—including video, the internet, pictures, performance, and installation—his practice draws from commercial graphics, amateur aesthetics, Pop, and the accumulation of art history. His work often incorporates the visual vocabulary of the internet, such as animated GIFs, stock images, and the gloss of web 2.0 design; it also references the semiotics of common computer programs and websites such as Adobe Creative Suite, Microsoft PowerPoint, YouTube, and Tumblr. His work has been exhibited and screened in museums and galleries internationally, including MoMA P.S.1, New York (2013); SFMOMA, San Francisco (2010); the 2008 Liverpool Biennial; the 5th Seoul International Media Biennial (2008); and the Hirshhorn Museum and Sculpture Garden, Washington, DC (2008).

JOSEPHINE BERRY SLATER is Editor of *Mute* magazine, a forum for cultural and technological questions in the postinternet globalized age. She teaches part-time at the Centre for Cultural Studies at Goldsmiths, University of London. Her PhD thesis was one of the first to address net.art, and her current research interests include urban politics of neoliberalism and the transformation of public and community arts within the context of urban regeneration.

CLAIRE BISHOP is Professor in the PhD Program in Art History at the Graduate Center, City University of New York. Her books include *Radical Museology, or, What's Contemporary in Museums of Contemporary Art?* (2013), *Artificial Hells: Participatory Art and the Politics of Spectatorship* (2012), and *Installation Art: A Critical History* (2005). She writes on contemporary art and performance and is a regular contributor to *Artforum*.

JOHANNA BURTON is Keith Haring Director and Curator of Education and Public Engagement at the New Museum. Prior to holding this position, she was Director of the Graduate Program at the Center for Curatorial Studies, Bard College (2010–13), and Associate Director and Senior Faculty Member at the Whitney Museum of American Art's Independent Study Program (2008–10). Burton has curated or co-curated a number of exhibitions including "Take It or Leave It: Institution, Image, Ideology" at the Hammer Museum, Los Angeles (2014); "XFR STN" at the New Museum, New York (2013); and "Sherrie Levine: Mayhem" at the Whitney Museum of American Art, New York (2011). Her writing has appeared in publications including *Artforum*, *October*, and *Texte zur Kunst*.

PAUL CHAN lives in New York.

MICHAEL CONNOR is a writer and curator whose work focuses on artists' responses to cinema and new technologies. He is currently at Rhizome, an internet-based arts organization-in-residence at the New Museum that promotes richer technology cultures through art. Connor has previously worked as Curator at FACT, Liverpool, and as Head of Exhibitions at BFI Southbank, London.

LAUREN CORNELL is Curator and Associate Director, Technology Initiatives, at the New Museum. From 2005 through 2012, she served as Executive Director of Rhizome and Adjunct Curator at the New Museum. Previously, she worked on the Andy Warhol Film Project at the Whitney Museum of American Art, New York, and, from 2002 through 2004, she directed Ocularis, a microcinema in Brooklyn.

PETRA CORTRIGHT is a Los Angeles–based artist whose practice encompasses animated GIFs, digital paintings, and webcam videos that explore the aesthetics and performative cultures of online consumption. Her work often reflects the intimacy and low fidelity of chat rooms and message boards. Cortright has shown at the Los Angeles County Museum of Art (2014); Rhizome, New York (2009); the Venice Biennale (2009); and the New Museum, New York (2008).

JESSE DARLING is a London-based artist and occasional essayist, whose dispersed practice centers on the human condition in networked subjectivity and the way that structures—architectural, [bio]political, philosophical—manifest in physical and social bodies and become transformed. Darling works in sculpture, installation, text, and *"dasein* by design"—the space where performance and unmediated experience meet. S/he explores the mediative forms of this post-Fordist, Ikea-furnished, playbouring phase of user-generated capitalism, imagining ways to productively engage these toward a constructive intensity.

DIS is a New York–based collective. Its cultural interventions are manifest across a range of mediums and platforms, from site-specific museum and gallery exhibitions to ongoing online projects. Most notably, these include *DIS Magazine*, a virtual platform that examines art, fashion, music, and culture, constructing and supporting new creative practices; DISimages, a fully functioning stock-image website; and DISown, an ongoing retail platform and laboratory to test the current status of the art object.

ALEKSANDRA DOMANOVIĆ currently lives and works in Berlin. Her work is concerned with the circulation and reception of images and information, particularly as they shift meaning and change register, traversing different contexts and historical circumstances. Her recent solo and group exhibitions include "Aleksandra Domanović" at Glasgow International (2014); the 12th Biennale de Lyon: "Meanwhile ... Suddenly, and Then" (2013–14); "The Future Was at Her Fingertips" at Tanya Leighton Berlin (2013); the ICP Triennial: "A Different Kind of Order," New York (2013); "Turbo Sculpture" at Space, London (2012); "Higher Atlas" at the Marrakech Biennale 4th Edition (2012); and "From yu to me" at Kunsthalle Basel (2012).

HARM VAN DEN DORPEL is a Berlin-based artist who works with methods from media theory, information science, philosophy, and semiotics, often using synthetic materials and self-developed online information systems to generate work. As part of a generation of artists interested in the participatory culture of the internet, van den Dorpel's collages, installations, websites, and animations address the way in which the internet has transformed how visual information is thought about, accessed, and appropriated.

DRAGAN ESPENSCHIED is a researcher, musician, and new media artist who works as Digital Art Conservator for Rhizome. Together with net.art pioneer Olia Lialina, he cofounded the Geocities Research Institute and has created a significant body of work concerned with how to represent and write a user-centric history of the networked age.

RÓZSA FARKAS is Founding Director and Curator of Arcadia Missa Gallery and Publisher, London. She has also curated projects at organizations such as tank.tv, South London Gallery, and the ICA, and she has written for *Nottingham Contemporary*, *Mute Magazine*, *Eros*, and *DPI Studioxx*, among other publications. Farkas continues to guest lecture at University of the Arts London, and in 2013 she completed a research fellowship for Leuphana University's Post Media Lab.

AZIN FEIZABADI is an Iranian-born filmmaker and visual artist who lives and works in Berlin. In 2009 Feizabadi launched his ongoing research and production framework entitled "A Collective Memory." Swaying between fact and fiction, as well as poetics and immediate politics, the multidisciplinary works within "A Collective Memory" create both political imagination and emancipatory participation. Azin is Cofounder of the artist group Reloading Images (2006). He has coedited the "Reloading Images" publication series (2007–09) as well as an artists' book for the 10th Sharjah Biennial, *then we went in search of somewhere to stay the night* (2011). His works have been screened and exhibited at the Berlinale Forum Expanded (2014 and 2012); Beirut, Cairo (2013); the Maxim Gorki Theater, Berlin (2013); Heidelberger Kunstverein, Germany (2012); Haus der Kulturen der Welt, Berlin (2010); the Queens Museum, New York (2010); Neuer Berliner Kunstverein, Berlin (2010); the Sheila C. Johnson Design Center, New York (2010); Silkroad Gallery, Tehran (2009); neue Gesellschaft für bildende Kunst, Berlin (2008); Azad Gallery, Tehran (2007); and the 52nd Oberhausen Short Film Festival, Germany (2006); among other venues and events.

ALEXANDER R. GALLOWAY is a writer and computer programmer working on issues in philosophy, technology, and theories of mediation. He is the author and coauthor of several books, most recently *Laruelle: Against the Digital* (2014).

BORIS GROYS is Professor of Russian and Slavic Studies at New York University and Senior Research Fellow at the Karlsruhe University of Arts and Design in Germany. A philosopher, essayist, art critic, media theorist, and internationally acclaimed expert on the Russian avant-garde and late-Soviet postmodern art and literature, he is the author of many books, including *Art Power* (2013), *An Introduction to Antiphilosophy* (2012), *The Total Art of Stalinism* (2011), *Going Public* (2010), and *Ilya Kabakov: The Man Who Flew into Space from His Apartment* (2006). Groys has also curated many exhibitions, including "Empty Zones," an exhibition at the Russian Pavilion at the 54th Venice Biennale (2011), comprising works by Andrei Monastyrski and the Collective Actions Group.

ED HALTER is a founder and director of Light Industry, a venue for film and electronic art in Brooklyn, New York. From 1995 to 2005, he programmed and oversaw the New York Underground Film Festival. Halter has written for *Artforum*, *Cinema Scope*, *Believer*, and *Village Voice*, among other publications, and has curated screenings and exhibitions at venues such as Artists Space, New York (2012); MoMA P.S.1, New York (2010); the Tate Modern, London (2012); and the 76th Whitney Biennial, New York (2012). He teaches in the Film and Electronic Arts Department at Bard College and is currently writing a critical history of contemporary experimental cinema in the US.

ALICE MING WAI JIM is Associate Professor of Contemporary Art in the Department of Art History at Concordia University, Montreal. She was Curator of the Vancouver International Centre for Contemporary Asian Art (Centre A) from 2003 to 2006. Jim is Founding Coeditor of the journal *Asian Diasporic Visual Cultures and the Americas*. Her main areas of research are in media arts, networked art practices, ethnocultural and global art histories, and curatorial studies, with a focus on contemporary Asian art and Asian-Canadian art.

CAITLIN JONES is currently Executive Director of the Western Front in Vancouver. Prior to this, she has worked as an independent curator and at the Solomon R. Guggenheim Museum, Rhizome, and Bryce Wolkowitz Gallery in New York. Her writings on contemporary art and new media have appeared in a wide range of periodicals and books, including *Mousse*, *The Believer*, and the Whitechapel Gallery's *Documents in Contemporary Art* series, among other international publications.

DAVID JOSELIT is Distinguished Professor in the PhD Program in Art History at the Graduate Center, City University of New York. He is the author of many books, including *After Art* (2013); *Feedback: Television Against Democracy* (2007); *American Art Since 1945* (2003); and *Infinite Regress: Marcel Duchamp, 1910–1941* (1998).

DINA KAFAFI is an independent cultural manager based in Cairo. She is also managing the artist residency program at the Townhouse Gallery, Cairo, and has run public programs and public relations campaigns for the gallery over the past four years. She co-curated "Citizens Reporting, A Collective Memory" at Mindpirates Projektraum (2012), a four-day symposium in Berlin that discussed the jaded line between citizen journalism and political art, and has since been developing branching concepts through her work and research. Kafafi's current project, "The Digital Resource Library" (DRL), occupies a permanent space in the Townhouse Gallery. It serves as the frame for curated programs with other collaborators addressing developments in digital technology and their pertinence to the sphere of creative activism, specific to the Arab region.

JOHN KELSEY is an American critic, artist, and a co-director of the gallery Reena Spaulings Fine Art in New York. Since 1999, he has been a member of the artist collective Bernadette Corporation.

ALEX KITNICK teaches art history at Bard College. His writing has appeared in *Artforum*, *May*, *October*, and *Texte zur Kunst*.

TINA KUKIELSKI was Co-curator of the "2013 Carnegie International" at the Carnegie Museum of Art, Pittsburgh, for which she also organized the exhibition "Cory Arcangel: Masters" (2012). Formerly of the Whitney Museum of American Art, she has coordinated exhibitions with numerous artists working in the early twenty-first century.

OLIVER LARIC is a Berlin-based artist whose work seeks to parse the productive potential of the copy, the bootleg, and the remix, and examine their role in the formation of both historic and contemporary image cultures. His work has been exhibited widely at international venues including the Hirshhorn Museum and Sculpture Garden, Washington, DC (2014); Fridericianum, Kassel, Germany (2013–14); FUTURA Centre for Contemporary Art, Prague (2013); MIT List Visual Arts Center, Cambridge, MA (2013); Palais de Tokyo, Paris (2012); Villa du Parc Centre d'art Contemporain, Annemasse, France (2012); Skulpturhalle Basel (2011); Westfälischer Kunstverein, Münster (2011); Mass MoCA, North Adams, MA (2011); Vancouver Art Gallery (2010); and the New Museum, New York (2008). Laric is a cofounder of the *VVORK* platform (vvork.com).

MARK LECKEY'S multidisciplinary practice encompasses sculpture, sound, film, and performance. He has exhibited widely and has had solo shows at WEILS, Brussels (2014); the Hammer Museum, Los Angeles (2013); and the Serpentine Gallery, London (2011), among other venues. His work has been included in numerous international exhibitions, including the Venice Biennale (2013); the 8th Gwangju Biennial, South Korea (2010); "Moving Images: Artists & Video / Film," Museum Ludwig, Cologne (2010); "Sympathy for the Devil: Art and Rock and Roll Since 1967," the Museum of Contemporary Art, Chicago (2007); the 9th International Istanbul Biennial (2005); and Manifesta 5, European Biennial of Contemporary Art, San Sebastián, Spain (2004). Leckey has participated in Performa 11, New York (2011), and has presented his lecture-performances at the Institute of Contemporary Arts, London (2009); the Museum of Modern Art, New York (2009); and the Solomon R. Guggenheim Museum, New York (2008). In 2008, Leckey received the Turner Prize.

DAVID LEVINE is an artist based in Brooklyn and Berlin. His performances and projects have been presented at the Museum of Modern Art, New York; MASS MoCA, North Adams, MA; documenta 12, Kassel; Townhouse Gallery, Cairo; Tanya Leighton Gallery, Berlin; and Blum & Poe, Los Angeles.

OLIA LIALINA is a journalist, film critic, net.artist, and Professor of New Media at Merz Akademie, Stuttgart. She writes on new media, digital folklore, and vernacular uses of the web. She cofounded the Geocities Research Institute with new media artist Dragan Espenschied.

GUTHRIE LONERGAN, coming from a community of internet surfers, confronts the DIY ethos of the internet from a basic computer user's perspective. Primarily using material found online, his work juxtaposes the default settings of consumer-level creative software (iPhoto, YouTube, Twitter, etc.) with the social defaults that evolve around every new kind of technology.

JENS MAIER-ROTHE writes, teaches, and makes exhibitions. He has exhibited internationally and has authored and coedited various publications. In May 2012, he cofounded the art initiative Beirut in Cairo, which offers a year-round public program of exhibitions, events, research, and educational activities. Recent projects include "A Guest without a Host is a Ghost" in collaboration with the Kadist Art Foundation in Paris (2014–15); "Here Today Gone Tomorrow" in collaboration with the Stedelijk Museum and Trouw in Amsterdam (2014); "Tape Echo" in collaboration with the Van Abbemuseum in Eindhoven (2013–14); and "The Magic of the State" in collaboration with the Lisson Gallery in London (2013).

JENNIFER AND KEVIN MCCOY are partners and collaborators, based in Brooklyn, New York, who are known for multimedia artworks that examine memory and language through installation, performance, and interactive mediums. The McCoys were 2011 Guggenheim Foundation Fellows and 2005 *Wired* Rave Award winners. Their work has been widely exhibited in the US and internationally; they have previously been included in exhibitions at Centre Pompidou, Paris (2013); the British Film Institute, London (2009); Southbank, London (2007); the Museum of Modern Art, New York (2007); and the Hannover Kunstverein, Germany (2005).

GENE MCHUGH is a writer based in Los Angeles. He is the author of *Post Internet: Notes on the Internet and Art: 12.29.09 > 09.05.10* (2011) and is currently Head of Digital Media at the Fowler Museum at UCLA.

TOM MOODY is an artist and musician based in New York City. His low-tech art—made with simple imaging programs, photocopiers, and consumer printers—has been exhibited at artMovingProjects, Derek Eller Gallery, and Spencer Brownstone Gallery in New York as well as other art institutions in the US and Europe. His videos have been screened in the New York Underground Film Festival, the Chicago Underground Film Festival, the Dallas Film Festival, and other venues. He and his work appear in the film *8 BIT* (2006), which premiered at the Museum of Modern Art, New York. His blog at tommoody.us was recommended in the 2005 *Art in America* article "Art in the Blogosphere." His music, made with a home computer and a variety of electronic gear, has been played at Apex Art in NYC, on WNYU FM, and on basic.fm.

CECI MOSS is Assistant Curator of Visual Arts at Yerba Buena Center for the Arts in San Francisco and a PhD candidate in Comparative Literature at New York University. Prior to her position at YBCA, she was Senior Editor of the art and technology nonprofit organization Rhizome and an Adjunct Instructor at New York University in the Department of Comparative Literature. Her writing has appeared in *Rhizome*, *ArtAsiaPacific*, *Artforum*, the *Wire*, *Performa Magazine*, and various art catalogues.

MARISA OLSON is an artist and media theorist whose work addresses the cultural history of technology and the politics of participation in pop culture. Her work has been exhibited at the Ullens Center for Contemporary Art, Beijing (2014); FACT, Liverpool (2012); the Nam June Paik Art Center (2011); PS122, (2010); the Sundance Film Festival, (2009); the 52nd Venice Biennale (2007); the São Paulo Biennial; Centre Pompidou, Paris; the Tate Modern, London ; the Tate Liverpool; the Whitney Museum of American Art, New York; the New Museum, New York; the British Film Institute; and the PERFORMA Biennial, New York.

TREVOR PAGLEN is a New York–based artist whose work blurs the boundaries between science, art, and reportage. His heavily researched projects, which manifest as photography and sculpture, intend to create new metaphors through which to grasp society and networked technology. Paglen's visual work has been exhibited at the Liverpool Biennial (2012); the Metropolitan Museum of Art, New York (2011–12); the Walker Art Center, Minneapolis (2011); the Tate Modern, London (2010); SFMOMA, San Francisco (2010); the 9th International Istanbul Biennial (2009); the 6th Taipei Biennial (2008); and numerous other solo and group exhibitions.

SETH PRICE is an artist who lives and works in New York City.

ALEXANDER PROVAN is the editor of *Triple Canopy*, a magazine and publishing platform based in New York, and a contributing editor of *Bidoun*. His writing on digital culture, aesthetics, literature, and politics has appeared in the *Nation*, the *Believer*, *n+1*, *Bookforum*, *Artforum*, and *frieze*, among other publications. Provan was a fellow at the Vera List Center for Art and Politics from 2013 through 2015.

MORGAN QUAINTANCE is a freelance London-based writer, musician, broadcaster, and curator. He is a regular contributor to *Art-Agenda*, *Art Monthly*, *ArtReview*, *Contemporary And*, *frieze*, and other curatorial websites and blogs. He is the producer of "Studio Visit," a weekly radio show broadcast on London's Resonance 104.4 FM that features international contemporary artists as guests, and works as a presenter with BBC Television's flagship arts program "The Culture Show." He is also a founding member of the curatorial collective DAM Projects.

DOMENICO QUARANTA is a contemporary art critic and curator, whose focus is the impact the current means of production and dissemination have on art. He is Artistic Director of the Link Center for the Arts of the Information Age and has curated numerous international exhibitions, including shows for 319 Scholes, New York (2012); House of Electronic Arts, Basel (2012); Spazio Contemporanea, Brescia (2011); and the Prague Biennial (2009). Quaranta is the author of several books, including *In My Computer* (2011) and *Media, New Media, Postmedia* (2010). With Matteo Bittanti, he coedited the book *GameScenes: Art in the Age of Videogames* (2006). Quaranta is a regular contributor to *Flash Art* and *Artpulse*.

THE RAQS MEDIA COLLECTIVE enjoys playing a plurality of roles, often appearing as artists, occasionally as curators, sometimes as philosophical agent-provocateurs. The group makes contemporary art and have made films; curated exhibitions; edited books; staged events; collaborated with architects, computer programmers, writers, and theatre directors; and founded processes that have left deep impacts on contemporary culture in India. The Raqs Media Collective was founded in 1992 by Jeebesh Bagchi, Monica Narula, and Shuddhabrata Sengupta. Raqs remains closely involved with the Sarai program at the Centre for the Study of Developing Societies (sarai.net), an initiative they cofounded in 2000.

ALIX RULE is a PhD candidate in Sociology at Columbia University and an editor at the *New Inquiry*. She is a grantee of the Creative Capital | Warhol Foundation Arts Writers Program (2008).

PAUL SLOCUM is an artist, software developer, curator, and musician. Previously a Director of And/Or Gallery, a new media art gallery in Dallas, he is now operating an iOS software company in Brooklyn, called SOFTOFT TECHECH, which creates music and art apps. He has performed music and exhibited artwork internationally at numerous venues, including the Dallas Museum of Art (2013 and 2004); Andrea Rosen Gallery, New York (2011); the New Museum, New York (2008 and 2005); the Contemporary Arts Museum Houston (2007); the National Center for the Arts, Mexico City (2005); and the README Software Art Conference, Aarhus, Denmark (2004).

REBECCA SOLNIT is a San Francisco–based writer, historian, and activist. She is the author of seventeen books about the environment, art, and politics including *Unfathomable City: A New Orleans Atlas* (2013); *The Faraway Nearby* (2013); *Infinite City: A San Francisco Atlas* (2010); *River of Shadows: Eadweard Muybridge and the Technological Wild West* (2004); and *Wanderlust: A History of Walking* (2001), for which she received a Guggenheim Fellowship, the National Book Critics Circle Award in Criticism (2003), and the Lannan Literary Award (2003).

WOLFGANG STAEHLE is a German artist who has produced an ongoing series of live online video streams of buildings, landscapes, and cityscapes, such as the Empire State Building in New York, Fernsehturm in Berlin, the Comburg Monastery in Germany, the atmosphere of lower Manhattan before and after 9/11, and a Yanomami village in the Brazilian Amazon.

HITO STEYERL is a filmmaker and writer based in Berlin. Through documentary films, videos, essays, and installations, she examines issues such as the circulation of images and the military-architectural-entertainment complex. A collection of her essays is published in *The Wretched of the Screen* (2012). Steyerl's work has been shown in numerous solo exhibitions at venues such as the Institute of Contemporary Arts, London (2014); Van Abbemuseum, Eindhoven (2014); the Art Institute of Chicago (2012); and e-flux, New York (2012).

MARTINE SYMS is a conceptual entrepreneur whose work examines the myths of American culture. She is publisher of Dominica, an imprint dedicated to exploring blackness as topic, reference, marker, and audience in visual culture.

BEN VICKERS is a curator, writer, network analyst, and technologist, whose interests lie in the way systems of distribution, both human and other, come to affect our personal perception of reality. As an active member of EdgeRyders, a global community of activists and social innovators, he facilitates the development of unMonastery, a new kind of social space designed to serve the local communities throughout Europe in solving key social and infrastructural problems. He is currently Curator of Digital at the Serpentine Gallery, London, and co-runs LIMAZULU Project Space in London.

MICHAEL WANG is an artist based in New York. His work uses systems that operate on a global scale as media for art: financial markets, species distribution, and climate change.

TIM WHIDDEN is a web developer and artist based in Brooklyn, New York. With artist Michael Sarff, Whidden formed the collaboration MTAA in 1996 with an interest in open communication and information exchange. In the form of websites, installations, sculptures, performances, and photographic prints, MTAA has examined networked culture, the economics of art, digital materials, and the institutional art world. MTAA's work has been shown at SFMOMA, San Francisco (2008); the Getty Center, Los Angeles (2005); the New Museum, New York (2005); the Whitney Museum of American Art, New York (2001); and MoMA P.S.1, New York (1999/2000); among other international venues.

DAMON ZUCCONI is a multimedia artist based in Providence, Rhode Island. Most recently, he has had a solo exhibition, "Windows in Progress," at JTT, New York (2013), and an online exhibition, "Multiple," for the New Museum's First Look series (2013).

INDEX

Freedia, 385, 386
Fried, Michael, 57
Friendster, 36, 103, 147
Frumin, Michael, 34
Funkadelic, 382–383

Galerie Dennis Kimmerich (Düsseldorf); illus. *339*
Gallery of Modern Art (Glasgow); illus. *121*
Galloway, Alexander R., 63, 475
 "Two Statements on Carnivore," xxviii, 69–77
Galloway, Thomas, 195
Games, computer video, 29–31, 33, 37, 39, 94–95, 102, 161
Gander, Ryan, 342
GChat, 465
Gelitin (group), 111
Genzken, Isa, 277, 341–342
Geyer, Andrea, 343
Ghani, Mariam, 321
Gibson, William, 326
GIF (graphics interchange format), animated, 101, 124, 105; illus. *131, 132, 151*
Gillick, Liam, 277
Glasgow International, 117; illus. *121*
Glitch art, 197
Goldberg, Adele, 6
Goldsmith, Kenneth, 349, 350
González-Torres, Félix, 377
Google, 222n20, 358, 445, 479
Graffiti Markup Language (.gml), 434
Graham, Dan, 52, 54, 55, 65, 343
Graham, Rodney, 57, 340
Gray, Lauren, 123
Great Internet Sleepover, 160
Greenberg, Clement, 309
Greene, Rachel, xvii, xix
Green Movement (Iran), 289, 299–300
Greenwich Street Capital (GSC) Group, 43
Griffin, Tim, 276, 277
Grindr, xx, 406, 452
Groys, Boris, 54, 475
 "Art Workers," xxx, 357–368
Guyton, Wade, 350n2

Haacke, Hans, 43, 46, 262, 264, 343
Habermas, Jürgen, 323

Hackers, 2, 3, 4, 69–70, 71, 76n2, 359
 hacker manifesto of 1986, 70
 hacking vrs. defaults, xxiii, 171, 173; illus. *172*
 The New Hacker's Dictionary, 12
 original MIT hackers of 1960s, 70
Hall, Stuart, 215
Hallenbeck, Travis, 149, 175, 177; illus. *176*
Halter, Ed, 37, 150, 183, 476
 "The Centaur and the Hummingbird," xxiv, 231–242
 "Hard Reboot," xv–xxxiv
 "Net Aesthetics 2.0 Conversation (Part 2)," 285–288
Hamilton, Richard, 161, 215, 217
Haraway, Donna, 327
Harrison, Rachel, 277, 306
Harvestworks, 29, 47n2
Hauenstein, Nathan, 153
Hawaii, University of, 69
Hebdige, Dick, 215
Heddaya, Mostafa, 321
Heemskerk, Joan, 39, 42
Hemphill, Tahir, 386; illus. *387–389*
Henrot, Camille, 355
Hiller, Susan, 348; illus. *364*
Hip Hop Word Count, 386, 390; illus. *387–389*
Hirsch, Ann, 452, 455–456
Hirschhorn, Thomas, 337, 342
Historiographic problem, xxv–xxvi
Hoet, Jan, 431
Hoggart, Richard, 215
Holmberg, Joel, 149, 177, 179, 233–234, 236, 242; illus. *178, 235*
Hondros, Chris, 251
Hopper, Chad; illus. 142, 143
Hou Hanru, 96
Huang, Andrew "Bunnie," 262
Huang He, 92
Huxtable, Juliana, xxii, 336n1
Huyghe, Pierre, 277
Hyperallergic (forum), 321

IAE. *See* International Art English
i-Mirror, 90, 91
Implementors. *See* Hackers
IMT Gallery (London), 423
Independent Group (IG, think tank), 214

MOSAIC browser, 5
Mosireen (collective; Egypt), xxviii, 298, 300; illus. *292*
Moss, Ceci, 447n4, 478
 "Internet Explorers," xxii, 147–157
Mott, Tim, 6, 10
Move, Richard, 342
MP3 (audio format), 1, 167, 179
M.River. *See* Sarff, Mike
MS Paint, 195
MTAA (collective; Mike Sarff, Tim Whidden), 286
Mul, Marlie, 461
Mulvey, Laura, 421–422, 458
Muniz, Vik, 343
Murray, Janet, 13
Murray Guy (New York gallery); illus. *339*
Museums, xviii, 103, 198, 357–358
Musson, Jayson (Hennessey Youngman), 377–379; illus. *378*
Muybridge, Eadweard, 252
Myspace, 147, 162, 174, 382

Nakamura, Lisa, 373, 383
Nash, Paul, 343
Nashashibi, Rosalind, 340
Nasty Nets (surf club), xxii, 115, 149, 155, 159–160, 162, 179, 184n1, 285
Nauman, Bruce, 421
Needham, Tyrand, 375–377
Negt, Oskar, 60
Nelson, Ted, 1, 6, 8, 10
"Net Aesthetics," xxiii
 "Net Aesthetics 2.0 Conversation, Part 1," 99–106
 "Net Aesthetics 2.0 Conversation, Part 2," 285–288
 "Post-Net Aesthetics Conversation, Part 3," xxix, 413–418
net.art (1990s), xvii–xx, 414
 political net.art, 287
 See also Internet art; Political art
Netmares/Netdreams (curatorial platform), 153
Nettime, xx, 100
Networks, 69, 83, 203, 270, 330, 331, 417
Newman, Michael, 273
New media art, xv

New media gang (NMG), 354
New Museum (New York), 73
 "Free" (2010), xxiv, 233–234, 236–238, 240–242; illus. *235, 239*
 "Montage" (2008), 165
 "Younger Than Jesus" (2009), 183
 See also "Net Aesthetics"
Nochlin, Linda, 165
Norman, Don, 6, 8, 12
Nostalgia for early internet, 105
Novitskova, Katja; illus. *396*
Nyrabia, Orwa, 296–297

Obadike, Keith, 379, 381–382; illus. *380*
Obrist, Hans-Ulrich, 116
Occupy movement, 289, 328, 341, 451
October (journal), 309, 310, 311, 320
Olesen, Henrik, 343
Oliveros, Pauline, 37
Ołowska, Paulina, 342
Olson, Marisa, 149, 155, 186, 196, 478
 "Lost Not Found," xxii, 159–166
 moiMovies, 103
 "Net Aesthetics 2.0 Conversation (Part 1)," 99, 103, 106
Open source/open access, 39, 62–63, 72, 85–86, 262, 446
 See also Public domain
Oppenheim, Lisa, 233
Osborne, Peter, 415
Ovechkin, Ilia, 174

Packet sniffing, 69, 74, 75
Paesmans, Dirk, 39, 42
Paglen, Trevor, 238, 243, 244, 246, 248, 252, 478
 "In Conversation with Lauren Cornell," xxviii–xix, 255–265; illus. *256, 259, 261, 263*
Paik, Nam June, 33, 46
PAINTED, ETC. (blog), 196
PAINT FX (collective), 194
Paolozzi, Eduardo, 215
Paper Rad (collective; Jacob and Jessica Ciocci, Ben Jones), xviii, xix, 16–17, 19–20, 22, 27, 124, 185; illus. *18, 21, 23–26, 143*
 paperrad.org, xix, 17, 20, 27

"Xeroxbook," 55
Xerox PARC (Palo Alto Research Center, Inc.),
 6, 8, 69

Yi, Anicka; illus. *397*
Yoon, Jin-me, 307
Young, Kevin, 371, 375, 377
Youngman, Hennessy. *See* Musson, Jayson
Yousefi, Hamed; illus. *297*
YouTube, 147
YTMND (you're the man now, dog;
 community), 124–125; illus. *127, 128*

Zaatari, Akram, 343; illus. *344–347*
Žižek, Slavoj, 251
Żmijewski, Artur, 341
Zuaiter, Wael, 343, 348
Zucconi, Damon, 110, 153, 480
 "Net Aesthetics 2.0 Conversation (Part 2),"
 285, 287